Nothing but the Clouds Unchanged

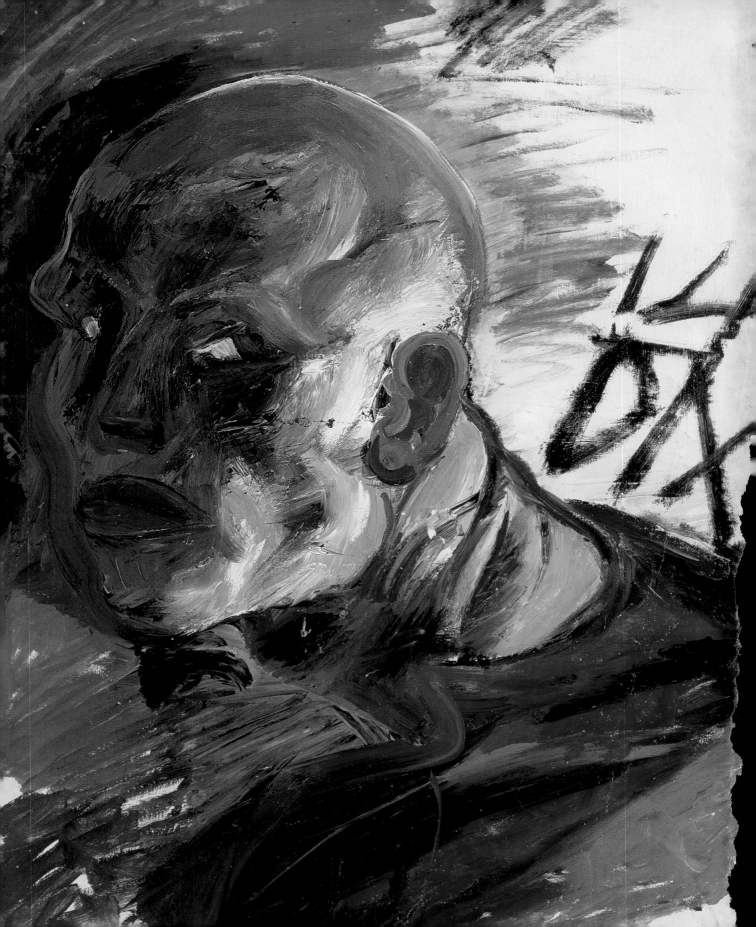

THE GETTY RESEARCH INSTITUTE

Nothing but the Clouds Unchanged

ARTISTS IN WORLD WAR I

EDITED BY GORDON HUGHES AND PHILIPP BLOM

Contents

INTRODUCTION **1**
Thomas W. Gaehtgens

FORCES UNBOUND: **4**
ART, BODIES,
AND MACHINES
AFTER 1914
Philipp Blom

"IN DEAD MEN BREATH": **15**
THE AFTERLIFE
OF WORLD WAR I
Gordon Hughes

ALLIED POWERS

PLATES **28**

ANDRÉ MASSON: **44**
INTO THE "HUMUS HUMAINE"
Charles Palermo

FERNAND LÉGER: **54**
OBJECTS, ABSTRACTION, AND
THE AESTHETICS OF MUD
Daniel Marcus

GEORGES BRAQUE: **62**
ARTILLERYMAN
Karen K. Butler

WYNDHAM LEWIS: **70**
"ART—WAR—ART"
Leo Costello

"IN THE MIDST OF THIS **80**
STRANGE COUNTRY":
PAUL NASH'S
WAR LANDSCAPES
Anja Foerschner

CARLO CARRÀ'S **88**
CONSCIENCE
David Mather

CENTRAL POWERS

98 PLATES

108 **OTTO DIX:**
WAR AND REPRESENTATION
Matthew Biro

118 **ERNST LUDWIG KIRCHNER:**
AN INNER WAR
Thomas W. Gaehtgens

128 **KILLING "MAX ERNST"**
Todd Cronan

138 **GEORGE GROSZ**
AND WORLD WAR I
Timothy O. Benson

146 **KÄTHE KOLLWITZ,**
THE FIRST WORLD WAR,
AND SACRIFICE
Joan Weinstein

156 **LÁSZLÓ MOHOLY-NAGY:**
RECONFIGURING THE EYE
Joyce Tsai

164 **OSKAR KOKOSCHKA:**
THE GREAT WAR AND LOVE LOST
Beatrice von Bormann

172 **OSKAR SCHLEMMER'S**
TRIADIC BALLET AND THE
TRAUMA OF WAR
Paul Monty Paret

180 APPENDIX:
SELECTED CULTURAL
FIGURES WHO SERVED
IN WORLD WAR I
Hannah Fullgraf
with Betsy Stepina Zinn

186 CONTRIBUTORS
188 ABOUT THE PLATES
188 ILLUSTRATION CREDITS
191 ACKNOWLEDGMENTS
192 INDEX

KARTE VON

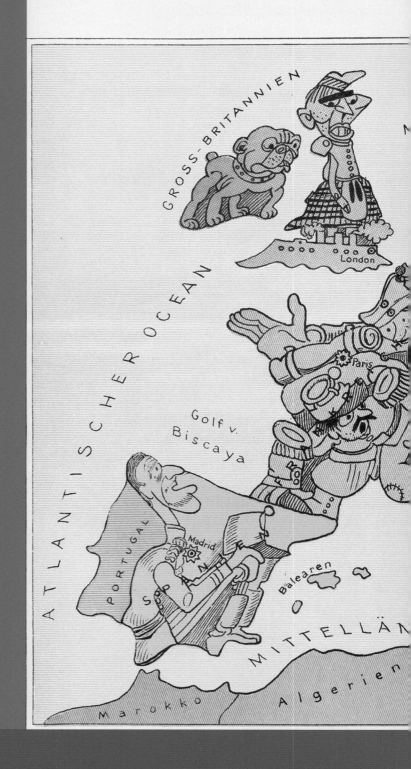

EUROPA IM JAHRE 1914

Gezeichnet von W. Trier

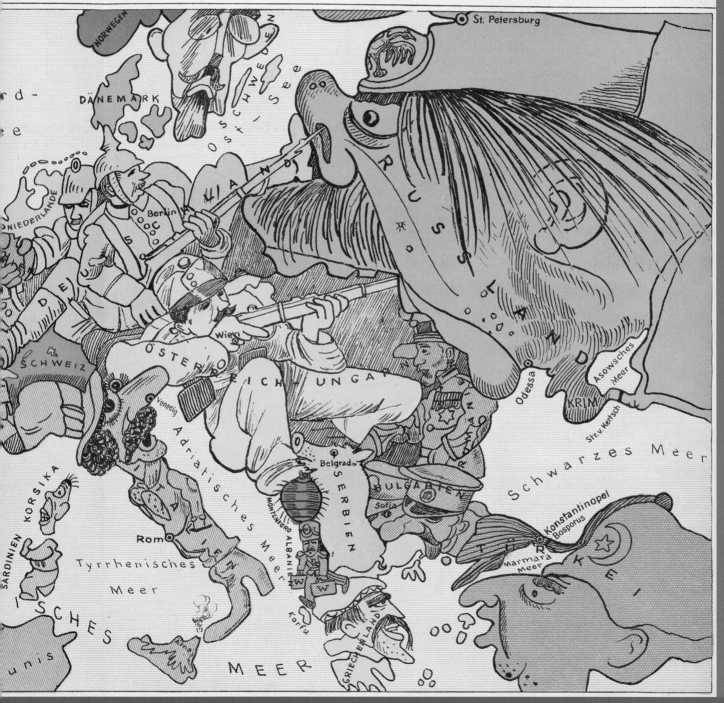

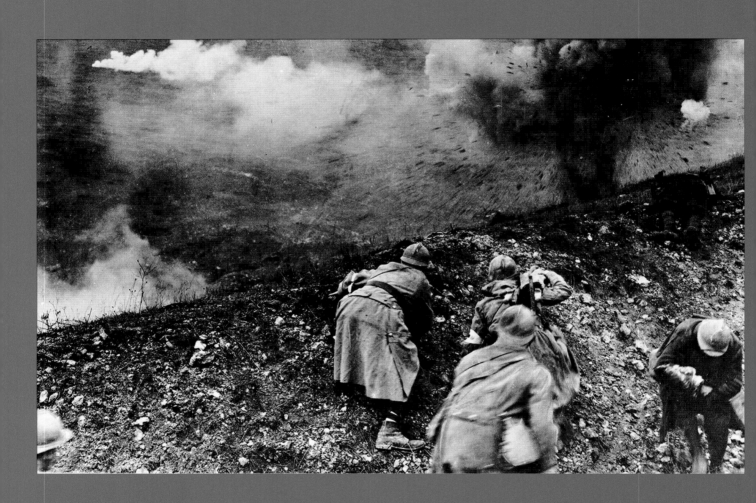

THE GETTY RESEARCH INSTITUTE (GRI) HOLDS MAJOR COLLECTIONS CONCERNING WORLD WAR I. Artists' letters, journals of the period, photographs from the trenches, posters, and other ephemera constitute a trove of material that illuminates this catastrophic event. To commemorate the war's centennial, a vast array of revealing documents has been selected by curators Nancy Perloff, Gordon Hughes, Philipp Blom, and Anja Foerschner for the exhibition entitled *World War I: War of Images, Images of War.*

The exhibition identifies two types of images that were characteristic for the period. The first type is printed material that was published in all European countries to disparage the cultures of neighboring nations. Before weapons were used in the hostilities, a fight began with images meant to ridicule and offend adversaries. The propagandistic campaigns supported and perhaps even inspired the naive enthusiasm and ardent feelings of patriotism that motivated many volunteers to enlist. Many artists, writers, musicians, and large numbers of the middle class took up arms under the illusion that the war would not only bring victory but also establish a new and purified social order.

Introduction

THOMAS W. GAEHTGENS

But never has illusion been so far from reality. World War I started with armies on horseback and became an apocalypse in the trenches. Mentally prepared to be eyeball to eyeball with the enemy, the soldiers found themselves in a conflict in which machines and mechanization took command. The second type of images on display records the terrible suffering sustained by the soldiers and the civilian populations of all countries involved in the conflict. Artists, despite being in extremely difficult and dangerous situations, left testimonies of their daily experiences between life and death. Images from these two perspectives—illustrating first enthusiasm and then disillusion—embody the schizophrenic condition of this calamitous event and form the topic of the GRI's centennial exhibition on World War I.

Written by specialists, this volume of essays on the life and oeuvre of fourteen artists reproduces a selection of the most telling examples of the testimonies shown in the exhibition and, at the same time, expands the focus of scholarly investigations. Although it arose from the preparation of the exhibition—the many enlightening discussions and the time spent digging in a fascinating collection of the visual culture of the period—this book is not a catalog. Rather, it specifically focuses on the wartime experiences of individual artists. The fundamental disruption and inner conflict of a whole generation is exemplified here by a select group of artists who experienced the full arc of the lead-up, combat, and aftermath of the war. Their stories are accompanied by visual material from the exhibition, appearing here as plates, which cannot be seen without emotion.

If the reader misses a profile of Umberto Boccioni, Franz Marc, or others who did not survive the war, existing scholarship is available. The central theme and

guiding consideration for the editors' choice of artists for this volume was an experience of the full cycle of the war. The idea was to trace and understand the confusing and existential itinerary from excitement for engagement to desperation, and then to analyze how these artists found their way back into life after escaping hell.

Some of the artists rendered the ordeal of the trenches in their works. Otto Dix is the German artist par excellence who illustrated his first-hand experiences of the horrors of war. Dix, who volunteered in 1914, was deeply impressed by his reading of Friedrich Nietzsche's philosophy; having survived the trenches, he created large canvases based on his battlefield sketchbooks after the war. In these works, he transformed his experience at the front into monumental allegories of a universal antiwar message. British artists such as Wyndham Lewis and Paul Nash represented their war experiences in a comparable way. Although engaged in vorticist abstraction, Lewis returned to figuration to render the mechanical elements of the war, stressing the vulnerability of the human body. The modernity of World War I—the use of new technologies such as airplanes, zeppelins, photography, film, and the telephone—fascinated artists such as Fernand Léger and László Moholy-Nagy and influenced their work.

Other artists demonstrated the political and social roots of the conflict. Although he never fought in the trenches, genial and sarcastic draftsman and painter George Grosz was deeply affected by his time in and observation of the war environment. He analyzed the social context of dubious heroism, war profiteers, and corruption. Grosz was part of the left-leaning Berlin Dada movement after the war but did not identify closely with any political party. However, he lived in hope, expressed in his art, that, even after the apocalyptic events and the cataclysmic changes to society, a new generation might build a better world.

This book explores the fascinating ways in which different artists reacted in the face of this historical conflict. Although Max Ernst spent the war in rather secure conditions, he declared that he died in 1914 and was resurrected in 1918, when he started a new artistic life as a Dadaist. By contrast, Oskar Kokoschka confronted real danger and was wounded several times. But it seems as if his confusing and heartbreaking relationship with Alma Mahler eclipsed even the most frightening fights. Ernst Ludwig Kirchner, after a very short encounter with the military far from the trenches, feigned "war sickness" to escape combat and eventually did become seriously ill, both physically and emotionally. Kirchner tried to come to terms with his psychological state by distancing himself from the war, but not without expressing his inner conflicts in works of art.

This escapist attitude was in strong contrast to the reaction of Käthe Kollwitz, who lost her son Peter in April 1916. After initially supporting his voluntary enlistment for the patriotic cause, she struggled with his decision and Peter's resulting "sacrifice" for the rest of her life. Unable to find consolation in the officially proclaimed virtue of heroism, her woodcuts and engravings represent some of the most moving images of grief in art history. Their appeal as antiwar symbols was so strong that her work was later defamed during the Nazi period as so-called degenerate art. This was a destiny she shared with many artists who, having experienced combat, denounced the war through their art.

All the artists in this volume were influenced by their involvement in the war; however, they expressed their experiences in very different ways, some of which are

not easily recognizable or conveyed in a metaphorical manner. Oskar Schlemmer, who volunteered, suffered injuries that removed him from the front lines. The disturbing impressions of war pursued him, especially after he returned home, where, like everyone else, he was confronted with mutilated veterans. Disfiguration, dismemberment, and prostheses thus became revealing motifs in Schlemmer's *Triadic Ballet* (1922). The elaborate, physically limiting costumes of the dancers mimic in a mechanical and symbolic manner the restricted movements of amputees while illustrating how human bodies are guided and controlled. Schlemmer's work is the artistic product of Bauhaus modernity, but it cannot fully be understood without knowledge of its creator's wartime experiences.

Similarly, in his cubist and postcubist paintings, Georges Braque seemingly repressed his time in the trenches and his experience of being critically injured on the battlefield in 1917; in fact, a change in his aesthetic approach can be detected. The still lifes he painted after the war seem, at first, to be works that distance the artist from the disastrous events. However, one could argue that the new tangible qualities and the materiality of "tactile space," as well as the visual disorder in the formal structure of Braque's paintings, represent his attempts to come to terms with what he endured at the front.

The true horrors of World War I were unprecedented. Even though the futurists proclaimed the necessity of fighting to rebuild a new society, Carlo Carrà's initial nationalistic and patriotic feelings crumpled when he faced the realities of war. He never volunteered but served for some time before suffering from a nervous breakdown due to the trauma of combat. Inspired by Giorgio de Chirico, Carrà's oeuvre moved away from the futurists after his stay in a military hospital. His metaphysical paintings developed from a struggle of conscience between prowar enthusiasm and the atrocities of battle.

After fighting at the Chemin des Dames—one of the most disastrous battlefields of World War I—and lying injured and immobilized for an entire night waiting to die, André Masson, like many others, had to overcome a deep psychological trauma. These events led Masson, as a surrealist painter, to explore and express the borderline between death and life, reality and dream, eroticism and violence.

These stories are all individual cases of devastating war experiences, but they have common elements that are independent of which side the artists were fighting on; just like every other soldier, the artists were unprepared for what they would have to endure. The war left a whole generation mentally disillusioned, physically injured, and psychologically wounded. However, unlike doctors or shoemakers who could go back to their professional life as it was before the war, artists could not easily return to their work without addressing the severe disruption the conflict had caused. Each one, in his or her own way, had to confront the hellish events and develop new modes of expression in which—consciously or unconsciously—the past was a part.

World War I did not create a new artistic style, and certainly was not the beginning of modernity, but it changed the empathy and the sensibility of many artists. The historic event presented a fundamental change in the artists' lives, which had to be faced in order for them to find a new orientation. They pursued different ways in their search for an adequate artistic language to express their experiences, but the apocalyptic events had traumatized them forever.

> A generation that still drove to school in horse-drawn carriages suddenly stood under the open sky in a landscape with nothing but the clouds unchanged, and in the center, in a force field of destructive currents and explosions, was the tiny, fragile human body.
> — Walter Benjamin[1]

WALTER BENJAMIN'S OFT-QUOTED ANALYSIS OF THE EXPERIENCE OF THE FIRST WORLD WAR is one of many insisting on the fact that after 1918 everything had changed—and changed "suddenly." History has, to a large extent, accepted this division as well as the fact that the force field engulfing and attacking the soldiers at the front was something quite unheard-of, an alien experience for the men who grew up with horse-drawn carts and the ways of the past before being engulfed by the modernity that would mark the interwar years. A world had passed, and another one had begun. European culture, and with it art, would never be the same again.

Forces Unbound
Art, Bodies, and Machines after 1914

PHILIPP BLOM

As popular as this version of modernity in the 1920s and 1930s is, it fails to account for both the origin and the profundity of this tide of change. More importantly, perhaps, the idea of sudden change does not address the accelerating tide of technological, cultural, and artistic innovation before 1914. In Germany, the thrusting advance of the new empire had contributed to a sensitivity toward the new. As early as 1889, German writer Hermann Conradi called modern urbanites "transitional people" (*Übergangsmenschen*); and during the same year, social theorist Max Weber wrote in a letter to a friend: "One has the impression of sitting in a railway carriage at high speed, but always in doubt whether the next point has been set correctly."[2]

Reconstructing the mental and cultural landscape of an era by reading not only its economic circumstances, popular culture, and political debates but also its works of art as witnesses to more general attitudes and preoccupations is necessarily an undertaking fraught with intellectual risk. Indeed, it is tempting to use individual artistic style and its evolution as direct evidence of an overwhelming experience such as the Great War and to flatten the complex interplay of creativity, individuality, and experience into mere illustrations of general cultural trends.

Several artists who served at the western front, however, would later write about the importance of their experience for their art. Painters such as Otto Dix, Max Ernst, George Grosz, Fernand Léger, and Paul Nash, all of whom had been in the trenches (Nash as an official war artist) and been wounded or severely traumatized, wrote about the ways in which their experiences had affected and informed their works, thereby inviting readings of their output and its stylistic progression in the light of their experience, particularly that of serving at the front.

While the war undoubtedly represented a cultural, social, and political water-shed in Europe (as well as, indirectly and to a lesser degree, in the United States) by creating the feeling of existential abandonment in Benjamin's "force field of destructive currents," Europe's great catastrophe was itself part of a larger development formed by energies and circumstances that completely reshaped the lives of urban Europeans, among them the artists who would later volunteer or be drafted into the army.

In 1917, one year before the end of the war, German Dadaist poet Hugo Ball proposed his own poetic and ecstatic analysis of modernity and life in the big city and their effects on culture, psychology, and, by inclusion, art. In a remarkable passage informed more by expressionism than by the Dadaism of the Café Voltaire, he exclaimed:

> God is dead. A world has collapsed. I am dynamite. World history has broken into two halves. There is a time before me. And a time after me. Religion, science, morality—phenomena originating in the fear of primitive peoples. An era collapses. A thousand-year culture collapses. There are no pillars and supports, no foundations, which would not have been shattered.... The world reveals itself to be a blind battle of forces unbound. Man lost his celestial face, became matter, conglomerate, animal, an insane product of thoughts twitching abruptly and insufficiently. Man lost his special status, accorded to him by Reason.... The titans arose and broke the heavenly fortresses.... The world became monstrous, uncanny, the relationship with reason and convention, the yardstick vanished.... The science of electrons caused a strange vibration in all surfaces, lines and forms. Objects changed their form, their weight, their relationships.... And another element collided destructively and menacingly with the desperate search for a new order in the ruins of the past world: mass culture in the modern metropolis. Complex the thoughts and sensations assailing the brain, symphonic the feelings. Machines were created, and took the place of individuals.... Turbines, boiler houses, iron works, electricity created force fields and spirits.... New battles, new trips to hell and to heaven, new feasts, heavens and hells. A world of abstract demons swallowed individual expression, swallowed individual faces into towering masks, engulfed private expression, robbed individual things of their names, destroyed the ego and agitated oceans of collapsed feelings.[3]

Ball's rhapsodic prose is remarkably similar in content to Benjamin's more soberly reasoned assessment, but it also expresses a crucial difference. For Benjamin, the "force field of destructive currents" was a creature of the war; Ball localized the crucial impetus of this change in the cities of pre-1914 Europe.

In his autobiography, American writer Henry Adams famously recognized an epochal change when confronted with huge dynamos at the Exposition Universelle of 1900 in Paris, a paradigm shift from the (Christian, fertile) Virgin to the Dynamo as the creative principle and emblem of its societies. Within less than a generation, Western societies were in the throes of a colossal transformation; machines,

trains, telephones, cinemas, and scientific instruments extended into the most intimate aspects of the lives and the self-perceptions of (mainly) urban Europeans and Americans.

In the years leading up to 1914, the denizens of the growing urban agglomerations had come to rely on mass transportation, mass-produced goods, food imported from across the globe, work in factories and offices, newspapers and cinemas, and everyday technologies such as condoms made from vulcanized rubber, which facilitated easier and less-risky access to sex. These technological advances changed not only daily lives but also the sense of self of those living in this way.

Mass production and large-scale professionalized planning led to a considerable democratization of entertainment and leisure, food and consumer goods, and education and travel. Technological innovation paved the way for social and cultural transformation. A wave of women's rights movements, the rise of political participation and union representation among industrial workers, strikes and socialist parties, and the beginnings of civil rights agitation by minorities and in the colonial empires all contributed to this new dynamic. The world had grown, and it had accelerated. Clocks, conveyor belts, timetables, telegrams, and telephones sped up daily life; racing cars, bicycles, planes, and even trains and ships dominated the news. New records were set and broken every day in a contest between human mechanical ingenuity and nature. Machines extended human abilities beyond most people's dreams. Sigmund Freud called these new creatures "mechanical gods."[4]

The headlong rush of history also caused deep anxieties. On a philosophical level, writers of various political stripes, ranging from racist mystics to fanatical and self-hating Otto Weininger and left-leaning humanist Émile Zola, all emphasized the point that modernity was devouring its children, that virtue and dignity were being swallowed by the rootless, internationalized, capitalist mass-production life of the big city.

Artistic responses to this new and dangerous instability were varied and diverse; they reached from the declamatory possessiveness of the Italian futurists to the collage and fragmentation of the cubists, and to the search for archaic authenticity in the pre-Christian past by, among others, artists Vassily Kandinsky and Pablo Picasso; composers Béla Bartók, Zoltán Kodály, and Igor Stravinsky; and the eccentric but immensely influential Russian symbolist poet Vyacheslav Ivanov.

In 1914, the majority of the artists who would serve in the war were only at the beginning of their careers, but some—among them, Umberto Boccioni, Georges Braque, Max Ernst, Ernst Ludwig Kirchner, Oskar Kokoschka, Fernand Léger, Wyndham Lewis, and Franz Marc—had already established themselves. Aesthetically and at times even politically, each of these artists had positioned himself within the rush of modernity; some had allowed the new mechanistic and uncertain world of mechanical forms and shaken identities to enter their work.

Speaking about Kandinsky in 1917, Hugo Ball gave a description of the vertiginous experience of modernity that reads like a manual for avant-garde painters: "The world became monstrous, uncanny, the relationship with reason and convention, the yardstick vanished.... The science of electrons caused a strange vibration in all surfaces, lines and forms. Objects changed their form, their weight, their relationships."[5]

At the same time, the warlike scenario of city life described by Ball is strikingly similar to the experience of life at the front as reported by soldiers: a hellish place of machines and technology, of constant threat and annihilated individuality—a place where everything is ruled by abstract demons. For artists who had served at the front, the challenge was not only how to live with the memories and the nightmares haunting them every day but also how to give expression to them, to find a language for communicating experiences for which there appeared to be no words, no colors, no shapes, and no sounds.

To Ball, the "blind battle of forces unbound" that was city life anticipated the horrors that were to come at Verdun and the Somme, as well as in the other theaters of war—Gallipoli, Isonzo—in which the fighting was tied down, highly mechanized, and consequently soul destroying. Life at the front made the soldiers experience total mechanization, rationalization, planning, and mass production; even killing had become an industrial process rather than an act of personal bravery or even heroism. Despite all their deprivations, the front lines were the most modern and most modernist places on earth.

For millions of soldiers, and their families in particular, the experience of the war intensified and accelerated their encounter with modernity. The armies on all sides were gigantic machines by which men, horses, millions of tons of food and ammunition, news, secrets, ideas, and experiences were transported, spread, and deployed over thousands of kilometers along sophisticated road and communications networks, all to be consumed at their destination and to kill and be killed. Telecommunications, airplanes, machine guns, poison gas, and barbed wire: the war used the most advanced technologies.

Countless men, especially those from rural areas, traveled to a foreign country for the first time in their lives, and as soldiers in uniform, they were little more than anonymous ciphers and meticulously kept statistics in a monstrous game played between generals and politicians. Far from being a radical break with human history in which "nothing but the clouds remained unchanged," the devastated landscape of no-man's-land was an accelerated and intensified version of modernity, as well as its bitter parody.

The technologized nightmare that was life at the front was devastating to many soldiers not only because of the unbearable stress caused by constant shelling, fear, dirt, and the presence of unburied decomposing bodies but also because it negated the very reasons for which particularly the first crop of volunteers had enlisted. Amid the vertiginous social and cultural change around them, many recruits articulated a sense of relief, of release from nervousness, uncertainty, and the effeminacy of civilization and a return to a mythical masculinity of heroism, courage, willpower, stamina, leadership, and strength. Before 1914, those who could not cope with the new demands of urban private and professional life had been declared "neurasthenics" and sent to mental hospitals to recuperate away from the constant haste of the metropolis. Others had sought refuge in rituals of masculinity such as bodybuilding and a cult of health and fitness. More duels were being fought than ever before, while the small advertisements in newspapers from Chicago to Berlin asked their readers whether they might be suffering from a secret "manly

weakness" or from "nervous exhaustion," counseling tinctures and electric baths to stimulate virility.[6]

Many of these volunteers signed up to face their enemy saber in hand, to reclaim "pure will" and "pure action" for themselves and be tempered in a "bath of steel" to emerge as new and transformed men. As we shall see, the motive of masculinity and transformation would run like a red thread throughout the interwar period. As the first, frequently enthusiastic soldiers volunteered in Munich and Manchester, Linz and Lyon, their ears were ringing with sermons, lessons, and public exhortations to follow the noble call of the fatherland, to find death or glory on the field of honor, to engage in a holy fight blessed by the Lord, one pitting man against man, saber against saber, courage against courage. For many, the war seemed the ideal panacea against life in a soulless modern world.

But not all those who were called up were supporters of the war, despite the fact that there was undoubtedly a degree of enthusiasm in the summer of 1914, a phenomenon referred to in German simply as the *Augusterlebnis,* the "August experience." This orgy of effusive articles, letters, diary entries, and public events proclaimed patriotic fervor on all sides and has long been thought to prove that the main actors and the elites before 1914 were naive and all too willing to rush to war.

Recent research has created a more nuanced account of soldiers' motivations. There was enthusiasm, and there is abundant evidence for this, but mainly because those who were enthusiastic—often young men from middle-class backgrounds—were precisely the kind of people who were likely to leave evidence in the form of letters, diaries, poems, and memoirs. This image, however, ignores the opposition to the war coming from workers and farmers on all sides (the former because their families would go hungry, and they saw the war as a capitalist plot; the latter because their fields would be left untended). It disregards the large, usually socialist peace demonstrations in Berlin, London, and Paris and the many voices declaring their shock and predicting a catastrophic end to the war even in August 1914. It also forgets to what extent the myth of the "August experience" was a conscious creation by conservative publicists, as seen in the *Kriegsbriefe deutscher Studenten* (War letters by German students), published in 1916 by Philipp Wittkop in Germany. Two hundred thousand copies of this highly selective and propagandistic work of retrospective hero worship were in circulation by the time Adolf Hitler came to power, and its popularity still informs the common assumption that soldiers as well as entire societies went into the war with feverish enthusiasm.

While many soldiers went to war feeling worry for themselves and their families, resentment at being forced to fight for a cause that was not theirs, and genuine enthusiasm for the gloriously dangerous life of a soldier and the cleansing "bath of steel," the experience in which they found themselves was worse than anything they might have feared. The highest hopes of heroism were dashed by the reality of mechanized warfare as soldiers sat waiting in waterlogged trenches until, at some random moment, a shell hurled by a gun kilometers away would come out of the sky and obliterate all life with cruel indifference to courage and patriotism. At the front, they encountered not the apotheosis of the individual but an overwhelming dystopia of technology run amok, leaving in its wake a trail of mangled, unnamed corpses.

The hope of an apotheosis of masculinity as an answer to the disorienting tide of modernity was a recurrent theme in the debates that followed in the wake of the war. Another important trope, especially for art and artists in the interwar period, had gained currency before 1914 but was rendered pressing by the experience of battle: the relationship between man and machine seemed to have been irrevocably tipped in favor of the latter. During the early 1900s, the fusion of muscle and steel had been celebrated by newspapers, films, and novels and praised by Italian futurists and Russian avant-gardists alike. Race-car drivers, pilots, cyclists, and all manner of mechanized adventurers had been the heroes of the age, despite the warnings voiced by writers Luigi Pirandello and H. G. Wells, among others.

With the cessation of hostilities came wave after wave of demobilized soldiers returning home. In Germany alone, 6 million men had served and were now discharged, 2.7 million of them severely wounded and often missing limbs. During the war, for obvious reasons, reconstructive surgery and prosthetics had made great strides, and after 1918, all industrialized nations made efforts to supply veterans not only with financial support but also with prosthetic limbs. The dream of the man/machine that was as old as Daedalus and the wings he had crafted for Icarus took an abrupt turn toward the sinister as disabled veterans with or without artificial arms and legs and with reconstructed faces were beginning to be a highly visible presence in the streets, often as human ruins, beggars, or match sellers.

Building on his own fighting experience, conservative German writer Ernst Jünger penned a surprisingly Marxist analysis of his experiences at the front:

> The war battle is a frightful competition of industries, and victory is the success of the competitor that managed to work faster and more ruthlessly. Here the era from which we come shows its cards. The domination of the machine over man, of the servant over the master, becomes apparent, and a deep discord, which in peacetime had already begun to shake the economic and social order, emerges in a deadly fashion. Here the style of a materialistic generation is uncovered, and technology celebrates a bloody triumph.[7]

But not only soldiers' bodies had been shattered. "Shell shock" entered the language as a term to describe the epidemic of cases of nervous exhaustion and post-combat trauma that was particularly intense in the mechanized environment of the western front. During the Battle of the Somme, thirty thousand men had been diagnosed with the condition on the British side alone. Shell-shocked soldiers were living reminders of the fragility of the human spirit and the danger of it being crushed by the mechanized hell of shelling, gas, machine guns, and, to a more limited extent, tank warfare.

Manifest cases displaying symptoms such as uncontrollable shaking, psychosomatic paralysis, deafness or blindness, amnesia, intense nightmares, and pathological fear of loud noises were treated in specialized clinics hurriedly set up or expanded during the war. The countless hidden cases of trauma, however, remained untreated as veterans simply returned home and struggled to take back the reins of their old lives. Most never talked about their experiences; and as war memorials and cenotaphs

were being constructed in cities and villages throughout the Western world and its colonies in an attempt to create a patriotic, heroic narrative of sacrifice, the actual lived reality of the war was often shrouded in horrified silence.

The ambivalent relationship of man and machine would remain a subject for philosophy and the arts, as would the experience of impotence in the face of overwhelming machines. From now on, it seemed, most men and women would be the slaves of machines constructed to create the wealth of others, a theme recurring throughout the 1920s and 1930s; the best-known examples include films such as Fritz Lang's *Metropolis* (1926) and Charlie Chaplin's *Modern Times* (1936).

"Ideas belong to human beings who have bodies," wrote American philosopher John Dewey in 1927, "and there is no separation between the structures and processes of the part of the body that entertains ideas and the part that performs actions."[8] The bodies of the soldiers, which both Benjamin and Ball described as having been abandoned to the "fields of destructive forces," had been sacrificed to the bloody triumph of the machine age, and the consequence was not only the face of mass death in the trenches but also a more subtle and more profound defeat.

Already a reality before the war but perceived as such only by a minority of farsighted observers, the machine age had asserted itself with its full, brutal force. The inferno of trench warfare was a product of sophisticated planning, logistics, and tactics, and of engineering and statistical analysis; it appeared to be a result of the pure reason of the Enlightenment and yet the result had been inhuman slaughter. The young men fighting in the trenches quickly came to understand that everything they had come to fight for, everything they had been taught at school and in church, everything they believed in was a myth propagated by people hopelessly out of touch with the brutal reality of their lives. They would not forget this lesson, and the idea of universal reason would come under sustained attack.

The depth of trauma for combatants and noncombatants and the pervasive feeling of total uncertainty so eloquently evoked by Ball may also offer insights into the artistic choices made by artists after the war. The intensification and acceleration of the experience of modernity in the trenches and the reporting about the war in countries that had transformed into war economies could be expected to be reflected in a new artistic language or with a push toward more experimental work; but with the exception of the surrealists, whose declared aim was to attack and undermine bourgeois moral and aesthetic ideas, and the Russian avant-gardists, very few artists or artistic movements went beyond the artistic universes of pre-1914 Europe.

Rather than attempting to push boundaries, artists such as Pablo Picasso recoiled from earlier experiments and sought inspiration in the beauty and serenity of classical antiquity. Many of his colleagues also discovered and formulated a neoclassical aesthetic with a notable celebration of physical, bodily beauty and spiritual integrity. The torso reemerged as a popular sculptural subject, echoing both the beauty and vitality of the human body — and, if sculpted without extremities, the damaged bodies of the veterans — while also creating small dramas of death and redemption. Composers such as Paul Hindemith, Maurice Ravel, Richard Strauss, and Igor Stravinsky found new interest in classical forms and harmonies; poets such as T. S. Eliot and Ezra Pound mined the Western canon for quotations and images;

and James Joyce wrote *Ulysses,* the most daring literary work of the epoch, with an underlying structure from Greek myth.

The transformative ideologies of fascism and bolshevism rose enormously in popularity in an attempt to address the crisis of reason and of morality characterizing the immediate postwar period. Combined with the neoclassical cult of physical beauty and strength, they would inform the rapid spread of sculpted supermen adorning public buildings and urban spaces, forming visions of bodies that had transcended the threat of the machine and been transformed into a luminous and pure race capable of overcoming all future challenges from man or machine. The inflationary aesthetics of fascism and bolshevism was not only a statement of an imagined future but also an answer to the haunting memories of shell-shock victims and mutilated veterans.

The lived experience of warfare eluded and even defied depiction, as famously exemplified by photographic stills of flat landscapes plowed by ordnance or crowds of resting or marching soldiers in moments of respite; in fact, these images did more to obscure than to reveal the apocalyptic scenes of carnage and naked panic during an attack or the mind-numbing boredom of waiting in the trenches. Writers such as Blaise Cendrars, Welsh poet David Jones, Erich Maria Remarque, and, in a very different and aestheticizing way, Ernst Jünger addressed these horrors with varying degrees of success. But with the solitary exception of Otto Dix, artists who created graphic representations of these dimensions of warfare struggled to find an idiom for experiences that were more horrific and alien in their technological terror than a single surface could express.

Both represented in the *World War I: War of Images, Images of War* exhibition, the *Apocalypse* watercolor series by Ernst Ludwig Kirchner and the cycle of etchings titled *The War* (*Der Krieg*) by Otto Dix give eloquent testimony of the ensuing artistic search for an adequate expression. While Kirchner drew on the Christian tradition and, more specifically, on Albrecht Dürer's treatment of the celestial vision of the Last Days, Dix chose secular guidance in the visual languages and etching techniques of Rembrandt van Rijn and Francisco de Goya.

The horror of the war remained elusive. British sculptor Jacob Epstein had embraced the mechanical pace and aesthetics of the metropolis in his towering sculpture *Rock Drill* (1913), in which a mechanical figure—part man, part beast, and all machine—was installed atop a rock drill that Epstein had purchased from a hardware store. Deeply affected by the deaths of friends and the seemingly interminable fighting, he modified his work by removing the drill as well as the legs, cutting off an arm, and casting the remaining truncated figure in bronze, creating a bitter memorial to the dreadful transformation the soldiers themselves had undergone as they were turned from largely peaceful private citizens into units of a gigantic killing machine.

The ambivalent relationship between organic human life, with its emotions and its capacity of reflection, and the coolly mechanical madness of unfeeling reason remained a discursive as well as an artistic focus of attention during the interwar period. Time and again, creatures of flesh and blood morphed into prosthetic parodies of humanity extended and alternated by science, becoming murderous monsters unable to resist the orders of their master yet struggling to break free.

This motive would surface in popular culture with film productions centered on damaged bodies and minds, such as the vampire in *Nosferatu* (1922), the nameless monster in *Frankenstein* (1931), *Dr. Jekyll and Mr. Hyde* (1931), the chained and innocently tormented *King Kong* (1933), and the pianist Orlac in *Orlacs Hände* (*The Hands of Orlac,* 1924), in which the artist loses his hands during a train crash and finds, after receiving a transplant pair, that the hands belonged to a murderer and he himself is now possessed by murderous fantasies.

Perhaps acting on the atmosphere in a vanquished country in which amputated ex-servicemen were a common sight, the German film industry was the first to dramatize the constrained body whose homicidal strength, suffering, and humiliation turn him into a hunted outsider unable to communicate with ordinary humans. Playing on a traditional Jewish legend, *Der Golem* was screened in 1920. The monster's name would later be borrowed by an Oxford linguist who was himself a veteran of the western front and who re-created the cabbalistic creature as a dehumanized body, a shell-shock victim whose wounds had never healed and whose stunted intelligence made him a slave to his lowest instincts; this was, of course, Gollum in J. R. R. Tolkien's 1937 novel *The Hobbit.*

In the war's aftermath, the immense energies of modernity continued to transform the countries of the West along the same axes as it had done before. Now, however, the optimism toward technology was gone; the idea of a glorious, uninterrupted march of progress lay in ruins; and faith in the values underpinning society was profoundly shaken. The great technological transformation continued unabated, but its conflicts changed in character. As the guns fell silent, the battles raged on, turning inward as many societies found that they were at war with themselves.

Fascism and bolshevism were at the extremes of a political spectrum that had expanded rapidly and whose arguments frequently turned into street fighting and even civil war. The catalytic effect of the war sped up and reignited debates and social conflicts that had been smoldering for decades, and the perceived moral vacuum of the interwar period was an ideal breeding ground for prophets of all creeds, offering some new great truth to supplant those that had been lost. The battered, vanquished, and humiliated human frame was once again to be healthy, clean, and above all powerful.

The shining city on the hill populated by supermen and constructed by ideologues of all persuasions formed a stark contrast with the political realities of Europe after the war, a time designated as peacetime by the signatories of the Treaty of Versailles, but in reality it was a state more akin to civil war and political uncertainty. In Germany alone between 1918 and 1923 (the year of the catastrophic hyperinflation), more than five thousand people were killed through political violence; and while other countries were not as deeply unsettled, there was also large-scale and sometimes murderous political unrest, violent strikes, rioting, and *coups d'état* in Austria, England, France, Hungary, Ireland, Italy, and Portugal, to say nothing of the proxy war fought after 1936 between fascists and socialists in Spain.

From the beginning of the war on 20 August 1914 to the armistice on 11 November 1918, only 1560 days separated two seemingly very different worlds from each other. Far from interrupting the ongoing seismic shifts between man and machine, men and women, culture and technology, the war acted as a catalyst, accelerating the

assimilation of new technologies into the lives of the millions who were transported across Europe or across continents to fight in a hell of artillery, barbed wire, machine guns, and tanks, and into the lives of their family members, who grieved their deaths or who had to care for and live with traumatized survivors.

Hugo Ball's poetic 1917 vision of an all-devouring modernity had been realized in the trenches and on the battlefields and had been carried back into the societies of victor and vanquished by millions of returning soldiers. What they had seen was to constitute a central concern for their lives, and for modernity itself. In Ball's words: "Machines were created, and took the place of individuals.... A world of abstract demons swallowed individual expression, swallowed individual faces into towering masks, engulfed private expression, robbed individual things of their names, destroyed the ego and agitated oceans of collapsed feelings."

– NOTES –

1 Walter Benjamin, *Illuminationen: Ausgewählte Schriften* 1 (Frankfurt am Main: Suhrkamp, 1977), 385–410. All translations are mine.

2 Max Weber to W. Baumgarten, 31 December 1889, in Johannes Friedrich Winckelmann, ed., *Gesammelte politische Schriften* (Tübingen, Ger.: J. C. B. Mohr Paul Siebeck, 1958), 323f.

3 Hugo Ball, "Kandinsky: Vortrag gehalten in der Galerie Dada (Zürich, 7. April 1917)," in Hans Burkhard Schlichting, ed., *Der Künstler und die Zeitkrankheit: Ausgewählte Schriften* (Frankfurt am Main: Suhrkamp, 1984), 41–43.

4 Sigmund Freud, *Das Unbehagen in der Kultur* (Vienna: Internationaler Psychoanalytischer, 1930), 50.

5 Hugo Ball, "Kandinsky," 42.

6 For a further discussion of the crisis of masculinity, see Philipp Blom, *The Vertigo Years, Europe, 1900–1914* (New York: Basic, 2008).

7 Ernst Jünger, *Feuer und Blut* (Magdeburg: Stahlhelm, 1925), 466.

8 John Dewey, *The Public and Its Problems* (New York: Henry Holt, 1927), 8.

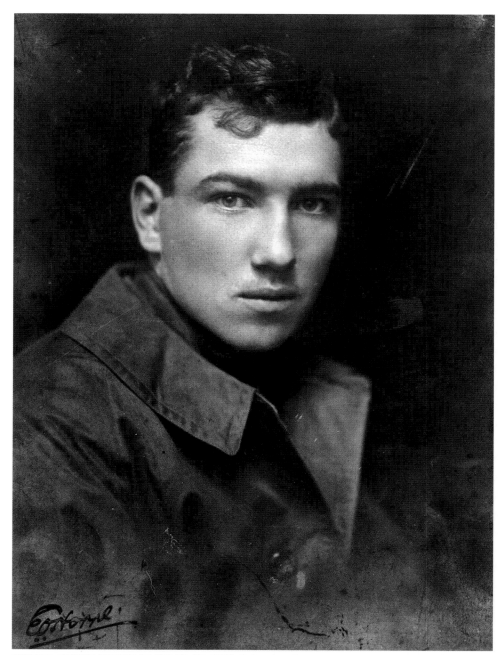

FIGURE 1. ROBERT GRAVES AT AGE 19, CA. 1915. Photographer unknown.

**We're here
Because
We're here
Because
We're here
Because we're here.**
— Soldier's song from World War I, sung to the tune of "Auld Lang Syne"

ROBERT GRAVES'S LUCK—QUITE EXCEPTIONAL UP TO THIS POINT, IN WAR
AND PEACE—ran out on 20 July 1916, during the Battle of the Somme (fig. 1). A German shell exploded immediately behind him, sending shrapnel deep into his upper thigh and clean through his chest, piercing a lung. Taken to a dressing station, Graves was reported dead the next day. Genuinely grieved, his colonel wrote to his parents informing them of their loss: "I very much regret to have to write and tell you your son has died of wounds."[1] Upon hearing the news, fellow fusilier Siegfried Sassoon wrote the obituary poem "To His Dead Body," in memory of his beloved friend: "When roaring gloom surged inward and you cried, groping for friendly hands, and clutched and died."[2] Graves's name appeared on the daily list

"In Dead Men Breath"
The Afterlife of World War I
GORDON HUGHES

of officer casualties in *The Times,* followed two weeks later, on 5 August, by another notice: "Captain Robert Graves, Royal Welch Fusiliers, officially reported died of wounds, wishes to inform his friends that he is recovering from his wounds at Queen Alexandra's Hospital, Highgate, N" (fig. 2).[3]

Recounting this episode in his 1929 memoir, *Goodbye to All That,* Graves clearly relishes the irony of being able to describe his own death. Almost too good to be true, Graves portrays the severity of his wounds as the straight-man comedic setup for the punch line to follow ("rumors of my demise," one can almost hear him chuckling to himself). In addition, Graves would later insist—knowing full well to the contrary—that he had "died" on 24 July, three days after he was taken for dead, so as to have the date fall on his twenty-first birthday. There was a certain poetry, he evidently felt, in having life and death come full circle; all the more so, when the immutable reality of death, one's own no less, is granted a reprieve after the fact. "As a poet and a scholar," remarks George Stade, Graves "has always preferred poetic resonance to the dull monotone of facts; and to die on a twenty-first birthday is to illustrate a kind of poetic justice."[4] Slight fudging of dates aside, Graves had no need of further embellishment; the story is verifiably true. That said, in the absence of fact-checking, it would be a mistake to take Graves's memoirs at face value. Anyone, historian Paul Fussell observes, "can easily catch Graves out in his little fictions."[5]

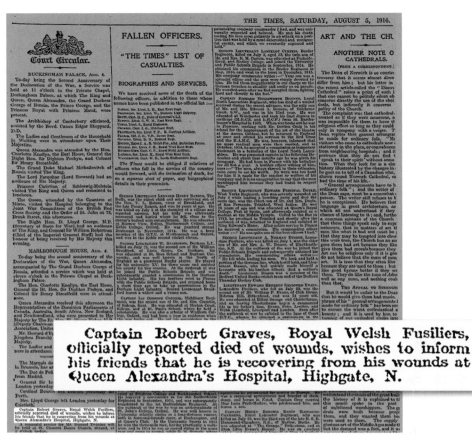

FIGURE 2. NOTICE, *THE TIMES* (LONDON), 5 AUGUST 1916, 9.

Graves's memoir, to be fair, was hardly unique in blending fact with fiction when it came to first-hand accounts of the war. Henri Barbusse's 1916 novel-as-memoir, *Le feu: Journal d'une escouade* (*Under Fire*, 2003)—broadly praised for its unflinching, often brutal portrayal of trench warfare—was among the earliest publications written by a combatant. Barbusse's book, historian Jay Winter notes, not only carried an air of truth but "expressed and signaled a growing consensus among French veterans that the war was not a source of nobility and honor; it was, they affirmed, a monstrous crime, a slaughterhouse."[6] And yet, for all its perceived veracity—indeed, *because* of its perceived veracity—*Le feu* was singled out for particularly harsh criticism by fellow veteran Jean Norton Cru in his 1929 book, *Témoins: Essai d'analyse et de critique des souvenirs de combattants édités en français de 1915 à 1928*. "In Norton Cru's view," Winter writes, "Barbusse, the truth-teller, had created a concoction of truth, half-truth, and total falsehood."[7] Along similar lines, Sassoon, in his three-part *Memoirs of George Sherston* (*Memoirs of a Fox-Hunting Man*, 1928; *Memoirs of an Infantry Officer*, 1930; *Sherston's Progress*, 1936), chose to thinly veil his own experiences of the war as a fictionalized autobiography. Ernst Jünger's memoir *In Stahlgewittern* (*Storm of Steel*, 2003) and Edmund Blunden's 1928 memoir *Undertones of War* also take significant "artistic" liberties in the telling of their respective autobiographical tales.[8]

Given Walter Benjamin's claim that "men returned from the battlefield [of World War I] grown silent—not richer, but poorer in communicable experience," does it hold, as he goes on to argue, that "the art of storytelling is coming to an end"? The writings of these authors—Graves, Barbusse, Sassoon, Jünger, Blunden, the list goes on—would suggest the contrary. Rather than remain mute, abandoning narrative in the face of incommunicable experience, the trick is to find a new means of storytelling, a modern form for a modern war, a new voice. "I must go over the ground again," Blunden writes of his perseverance in the face of his failed efforts. "A voice, perhaps not my own, answers within me. You'll be going over the ground again, it says, until that hour when agony's clawed face softens into the smilingness of a young day ... then we'll change our ground."[9] To change ground—to give voice to the otherwise incommunicable—is for Blunden to change the very foundation of storytelling; likewise for poetry, as Blaise Cendrars (who lost an arm in the fighting at Champagne) suggests in the concluding lines of his 1918 war poem *J'ai tué* (I've killed). Writing in the first person, Cendrars describes a wrenching account of killing a German soldier in hand-to-hand combat: "Just the two of us now. Striking with fists, with knives. No mercy. I jump on my enemy. I attack him, terribly. The head's almost ripped off. I've killed the Kraut. I was livelier and quicker than he. More direct. I hit first." For Cendrars, only a *poetic* relation to truth allows him—which is to say his poem—to live rather than being killed: "I've a greater sense of reality, me, poet. I've acted. I've killed. Like someone who wants to live."[10]

Graves, in fact, made no bones about the liberties he took in writing *Goodbye to All That*. "I have more or less deliberately mixed in all the ingredients that I know are mixed into other popular books," he wrote in a 1931 retrospective essay on his memoir:

> For instance, while I was writing, I reminded myself that people like reading about food and drink, so I searched my memory for the meals that had significance in my life and put them down. And they like reading about murders, so I was careful not to leave any of the six or seven that I could tell about. Ghosts of course, there must be at least one ghost story with a possible explanation, and one without an explanation, except that it was a ghost. I put in three or four ghosts that I remembered.[11]

Amid all this artistic license, however, one particular embellishment took precedence: "The most painful chapters have to be the jokiest."[12] Good to his word, Graves describes the trauma of the trenches with a sardonic tone of detachment. We see this, for example, in his description of one of the above-mentioned murders. After two enlisted men decide to kill their abusive sergeant, they report to their commanding officer: "'We've come to report, Sir, that we're very sorry but we've shot our company sergeant-major.' The Adjutant said: 'Good heavens, how did that happen?' 'It was an accident, Sir.' 'What do you mean, you damn fools, did you take him for a spy?' 'No, Sir, we mistook him for our platoon sergeant.'"[13] For Fussell, such incidents—and there are many—make it clear that, contrary to the opinion of those who want to see *Goodbye to All That* as "harshly actual" and "direct and factual autobiography,"[14] Graves's blending of fact and fiction is a form of "satire, built out of anecdotes heavily

influenced by stage comedy."[15] The sharp poignancy of Graves's memoir, for Fussell, lies in its irony — in the disjunction between hellish experience and slapstick wit. But there are times — for me, the most wrenching — that, try as he might, the joke gets caught in Graves's throat. A few pages after the bungled murder plot, for example (proximity to the joke is important), we find another story:

> Suddenly I saw a group bending over a man lying at the bottom of a trench. He was making a snoring noise mixed with animal groans. At my feet lay the cap he had worn, splashed with his brains. I had never seen human brains before.... One can joke with a badly wounded man and congratulate him on being out of it. One can disregard a dead man. But [one] can't make a joke that sounds like a joke over a man who takes three hours to die, after the top part of his head has been taken off by a bullet fired at twenty yards' range.

Or, in another instance, Graves recounts how a fellow officer "heard a scuffling, shone his torch on the bed, and found two rats on his blanket tussling for the possession of a severed hand. This story circulated as a great joke."[16] One doesn't exactly get the sense that Graves joined in the merriment. "Anything to make people laugh," he writes. "But we found the going hard."[17]

It is at these moments, when Graves's gallows humor fails him, that we catch a glimpse — fleeting, undigested, inchoate — of a breakdown, not just in satire but in representation more broadly. And from this first representational breakdown comes another collapse — that of Graves himself. "My breaking point was near now," he writes, following the death of a friend in the fighting. "It would be a general collapse," Graves predicts, "with tears and twitchings and dirtied trousers; I had seen cases like that."[18] Sure enough, Graves soon after began to suffer from shell shock, the symptoms of which plagued him well into the postwar years:

> I was still mentally and nervously organized for war. Shells used to come bursting on my bed at midnight, even though Nancy shared it with me; strangers in daytime would assume the faces of friends who had been killed. When strong enough to climb the hill behind Harlech and revisit my favorite country, I could not help seeing it as a prospective battlefield. I would find myself working out tactical problems, planning how best to ... hold against an attack from the sea, or where to place my Lewis gun ... and what would be the best cover for my rifle-grenade section.[19]

Tucked in among the long list of traumatic symptoms, Graves includes "difficulty in telling the truth." Which brings us back to the question of fact and fiction, truth and embellishment, writing and breakdown.

Reading the unrelenting horrors of Graves's war memoir, one is immediately struck by its mood of detachment. No doubt this is partly an effect of Graves's irony, as Fussell argues. But irony, especially in those passages where the joke falls flat, cannot fully account for the distant tone of Graves's writing. More often than not, especially when he is describing the obscenity that surrounds him, he sounds more

as if he were reporting the contents of a dream or a film he had seen, than an event he had experienced firsthand. It is one thing to be deadpan; it is quite another to describe certain horrors so blankly, so matter-of-factly, at such a remove and with such a flattening of affect that the humor begins to feel less like black comedy in a world gone mad, as Fussell sees it, and more like a shield, mental as much as rhetorical, against the trauma he found himself battling.

I would hardly be the first to suggest that the cumulative effect of detachment in Graves's memoir mimics, or possibly enacts, one of the most significant symptoms of combat neurosis—a dissociative sense of separation from the self. As one World War II veteran described this: "[My] body and soul seemed to be entirely divorced, even to the extent that I felt I no longer inhabited my body. My shell at the bidding of purely automatic forces, over which I had no control, ran hither and thither.... But my mind was a separate entity. I seemed to hover at some height above my own body and to observe its doing and the doings of others with a sort of detached interest."[20] This sense of internal dissociation flows throughout the diction, form, and content of *Goodbye to All That,* reflecting what Daniel Hoffman calls "the divided selves of Robert Graves" that stem from his "serious traumatic disorientation."[21] Indeed, as massive numbers of soldiers began to break down over the course of World War I (a full 25 percent of all discharges were categorized by the military as "psychiatric casualties"),[22] the experience of dissociation began to take on increasing importance from a therapeutic standpoint. More than just one symptom among many, dissociation, for many psychotherapists, became the key to understanding, and possibly curing, shell shock.

Take British psychologist William Brown, who worked extensively with traumatized soldiers during the First World War. Following Sigmund Freud and Josef Breuer, Brown argued that dissociation, along with the many other symptoms typical of traumatic war neurosis—loss of sight and/or speech, trembling and convulsions, depression, incontinence, insomnia, nightmares, repetitive flashbacks, uncontrollable anger, sensitivity to sound, and so on—are the physical or psychological manifestations of an obstructed or repressed emotion. Unable to discharge the intense affect incurred by the traumatic event, the raw, unprocessed emotion becomes "stuck" within the mind, producing a cognitive divide between that which can and cannot be mentally processed. It is this internal division—cognitive understanding on the one hand and intense, unrepresentable emotion on the other—that produces the effect of dissociation. For Brown, the necessary discharging of emotion was further hindered by the nature of military culture, whereby soldiers are either unable to discuss or discouraged from expressing emotions within combat situations. As Ruth Leys describes it: "Brown reasoned that when a soldier was confronted with the need to maintain self-control and army discipline in frontline conditions of unremitting physical and psychological stress, he likely responded to any significant trauma by breaking down."[23] Observing that one of the most significant traits of combat trauma was its resistance to recollection, often to the point of complete amnesia, Brown turned to hypnosis, a therapeutic technique that had fallen into disfavor since its repudiation by Freud in the late nineteenth century. Hypnotizing his patients, Brown sought to have patients relive, and thus psychically discharge, the traumatic affect lodged within the mind. Re-experiencing the original traumatic affect would, Brown believed, release

the repressed emotion (through a process Freud called "abreaction") and, in so doing, heal the dissociative split in the psyche.

A different approach to the problem of traumatic dissociation during World War I appeared in the therapeutic work of C. S. Myers and William McDougall. Unlike Brown, Myers and McDougall, took a more "cognitive" approach, explicitly rejecting Brown's emphasis on emotional abreaction. Like Brown, they also believed that the key to treating trauma lay in restoring the repressed memory of the event. Unlike Brown, however, they minimized the role of emotion in this process, arguing instead that the patients must consciously remember, understand, and represent the event in order to integrate the repressed memory into the overall continuum of the patient's personal history. This process of rationally integrating a lost or "missed" memory into a sequential chain of events would, they believed, eliminate the symptoms of dissociation. "[T]he force of Myers' and McDougall's denial of the importance of emotional abreaction," Leys writes, "was to insist that what mattered in the hypnotic cure was to enable the traumatized soldier to win a certain knowledge of, or relation to, himself by recovering the memory of the traumatic experience." By representing past experience within cognition, the subject would "achieve an intellectual reintegration or resynthesis of the forgotten memory so that he could overcome his dissociated, fractured state and accede to a coherent narrative of his past life."[24]

Over the course of *Goodbye to All That,* the "coherent narrative" gives voice to Graves's life battles with the "dissociated, fractured state" of another, more evasive voice. The narrative — organized, coherent, witty, well written, sympathetic, and self-serving — makes sense as it represents; the other voice — distant, unspoken, humorless, fissured, aloof, and often little more than a tone or a mood — resists sense, resists representation. The unresolved tension between these two registers, as I read it, marks the traumatic tone of Graves's book. "A voice, perhaps not my own, answers within me," writes Blunden, as he struggles to let it speak, however inaudibly.

As Leys argues, more is at stake in the differences expressed by the proponents of emotional abreaction, such as Brown, and those who supported a more cognitive approach, such as Myers and McDougall, than in the dispute over the role of emotion and narrative understanding within therapeutic psychology. Each approach, Leys claims, represents two competing accounts of agency. In the case of Brown, which Leys calls "the *surgical* account," the patient is acted upon, assuming a passive role akin to the use of drug therapy or surgery; in the case of Myers and McDougall, which Leys calls "the *participatory* account," the patient becomes an active player in a collaborative process. Although these opposing conceptions of the active or passive role of the patient certainly predate 1914, the mass breakdown of soldiers during World War I forced these two views of the doctor-patient relationship into the mainstay of psychiatric practice. The first modern war brought about not only an array of modern symptoms but also modern ways of theorizing and combating those symptoms.[25]

So why, over one hundred years later, should we care about these arcane and seemingly distant disputes over the treatment of war trauma? Why should we care about the role of agency or its absence when it comes to thinking about the historical event of a long-past war — when it comes to thinking about trauma and history? What does shell shock have to do with us? Indeed, beyond simple historical interest, why

should we care about World War I at all? And more specifically, why should we care about the representations that came out of this war, written or visual?

Beginning with the biggest question first, perhaps the most frequently evoked answer as to why we should care about World War I, and indeed why it continues to claim our attention, rests in the fact that it was not simply the first in a series of unprecedented disasters to mark the century to come but, directly or indirectly, responsible for the procession of disasters that came in its wake. "The horrors of Europe's twentieth century were born of this catastrophe,"[26] writes historian Christopher Clark; it was "the calamity from which all other calamities sprang,"[27] as Fritz Stern puts it. Forming a veritable chain reaction of disaster—the rise of Adolf Hitler, the Second World War, the Holocaust, Hiroshima and Nagasaki, the Armenian genocide—the horrors unleashed by the First World War throughout the twentieth century continue to spawn fresh calamities into the present. Thus, in a recorded video statement released immediately after the September 11 attacks, Osama Bin Laden claimed justification in response to eighty years of "humiliation and disgrace," a reference to the Sykes-Picot Agreement, which divided the Arab provinces of the conquered Ottoman Empire following World War I.[28]

The sheer toll of the First World War, as most know, is staggering: 20 million military and civilian dead, 21 million wounded, mass trauma, and untold damage to the physical infrastructure and cultural monuments of Europe. The apocalyptic scale of the devastation, unleashed by one man's action in a far-flung corner of Europe—Gavrilo Princip's double assassination of Archduke Franz Ferdinand of Austria and his wife, Sophia, in Sarajevo—has come to be understood, rightly, as a tragic lesson in just how wrong and how fast massively devastating historical events can unfold in a direction that no one imagined or wants. As Thomas Laqueur suggests, it was for this very reason that Barbara Tuchman's 1962 *The Guns of August* became a bestseller during the Cold War. As Laqueur writes: "John Kennedy read *The Guns of August* as a parable for the Cuban Missile Crisis," noting how his brother, Robert Kennedy, quoted the president as saying, "I am not going to follow a course which will allow anyone to write a comparable book about this time [called] 'The Missiles of October.'"[29] More recently, historian Christopher Clark has argued in his 2013 book *The Sleepwalkers: How Europe Went to War in 1914* that the beginning of World War I should be cast as a cautionary tale for the new millennium. "The Cuban missile crisis was complex enough," Clark writes in clear reference to Tuckman, "yet it involved just two principal protagonists (the USA and the Soviet Union) plus a range of proxies and subordinate players."[30] By contrast, for Clark, "since the end of the Cold War, a system of global bipolar stability has made way for a more complex and unpredictable array of forces, including declining empires and rising powers—a state of affairs that invites comparison with the Europe of 1914."[31] We should pay heed to the calamity that befell 1914, Clark argues, as it bears a remarkably close resemblance to the world in which we currently find ourselves one hundred years later. Like the assassinations in Sarajevo, Clark warns, "the attack on the World Trade Center in September 2001 exemplified the way in which a single, symbolic event—however deeply it may be enmeshed in larger historical processes—can change politics irrevocably, rendering old opinions obsolete and endowing new ones with an unforeseen urgency."[32]

Ultimately, the differences between historians such as Tuchman and Clark extend beyond the ways in which each wants to position World War I in relation to the time in which they write. As Laqueur notes, the work of historians investigating the origins of the war "tends to fall on one side or the other of the necessity-contingency divide." Put otherwise, for historians such as Tuchman, "by virtue of its magnitude and consequences, the Great War must have great causes: the crisis of imperialism . . . ; nationalism and its conservative turn in the 19th century; the forty-year arms race; the system of alliances; the domestic politics of left and right; . . . great architectonic pressures, which began to sweep away the old regimes of Europe in 1789 and finally succeeded by 1918."[33] Subsumed by one or all of these master narratives, individuals are acted upon by historical forces rather than vice versa. This stands in marked contrast to Clark's approach, which, as he emphasizes, is "saturated with agency."[34] Without in any way denying the larger historical factors at play, Clark's writing tries to demonstrate how the outbreak of war resulted from "the culmination of decisions made by political actors with conscious objectives," each of whom, Clark writes, "were capable of a degree of self-reflection, acknowledged a range of options and formed the best judgments they could on the basis of the best information they had to hand."[35]

This brings us to the question of agency as it pertains to trauma and history. Thus, for all their obvious differences in subject and approach, Clark and Leys align in their emphasis on individual agency, an issue they both understand as central to the continued historical importance of World War I. Moreover, Clark and Leys cast the relation between agency and World War I not simply in terms of origins—be it theories of trauma that developed as a result of the war, or the war itself—but, more pressingly, because of the ways in which the historical issue of agency resonates into the present. Now, as before, the roles of agency—judgment, interpretation, misinterpretation, intention, dispute, self-reflection, insight, lack of insight, decisions made and decisions avoided—are under particular pressure, politically, theoretically, and artistically. And this, they suggest, is why the war continues to matter.

Such emphasis on agency is, of course, very much at odds with a structuralist or poststructuralist account of causality and intention, typically encapsulated by the phrase "the death of the author." It is not so much authors or individuals who intentionally generate the meaning of books, paintings, or historical events, the claim goes, but a larger system of structural conditions that produce "text." And one effect of this emphasis on the text as opposed to the author has been to mitigate, if not outright eliminate, not only the agency of the writer or artist but, as a result, the importance of the maker's biography. Ironically, however, the opposite is also true: one of the most common ways by which authorial agency is circumvented, particularly within art history, is though a misplaced emphasis on the facts surrounding an individual's life. This is perhaps nowhere more evident than in those mythologized creators—Pablo Picasso being the prime example—whose biographies are taken as the interpretive key to their work. Recently, many leading art historians have criticized this bait-and-switch tactic of passing biography off as interpretation. Attacking what he calls "the idiot X-equals-Y biography" in the writing on Picasso, T. J. Clark wonders aloud about the influence of Picasso's sexual relationship with Marie-Thérèse Walter, his much younger lover, on his most transgressive imagery: "Who knows? Who cares? At

points like these — and these are the points that matter in art — biography is banality or speculation."[36] For Rosalind Krauss, this "art history of the proper name," is akin to "the detective story or *roman à clef,* where the meaning of the tale reduces to just this question of identity."[37] Uncover who did what, when, where, and to whom, and you uncover the simple truth of the artwork. Voilà.

The merest glance at the writing on Picasso, Jackson Pollock, Andy Warhol, or Gerhard Richter is enough to confirm Clark's and Krauss's diagnosis. But is it possible that there are certain kinds of biographical events that, on an interpretive level, *do* matter and are not so easily dismissed as "second-rate celebrity literature," per Clark? Which brings us to the final question, why we should care about works of art or literature that developed out of the war experience. There are, I believe, certain rare instances in which a life experience so profoundly shatters the subjective constitution of the artist as to be integral to, rather than independent of, the meaning and structure of their artwork. For those artists that were directly and profoundly affected by war, can we simply relegate the trauma or bereavement they incurred to mere biographical distraction? If trauma, by definition, is the incessant repetition of a failing process to work through an event that haunts an individual — radically altering a person's view of the world and changing his or her understanding of the self and others — is it not possible, likely even, that visual artists as much as writers attempted to represent and "give voice" to that altered ground? If the net effect of biographical art history, self-consciously or not, is to deflect interpretation away from the art object onto the contingencies of personal history, functioning, for Clark, "like a set of gargoyles erected to keep an evil spirit at bay," what about those evil spirits that inhabit the artwork as a result of biography?[38]

Each of the authors in the essays that follow explores the possibility that the experience of World War I altered not only the course of these artists' lives but also — and as a result — their work. Like the "jagged crack in the looking glass,"[39] — J. B. Priestley's image, penned after he was wounded out of the trenches in 1916 — the war created a fissure, not only before and after, historically and personally, but in how these artists reflected the world.

— NOTES —

The essay title comes from Robert Graves's 1918 poem "Two Fusiliers"; the last stanza reads:
Show me the two so closely bound
As we, by the red bond of blood,
By friendship, blossoming from mud,
By Death: we faced him, and we found
Beauty in Death,
In dead men breath.
—Robert Graves, "Two Fusiliers," from *Complete Poems in One Volume,* originally published in *Fairies and Fusiliers* (New York: Alfread A. Knopf, 1918). Reprinted with permission from Carcanet Press Limited.

1 Robert Graves, *Goodbye to All That* (New York: Random House, 1998), 219.

2 Siegfried Sassoon, "To His Dead Body," in *The Old Huntsman and Other Poems* (London: E. P. Dutton and Co., 1918), 33.

3 *The Times,* 5 August 1916, 9.

4 George Stade, *Robert Graves* (New York: Columbia University Press, 1967), 10–11; quoted in Paul Fussell, *The Great War and Modern Memory* (Oxford: Oxford University Press, 2000), 215.

5 Fussell, *The Great War,* 206. Fussell points to Graves's anecdote about exchanging machine-gun fire across enemy lines, whereby each side would remove cartridges from the ammunition belt in order to tap out the rhythm of the well-known prostitute's call: "'MEET ME DOWN in PICC-a-DILL-Y' to which the Germans would reply, though in slower tempo, because our guns were faster than theirs: 'YES, with-OUT my DRAWERS ON!'" Graves, *Goodbye to All That,* 170–71. "Very nice," admires Fussell. "But the fact is if you remove cartridges from the belt the gun stops working when the empty space encounters the firing mechanisms." Fussell, *The Great War,* 207.

6 Jay Winter, "Introduction," in Henri Barbusse, *Under Fire* (New York: Penguin, 2004), xii.

7 Winter, "Introduction," xiii. For more on Norton Cru, see Jay Winter, *Remembering War: The Great War between Memory and History in the Twentieth Century* (New Haven, Conn.: Yale University Press, 2006), ch. 11; Frédéric Rousseau, *Le process des témoins de la grande guerre: L'affaire Norton Cru* (Paris: Seuil, 2003); Leonard V. Smith, "Jean Norton Cru and Combatants Literature of the First World War," *Modern and Contemporary France* 9 (2001): 161–69.

8 *In Stahlgewittern* was first published in 1920 before being radically rewritten in 1924 as a nationalistic glorification of the war experience. Numerous revisions were published in subsequent decades. Michael Hofmann's prize-winning 2003 translation, *Storm of Steel,* was based on the 1961 revised edition.

9 Edmund Blunden, *Undertones of War* (Chicago: University of Chicago Press, 2007), xv–xvi.

10 Blaise Cendrars, *J'ai tué* (Paris: Georges Crès, 1919), 21 (translation mine). A Swiss poet living in Paris, Cendrars joined the French Foreign Legion following the outbreak of the war, losing his right arm in the fighting at Champagne in September 1915.

11 Robert Graves, "P.S. to 'Goodbye to All That,'" in *But It Still Goes On* (New York: Jonathan Cape, 1931), 3; quoted in Fussell, *The Great War,* 204.

12 Graves, "P.S. to 'Goodbye to All That,'" 6.

13 Graves, *Goodbye to All That,* 109.

14 J. M. Cohen, *Robert Graves* (London: Oliver and Boyd, 1960), 68; quoted in Fussell, *The Great War,* 204.

15 Fussell, *The Great War,* 207.

16 Graves, *Goodbye to All That,* 138.

17 Graves, *Goodbye to All That,* 254.

18 Graves, *Goodbye to All That,* 198.

19 Graves, *Goodbye To All That,* 287.

20 Testimony of Ivone Kirkpatrick, in "Psychiatry–Arakan Campaign" [n.d.], 3, Public Records Office, London; quoted in Joanna Bourke, *An Intimate History of Killing: Face to Face Killing in 20th Century Warfare* (New York: Basic, 1999), 208–9.

21 Daniel Hoffman, "Significant Wounds," in Harold Bloom, ed., *Modern Critical Views: Robert Graves* (New York: Chelsea House, 1987), 62 and 65; excerpted from Daniel Hoffman, *Barbarous Knowledge: Myth in the Poetry of Yeats, Graves, and Muir* (Oxford: Oxford University Press, 1967). Commenting on Graves's description of his writing as constituted by a "Jekyll and Hyde" split, Hoffman attributes the description to W. H. R. Rivers, a British psychiatrist best known for his treatment of shell-shock victims in World War I, including Graves's friends Sassoon and Wilfred Owen. As Hoffman writes, "In Graves's later work, we see the doubling and redoubling of these antagonistic selves, striving to be reconciled." Hoffman, *Barbarous Knowledge,* 61.

22 Bourke, *An Intimate History of Killing,* 234.

23 Ruth Leys, *Trauma: A Genealogy* (Chicago: University of Chicago Press, 2000), 84.

24 Leys, *Trauma,* 86.

25 The debates that originated during World War I surrounding the theorization and treatment of trauma are very much ongoing. Intellectual historians, medical anthropologists, philosophers, and theorists such as Leys, Allan Young, and Ian Hacking support a cognitive approach to trauma, while theorists such as Cathy Caruth and Bessel van der Kolk, for example, promote an anticognitivist

approach. As Leys explained in a recent interview, she believes that the anticognitivist approach has become especially widespread and influential of late—lamentably so, in her view—due to a set of shared "epistemological-ontological" commitments that bring together a range of disciplines across the humanities, social sciences, psychology, psychiatry, and neuroscience. Describing the work of Caruth, a literary theorist, and van der Kolk, a psychiatrist, Leys notes: "They both think traumatic flashbacks and nightmares are vertical memories of past traumatic events, and they both believe that those symptoms are literal replicas of the trauma that as such stand outside all representation." Leys, "Navigating the Genealogies of Trauma, Guilt, and Affect: An Interview with Ruth Leys," *University of Toronto Quarterly* 79, no. 2 (2010): 666. The problem with such approaches, Leys claims, is that they divert the focus of trauma "from the mind back to the *body* by explaining traumatic memory in neurobiological terms," *Trauma,* 6. Leys is especially critical of the ways in which the current trend of "affect theory," spurred largely by the research of Silvan Tomkins and Paul Ekman, have prompted a move from a "cognitivist" view of survivors guilt to an anticognitivist view of traumatic "shame." Even art historical research on the First World War has begun to feel the effect of this shift from guilt to shame, as is evident, for example, in Paul Fox's essay "Confronting Post-War Shame in Weimar Germany: Trauma, Heroism, and the War Art of Otto Dix" *Oxford Art Journal* 29, no. 2 (2006): 247–67. Leys and Young are especially critical of the ways in which various anticognitivist arguments have arisen within recent theories of post-traumatic stress disorder (PTSD). In addition to Leys's invaluable *Trauma,* see, especially, Leys, *From Guilt to Shame: Auschwitz and After* (Princeton, N.J.: Princeton University Press, 2007); Allan Young, *The Harmony of Illusions: Inventing Post-Traumatic Stress Disorder* (Princeton, N.J.: Princeton University Press, 1997); and Ian Hacking, *Rewriting the Soul: Multiple Personality and the Sciences of Memory* (Princeton, N.J.: Princeton University Press, 1998).

26 Christopher Clark, *The Sleepwalkers: How Europe Went to War in 1914* (New York: Harper Collins, 2013), xxiii.

27 Fritz Stern, cited in David Fromkin, *Europe's Last Summer: Who Started the War in 1914?* (New York: Knopf Doubleday, 2004), 6.

28 For more on this, see Fromkin, *Europe's Last Summer.*

29 Thomas Laqueur, "Some Damn Foolish Thing," *London Review of Books* 35, no. 23, 5 December 2013, xxx.

30 Clark, *The Sleepwalkers,* xxvi.

31 Clark, *The Sleepwalkers,* xxvii–xxviii.

32 Clark, *The Sleepwalkers,* xxix.

33 Laqueur, "Some Damn Foolish Thing," xxx.

34 Clark, *The Sleepwalkers,* xxix.

35 Clark, *The Sleepwalkers,* xxix. As Laqueur is right to point out, Clark's metaphor of "sleepwalking" directly contradicts the "watchful, calculated steps" of individual agency that he argues throughout his book.

36 T. J. Clark, *Picasso and Truth: From Cubism to Guernica* (Princeton, N.J.: Princeton University Press, 2013), 172.

37 Rosalind Krauss, "In the Name of Picasso," *October* 16 (1981): 10.

38 Clark, *Picasso and Truth,* 5.

39 J. B. Priestley, *Margin Released* (New York: Harper & Row, 1962), 88.

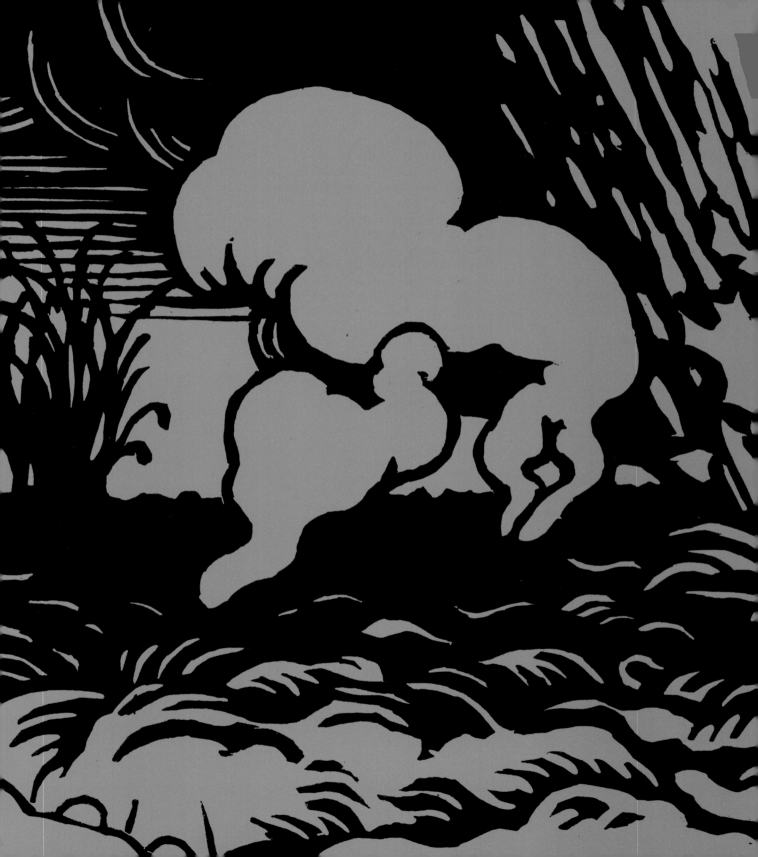

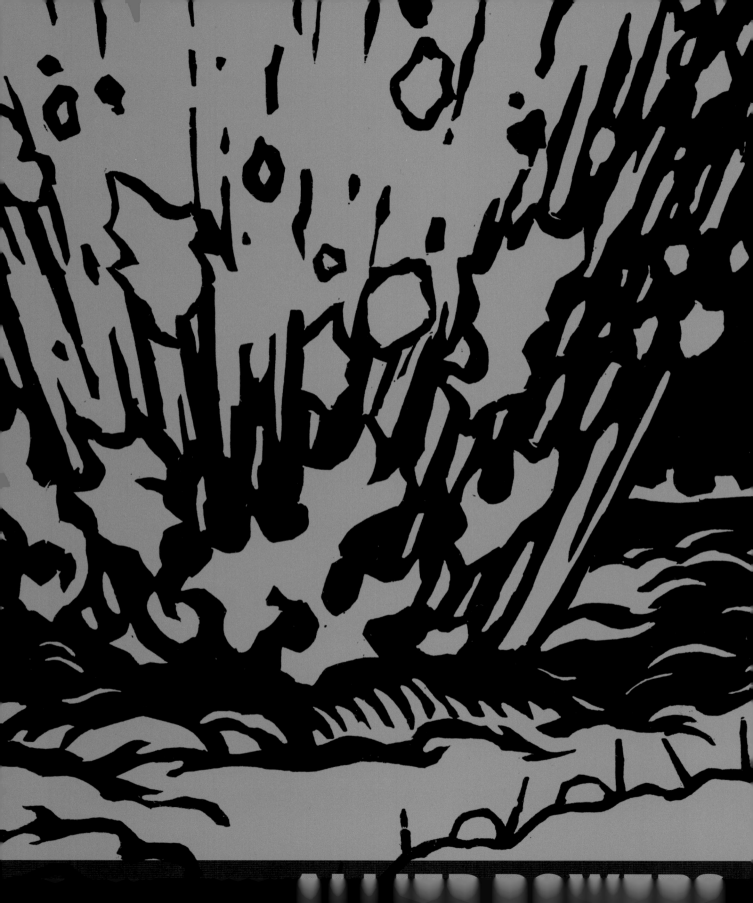

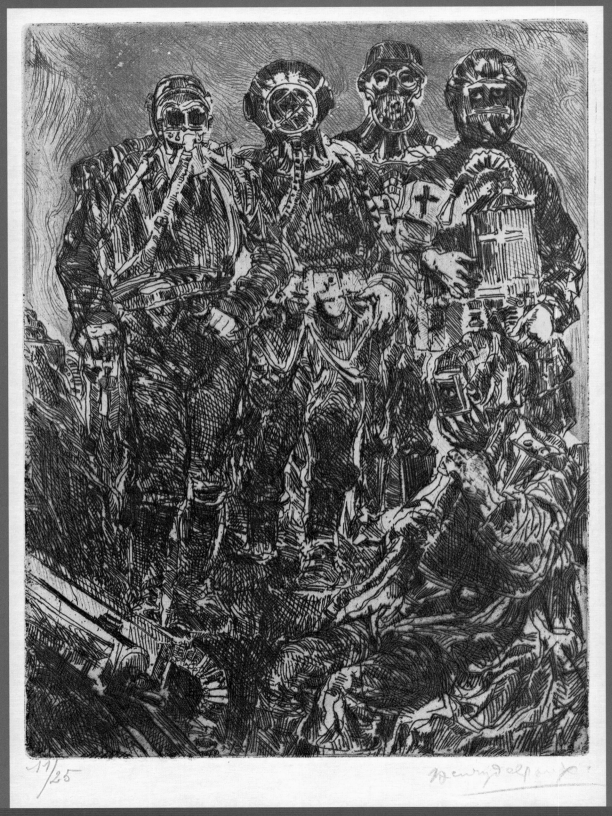

11/25

Henry de Groux

PLATE 3 **HENRY DE GROUX (BELGIAN, 1867–1930).** *Masked Soldiers*, etching and soft-ground etching, sheet: 40.2 x 28.8 cm
(15⅛ x 11⅜ in.). From *Le visage de la victoire*, 1914–16, series of prints depicting scenes related to World War I. Los Angeles, Getty Research Institute.

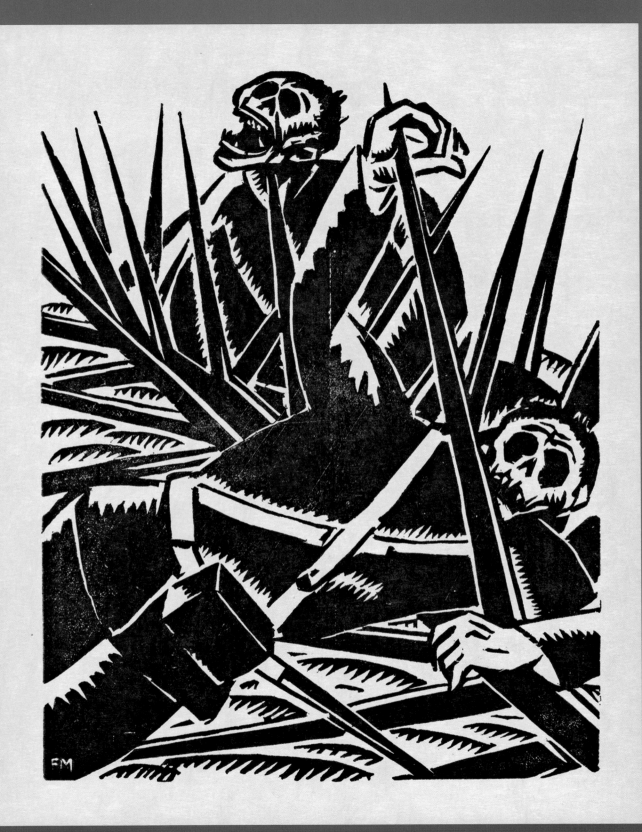

FRANS MASEREEL (BELGIAN, 1889–1972). Dead soldiers, woodcut, sheet: 32.2 x 25 cm (12¼ x 9⅛ in.). **PLATE 4**
From *Debout les morts: Résurrection infernale*, 1917, ten loose plates. Los Angeles, Getty Research Institute.

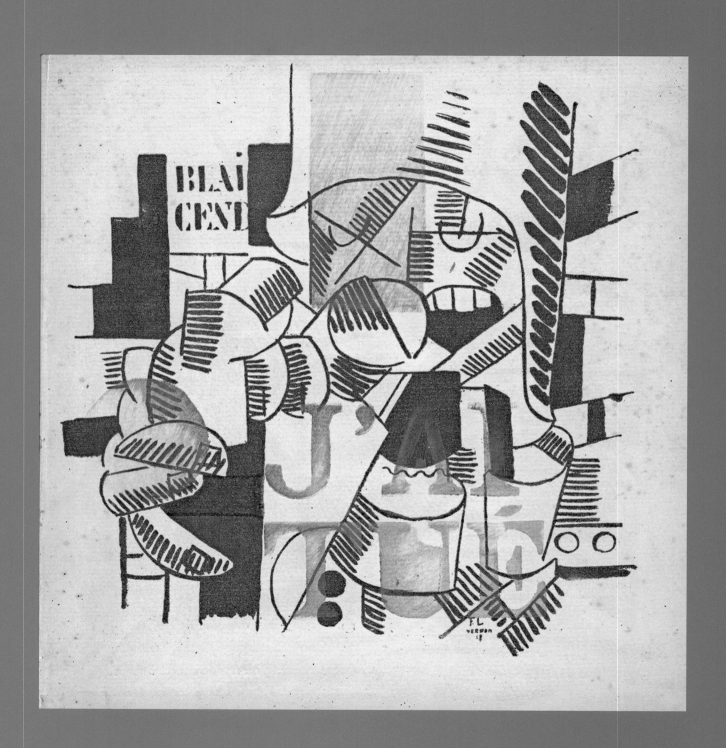

PLATE 5 **FERNAND LÉGER (FRENCH, 1881–1955).** Cover of Blaise Cendrars, *J'ai tué* (Paris, 1918). Los Angeles, Getty Research Institute.

APRÈS LE THÉATRE
Le rêve du Poilu.

PLATE 7 **AUGUSTE JEAN BAPTISTE ROUBILLE (FRENCH, 1872–1955).** *Après le théâtre: Le rêve du poilu* (After the theater:
The dream of the French soldier). From *À coups de baïonnette* 7 (January 1917): 56–57. Los Angeles, Getty Research Institute.

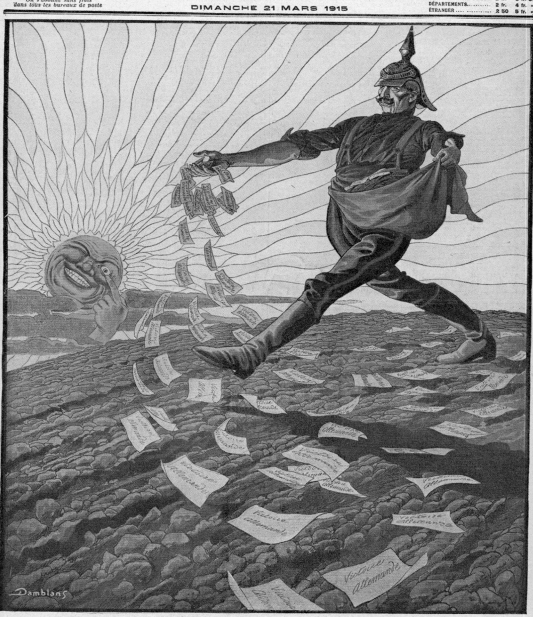

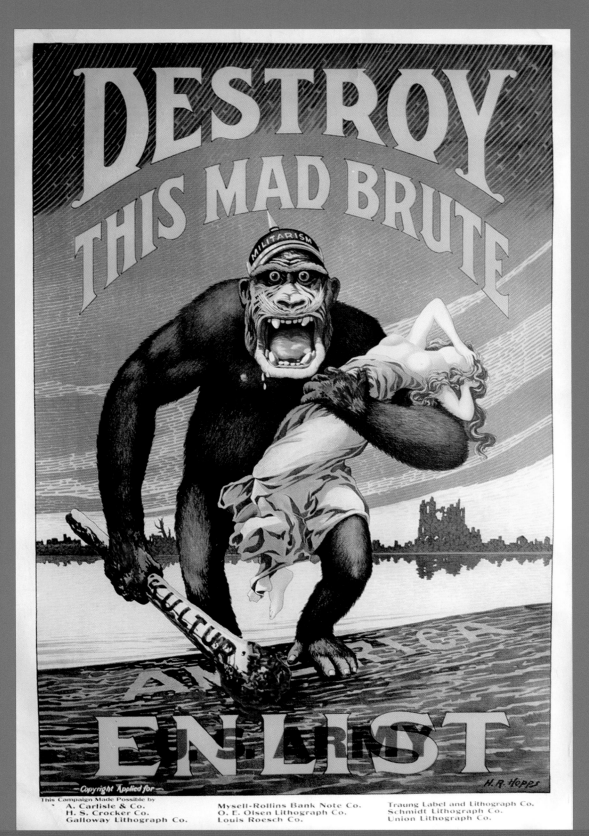

HARRY R. HOPPS (AMERICAN, 1869–1937). *Destroy This Mad Brute—Enlist,* ca. 1917, color lithograph, **PLATE 10**
106 x 71 cm (41¾ x 28 in.). Saint Louis, Washington University in St. Louis, Modern Graphic History Library.

SUPPLÉMENT ILLUSTRÉ DU PETIT JOURNAL

LES TANKS

PLATE 11 EUGÈNE DAMBLANS (FRENCH, 1865–1945). *Les tanks* (The tanks). From *Le petit journal: Supplément illustré* 28, no. 1375 (29 April 1917): 132–33. Los Angeles, Getty Research Institute.

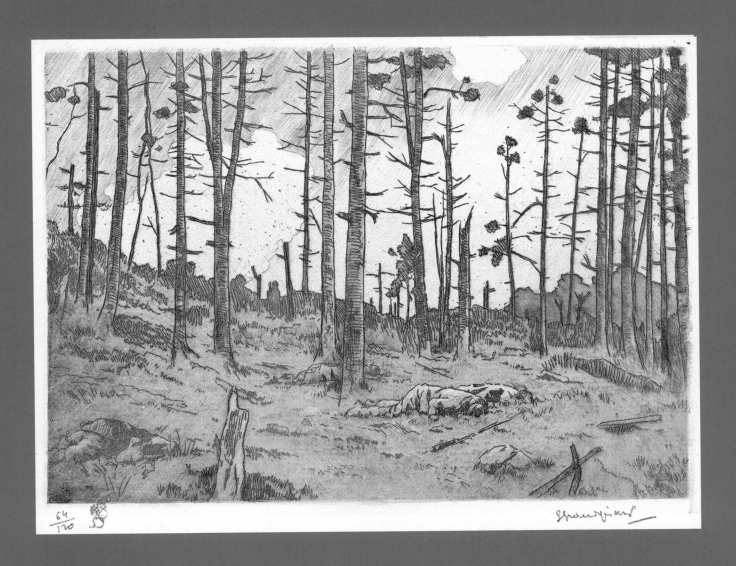

64/120

Grandgérard

LUCIEN HENRI GRANDGÉRARD (FRENCH, 1880–1970). *Le Vieil-Armand (Hartmannswillerkopf)*, 1916, etching and **PLATE 12**
aquatint, 15.7 x 21.1 cm (6³⁄₁₆ x 8⁵⁄₁₆ in.). From *De l'Yser au Vieil Armand*, plate 10. Los Angeles, Getty Research Institute.

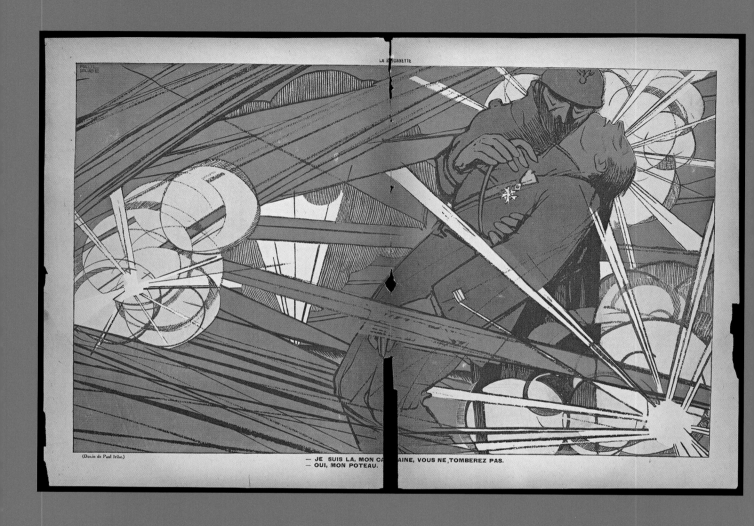

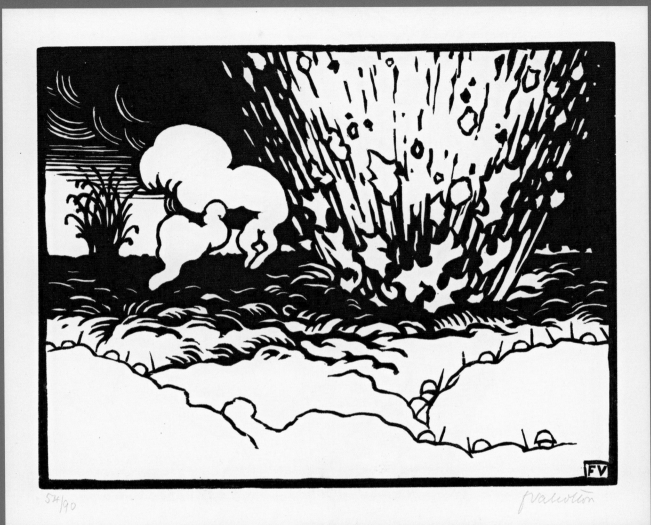

54/90

valotton

FÉLIX VALLOTTON (SWISS, 1865–1925). *The Trench,* woodcut, 17.6 x 22.3 cm (7 x 8⅛ in.). **PLATE 14**
From *C'est la guerre!,* 1915–16, suite of six prints, plate 1. Los Angeles, Getty Research Institute.

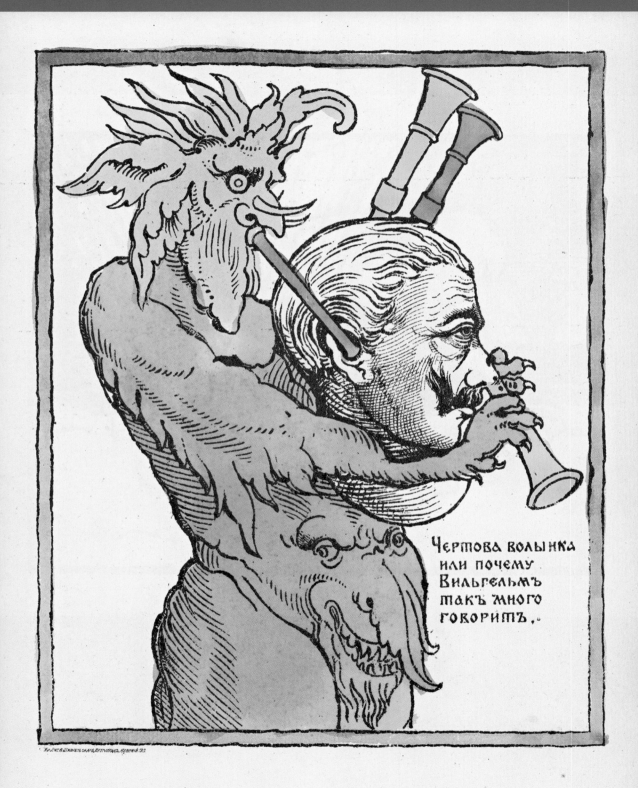

ЧЕРТОВА ВОЛЫНКА
ИЛИ ПОЧЕМУ
ВИЛЬГЕЛЬМЪ
ТАКЪ МНОГО
ГОВОРИТЪ.

PLATE 15 *THE DEVIL'S BAGPIPES*, **1914,** hand-colored lithograph, sheet: 31.8 x 23.5 cm (12½ x 9¼ in.).
Artist unknown. From *Kartinki—voina russkikh s nemtsami* (Petrograd, 1914). Los Angeles, Getty Research Institute.

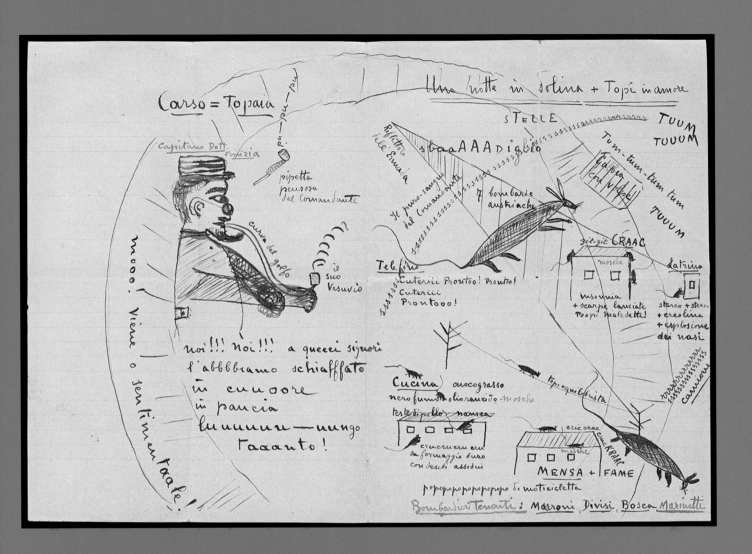

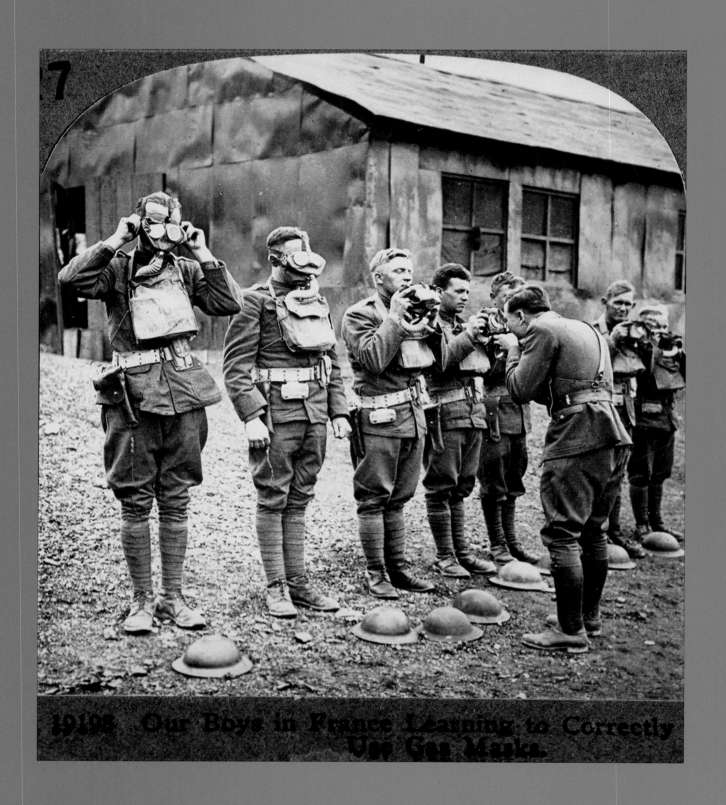

19198 Our Boys in France Learning to Correctly
Use Gas Masks.

PLATE 17 **KEYSTONE VIEW COMPANY (AMERICAN STEREOGRAPH STUDIO, 1890S–1970S).** *Our Boys in France Learning to Correctly Use Gas Masks* (detail), stereograph, gelatin silver print, 9 x 18 cm (3⅝ x 7⅛ in.). Los Angeles, Getty Research Institute.

6th Position.

H. SCOTT ORR (ENGLISH). *The Shooting Down of a German Dirigible over London,* 3 September 1916, **PLATE 18**
gelatin silver print, 13.5 x 8.3 cm (5⅜ x 3¼ in.). Los Angeles, J. Paul Getty Museum.

ANDRÉ MASSON (1896–1987) IS BEST KNOWN AS A SURREALIST. While he was, at least during certain important periods in his career, closely associated with the movement and with its leader, André Breton, the most important factors in his development arrived by other avenues. If we consider the central themes of his work — eroticism, violence, and the relation of the self to the universe — we will see that Masson's participation in the First World War was decisive for his artistic development. As a formative experience, it may well outstrip Masson's more famous participation in surrealism.

The war interrupted Masson's artistic training. That training began, formally, in Brussels at the Académie Royale des Beaux-Arts when he was eleven years old; he continued in Paris at the École nationale supérieure des Beaux-Arts. Among the artistic influences on this early phase of Masson's development were James Ensor, the Nabis, Nicolas Poussin, Pierre Puvis de Chavannes, and Medardo Rosso. An early brush with cubism made little useful impression on Masson.[1] Early reading in philosophy was much more immediately profitable for him. He was drawn to pre-Socratic philosopher Heraclitus and to Friedrich Nietzsche.

André Masson
Into the "Humus Humaine"

CHARLES PALERMO

In a letter more than twenty years after the war, addressed to his close friend Georges Bataille, Masson wrote with excitement about discovering an explicit connection between his two philosophical heroes. In fact, the discovery of the connection moved Masson to transcribe directly from Nietzsche's note on the Greek philosopher in *Ecce Homo:*

> The *tragic wisdom* was absent — I have searched in vain for signs of it even among the *great* Greek philosophers, those who lived in the two centuries *before* Socrates. I still had some doubt about *Heraclitus,* in whose presence I feel warmer and happier in general than anywhere else. The affirmation of flux *and destruction,* the decisive element in a Dionysian philosophy, to contradiction and strife [Masson writes *lutte*], the notion of *Becoming,* along with the radical rejection of even the concept, "Being" — therein I am forced to recognize in any event that which is closest to me of all that has previously been thought.[2]

The passage, in addition to uniting Masson's two philosophical inspirations, demonstrates his deep and important sensitivity to a dialectical notion of ontology. That is, rather than viewing worldly entities as having "being," Masson (following his heroes) sees them as in perpetual states of becoming. The point is not difficult to grasp. Heraclitus is the philosopher most famous, after all, for pointing out the impossibility of stepping into the same river twice. That is, while one may wade into the Mississippi or the Indus twice, the rivers themselves are not static but rather ever-changing

channels of flowing water, constantly replenished, never still, never the same. Banks eroding, sediment building, water emptying and emerging — a river may be ancient, but it is truer to say it is better characterized as a process of constant change, of *becoming,* than as a persistent object, with a property of *being.*

This is the view that captured Masson's imagination early on. It was as clear to him as it was to Nietzsche (in the passage Masson copied) that this view of things implied a violence — an ongoing work of destruction — as the bedrock of the world. To affirm life in the world is to affirm the ongoing work of destruction that replaces rivers (and their contents and their banks and their bathers) constantly and relentlessly. Not without reason, then, does Nietzsche equate this becoming with strife.

When the First World War broke out, Masson was on vacation from his studies, staying in Switzerland with friends. While he was there, a convalescing German casualty of war advised him to stay in Switzerland and to avoid returning to France and to military service. War would change even the most fortunate survivors irrevocably. Masson decided in favor of change, of becoming, of destruction.

Masson returned to France, joined the infantry, and saw some of the war's most ferocious battle. He took part in the long, bloody Somme offensive in 1916, which he survived. The following spring, however, he was severely injured in the fight for the Chemin des Dames ridge. The offensive was poorly conceived amid confusion in French political and military leadership. The plan was the brainchild of General Robert Nivelle, who, fresh from success at Verdun, seemed like a logical replacement for Joseph Joffre as commander of the French forces. Nivelle concocted a plan to attack a German salient between Arras and Craonne.[3] The British army was to attack one shoulder of the salient while the French attacked the other, forcing the Germans to divide their resources. Once they had pierced the German line, the French and British could exploit their advantage. When, in a brilliant move, the Germans retreated to a more heavily fortified position (the Siegfried, or Hindenburg, Line), Nivelle decided to carry out the plan anyway. It was well known that the plan — even in its details — was no longer secret; yet, even after the primary target of the offensive (the German salient) was removed, Nivelle ordered the attack on the two ridges. The British army gained some territory and kept the Germans engaged successfully for days. The French were not as successful.

The ridge of Chemin des Dames was a difficult target. First, the shape of the ridge itself made it hard to attack: "Whereas the northern side is substantially a straight and solid wall, the southern side is cut by many deep ravines or glens through which brooks pass to the Aisne [river]. On a relief map, the Craonne Plateau suggests a comb with the teeth pointed southward, the spaces between the teeth representing the little valleys."[4] A combination of natural cover and concrete "pillboxes" concealed a multitude of machine-gun installations, which protected the ridge with interlocking fields of machine-gun fire.[5] German artillery, positioned atop the ridge, was completely covered. Aerial reconnaissance (and a captured copy of Nivelle's plans) gave the Germans a detailed understanding of the French attack.[6] The French were forced to approach this natural fortress without cover or surprise.

And yet, morale was high. The United States had just announced its entry into the war. Nivelle's optimism was buoyant (for anyone who did not doubt him). Once

the attack began, though, the French forces flagged almost immediately. Heavy fire stopped the offensive's progress and machine-gun fire mowed down the elite troops at the fore. Thirty thousand French soldiers died. Under the command of the overconfident Nivelle, the French medical corps had prepared for fifteen thousand wounded soldiers. There were one hundred thousand.[7] One of them was Masson.

Masson's injuries incapacitated him on the battlefield, where medics were unable to retrieve him before nightfall. Stranded and exposed amid fire, Masson spent the night expecting to be killed:

> The indescribable night of the battlefield, streaked in every direction by bright red and green rockets, striped by the wake and flashes of the projectiles and rockets—all this fairytale-like enchantment was orchestrated by the explosions of shells which literally encircled me and sprinkled me with earth and shrapnel. To see all that, face upward, one's body immobilized on a stretcher, instead of head thrown down as in the fighting where one burrows like a dog in the shell craters, constituted a rare and unwonted situation. The first nerve-shattering fright gives way to resignation and then, as delirium slips over you, it becomes a celebration performed for one about to die.[8]

FIGURE 1. ANDRÉ MASSON (FRENCH, 1896–1987). *Man and Lioness,* 1939,
Chinese ink on blue paper, 42.5 x 55.6 cm (16¾ x 21⅞ in.). New York, private collection.

The relation of Masson's incapacitated body to the night sky and the bursting ordnance above both recalls his interest in the world as a process (sometimes violent, sometimes gradual) of becoming and forecasts his deeply related theme of the individual's mirror relation with the universe. After all, if every being, through some now-incremental, now-catastrophic exchange, is becoming one with the universe, representing the individual means revealing the work of becoming.

This experience supplied Masson with some important iconographical references. As he himself explained—for instance, apropos a drawing of 1939[9]—an encounter with a dead soldier propped up on his elbows returned to Masson's mind in the form of the Dying Lioness from Nineveh (figs. 1, 2). The drawing, as William Rubin rightly notes, adds an intense eroticism to the image of the dead soldier's frozen pose and the lioness's agony. The lioness is part human (note the pendulous breasts), and the nude male human attacker seems ambiguously poised to assault his victim sexually. Eroticism is a persistent theme—and one that cannot be separated from violence—throughout Masson's mature oeuvre.

Eroticism, in the formulation of Masson's close friend Georges Bataille, ceases to be simply or merely about sexuality in the sense we ordinarily encounter it; rather, it comes to stand for the drama of separation that lies at the core of all reproduction.

FIGURE 2. ASSYRIAN. Dying Lioness. Detail of The Great Lion Hunt, from the palace of King Ashurbanipal, Nineveh, ca. 645–635 BC, bas relief, 160 x 124 cm (63 x 48⅞ in.). London, British Museum.

FIGURE 3. ANDRÉ MASSON (FRENCH, 1896–1987). *Skull City,* 1939, ink, 47.9 x 62.9 cm (18⅞ x 24¾ in.). Paris, private collection.

As such, it combines the impulse to live with the fact of our difference from each other—one being from the next—that makes violence possible and reveals death's place in reproduction. A cell divides and is replaced by two, neither of which is the original cell. Eroticism, one might say, shows that the essence of being is destruction, transformation, becoming. Masson also connected eroticism (doubtless in a sense close to Bataille's) to his automatic drawing.[10] This is not the place to explore the possibility further, but the deep relation of death, parturition, traumatic fear of death in war, and the sort of dissociation that was seen at the time as a condition of automatism was a subject of considerable discussion after the war.[11]

Rubin also links Masson's experience of war to a pair of anthropomorphic landscapes that feature central skull-like formations. Rubin connects these to Masson's observation that Craonne, the name of the plateau on which the Chemin des Dames ridge is located and the name of a nearby town, and Craonnelle, the name of another nearby town, are "strangely cranial."[12] One of the drawings, in fact, sets the skull-like edifice deep in an elevated ridge (fig. 3).[13] Several ravines—which must recall the teeth of the comb that Frank Simonds compared to the Chemin des Dames ridge—surround the central space, so that the face of the skull, with its complexes of caverns and stairs,

might be thought of as one of those ravines, filled with the chalk caves and pillboxes the Germans tunneled through and filled with invisible machine-gun emplacements. A true death's-head.

Masson was hospitalized—first for his injuries and then for depression. It is well known that his hospitalization for depression was precipitated by an angry outburst against an officer who treated him abusively. What is less commonly discussed is the relation of this outburst to a widespread mutiny that followed the failed attempt to take the ridge of the Chemin des Dames. Already in March, before the offensive, Nivelle recognized the problems in a note to army commanders. He wrote that he found "in a large number of units a certain lassitude and a hardly satisfactory state of morale. Recriminations are numerous and directed at the most varied subjects: bad food, poverty of clothing, fatigues endured, ignorance or indifference of superiors, duration of inaction."[14] "Responsibility for this situation," he added, "belongs entirely to command."[15] After the offensive, breaches of discipline, organized disobedience, dereliction of duty, and other offenses reached a crisis proportion—involving perhaps between thirty thousand and forty thousand men.[16] Masson's outburst was one of many, part of a general reaction to harsh circumstances, to a sense that the soldiers' sacrifice had been out of proportion to the rewards, and to a crisis of confidence in leadership. After replacing Nivelle, General Henri-Philippe Pétain moved quickly to address the troops' grievances, and the mutinies subsided.[17]

After Masson left the army, he joined a generation of young artists marked by the war. The remainder he took away from his service was complex. He was once again representative, rather than extraordinary:

> I gave and received blows.... If war had had the continuous horror described by Barbusse in *Under Fire* or by Remarque in *All Quiet on the Western Front,* it would have been unbearable. There were compensations, huge compensations. They have since been described time and again by psychologists. There were moments of real happiness, even under fire. There were things which were crudely beautiful to see.... The rockets, the smell of the battlefield which was intoxicating. Yes, all that. "The air was drenched in a terrible liquor." Yes, all that Apollinaire had seen. Only a poet could say that. My God, he even mounted a defense of war. No. It was merely a defense of life in death. He defended peace in war. Because peace within war, that is something. Relaxation, all of a sudden.[18]

Masson was both shocked by Guillaume Apollinaire's apology for war and able to join him in appreciating certain features of it.

Returning to civilian life, Masson was told to avoid the stress and stimulation of city living. Instead of following the advice, he moved to Paris and began working intensely, using stimulants to help him cobble together a living for himself and his small family from various jobs. He found a studio in the rue Blomet, where he came to know his neighbor, Joan Miró, and a group of comrades including Michel Leiris, Armand Salacrou, and Roland Tual, and visitors such as Antonin Artaud, Bataille, and others. The little community in the courtyard of the building became

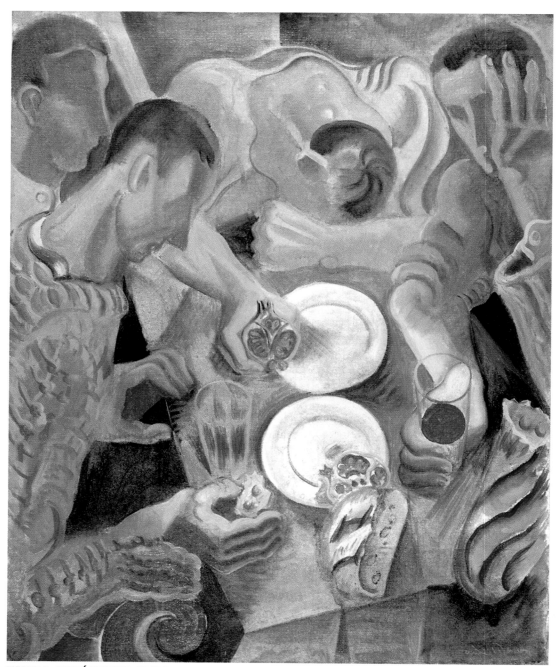

FIGURE 4. ANDRÉ MASSON (FRENCH, 1896–1987). *The Repast,* 1922, oil on canvas, 81 x 65 cm (31⅞ x 25⅝ in.). Barcelona, Galeria Marc Domènech.

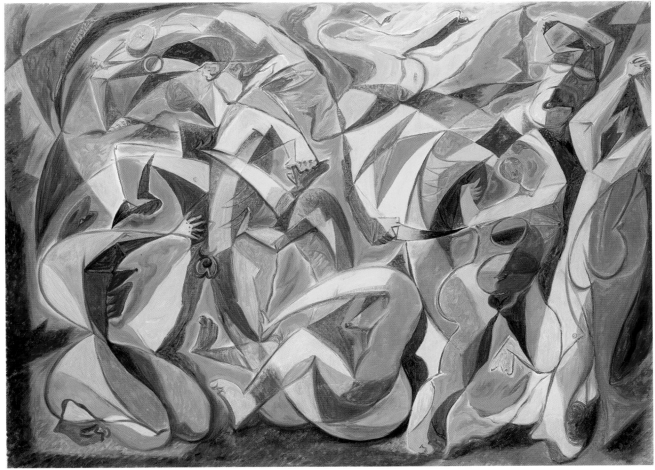

FIGURE 5. ANDRÉ MASSON (FRENCH, 1896–1987). *Massacre,* 1931, oil on canvas, 120 x 160 cm (47¼ x 63 in.). Berlin, The Ulla and Heiner Pietzsch Collection.

important to all the participants, who referred to it often in later years. Masson made paintings that evoke it. They reveal his inventive appropriation of cubist pictorial methods — cubism's transparency and destruction of the stable point of view. Yet, as Daniel-Henry Kahnweiler, who was the cubists' and Masson's dealer, points out, Masson's world is violent, while the cubists' knew no death.[19] Even such moments as the evening gatherings in the courtyard of the rue Blomet, however, afforded Masson occasions to reflect on the presence of death. *The Repast* (fig. 4) shows the drowsy revelers arrayed around a pomegranate, which, as Carolyn Lanchner explains, carries multiple significances in its frequent appearances in Masson's work, including fertility, as a womb, for instance, and death, as the crushed skull of a soldier.[20] (Perhaps it is worth adding that the word *grenade* in French names the fruit, pomegranate, and a small explosive shell, such as a hand grenade, which appears on a badge as an element of military insignia.)

Shortly afterward, Masson became a member of the surrealist movement. He was also among the first to be expelled when André Breton forced the issue of political participation. During his involvement with the young surrealist movement, Masson experimented with automatic drawing. Later, his imagery retained a metaphorical association between meandering lines and erotic violence. (Laurie Monahan explains this point with special attention to Masson's *Massacre* of the early 1930s [fig. 5].) These associations—among violence and eroticism and the earth and line, among change and death and life and his own art—remained in force throughout Masson's oeuvre for the rest of his long, productive career. Much of it can be traced back to his traumatic but important experience in the First World War: "'The field of battle made a human being of me,' he says. 'It literally threw me into the *humus humain.*'"[21]

– NOTES –

1 Carolyn Lanchner, "André Masson: Origins and Development," in William Rubin and Carolyn Lanchner, *André Masson* (New York: Museum of Modern Art, 1976), 82–83.

2 Masson refers to his source as "Notes" from 1888 "extracted from little-known pages preserved by the Nietzsche-Archiv." See André Masson, letter to Georges Bataille, dated Sunday (June 1936), in Françoise Levaillant, ed., *Le rebelle du surréalisme: Écrits,* rev. ed. (Paris: Hermann, 1994), 290. I give the corresponding passage from Nietzsche's note on *The Birth of Tragedy,* §3, in *Ecce Homo* as it appears in Friedrich Nietzsche, *Ecce Homo: How One Becomes What One Is and the Antichrist: A Curse on Christianity,* trans. Thomas Wayne (New York: Algora, 2004), 51 (emphasis Nietzsche).

3 Michael S. Neiberg, *Fighting the Great War: A Global History* (Cambridge, Mass.: Harvard University Press, 2005), 232–33.

4 Frank H. Simonds, *History of the World War* (Garden City, N.Y.: Doubleday, Page, 1919), 4:142.

5 Simonds, *History of the World War,* 143–44; and Neiberg, *Fighting the Great War,* 241.

6 Neiberg, *Fighting the Great War,* 240–41.

7 Neiberg, *Fighting the Great War,* 244.

8 André Masson, as in Gilbert Brownstone, *André Masson: Vagabond du surréalisme* (Paris: Éditions Saint-Germain-des-Prés, 1975), 29, cited in William Rubin, "André Masson and Twentieth-Century Painting," in Rubin and Lanchner, *André Masson,* 30–31.

9 William Rubin, "André Masson and Twentieth-Century Painting," in Rubin and Lanchner, *André Masson,* 30.

10 Masson, cited in Gilbert Brownstone, "André Masson," in idem, *André Masson* (Milan: Galleria Schwarz, 1970), 24: "Painting requires preparation…however, one must emphasize the aspect of revolt against artistic tradition which is in automatism. As I've already told you, it was a way of turning eroticism, quite simply, into a noble art." Laurie Monahan tells a different kind of story—not necessarily in disagreement with Masson's recollection—in which Masson's use of automatism becomes aligned with a surrealism he refuses *because* it is a merely an artistic revolt, because its art is noble. See Laurie Jean Monahan, "A Knife Halfway into Dreams: André Masson, Massacres, and Surrealism of the 1930s" (PhD diss., Harvard University, 1997), chap. 2. For instance (pp. 68–69):

> In contrast to the images of the 1920s, the *Massacres* appear to reject automatism insofar as a premeditated and figurative subject is plainly presented: in both the paintings and the drawings of the series, bodies are clearly delineated, each act of violence legible. Erotic violence, struggle—these are *secured* through figuration, as though Masson has turned away from representing the unconscious as a *process,* electing instead to picture what the unconscious—as pure libido, stripped of "civilized" trappings—might look like. If automatism provided Masson with the means to represent or replicate the unconscious *process,* figuration would fix a consciously conceived image of the unconscious self.

11 See Ruth Leys, "Traumatic Cures: Shell Shock, Janet, and the Question of Memory," *Critical Inquiry* 20, no. 4 (1994): 623–62, esp. 633–34.

12 Rubin, "André Masson and Twentieth-Century Painting," 31; citing Jean-Paul Clébert, *Mythologie d'André Masson* (Geneva: Cailler, 1971), 22.

13 Rubin, "André Masson and Twentieth-Century Painting," 33.

14 *Les armées françaises dans la Grande Guerre,* tome 5, vol. 2, volume of annexes 1 and 16, cited in Guy Pédroncini, *Les mutineries de 1917* (Paris: Presses Universaires de France, 1967), 51 (translation mine).

15 Pédroncini, *Les mutineries de 1917,* 51.

16 Pédroncini, *Les mutineries de 1917,* 308.

17 Pédroncini, *Les mutineries de 1917,* 311; and Neiberg, *Fighting the Great War,* 248.

18 Georges Charbonnier, *Entretiens avec André Masson* (Marseille: Ryôan, 1985), 38–40 (from a radio interview of 1957), cited in Annette Becker, "The Avant-Garde, Madness, and the Great War," *Journal of Contemporary History* 35, no. 1 (2000): 72.

19 Daniel-Henry Kahnweiler, "Preface," in *André Masson,* exh. cat. (New York: Buchholz Gallery, 1942), n.p., cited in Rubin, "André Masson and Twentieth-Century Painting," 15.

20 Lanchner, "André Masson: Origins and Development," 93. Masson describes such a sight himself in a later piece of writing that reflects on his intellectual development: "As an adolescent, I have seen among the casualties of combat a shattered skull: a ripe pomegranate and blood on the snow design the scutcheon of war. Later in the solitude of the Alps, I discovered the flight of the eagle tracing its perfect geometry in filigrane on the arena of heaven. The secret world of Analogy, the magic of the Sign, the transcendence of Number were thus revealed to me." André Masson, *Anatomy of My Universe* [1940] (New York: Curt Valentin, 1943), prologue, section v.

21 Brownstone, *André Masson: Vagabond du surréalisme,* 15, cited in Rubin, "André Masson and Twentieth-Century Painting," 31.

Revolution's task: de-reification, destruction of the object in order that humankind may be saved.

— Carl Einstein[1]

Our young recruits have a real tenderness for [the 75-millimeter field gun]. Upon encountering the batteries along the roadside, they run their fingers over the grey tubes of each unit, just as cavaliers once touched the necks of their horses.

— Louis Baudry de Saunier[2]

IN A LETTER TO HIS ART DEALER, LÉONCE ROSENBERG, written in the early 1920s, Fernand Léger (1881–1955) cast a retrospective glance over the previous decade of his career, noting that he "had been extreme two times, in 1914 (forms and contrasts) and in 1918, Disks. Cities."[3] Until the publication in 1990 of a volume of fifty letters sent from Léger to his childhood friend Louis Poughon between 1914 and 1917, it was difficult to thread the gap between these two "extremes," other than to say that the experience of war radically recast the painter's approach to cubism.[4] Although he was conscripted into the *génie,* or engineering corps, during the national mobilization on 1 August 1914, Léger apparently did not cut the figure of a born sapper; as of that October, his commanding major, who had taken a liking to the artist, reassigned him to serve as a stretcher-bearer in the same company—less arduous, although by no means safer, work. Nonetheless, over the course of the next three years, Léger would try every way he could think of to be removed from the front, enlisting Poughon, who had been appointed prefectural adviser in Deux-Sèvres, to help him secure transfer to the camouflage unit, and, when that effort failed, to a rearward medical unit—an equally futile gambit.[5]

Fernand Léger
Objects, Abstraction, and the Aesthetics of Mud
DANIEL MARCUS

As for the artist's activities and whereabouts: Léger's company was stationed at various sites in the Argonne forest from 12 August 1914 until at least August 1916. In the summer of 1915, he received his first permitted leave and returned to Paris for six days, where he was able to reestablish ties with the avant-garde and acquire art supplies. Upon his return to the Argonne, he made drawings in pencil and ink, watercolors, and paintings on panel, some of which were commissioned work for his fellow soldiers and commanding officers. As of January 1917, his company had moved to Champagne, where Léger found himself in "a ridiculously calm sector," as he put it in a letter to Poughon.[6] While on leave in Paris during late July, he took ill with rheumatism and spent the better part of a year in and out of military hospitals. In the summer of 1918, he continued his convalescence at a rented house in the town of Vernon. It was during this period of medical leave that Léger resumed painting and secured a contract with Rosenberg.

How, then, did Léger's experience of World War I alter the stakes of his art? In an often-cited 1949 interview, Léger suggested that the social and environmental conditions of combat steered him away from the formalist concerns of the prewar years:

> The super-poetic atmosphere of the front excited me to the core. God! What faces! And cadavers, mud, cannons. I never made any drawings of cannons, I had them in my eyes. It was in the war that I put my feet into the dirt. I left Paris during a period of full-blown abstraction, era of pictorial liberation. Without transition, I found myself among the people of France; sent to the *génie,* my new mates were miners, pavers, woodworkers, metalworkers.... At the same time, I was astounded by the open breech of a 75 [millimeter cannon] in full sunlight, magic of light on white metal. It didn't take much more for me to forget the abstract art of 1912–1913. The roughness, the variety, the humor, the perfection of certain types of men around me, their exact sense of useful reality [*le réel utile*] and its right application in the midst of this drama—life and death—in which we were mixed up; more than that, [they were] poets, inventors of everyday poetic images; I have in mind their slang, so fast-paced, so colorful. Once I had a taste of that reality, the object never again left me [*l'objet ne m'a plus quitté*].[7]

What sorts of objects did Léger have in mind, and what did it mean to rediscover them in the midst of battle, under conditions that had left the physical object-world pulverized? How should we interpret the initiatory role played by the famed 75-millimeter field gun, or 75—a machine that had been in circulation since the late nineteenth century and that served as the mainstay of France's artillery sector during World War I?[8] Art historians have tended to answer these questions by gesturing to the implicit resonance of cubist methods with the physical destruction and fragmentation of the landscape.[9] Likewise, Léger's totemic vision of the 75 might seem to conform to a similar logic: the painter discovered a species of object suited to the planar faceting of cubist still life. He had merely to depict what he saw, or near enough to it.

Ultimately, I will offer quite a different interpretation of Léger's "return to objects" during and after the war. As a preliminary, however, I must touch briefly on his work made prior to 1914, in particular the series *Contrasts of Forms,* for it was in the prewar period that Léger first began to interrogate the dyad of abstraction and objecthood. Although he veered sharply from the depiction of discrete, identifiable objects in this body of work, Léger nonetheless retained many of the definitive signifiers of thingness. Far from jettisoning volumetric modeling or spatial recession, Léger deployed these conventions to excess, launching cubism in the direction of abstraction, yet doing so, paradoxically, by means of objects.

For example, in the largest work of the series, the *Contrast of Forms* held in the collection of the Philadelphia Museum of Art (fig. 1), one can readily identify all the raw materials of a still life, or even a figure painting. Two sequences—we could call them chains—of cylinders wend along the sides of the canvas, each receding from center to periphery in a trail of blue and yellow. Interspersed within and superimposed

over this circuitry of cylinders are rectilinear planes of red, orange, green, and mauve. In this work, "contrast" is a matter of color, but also, more importantly, of the conflict between surface and depth. Taken on their own, the cylinders could conceivably depict a riot of drums or swarming bees, and they almost conjure the figure of a hooded serpent. Ultimately, however, these proto-objects fail to yield any particular subject or content. Even when tangible subject matter reemerged in Léger's work of the following year, as in *Still Life: Alarm Clock* (1914), objects were merely a pretense,

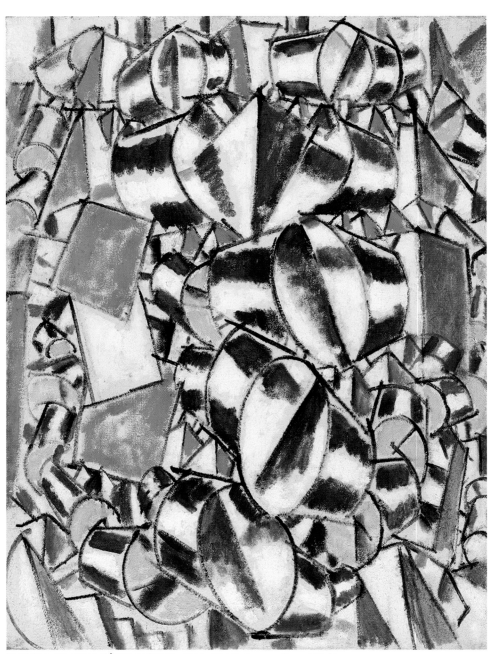

FIGURE 1. FERNAND LÉGER (FRENCH, 1881–1955). *Contrast of Forms*, 1913-14, oil on burlap, 130.2 x 97.6 cm (51¼ x 38½ in.). Philadelphia, Philadelphia Museum of Art.

not ends in themselves. Summoning a glut of contours and volumes, he used them not as the constituent parts of a totality but rather as host bodies for colors applied in thin, dry blotches.

The *Contrasts of Forms* was a crux for Léger; it would not be simple to walk back from the high-water mark set in 1913. During the war, however, Léger emerged as a critic of his own attitude toward objects, as well as a skeptic of abstraction—a shift he framed in terms of class. Thrown into a company of peasants, laborers, and artisans, Léger was acutely aware of his displacement as a cultivated city dweller among the salt of the earth. Expressing fascination more than resentment, Léger's letters to Poughon brim with mentions of his countrymen's preternatural sense of an object's "value," a term that implied something more than mere monetary value. For Léger, the sudden absence of a market economy on the front had the effect of intensifying the fetish character of everyday commodities (which did not cease to be commodities); objects became newly visible, and therefore valuable, precisely because no amount of money could buy them. Writing from the Argonne about life in the trenches, he observed, "Money no longer exists, every raw material becomes of enormous value. There's bread, meat, potatoes and wine. I know what it is to choose potatoes. I've learned not to waste bread. A pants button costs an arm and a leg, and socks would be beyond price if prices existed."[10] In another letter to Poughon, Léger harangued his friend for not having undergone the transformative privation of life in the trenches, avowing that, were it possible to take a leave in Paris, "I'm sure that I wouldn't waste a single minute there—I used to waste entire months—because I would see things in their 'value,' their true, absolute value, by God! I know the value of each object, understand, Louis, my friend? I know what bread is, and wood, and socks, etc. Do *you* know that? No, you can't know because you've not been to war."[11]

Although we might expect that Léger would have responded to his newfound sympathy for objects by returning to the still-life format, these precious wares appear to have loomed so large—and so valuable—as to fall beyond depiction. In any event, no drawings of bread, socks, buttons, and the like survive among his drawings from the front. Having acquired drawing supplies during a leave from combat in September 1915, Léger began to make studies of the surrounding landscape, at least when it was safe to do so, and of his fellow soldiers hunkered in the trenches.[12] Art historian Kenneth Silver has described these drawings as "genre scenes": unassuming sketches, they depict the common soldier, or *poilu,* at rest, smoking a pipe, playing cards, or gathering around a horse-drawn mess carriage. Silver suggests that Léger "found cubism appropriate for life in the trenches (trench warfare itself being an essentially new form of battle);" yet it was less the novelty of this mode of shelter that the drawings index than its inescapable poverty. From Verdun, Léger wrote Poughon: "We're stuck in the ground, we're absorbed by it, we press ourselves close to the earth to evade the death that is everywhere."[13] Months earlier, he had marveled at the way his fellow *poilus* managed to live, work, and sleep "knee-deep in water and [still] make little paper boats" to amuse themselves.[14] In his drawings from the front—such as *The Drillers,* a study of two men laboring underground (dated winter 1916, near Verdun) (fig. 2)—Léger bent the cubism of his *Contrasts of Forms* into a kind of pictorial materialism, a figure of the *poilu*'s phenomenology; it is not just the body but also the

FIGURE 2. FERNAND LÉGER (FRENCH, 1881–1955). *The Drillers,* 1916, possibly pencil and gouache on paper, 28 x 19.5 cm (11⅛ x 7¾ in.). Location unknown.

soldier's ego, his face and voice, that bleeds into the muddy surround, into fragmentary objects. Man becomes not machine but mineral, barely distinguishable from the chalky faceting of the background plane. Léger never joined the camouflage unit, but he saw a parallel between the *poilu*'s ability to disappear — to *be* the mud — and his own brand of object-oriented abstraction.

· · ·

The ethics of cubism were obviously on Léger's mind during his years on the front: on the one hand, he saw that the same operations that had generated abstract paintings prior to the war could be mobilized to celebrate the *poilu*'s resiliency and instinctive self-preservation (and even self-abnegation); yet on the other hand, he recognized an unsettling kinship between his own artistic powers and the mechanical forces responsible for "the death that is everywhere." Cubism could champion the underdog, but it could also dominate space with the same totalizing efficacy as the *canon de 75;*

both possibilities remained open to Léger during the war. The shattered, cratered landscapes of Verdun obsessed Léger, and he wrote Poughon enthusiastically in November 1916:

> I love Verdun. Maybe I already told you so. This old city all in ruins with its powerful calm. I love to spend afternoons here. . . . Here at Verdun there are completely unheard-of subjects, a delight to my cubist soul. For example, you'll see a tree with a chair perched on top of it. So-called sensible people will treat you like a madman if you present them with a painting composed that way. Here, however, one has only to copy it. Verdun authorizes every kind of pictorial fantasy.[15]

Léger was aware of the logic underlying this pattern of juxtapositions: the truth of the war was "as linear and dry as a geometry problem. So many shells in so much time over such a surface, so many men by meter per hour fixed in order. Everything unfolds mechanically. It's pure abstraction, purer even than Cubist Painting 'himself.' "[16] In his own renderings of the landscape, however, no such order offers itself to the eye; far from conjugating pictorial geometry with the mathematics of killing, Léger's drawings take stock of the damage *after* the violence has passed — and, perhaps, as a means of warding against its return.

In another body of work, however, Léger began to address this "geometry problem" head-on. A trio of drawings, all made near Verdun in 1916, focus closely on what is almost certainly the aiming mechanism of a *canon de 75* (figs. 3, 4); they represent the artist's only foray into still life during the war and are also his sole exploration of an explicitly mechanical object from close-up.[17] One of these studies is titled *Mechanical Elements;* the others occupy the recto and verso of a single sheet of paper (now held at the Musée d'art moderne et contemporain de Strasbourg) inscribed "Souvenir de guerre." Strikingly inventive, these drawings foreshadow the radically attenuated surface-level compositions that would come to occupy Léger in the war's aftermath, such as *The Disks* (1918) and *The City* (1919). With the drawing titled *Mechanical Elements,* for example, the artist constructed a shallow facade of vertical columns and intersecting lines studded with pseudo-mechanical forms — including crank handles, various valves, and contours — that suggest the smooth precision of machine-tooled fabrication. Yet the drawing stops short of depicting any recognizable mechanism; various elements of the aiming mechanism are identifiable, but the picture picks and chooses according to its own logic, de-objectifying what was otherwise the summa of military engineering and a totem of national pride.

By the time he painted *The Motor* (1918), enlarging and refining the pictorial grammar first sketched in *Mechanical Elements,* it seems Léger had shed his former resistance to abstraction, instead positioning himself as a celebrant of machines and mechanized landscapes. Despite this shift in attitude, however, Léger continued to mishandle his array of source objects, from coal-powered tugboats to Taylorized factories, refusing to depict the commodity-form as such. As with his drawings of artillery, there was nothing mechanical — no coherent arrangement of functional parts, nothing that could be designated "object" with any certainty — to be discovered

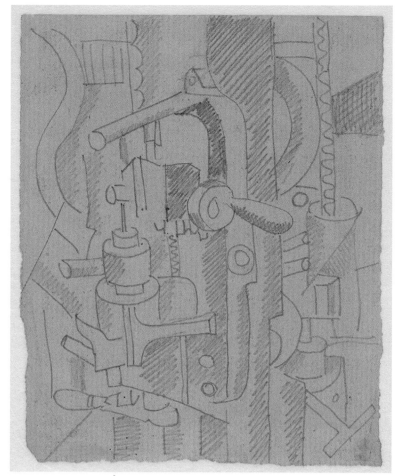

FIGURE 3. FERNAND LÉGER (FRENCH, 1881–1955). *Mechanical Elements,* 1916, graphite on paper, 16.3 x 12.6 cm (6½ x 5 in.). From the series *Dessins de guerre.* Paris, Musée national d'art moderne, Centre Georges Pompidou.

FIGURE 4. DETAIL OF THE AIMING MECHANISM OF A *CANON DE 75.* From *Manuel du gradé de l'artillerie de campagne: À l'usage des sous-officiers, brigadiers, et élèves brigadiers, des élèves officiers de réserve et des candidats à l'école militaire de l'artillerie* (20th ed.) (Paris: H. Charles-Lavauzelle, 1915), 297. Paris, Bibliothèque nationale de France.

in Léger's paintings of machines. The sight of a sun-dazzled 75 may have roused the artist's admiration, but he broached the subject of modern machinery from a faux-naïf perspective, as if convinced that these icons of abstraction were the most material — we could even say the flimsiest — things on earth, amalgams of planes and lines, nothing more. Rather than "destroy objects," as demanded by critic Carl Einstein, Léger instead deployed cubism's modest powers — its weak abstraction — in defiance of the superior abstractions of war and capital, countering precision with improvisation and solidity with incoherence. Armed with charcoal and ink, one had no way of smashing (or surmounting) the *canon de 75;* it was enough — all one could do — to draw abstraction down into the mud, where bodies and things become indistinct and indistinguishable.

1 Carl Einstein, "The Revolution Smashes through History and Tradition," trans. Charles Haxthausen, *October* 107 (2004): 140.

2 Louis Baudry de Saunier, *Le canon de 75* (Paris: Flammarion, 1922), 7. All translations are mine unless otherwise noted.

3 Fernand Léger to Léonce Rosenberg, undated letter. Reprinted in *Fernand Léger: Une correspondance d'affaires* (Paris: Les cahiers du Musée national d'art moderne, 1996), 114.

4 I am by no means the first scholar to make use of this collection of letters. For example, the chronology written for the Museum of Modern Art's most recent Léger monograph closely follows the Poughon correspondence; see Carolyn Lanchner, ed., *Fernand Léger* (New York: The Museum of Modern Art, 1998). My essay offers only a relatively brief summary of the artist's wartime itinerary; readers are referred to the correspondence for further details. See Fernand Léger, *Une correspondance de guerre à Louis Poughon* (Paris: Centre Georges Pompidou, 1990).

5 For a more detailed account of Léger's efforts to be transferred away from the front (a practice known in French as *embusquage*), see Charles Ridel, *Les embusqués* (Paris: Armand Colin, 2007), esp. chap. 6.

6 Léger to Louis Poughon, 9 January 1917. Léger, *Une correspondance de guerre,* 75.

7 "Que signifie: Être témoin de son temps?," *Arts,* Paris, no. 205 (11 March 1949), 1.

8 The *canon de 75* was an object of national veneration in France during the First World War, its diminutive stature casting it as David to the German Goliath. To raise funds for the war effort through the sale of commemorative medals, a *journée du 75* was held on 4 February 1915.

9 For a representative sample of this argument, see the following passage from Kenneth Silver's landmark study of French modernism during and after World War I:

> [Cubism's] dissonant, visually explosive style was an especially appropriate language in which to describe the destructive powers of modern warfare. Cubism offered both a system for the breaking down of forms and a method for organizing pictorial decomposition. For a war that—with its trench fighting, new incendiary devices, modern artillery, and poison gas—was unprecedented in almost every way, Cubism's lack of association with the past was the analogue of the *poilu*'s general sense of dissociation. As a new visual language with a radically altered perspective, Cubism was an excellent means for portraying a war that broke all the rules of traditional combat. For those who had actually been in the trenches, the image of a wounded cuirassier could not possibly translate or epitomize lived experience: Cubism, on the other hand, for rendering one's comrades whether at leisure or in the midst of battle, seemed to have a ring of truth.

Kenneth Silver, *Esprit de Corps: The Art of the Parisian Avant-Garde and the First World War, 1914–1925* (Princeton, N.J.: Princeton University Press, 1989), 84–85.

10 Léger to Louis Poughon, 5 October 1914. Léger, *Une correspondance de guerre,* 12.

11 Léger to Louis Poughon, 12 April 1915. Léger, *Une correspondance de guerre,* 35 (emphasis Léger).

12 At Leger's suggestion, Douglas Cooper published a selection of forty-four of these wartime drawings and gouaches; see Cooper, *Fernand Léger: Dessins de guerre, 1915–16* (Paris: Beggruen, 1956).

13 Léger to Louis Poughon, 7 November 1916. Léger, *Une correspondance de guerre,* 70.

14 Léger to Louis Poughon, 17 December 1914. Léger, *Une correspondance de guerre,* 26.

15 Léger to Louis Poughon, 23 November 1916. Léger, *Une correspondance de guerre,* 72. It is noteworthy that in the drawing *Dans Verdun,* annotated by Cooper in *Fernand Léger: Dessins de guerre* with the recto caption "autre dessin (crayon) avec chaises et arbres," the chairs are depicted on the ground, not in the trees.

16 Léger to Louis Poughon, 30 May 1915. Léger, *Une correspondance de guerre,* 36.

17 Other drawings show various pieces of war material in landscape format. See, for example, *La cuisine roulante* (1915), *Hissage de forme mobile* (1916), and *L'avion brisé* (1916).

ON 2 AUGUST 1914, AFTER BEING CONSCRIPTED INTO THE FRENCH ARMY, Georges Braque (1882–1963) left his studio in the town of Sorgues for the trenches.[1] This event would prove to have a profound impact not only on him but on the history of art, as it signaled the end of his collaboration with Pablo Picasso and the shared artistic enterprise known as cubism. In 1915, Braque was badly wounded fighting in the war and required an extended convalescence. When he returned to painting in 1917, near the end of the war, Braque appeared to take up where he had left off in 1914. The paintings made in the years during and immediately after the war employ many of the stylistic devices of prewar cubism as well as much of its subject matter, leading some scholars to view the works as a repression of his war trauma.[2] And yet, these works are not entirely unchanged; overall, many of them display an increased focus on the material qualities of things and an obsessive engagement with the physical experience of space. Although these are subtle differences in an artistic production that remains overtly apolitical and formalist, displaying a continued self-reflexive attention to questions of medium and aesthetic experience, it bears asking if any of this is indeed connected to Braque's time at the front.

Georges Braque
Artilleryman

KAREN K. BUTLER

This essay has before it a difficult task: how to consider what the effects were of a series of external events—fighting in a war, enduring a devastating physical wound, and overcoming an extended hiatus from painting—on Braque's largely internalized aesthetic practice. Braque's avowed belief in the autonomy of painting, in the notion that art was independent from society and sociopolitical events, would appear to foreclose any direct links between his artistic production and the traumatic events of World War I. Is it, then, even possible to discuss the relationship of an artist's work to the war when the work does not possess any literal or iconographic representation of the war?

By all accounts, Braque was profoundly affected, both physically and mentally, by combat. After being mobilized in August, he was assigned to the 329th Infantry Regiment as a sergeant and sent to Lyon, where he received training on the machine gun.[3] On 14 November, he was promoted to sublieutenant and sent to the front on the Somme, where he first saw action. Writing to Picasso on 29 November, he conveyed some of the devastation and destruction he must have encountered: "I had my baptism about a week ago.... There's been a lot of fighting here and we've taken up guard among dead Boches and also unfortunately some [French] marines. Now the area is fairly calm. You can't imagine what a battlefield is like with the uprooted trees and the earth dug up by the shells."[4] A month later, he sent a photo to his companion, Marcelle Lapré (whom he married in 1926), in which he appears meditatively holding a cigarette and wearing a thick knit sweater under his uniform, a poignant reminder of the cold winter in the trenches. The photo is movingly signed with a simple note:

"Souvenir of the attack of 17 December 1914, Maricourt."[5] In April 1915, his regiment (he had been reassigned to the 224th Infantry Regiment in January of that year) was engaged in the second battle of Artois. On 11 May, amid heavy enemy shelling in the fighting for Neuville-Saint-Vaast, he received a severe head wound, was left for dead on the battlefield, rescued, and trepanned and then spent forty-eight hours in a coma. When he awoke, he was temporarily blind. During his long recovery, he stayed at his studio in Sorgues but painted little. He spent the last six months of 1916 at a military training depot but never went back to the front. He fully resumed painting in 1917, and he was officially demobilized in March of that year.

Braque's own words on the war provide glimpses of what must have been an extremely emotionally disturbing experience. In a 1954 interview with art critic Dora Vallier, Braque said that upon his return, "I wanted to continue, to clear myself by working," suggesting his desire to repress the traumatic events of the war by immersing himself in the aesthetic world of painting.[6] When questioned by poet and artist André Verdet about his wound and the long period of recovery that followed, Braque stated that what most disturbed him was not the wound, "but the impossibility of painting for those long months. It was more the mental than the physical wounding."[7] This is the only statement Braque ever made that acknowledges the psychological suffering inflicted by the war, though even it refers only to his time recovering from the wound and conveys nothing of the actual nature of battle. Philippe Dagen, author of *Le silence des peintres,* an analysis of a general absence of response in the art of the generation of French artists who lived through the horrors of World War I, argues that Braque's return to painting with little recognition of the war is part of a broader artistic form of repression, an erasure of the shock of war.[8] Dagen's interpretation rests on two counts: first, the observation that Braque's work after fighting in the war does not appear to break with the synthetic cubism of 1913 and 1914; and second, his reading of a series of aphoristic statements on cubism titled "Pensées et réflexions sur la peinture" that Braque published toward the end of the war in the journal *Nord-Sud.*[9] Many of these statements — such as "I love the rule which corrects the emotion" or "The senses deform; the mind forms. Work to perfect the mind. There is certainty only in what the mind conceives"[10] — show his preference for an aesthetic system derived from the rational order and logic of the mind rather than one of bodily sensation or individual subjectivity. They can be read as repressive of the violence and suffering of the war, though none of them overtly refer to the war itself. Dagen's position is compelling, particularly his interpretation of Braque's troubling reflections on painting. Yet I propose an alternative reading of some of the paintings, one that is not necessarily at odds with an interpretation of Braque as invested in an aesthetic practice set apart from the trauma of war, but one that nonetheless sees Braque's heightened emphasis on tactile qualities as mediated by his experience of the war.[11]

• • •

I am interested here in works that are more phenomenologically oriented than those of the prewar period — works that through their material excess, sensuous surfaces, and perceptual ambiguities create a fissure between the beholder and the pictorial

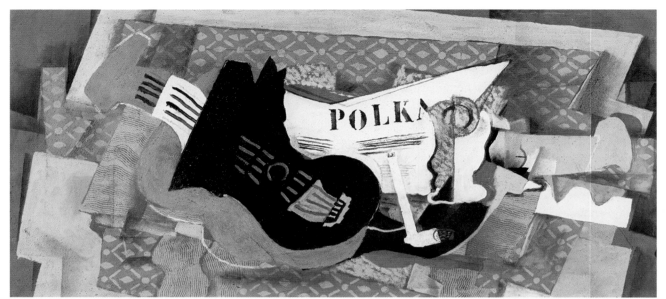

FIGURE 1. GEORGES BRAQUE (FRENCH, 1882–1963). *Guitar and Pipe (Polka)*, 1920–21, oil and sand on canvas, 43.2 x 92.4 cm (17 x 36⅜ in.). Philadelphia, Philadelphia Museum of Art.

world. This is most evident in a group of large-format still lifes featuring objects on tables and mantelpieces painted on a black ground; they were begun around 1919 and continued on and off throughout the 1920s.[12] On one level, these paintings seem to overtly reject the war, for the war as subject is certainly absent from the still-life objects and bourgeois interiors of the paintings. But on another level, their intense focus on tangible qualities and what Braque called "tactile space" (*l'espace tactile*) can be related to the physicality of Braque's time as a soldier.[13]

Guitar and Pipe (Polka)—with its music score titled "Polka," a pipe with embers still smoldering, a guitar, and a wineglass on a wooden table—is an example of this dichotomy (fig. 1). On an iconographical level, it has nothing to do with the war; and, in fact, its depiction of objects conveys an intimate world that is far apart from the chaos of war. Yet, the contradictions of its formal structure suggest something else. There is a tension between the invitation to touch educed by the tactile surfaces of individual objects and the representation of many of these objects as flat-colored planes equivalent to cut-out pieces of paper. Moreover, in the midst of this strangely arranged world, or, more precisely, at the edges of things within this world, there is also a kind of visual and spatial disorder—gaps and ambiguities of shape and substance, of distance and presence, amid the overt logic of the flat forms. The painting itself is structured by a duality between the sensuous and often-beautiful surfaces of the objects—the tangible qualities of the grooves made by a painter's comb in false woodgrain patterns or the textured nature of sand mixed into paint throughout the canvas that directly evokes touch—and the rendering of the space in the canvas as disjunct and impossible to enter, as both flat and three-dimensional. It is precisely this tension between the immediacy of touch and the impossibility of ever entering into that space that implies a kind of psychological rupture and that may allude to Braque's physical experience in the war.

Throughout his career, Braque explained that his goal had long been to render the space that exists between humans and the objects that make up everyday life. He called this "tactile space" and often associated it with cubism: "What attracted me most—and which was the main goal of cubism—was the materialization of this new space."[14] Although Braque's interest in creating tactile space is well known and often referred to by scholars of French modernism, what is frequently overlooked is Braque's association of tactile space with fighting on a battlefield.[15] In a richly evocative statement first made in 1947 and often cited as proof of Braque's interest in tactility and perception but rarely considered in relation to how combat influenced him, he said: "Visual space separates objects from one another. Tactile space separates us from the objects. V.S.: the tourist *looks* at the site. T.S.: the artilleryman *hits* the target. (The trajectory is the prolongation of his arm.)"[16] The statement, which posits the physical immersion into war and battle and thus of painting as a phenomenologically oriented encounter, is profoundly contradictory. On one level, it clearly separates the traditional optical space of painting in which objects appear in a logical, perspectival relationship to one another (visual space)—which he categorizes as reinforcing a kind of disembodied looking—from a physical, embodied form of aesthetic encounter that attempts to materialize the space between humans and things (tactile space). This kind of space, or the experience of this kind of space, he says is akin to the being-in-the-moment of the artilleryman, one who does not look but one who acts; thus he senses the trajectory of the bullet as "the prolongation of his arm." But on another level, with the absorption of mentally and physically disturbing circumstances into a purely aesthetic realm, one wonders if in Braque's own statement there is an element of repression, a disavowal of the mechanization of war, that is made manifest in an inverse relationship in his paintings.

It is worth pausing here to consider what Braque's time at the front might have been like. Trench warfare was most certainly an incomprehensible combination of impersonal, mechanized destruction and extreme sensory overload. In World War I, new weaponry was used, including howitzers, mortars, and machine guns (on which Braque was trained). For soldiers on the front lines, artillery was a particularly horrific aspect of the war; survival depended upon sensory assimilation. Fired just ahead of an attack by foot soldiers to destroy enemy trenches, an artillery barrage was a terrifying assault created by deafening shells that threw enormous amounts of earth into the air. Soldiers developed an acute ability to read a bombardment by listening to it: "As the shells approached, soldiers could often identify their direction, caliber, and probable point of impact, often in time to take cover accordingly."[17] And yet, at the same time, artillery fire, which was used to destroy land and men, was an overwhelming physical experience; and death or survival, independent of the sensory abilities of the individual, was often a matter of chance.[18] Braque's famous statement about the artilleryman, then, with its implication of both control (he hits his target) and physical presence, provides only one side of the equation; it leaves out what must also have been the devastating sensory chaos of the war and the lack of control the soldier must have felt before artillery fire. It is my position

that some of the irreconcilable aspects of Braque's war experience that are found in this statement — a kind of perceptual gap between distance and presence, as well as an emphasis on tactility and physical experience before the mechanization of war — find a way into his postwar paintings.

• • •

One can see in Braque's still lifes from the 1920s a kind of sensuous materiality and a spatial construction that invites physical participation and yet also denies it. The works increasingly highlight the tension between surface and depth, but there are also often gaps in this opposition — areas where the distinction breaks down, where ambiguity and disorder enter the scene. *The Buffet Table* (1920) exemplifies this intuitive approach to spatial texture (fig. 2). The painting has two main viewpoints: an upright wall with wainscoting seen straight on and a tabletop depicted as if seen from above (the objects on the table mirror this duality: fruit is shown frontally and the guitar from above, flat as a pancake). But within the work are areas that defy this opposition: at the top, in the dark ground, are two diagonal sections of white shading (folds? reflections?), and a third appears just a bit lower down in the white panel,

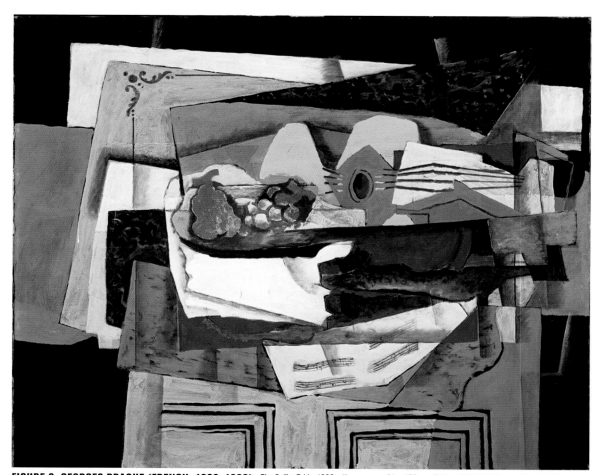

FIGURE 2. GEORGES BRAQUE (FRENCH, 1882–1963). *The Buffet Table,* 1920, oil on canvas, 81 x 100 cm (31⅞ x 39⅜ in.). Vienna, Albertina Museum.

suggesting the spatial ambiguity of depth. But even more confusing is the centrifuge of overlapping and intertwining forms in the center of the canvas—the various colored planes that suggest a salmon-colored tablecloth, a marble panel, a sheet of music, the outer curves of a guitar, a plate of fruit, and a white napkin, among other things. Placed against the more clearly upright form of the wainscoted wall, these fragile planes are perched at an impossible angle. We see them from above, yet we implicitly know they are set horizontally on the table; there is a gap between what is visually conveyed and what is perceptually discerned.[19] In the artist's skillful, almost-virtuoso, application of painted materials, there is an emphasis on the tactile immediacy of both the painter's and the beholder's experience: for instance, the black ground, which gives depth and atmosphere throughout, is particularly visible in the salmon tablecloth and forms the base color of the veined marble panels.

The remarkable mantelpiece works, begun in 1920 and continued intermittently through 1928, are some of the most complex and bothersome examples of Braque's exploration of painting process and the possibilities of material surfaces. Paintings such as *Still Life with Guitar I* (*The Mantelpiece—Waltz*) (1920–21), *The Mantelpiece* (1921), *Guitar and Still Life on a Mantelpiece* (1921) (fig. 3), and *The Mantelpiece* (1928) (fig. 4) form a cycle of works. Each one is from a slightly different

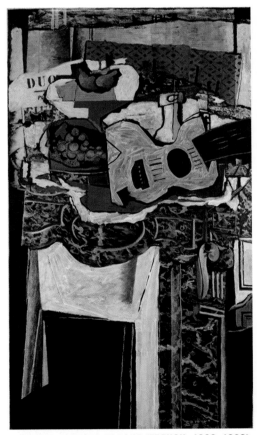

FIGURE 3. GEORGES BRAQUE (FRENCH, 1882–1963).
Guitar and Still Life on a Mantelpiece, 1921, oil with sand on canvas, 130.5 x 74.3 cm (51⅜ x 29¼ in.). New York, Metropolitan Museum of Art.

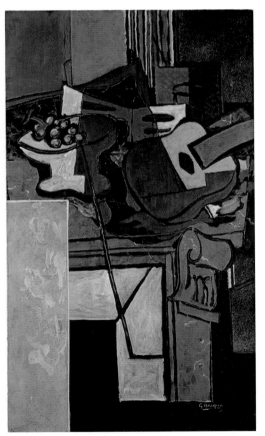

FIGURE 4. GEORGES BRAQUE (FRENCH, 1882–1963).
The Mantelpiece, 1928, oil on canvas, 130 x 74 cm (51¼ x 29¼ in.). Zurich, Kunsthaus Zürich, Vereinigung Zürcher Kunstfreunde.

vantage point, has a variety of decorative surfaces, and depicts the same motif: a still life of a guitar, fruit in a compote bowl, a bottle and a wineglass, and music scores or newspapers set on a decorative mantelpiece. Amid the masterful demonstration of false marble surfaces that evoke the decorative interior of a nineteenth-century bourgeois home is the particularly unsettling black opening of the fireplace itself, which appears as both a flat, impenetrable wall and a point of entry into endless depth. It suggests a kind of perceptual disjunction that is at once about the continuity of space between a beholder and an object and the impossibility of ever overcoming their separation. In the end, Braque always throws us back against the two-dimensional surface of the canvas. The possibilities of tactile space are precluded in particularly poignant and sometimes even violent ways.

Admittedly, after one steps back out of the entangled space of the canvas and takes a distanced view, it is difficult to connect these still lifes and interiors in any overt way to the war. And yet it is worth considering whether the serial nature of these canvases, which return again and again to the same motif with only slight variations in subject or perspective, is in some way suggestive of a psychological response to trauma—a response that is both a repression of the experience of war and an unconscious reiteration of its tactile space. For Braque, who strives to hit his target like the artilleryman, I propose that his emphasis on the material qualities of the artwork is deeply tied to the devastating encounter with industrialized mass destruction that emerged in the trench warfare of World War I.

– NOTES –

1 Braque, who performed his required military service in 1902–3, was called up in the initial mobilization of French troops, even before the actual declaration of war on 3 August 1914.

2 See Philippe Dagen, *Le silence des peintres: Les artistes face à la Grande Guerre* ([Vanves, Fr.]: Hazan, 2012), esp. 284–87. See also mention of Braque's postwar work with respect to the *retour à l'ordre,* a general stylistic neoclassicism and conservative subject matter in the work of the avant-garde after World War I, in Kenneth Silver, *Esprit de Corps: The Art of the Parisian Avant-Garde and the First World War, 1914–1925* (Princeton, N.J.: Princeton University Press, 1989); Romy Golan, *Modernity and Nostalgia: Art and Politics in France between the Wars* (New Haven, Conn.: Yale University Press, 1995); and Kenneth Silver, "A More Durable Self," in idem, *Chaos and Classicism: Art in France, Italy, and Germany, 1918–1936,* exh. cat. (New York: The Solomon R. Guggenheim Foundation, 2010), 14–51.

3 For a detailed account of Braque's service in the war, see Alex Danchev, *Georges Braque: A Life* (New York: Arcade, 2005), 123–45. See also Lauriane Manneville, "Chronologie: 1882–1963," in Brigitte Leal, ed., *Georges Braque, 1882–1963,* exh. cat. (Paris: Réunion des Musées Nationaux, 2013), 275–77. Manneville inaccurately states that Braque was wounded in the first battle of Artois, rather than the second battle of Artois, which took place from 9 May to 18 June 1915; see Leonard V. Smith, Stéphane Audoin-Rouzeau, and Annette Becker, *France and the Great War: 1914–1918* (Cambridge: Cambridge University Press, 2003), 80.

4 Braque to Pablo Picasso, 29 November 1914, cited in Danchev, *Georges Braque,* 122–23.

5 This photo can be found in Leal, *Georges Braque,* 75, fig. 3. These amateur snapshots were common during the war. Often sent from the front to family members back home, they served a variety of purposes, from self-assertion and self-affirmation in the face of the deadly perils of war (as is likely the case here) to more anecdotal and humorous depictions of soldiers' lives that alleviate some of the intense horror of the war; see Bodo von Dewitz, "German Snapshots from World War I: Personal Pictures, Political Implications," in Anne Wilkes Tucker and Will Michels, eds., *War/Photography: Images of Armed Conflict and Its Aftermath,* exh. cat. (Houston: The Museum of Fine Arts, 2012), 152–60.

6 Braque to Dora Vallier, in Dora Vallier, "Braque la peinture et nous," *Cahiers d'art,* no. 1 (1954): 19. All translations are mine unless otherwise noted. This was one of the first published interviews in which Braque commented, albeit briefly, upon his experiences in the war.

7 Braque to André Verdet, in André Verdet, *Entretiens, notes, et écrits sur la peinture* (Paris: Éditions Galilée, 1978), 25.

8 Dagen, *Le silence des peintres,* 284–87.

9 Dagen, *Le silence des peintres,* 284–87.

10 These aphorisms—seventeen short statements—were written during his convalescence from his head wound and published at the initiative of Pierre Reverdy in *Nord-Sud* in 1917; see Georges Braque, "Pensées et réflexions sur la peinture," *Nord-Sud,* no. 10 (December 1917): 4. For a more detailed discussion of the relationship between Reverdy and Braque and his role in the publication of these statements, see Étienne-Alain Hubert, "Braque, Apollinaire, Reverdy," in Leal, *Georges Braque,* 95–105.

11 I have explored similar questions about the relationship of Braque's art to the sociopolitical context of World War II in "Georges Braque and the Cubist Still Life, 1928–1945: The Known and Unknown Worlds," in Karen K. Butler, ed., *Georges Braque and the Cubist Still Life, 1928–1945,* exh. cat. (New York: DelMonico·Prestel, 2013), 12–29.

12 For examples of the mantelpieces, see Nicole S. Mangin, ed., *Catalogue de l'oeuvre de Georges Braque: Peintures, 1916–1923* ([Paris]: Maeght, 1973), nos. 85, 86, 88–90, 111; and Nicole S. Mangin, ed., *Catalogue de l'oeuvre de Georges Braque: Peintures, 1928–1935* ([Paris]: Maeght, 1962), no. 93. Many of these appear grouped together in the recent Braque retrospective catalog, spanning the years 1919 to 1928; see Leal, *Georges Braque,* cat. nos. 114–23.

13 Georges Braque in Jacques Lassaigne, "Un entretien avec Georges Braque," *XXe Siècle* 35 (1973): 6.

14 Braque to Dora Vallier, in Vallier, "Braque la peinture et nous," 16. See also Braque's statement about tactile space to John Richardson, in John Richardson, "Braque Discusses His Art," *Réalités,* no. 93 (1958): 28.

15 For examples, see Christine Poggi, *In Defiance of Painting: Cubism, Futurism, and the Invention of Collage* (New Haven, Conn.: Yale University Press, 1992), 97; and Yve-Alain Bois, "The Semiology of Cubism," in Lynn Zelevansky, ed., *Picasso and Braque: A Symposium* (New York: The Museum of Modern Art, 1992), n. 78, 207.

16 Georges Braque, *Cahier de Georges Braque, 1917–1947* (Paris: Maeght, 1947; reprint, New York: Curt Valentin, 1948), 78. The emphasis is Braque's. Interestingly, this statement appears in a revised and expanded luxury edition of Braque's 1917 "Pensées et réflexions sur la peinture," first published in 1947 by his then dealer Aimé Maeght. The original seventeen statements appear again, most in revised form, along with a number of new statements on art. Only after living through World War II in occupied Paris, an event that must have been even more traumatic for the artist given his experience fighting in the First World War, did Braque begin to make more overt associations between aesthetics and the experience of war.

17 Smith, Audoin-Rouzeau, and Becker, *France and the Great War,* 86. For an analysis of the ways in which soldiers responded symbolically to the technology of warfare that emphasizes the sensory experience of war, see Mary R. Habeck, "Technology in the First World War: The View from Below," in Jay Winter, Geoffrey Parker, and Mary R. Habeck, eds., *The Great War and the Twentieth Century* (New Haven, Conn.: Yale University Press, 2000), 99–124.

18 Long-range artillery and machine guns were some of the most deadly forms of weaponry in the war; the artillery, for instance, inflicted more than two-thirds of wounds in the war. Artillery fire was a constant threat to the soldier; and a barrage, which frequently preceded an enemy attack and could last for days, often made it impossible to eat or sleep, producing a feeling of total helplessness among soldiers. See Smith, Audoin-Rouzeau, and Becker, *France and the Great War,* 78, 85–86.

19 For an embodied reading of Braque's production as a whole, see Gordon Hughes, "Braque's *Regard,*" in Butler, *Georges Braque and the Cubist Still Life,* 74–89.

WAR IS A UNIQUE BIOGRAPHICAL EVENT IN RELATION TO CULTURAL PRODUCTION.
The events of war, World War I in this case, are so undeniably omnipresent as to allow us to trace their impact across a wide range of phenomena. War can provide an extraordinary pairing of termini ante- and post-quem around which to organize our interpretations. We are aided in this by the fact that artists themselves are often forthcoming about the effects of war, in ways they might not be with other experiences in their lives. It will be the goal of this essay, in part, to trace those effects in the work of British artist and writer Wyndham Lewis (1882–1957). At the same time, however, I would like to indicate that making distinctions between before, during, and after the war is more difficult than it would initially appear. In tracking certain disjunctions and continuities in Lewis's work of around 1912–19, we can use him as a test case for the particular opportunities and challenges presented by studying the relation of artistic productions (text) to war (context) and, indeed, by undoing the opposition between these terms that structures so much art history.

To begin, we should note that there is considerable evidence that Lewis saw World War I as an absolute dividing line in European culture.[1] Art historian David Peters Corbett has discussed Lewis's persistent figuration of the war as a "barrier" beyond or over which one cannot look or travel into the past.[2] Even after the next war, a character in one of Lewis's novels says: "The world war (1914–18), is like a mountain ridge in the historic landscape. It is, at once, composed of mountains of criminal destructiveness, and a piling-up of tremendous creative inventiveness. Those four years marked in fact the mass-arrival of the cinema, the aeroplane, the motorcar, the telephone, the radio, etc. This is, as it were a perpendicular wall of great height, a mountainous barrier, behind which the past world lies."[3] This notion of a linked creativity and destruction, a "piling up" and a tearing down, and a beginning and an end offers a means into the complexity of Lewis's response to World War I.

The duality that Lewis describes should make us skeptical about one of his better-known statements, in which he reaches into the past, beyond the barrier of the war. Writing a letter in 1941 to one of his mentors from the first years of the new century, Thomas Sturge Moore, while in exile during another world war, Lewis said,

> How calm those days were before the epoch of social revolutions when you used to sit on one side of your worktable and I on the other, and we would talk—with trees and creepers of the placid Hampstead domesticity beyond the windows.... It was the last days of the Victorian world of artificial peacefulness—of the R.S.P.C.A. and London bobbie, of "slumming" and Buzzards cakes. As at that

Wyndham Lewis
"Art—War—Art"
LEO COSTELLO

time I had never even heard of anything else, it seemed to my young mind in the order of nature. You — I suppose — knew that it was all like the stunt of an illusionist. You taught me many things. But you never taught me that. I first discovered about it in 1914 — with growing surprise and disgust.[4]

The formulation is unmistakably familiar; it captures perfectly the sense of a golden age in England before the war, and Lewis's evocation of a "growing surprise and disgust" signals the beginning of a widespread disillusionment detailed wonderfully by scholar and critic Paul Fussell.[5]

But, coming from Lewis, nostalgia is a surprising note to hear: "trees and creepers of the Hampstead domesticity"? This is difficult to reconcile with both the rhetoric of Lewis's publication *Blast* and a typical picture such as *Composition* (fig. 1) from before the war (for reasons that will become clear, I want to avoid the words "pre-" or "postwar"). As much as Lewis and the vorticist movement kept the nihilist and mechanized aesthetics of futurism and Filippo Tommaso Marinetti at a distance, Lewis, in both text and image, was similarly aggressive in rejecting sentimentalism, anecdote, politeness, and traditionalism. A passage in *Blast,* no. 1, is typical of this approach:

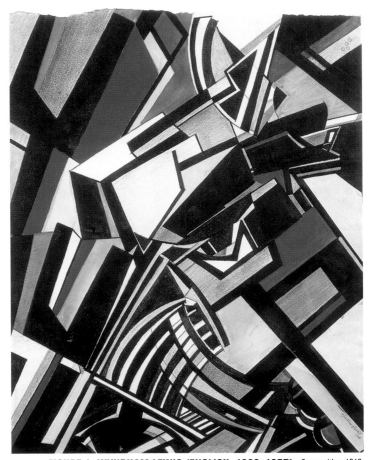

FIGURE 1. WYNDHAM LEWIS (ENGLISH, 1882–1957). *Composition,* 1913, watercolor, ink, and graphite on paper, 34.3 x 26.7 cm (13½ x 10½ in.). London, Tate.

BLAST HUMOUR—
Quack ENGLISH drug for stupidity and sleepiness.
Arch enemy of REAL, conventionalizing like
gunshot, freezing supple
Real in ferocious chemistry
of Laughter.[6]

If Lewis already stood against the world usually represented by the idea of a last golden summer of 1914, then what did he begin to learn that year, as he put it to Moore? He gives no end date for the discovery that began in 1914, but we may assume he means the war and the world it engendered. It must be that Lewis began to discover that what he proposed to reject, the polite world that he had marshaled his art toward tearing down, was itself a chimera, a straw man.

This slightly altered sense of disillusionment was felt primarily, I think, as a loss of artistic certainty, and it takes on an explanatory force in the comparison of *Composition* and *A Battery Shelled* (fig. 2). The clipped, restrained, nearly monochrome expression of the latter picture is a far cry from the dynamism and exuberance of *Composition.* On the one hand, Lewis carefully balances this bursting energy against a desire for geometric stability and order in the earlier picture; its centralized composition speaks to an expansiveness and confidence in attracting attention to itself as it breaks down distinctions between form and space. On the other hand, the abstract elements of *A Battery Shelled* cling to the definition of form, most of it low, in the ground, or at the upper-left margin of the canvas. Indeed, the main part of the picture expresses uncertainty and caution as much as any other quality. As art sociologist Tom Normand notes, the smaller, faceless figures in the center are running for cover as shelling begins.[7] This logic of cover seems to inform the entire picture. If one looks at the central group of three figures, it appears that the primary form of *Composition* has been pulled apart and the background flattened to the earth, while the viewer is distanced and pulled away to the margins. To the extent that this is a landscape, it calls to mind geographer Jay Appleton's notion of "prospect-refuge," the tendency of landscape imagery to appeal to primitive urges to avoid being seen and to survey the landscape from a safe vantage point.[8]

It is instructive to compare works such as *A Battery Shelled,* the two *Siege Batteries Pulling In* (1918, private collection and Manchester City Art Galleries), and *Battery Position in the Wood* (1918, London, Imperial War Museum)[9] to the section in his autobiography *Blasting and Bombardiering* (1937) in which Lewis describes his time at the front. Lewis states, "It is my business here to give an intelligent record if possible of the sort of war I know about," and it is this world of dugouts and gun pits that we see most often in his 1918–19 works.[10] This statement echoes his foreword to the catalog for the *Guns* show, in which he claims, "I have attempted only one thing: that is in a direct, ready formula to give an interpretation of what I took part in in France."[11] Lewis describes a gunner as "a very dangerous type of spectator," someone who did not typically fight at the front like the infantry and was therefore out of touch with an unseen enemy.[12] "A gunner," writes Lewis, "merely shells and is shelled."[13] Indeed, much of his time was spent idle in or near his dugout but with shells raining

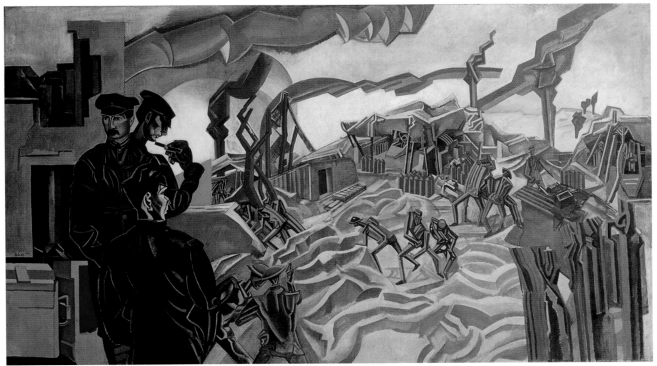

FIGURE 2. WYNDHAM LEWIS (ENGLISH, 1882–1957). *A Battery Shelled,* 1919, oil on canvas, 182.8 x 317.5 cm (72 x 125 in.). London, Imperial War Museum.

down almost constantly, or near the frontline trenches, more exposed, in an observation post. These pictures capture very accurately the drab landscape and repetitive activity he describes, articulating visually the particular combination of boredom and terror that characterized his time near the line.

While the war drawings tend to be more episodic, *A Battery Shelled* is comprehensive and also corresponds to Lewis's depiction of his fellow soldiers. Whereas the enlisted men in the distance, like those in the drawings, appear as a set of repeated shapes forming faceless automatons, the officers at the left take on more individuality, as they do in Lewis's vivid descriptions in the book. The three faces here, especially the two at the top, seem to stem from one body, to be three particularized manifestations of a typology, as are the groups of figures in the main part of the painting.[14] At the same time, the larger picture lacks one of the defining characteristics of Lewis's written account: humor. As Normand notes, for instance, Lewis's description of being shelled is coupled with the story of a fellow officer's flatulent response to the dropping of each shell.[15] However, some of the drawings — *Gossips* (1917, London, Victoria and Albert Museum), *Pastoral Toilet* (1917, London, Victoria and Albert Museum), and *Run Ration* (1918, Sheffield, Graves Gallery), for example[16] — seem closer to the characteristic wit of Lewis's writing as well as the formal language of his work of 1912–14.

But the visual work is largely silent about the more engaged aspects of his experience. First of all, as scholar Alan Munton notes, the paintings and drawings by and large do not show violence.[17] There is not much to be found in *Blasting and Bombardiering,* either, though the book does feature a couple of extended, very visual descriptions of the battlefield. In one section, Lewis describes going forward with his commanding officer to scout out a new observation post in the wake of a British attack, which had reformed the front lines. In separate passages, he describes the scene and then notes, "To make a reconstruction of this landscape for a millionaire-sightseer, say, would be impossible.... This is a museum of sensations, not a selection of objects. For your reconstruction you would have to admit Death there as well, and he would never put in an appearance, under those terms. You would have to line the trenches with bodies guaranteed fresh killed."[18] Lewis works here, tellingly, by apophasis: he describes what he says cannot be shown. While the stump trees and bleak empty space lurk in the background of many of the drawings, the wounded are still walking, to the extent that they appear at all (*Walking Wounded,* 1918, present location unknown).[19]

As critics somewhat gloatingly noted, Lewis's war pictures marked a return to figuration, a distinct step away from the abstraction of 1912–14. Some of the hesitancy of *A Battery Shelled,* the sense of keeping to cover, informs Lewis's need to justify his "naturalism" (it seems to me an irony worthy of Fussell's account that Lewis's denuded scenes and mechanized figures could be considered a return to "nature"). Lewis's account is placed in art historical terms, which may indicate the challenge he faced. However, he rejects the model of Paolo Uccello's *Battle of San Romano* (circa 1438–40), in the National Gallery, London—which was familiar to British artists and viewers alike—as "a perfectly placid pageantry." This he contrasts with the "alternately sneering, blazing, always furious satire" of Francisco de Goya's *Disasters of War* (1810–20).[20] Lewis's war pictures seem to seek some place between these modes—neither fully engaged nor distanced—much like his experience of the war as a whole. But Lewis's subsequent response speaks to his dissatisfaction and his desire to disassociate from the work shown in *Guns.*[21] Writing to a patron in 1920, he called the war years a "sheer loss of time, the big war-paintings included."[22] He went on to say that he would not mind if the patron disliked the war works "because they are an episode in my life. They were done under conditions unfavourable to art production."[23] Impressive understatement, that.

Indeed, if I have discussed the war as a before/after barrier for Lewis and a source of his growing disillusionment, there is reason to modify this perspective, to see the war instead as an aberration, a trough. In a later autobiography, Lewis called the war "a sleep, deep and animal, in which I was visited by images of an order very new to me. Upon waking I found an altered world; and I had changed too. The geometrics which had interested me exclusively before, I now felt were bleak and empty."[24] The war here figures as an altering artistic experience, but Corbett has convincingly argued that it was less the effects of the war on Lewis that were disillusioning and more the changed relation between art and society in the period after the war that affected Lewis. Indeed, as Corbett notes, Lewis, to a remarkable degree, attempted to pick up where he had left off in 1914: at the center of an avant-garde,

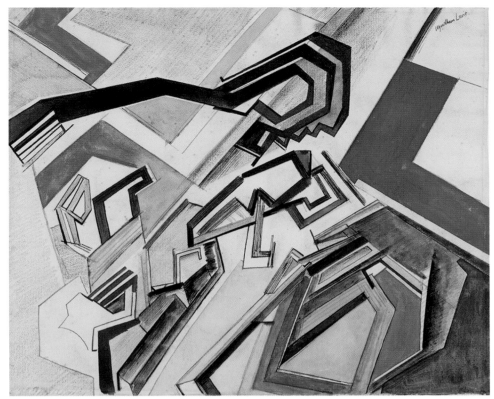

FIGURE 3. WYNDHAM LEWIS (ENGLISH, 1882–1957). *Planners: Happy Day*, 1912–13, ink, gouache, and graphite on paper, 31 x 38 cm (12¼ x 15 in.). London, Tate.

radical movement. With the failure of that attempt in a postwar society no longer receptive to radicalism and abstraction, Lewis was forced to redefine his ambitions and means of working, to see the artist as isolated rather than engaged, and to move to text instead of imagery.[25] The break for Lewis, then, was the immediate period after the war, rather than the conflict itself.

Seen from this perspective, 1914–18 does not quite form the ready-made category we might expect. Indeed, once one begins to examine the question of "pre-" or "postwar," the more complex it gets. The war drawings and paintings I have primarily discussed were done both before and after the end of the war, and I have compared them to two "postwar" texts. But *Blasting and Bombardiering* was self-consciously written under the gravitational pull of another war, and so is, in some sense, a "prewar" work as well. This suggests that the art and writing of *Guns* (which straddles 1918) are as much "interwar" as anything else. Furthermore, where might we begin to call things "prewar" for Lewis in the teens? Before the declaration in August 1914, certainly, but what matters is where we might see the war's effect on the work, the influence of context on text. Might we locate it when the realities of trench warfare set in to a horrified public by the end of 1914? When Lewis enlisted? Saw his first action? In one sense, the latter seems best, but it fails to explain the relation of pictures such as *Planners: Happy Day* (fig. 3) and *Combat No. 2* (fig. 4) to the war, or Lewis's later depictions of it. These seem drawn to the war, in different ways, by subject matter, but

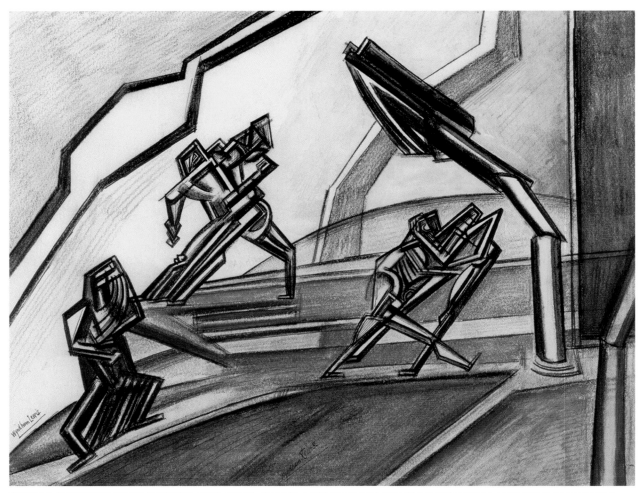

FIGURE 4. WYNDHAM LEWIS (ENGLISH, 1882–1957). *Combat No. 2,* 1914, ink and pastel, 27.6 x 33.3 cm (10⅞ x 13⅛ in.). London, Victoria and Albert Museum.

also in the angular, driving forms of the cover of *Blast,* no. 2 (fig. 5). In considering the "prewar" pictures, we might note too that Lewis was very much aware of the relation between the events that led up to the war and the Franco-Prussian War, understanding them to be a part of a continuum of French-German relations.[26] Seen this way, "prewar" works from 1912–14 are also to be thought of as "interwar."

To what extent do pictures such as *Planners: Happy Day* and *Combat No. 2* anticipate the war? To what extent are they intertwined with it, even if they precede it chronologically? Are we enabled to see Lewis looking into the future? In *Blasting and Bombardiering,* Lewis reflects on these questions in typically cryptic ways. The book's title separates his artistic and military personas, but the narrative begins with the chapter "Bombardiering," which describes Lewis the artist being interrogated on the drilling field by a confused sergeant major seeking clarity about Lewis's aesthetic theories. At the start of the second section of the book, Lewis claims that the book is structured as three panels: "Art—War—Art."[27] But neither the book nor his work, as we have seen, permits such easy distinctions. Lewis offers a more complex formulation

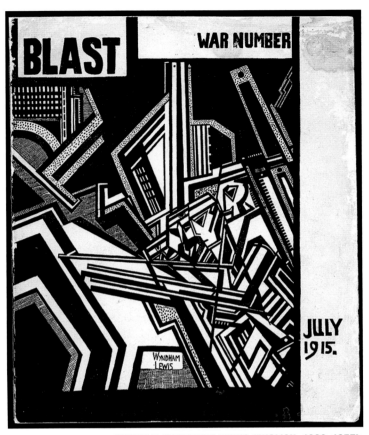

FIGURE 5. WYNDHAM LEWIS (ENGLISH, 1882–1957).
Cover of *Blast,* no. 2 (1915). Los Angeles, Getty Research Institute.

in the introduction, which says, "You will be astonished to find how like art is to war, I mean 'modernist' art. They talk a lot about how a war just-finished effects [*sic*] art. But you will learn here how a war *about to start* can do the same thing. I have set out to show how war, art, civil war, strikes and coup d'états [*sic*] dovetail into each other."[28]

In one sense, then, while we might well look upon the abstract vision of violence in *Combat No. 2* as naive from the perspective of the 1917–18 works, with the two figures at right engaged in the kind of close contact that Lewis notes was rare in World War I, the resemblance between the automated, geometrized figures and their background here and in *A Battery Shelled* is unmistakable. Lewis scholar Paul Edwards claims even more specifically that in works such as *Slow Attack* and *Plan of War* (both 1914, reproduced in *Blast! 1,* present locations unknown),[29] which are more mechanical than *Combat No. 2* but were painted before the war, "Lewis sees how the violent energies pent up in Europe will be released in war."[30] He also notes that the similarities between the geometric shapes of Lewis's paintings and those of battle plans and maps had already been recognized in 1914. This suggests an anticipation

of the cruel geometry of the trenches in Lewis's twisting, jagged parallel lines. What might we see of the architects of the western front in *Planners: Happy Day,* with its bent figure seemingly poring over geometric plans, unaware of a human context? Its very naïveté becomes the mark of its prescience in foreseeing the failure of military planning in the coming years. Again, Lewis himself seems to model this kind of interpretation, discussing himself before and during the war in terms of a mixture of ignorance and clairvoyance.[31] In a well-known passage on the Passchendaele "battle-bog," as he put it, Lewis wrote: "The very name, with its suggestion of *splashiness* and of *passion* at once, was subtly appropriate. This nonsense could not have come to its full flower at any other place but *Passchendaele.* It was pre-ordained. The moment I saw the name on the trench-map, intuitively I knew what was going to happen."[32]

It would be fallacious to say that all of Lewis's work was about the war; instead, one could say that, at some level, it is all *of* the war—his work belongs to it, was in its orbit, was pulled to it. At the same time, the war was within the pictures at a structural level. A cipher for this quality is the particular shape formed by the flexed legs of the figures out in the open in *A Battery Shelled.* The obtuse angle opened just past ninety degrees is repeated in legs throughout the picture, and one can find it again throughout the figures of Lewis's war pictures. In *Action* (1918),[33] it is even subtly present in the angle of the gun in relation to the standing figures who man it. Once noticed, the same angle is discovered as a central feature in numerous works not directly related to the war. It dominates the abstract *Composition,* defining the angular form at the center left that slants back into the picture. It is present throughout *Slow Attack* and, with slight variations in degree, defines the central forms in *Red Duet* (1914).[34] There is perhaps even an echo of it in the characteristic shape of the lips that form the leering grin of the Tyros, a recurring series of characters in Lewis's work of the early 1920s. This flexed angle, then, seems to transcend chronological boundaries of the war, as well as distinctions between abstraction and figuration. As such, it can stand, I think, for how we may see the war as interleaved at every level in Lewis's art of 1912–19. I do not mean by this to reduce Lewis's art to war. One might ask, what of Lewis's many art historical influences on the war pictures—Luca Signorelli and William Hogarth seem two of the most important.[35] But it is my contention that none of these influences or references existed independently of the war and that the war exercised a kind of tidal pull on everything Lewis did, whether we think of it as before, during, or after the war.

– NOTES –

1 Paul Edwards has noted that the personal results of Lewis's experience as an artillery officer are, by Lewis's own example, less frequently discussed than the large-scale changes wrought on his work by the war period. See Paul Edwards, "Wyndham Lewis and the Uses of Shellshock: Meat and Post-modernism," in Andrzej Gąsiorek, Alice Reeve-Tucker, Nathan Waddell, eds., *Wyndham Lewis and the Cultures of Modernity* (Burlington, Vt.: Ashgate, 2011), 224–25.

2 David Peters Corbett, "'Grief with a Yard-Wide Grin': War and Wyndham Lewis's Tyros," in idem, ed., *Wyndham Lewis and the Art of Modern War* (Cambridge: Cambridge University Press, 1998), 100–101. As Corbett notes (n. 5, p. 227), this was a common figuration for disparate thinkers in the postwar period.

3 Wyndham Lewis, *Self-Condemned* (London: Methuen, 1954), 89–90.

4 W. K. Rose, ed., *The Letters of Wyndham Lewis* (London: Methuen, 1963), 293.

5 Paul Fussell, *The Great War and Modern Memory* (Oxford: Oxford University Press, 1975), 3–35.

6 Wyndham Lewis, *Blasting and Bombardiering* (London: Calder & Boyars, 1967), 40.

7 Tom Normand, "Wyndham Lewis, the Anti-war War Artist," in Corbett, *Wyndham Lewis,* 51–52.

8 Jay Appleton, *The Experience of Landscape* (New York: Wiley & Sons, 1975).

9 For this work, see Walter Michel and C. J. Fox, eds., *Wyndham Lewis on Art: Collected Writings 1913–1956* (New York: Funk & Wagnalls, 1969), 268, 269, 267.

10 Lewis, *Blasting and Bombardiering,* 126.

11 Wyndham Lewis, "Guns," in Michel and Fox, *Wyndham Lewis on Art,* 104.

12 Lewis, *Blasting and Bombardiering,* 128.

13 Lewis, *Blasting and Bombardiering,* 125.

14 For a discussion of these figures and Lewis's depictions of officers and enlisted men, see Christine Hardegen, "Wyndham Lewis's First World War Art and Literature," in Corbett, *Wyndham Lewis,* 71–77. Hardegen traces these depictions to Lewis's separation of individual and crowd, and actors and spectators, in his work before and after the war.

15 Normand, "Anti-war War Artist," 53.

16 Michel and Fox, *Wyndham Lewis on Art,* 252, 256, 308.

17 Alan Munton, "Wyndham Lewis: War and Aggression," in Corbett, *Wyndham Lewis,* 20. Munton notes the predominance of work in the war drawings, while also placing emphasis on the contemplative quality of *A Battery Shelled,* arguing that Lewis used this as a means to control the worst, most violent aspects of modernity (pp. 20–27). This contrasts with the overriding aggression that most interpreters have attributed to Lewis.

18 Lewis, *Blasting and Bombardiering,* 134.

19 Michel and Fox, *Wyndham Lewis on Art,* 322

20 Michel and Fox, *Wyndham Lewis on Art,* 105–6.

21 Corbett calls the realism of the war pictures "an uneasy and temporary compromise." Corbett, "'Grief with a Yard-Wide Grin,'" 106.

22 Rose, ed., *The Letters,* 120.

23 Rose, ed., *The Letters,* 110.

24 Wyndham Lewis, *Rude Assignment: A Narrative of My Career Up-to-Date* (London: Hutchinson, 1950), 128.

25 David Peters Corbett, *The Modernity of English Art, 1914–1930* (Manchester: Manchester University Press, 1997), 127–51. For an interpretation of Lewis's Tyro pictures in this context, particularly related to the artist's dissatisfaction with Bloomsbury/Parisian modernism, see Corbett, "'Grief with a Yard-Wide Grin,'" 108–23.

26 Munton, "War and Aggression," 28–30.

27 Lewis, *Blasting and Bombardiering,* 63.

28 Lewis, *Blasting and Bombardiering,* 4.

29 Michel and Fox, *Wyndham Lewis on Art,* 12, 13.

30 Paul Edwards, *Wyndham Lewis: Art and War,* exh. cat. (London: Lund Humphries, 1992), 27. See also Vincent Sherry, *Ezra Pound, Wyndham Lewis and Radical Modernism* (Oxford: Oxford University Press, 1993), 94–97.

31 Lewis, *Blasting and Bombardiering,* 56–59.

32 Lewis, *Blasting and Bombardiering,* 151.

33 Michel and Fox, *Wyndham Lewis on Art,* 263.

34 Michel and Fox, *Wyndham Lewis on Art,* 170.

35 Lewis alludes to Signorelli in the last paragraph of his 1919 essay "The Men Who Will Paint Hell: Modern War as a Theme for the Artist," in Michel and Fox, *Wyndham Lewis on Art,* 108. For an excellent discussion of the art historical influences on the war pictures, among other things, see Edwards, *Art and War,* 19–55.

FOR PAUL NASH (1889-1946), THE FIRST WORLD WAR WAS, BOTH IN ARTISTIC AND IN PERSONAL TERMS, an incision, after which "it was another life, another world."[1] In the prewar years, the British artist, then a young man in his early twenties, was struggling to find and articulate his artistic language. Nash was drawn to things he found mysterious, imaginative, and emotional.[2] The expression of these interests formed his central artistic focus—which he achieved most successfully under the impression of his experience at the front—and also accounts for one of the most striking characteristics of his art: its ability to let us trace the artist's psychological disposition through his images.

Initially trained as an illustrator, Nash enrolled in 1910 at the Slade School of Fine Art, where he mainly studied figure drawing under Henry Tonks. The new artistic direction he was subjected to did not help him find his artistic identity—Tonks's very logical, almost scientific approach to figure drawing, which never was and never would be Nash's strength, formed a stark contrast to the young artist's romantic sensibility.[3]

Nash lasted only four terms at the Slade and, after leaving, turned his artistic focus to landscapes, a discipline in which he had no training.[4] For Nash, a landscape was not merely a natural environment; rather, he understood it as a spiritual entity, a place in which his imaginative worlds and dreams could unfold.

"In the Midst of This Strange Country"
Paul Nash's War Landscapes
ANJA FOERSCHNER

He wrote: "It was always the inner life of the subject rather than its characteristic lineaments which appealed to me."[5] Thus, his landscapes were less about a formal view than the "things behind."[6] He achieved this not by mythological or religious allusions but rather by reduction: the large empty spaces, sparse detailing, and strong contrast of light and shadow in drawings such as *The Field before the Wood* (1912, private collection) challenge the viewer to fill the void with his or her own projections and imaginations. Nash's training as an illustrator, however, remains visible in his decorative, carefully articulated line work and coloring.[7]

The first exposure of his work to the public, at his exhibition at Carfax Gallery in 1912, triggered a surge of uncertainty for Nash at a moment when he had just attempted to define his artistic vocabulary. He became very concerned with technical issues and style, which kept him from achieving a natural flow and authenticity in his art.[8] His emotions and preoccupation with technique seem to have collided with each other and inhibited him in his creative work; thus, several of his works of the prewar period—for example, *Trees in Bird Garden* (1913, Birmingham City Art Gallery)—might be pleasing to the eye but "lack immediacy"[9] and are absent of feeling.

Nash certainly was not the only artist during the early twentieth century to emphasize spirituality and emotionality rather than merely the physical world in his art. He studied a variety of different artists and styles for his work—among them, early on, Dante Rossetti's medieval-influenced art of the 1850s and Albert

Rutherston's seminaturalism. He even briefly considered the postimpressionist movement chaperoned by Roger Fry — but he was not able to identify with any of them.[10] Unexpectedly, it was the First World War that would prove to be the necessary catalyst for the artist.

Nash initially did not have particularly patriotic feelings or the urge to participate in the higher cause that the war promised for so many: "I am not keen to rush off and be a soldier. The whole damnable war is too horrible of course and I am all against killing anybody.... I don't see the necessity for a gentleminded creature like myself to be rushed into some stuffy brutal barracks and spend the next few months practically doing nothing but swagger about di[s]guised as a soldier *in case* the Germans poor misguided fellows — should land."[11]

He enlisted in 1914 with the Artists' Rifles for home service only and managed to steer clear of combat until 1917. The military experience at home, the exercise, and, to a degree, the feeling of companionship suited Nash. Although he maintained a skeptical attitude toward the fighting, he did get an understanding of this innate component of war enthusiasm: "Every man must do his bit in this horrible business."[12]

Naturally, his artistic output in those first war years, which continued to explore often-nocturnal landscapes and visionary scenes, was comparably meager as he devoted much of his time to military training. The images of this period — for example, *Apple Pickers* from 1914 (The Higgins Bedford) and *Summer Garden* (fig. 1) — show a certain refinement of his previous efforts to hone his technical

FIGURE 1. PAUL NASH (ENGLISH, 1889–1946). *Summer Garden,* 1914, watercolor, ink, and chalk, 22.8 x 39.4 cm (9 x 15½ in.). Collection Constance Fettes.

skills, while attesting to his rejection of the vanguard movements that had either been developed or adopted in Britain.

In February 1917, however, things changed when Nash was sent to the front. He only stayed for a little more than two months in the Ypres Salient with the Third Batallion of the Hampshire Regiment, where he served as a second lieutenant. Very shortly before most of his companions were killed in the attack on Hill 60, he fell in a trench at night, fractured his rib, and was sent back to Britain without ever having experienced actual combat.[13]

Nash met the combat landscape with an amazement and curiosity that appears almost bizarre. In his letters to his wife, Margaret, he marveled: "Flowers bloom everywhere and we have just come to the trenches . . . and the place is just joyous, the dandelions are bright gold over the parapet and nearby a lilac bush is breaking into bloom."[14] Aided by his romantic and dreamy personality, Nash viewed the scenery only through the eyes of an aesthete and artist. In his letters, he decried the war, calling it "pitiless, cruel and malignant,"[15] but he seemed to be unable or unwilling to empathize and identify with the other soldiers and the circumstances; instead, he adopted an attitude of indifference and a "rigid fatalism."[16]

His enchanted reception produced a series of drawings in which he applied his precise, decorative lines and colors to the scenery he encountered. This resulted in strangely detached images that depict the devastated battlefields while merely hinting at the gruesome events unfolding on them.[17] For example, *Chaos Decoratif,* in which a few scarred trees are situated in a lush green setting, attests to the artist's preoccupation with technique and his still-romantic outlook on the world (fig. 2).

As his accounts indicate, Nash's fascination with the war drew him back to the front, and certainly not only because of the landscape. Although he did not share the naive enthusiasm for the war exhibited by many of his fellow countrymen and -women, he did face the conflict with hope for some form of inspiration, a stimulation of his mind, and possibly a cathartic experience. Life in the war zone, he admitted to Margaret once, had a "greater meaning . . . and a new zest, and beauty is more poignant."[18] Therefore, he successfully campaigned to become an official war artist and was sent back to the western front in October 1917.[19] He stayed for a little over a month and, this time, looked for a more intense experience:

> We have all a vague notion of the terrors of a battle . . . but no pen or drawing can convey this country—the normal setting of the battles taking place day and night, month after month. Evil and the incarnate fiend alone can be master of this war, and no glimmer of God's hand is seen anywhere. Sunset and sunrise are blasphemous, they are mockeries to man, only the black rain out of the bruised and swollen clouds all through the bitter black night is fit atmosphere in such a land.[20]

Nash went to work with enormous zeal, creating more than a dozen drawings a day and going to great lengths to get as close as possible to combat.[21] He wanted to be a "messenger who will bring back word from the men who are fighting to those who want the war to go on for ever."[22]

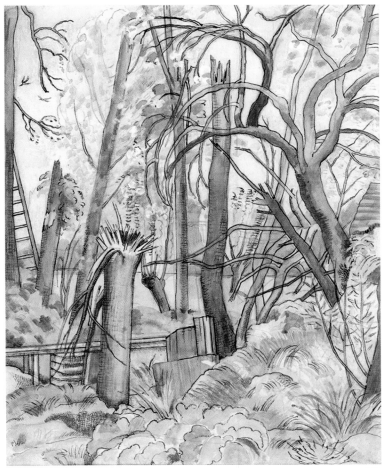

FIGURE 2. PAUL NASH (ENGLISH, 1889–1946). *Chaos Decoratif*, 1917,
pen and ink and watercolor on paper, 25.3 x 20 cm (10 x 7⅞ in.). Manchester, Manchester Art Gallery.

When we read Nash's accounts of the war, it becomes clear that he was torn between conflicting emotions. On the one hand, he realized with horror the true nature of war—the toll it took on the soldiers as well as his beloved environment. On the other hand, he was fascinated by the romantic notion of heroism and the morbid stories told by the scarred landscape.[23] This conflict would prove to be a great creative stimulus: it gave him a multitude of impressions that would last him "a lifetime as food for painting and drawing," and it had a profound impact on his visual language and ability to express his emotional disposition in his art.[24]

Over the course of the war, his style lost more and more of the decorative and detailed renderings that defined his pre- and early war works. His wartime drawings and the images he created from them after his return to Britain in 1918–20 remained focused on landscapes, the ruins, the mud, and often the trees that Nash valued so much, but they became more authentic and immediate. These images are dominated by vast empty spaces, and the rain, incessantly pouring down from above, becomes a frequent aspect. Paths zigzagging through the pictures lead to nowhere; dilapidated fences and tree stumps obstruct the view. Nash replaced his delicate coloring with

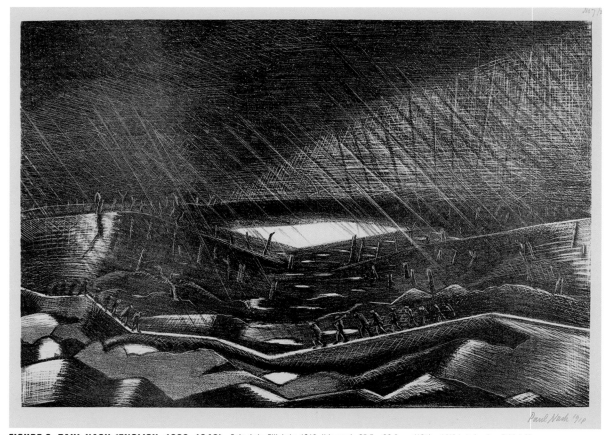

FIGURE 3. PAUL NASH (ENGLISH, 1889–1946). *Rain, Lake Zillebeke,* 1918, lithograph, 25.5 x 36.2 cm (10⅛ x 14¼ in.). London, British Museum.

stronger, often dark and muted tones. His hitherto light, playful outlines do not do the devastation justice and give way to heavier lines, stark diagonals, and bold shapes in works such as *After the Battle* (1918, London, Imperial War Museum).

None of these works are comparable to Nash's pre-and early war works. In a letter to Margaret in spring 1917, Nash indicated a change of direction and more openness to contemporary art movements in order to tell his story of the war. In the face of the ruinous landscapes of Flanders, he claimed, he started to "believe in the Vorticist doctrine of destruction almost."[25] Around the same time, he requested some etchings of fellow war artist C. R. W. Nevinson, claiming they were part of the world he was now interested in.[26]

Nash had been looking for an adequate way to express his emotions in his art, and it was the war that helped him find it. For his images of war, the artist—certainly helped by the necessity to work quickly at the front—was able to develop an entirely different visual vocabulary, opening up to a more radical and finally more modern approach.

After his return, he prepared an exhibition of his work as an official war artist at the Leicester Galleries in 1918. The change toward more authenticity that the war brought for Nash's art did not go unseen by London's art world, and his exhibition was well received.[27] In this period, Nash chose, for the first time, oil as a medium

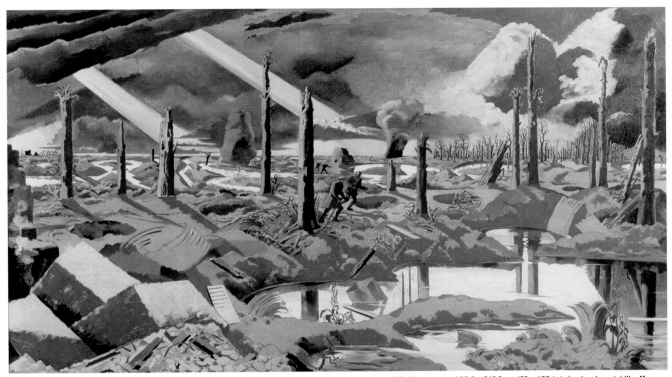

FIGURE 4. PAUL NASH (ENGLISH, 1889–1946). *The Menin Road*, 1919, oil on canvas, 182.8 x 317.5 cm (72 x 125 in.). London, Imperial War Museum.

and, from his drawings, created works such as *The Mule Track* (1918, London, Imperial War Museum) and *We Are Making a New World* (1918, London, Imperial War Museum). Equally important were the lithographs, including *Rain, Lake Zillebeke* (1918; fig. 3), and the large-scale paintings from 1919–20, such as *The Menin Road* (fig. 4) or *A Night Bombardment* (Ottawa, National Gallery of Canada).[28] Charred and splintered trees, muddy craters, and cold rays of light cutting diagonally through the images dominate most of these somber works. With these depictions, Nash carried the devastation and infinite tristesse of the war to its extreme, while increasingly embracing abstract forms.

Although Nash later lacked confidence in these paintings, they are undeniably strong, condensed representations of the apocalyptic landscape of the war.[29] It seems as if Nash, not unlike Otto Dix, benefited from how temporal distance could infuse his drawings with memories and imagination, creating works of painterly and emotional strength.

Nash told the story of the war from a different angle than many of the other artists at the front, who depicted the suffering of the soldiers to convey its horrors. He diminished figures, which were mostly absent in his works, to more generalized shapes that are dwarfed by the vast emptiness around them. The artist's focus

remained on the natural environment, which he rendered in a sober and reduced manner. In their postcombat state, Nash's abandoned landscapes make the battles and human tragedies that took place in them unfold anew in the viewer's imagination. The scars borne by his landscapes represent the scars that remained on those who fought in the war. As such, these haunting visions that Nash created are subtle but all the more powerful. The more he veered away from deliberate depictions, the more he succeeded in his ultimate goal to convey the emotional rather than the physical realities of the war.

The reservations that Nash had in retrospect about his work as a war artist are surprising, given that until 1917, he was still unsure about which direction to go with his art.[30] The First World War did not interrupt his artistic development or set it back; instead, it proved to be a decisive push in his search for an individual language and an artistic legacy.[31] It opened his mind to more modern approaches in his art, which would return later in his life with his surrealist practice.[32] Nash's goal to depict not merely what presented itself before him but rather what was unseen is achieved in a very convincing way in his works from 1917 to 1920.

– NOTES –

1 Paul Nash to his friend Gordon Bottomley, July 1945, in Claude Colleer Abbott and Anthony Bertram, eds., *Poet & Painter: Being the Correspondence between Gordon Bottomley and Paul Nash, 1910–1946* (New York: Oxford University Press, 1955), no. 265.

2 Nash's autobiography, *Outline,* gives an impression of the artist's sensitive personality and the dreams and fantasies of his youth. See Paul Nash, *Outline, an Autobiography and Other Writings* (London: Faber & Faber, 1948), 26–27, 57, 75.

3 Even though he could not relate to Tonks's artistic proclivity, Nash actually was very fond of the notoriously harsh and sarcastic teacher. See Nash, *Outline,* 89. For a detailed account of Nash's time at the Slade, see also David Boyd Haycock, *A Crisis of Brilliance* (London: Old Street, 2009).

4 In this decision, Nash was supported by artist Sir William Richmond, godson of William Blake, to whom he was introduced upon his move to London in 1911. Richmond saw Nash's struggle and for a while took on the role of his mentor. He also facilitated Nash's first exhibition at Carfax Gallery. See Nash, *Outline,* 97–98.

5 Nash, *Outline,* 36. In his autobiography, Nash gives a vivid description of the gardens of his childhood, the feeling of freedom they gave him, and the mysteries hidden within them. See Nash, *Outline,* 33–37.

6 Paul Nash to Gordon Bottomley, 1 August 1912, in Abbott and Bertram, *Poet & Painter,* no. 42.

7 In order to be in closer proximity to the Slade, Nash moved to London in 1910. He was excited and inspired by the city, but, being more drawn to nature, he decided in 1911 to return to Iver Heath, where his family had moved in 1901. Iver Heath would remain his main home through much of the war and most of his landscapes of that period depict the local area.

8 See Nash, *Outline,* 139–40. A letter to artist and friend Will Rothenstein further details his struggle. See James King, *Paul Nash: Interior Landscape* (London: Weidenfeld & Nicolson, 1987), 68–69.

9 Andrew Causey, *Paul Nash* (Oxford: Clarendon, 1980), 49. Another factor to be taken into account here is Paul Nash's lack of exchange about his work, which he created mainly in private. Other artists and fellow students at the Slade included William Roberts, Stanley Spencer, and C. R. W. Nevinson, but Nash did not cultivate friendships with them. See Causey, *Paul Nash,* 4.

10 Drawing from Nash's autobiography as well as letters and other documents, Anthony Bertram compiled a very detailed biography of Nash in which he describes the various influences on

the young artist, among them his fascination with poetry and drama. See Anthony Bertram, *Paul Nash: The Portrait of an Artist* (London: Faber & Faber, 1955), 53, 77. See also A. P. Duffy, "'We Are Making a New World' (Paul Nash)," *British Art Journal,* no. 2 (2010/11): 86–91.

11 Paul Nash to Gordon Bottomley, mid-August to early September 1914, in Abbott and Bertram, *Poet & Painter,* no. 92 (emphasis by Nash).

12 See Abbott and Bertram, *Poet & Painter,* no. 94. For a detailed description of Nash's time in the military and his artistic output see Paul Gough, *A Terrible Beauty: British War Artists in the First World War* (Bristol, U.K.: Samson & Company, 2010), 127–64.

13 For a more detailed description of the events, see Gough, *A Terrible Beauty,* 134–47.

14 Nash, *Outline,* 187.

15 Nash, *Outline,* 187.

16 Nash, *Outline,* 193.

17 For a complete list of Nash's drawings of that period see Andrew Causey, *Paul Nash* (Oxford: Clarendon, 1980), 359–60.

18 Nash, *Outline,* 189.

19 See Bertram, *Paul Nash,* 94. Nash also wrote to Gordon Bottomley about his desire to become a war artist and asked for a supporting letter to director of information John Buchan. See Abbott and Bertram, *Poet & Painter,* no. 104.

20 Nash, *Outline,* 210–11.

21 Unlike with his first deployment to the front, which occurred during a rather quiet time, Nash now arrived at the Ypres Salient in the last week of the devastating Battle of Passchendaele. In his function as official war artist, Nash was assigned a driver, with whom he took audacious tours as close to the battle lines as possible. Upon his arrival, he had complained in letters to Charles Masterman, head of the British War Propaganda Bureau, that he was lacking the proximity to combat that he obviously considered necessary for his work. See Gough, *A Terrible Beauty,* 150–51.

22 See Nash, *Outline,* 211.

23 Nash was always inwardly drawn to dark and melancholic themes. This tendency was exemplified in his visionary scenes, his second artistic focus, including *The Pyramids in the Sea* (1912, Tate Gallery) and *In a Garden under the Moon* (1913, collection of Christine Pemberton).

24 Nash, *Outline,* 194.

25 Quoted from Gough, *A Terrible Beauty,* 152.

26 See Nash, *Outline,* 192.

27 Several of the exhibited works were published in volume 3 of *British Artists at the Front.* In his foreword, Jan Gordon (John Salis) recognized Nash's particular strength: "It is not possible to paint truly how war has swept man…[but it] is possible to depict the devastation of Nature, partly because we cannot understand the full horror, and partly because through it we may come to a deeper realisation of what catastrophe may mean to man." C. E. Montague and John Salis (Jan Gordon), eds., *British Artists at the Front,* vol. 3 (New York: George H. Doran, 1918), n.p.

28 These two paintings, created after the Leicester exhibition, were both public commissions; *The Menin Road* was intended for the Ministry of Information, to be featured in a projected Hall of Remembrance that was never completed; *A Night Bombardment* was commissioned by the Canadian War Records.

29 See Causey, *Paul Nash,* 82–83.

30 See also Paul Nash to Will Rothenstein, 1919, in Meirion Harries and Susie Harries, *The War Artists: British Official War Art of the Twentieth Century* (London: M. Joseph, The Imperial War Museum, Tate Gallery, 1983), 59.

31 Nash's treatment of landscape as witness to a historical conflict reappears, for example, in Anselm Kiefer's barren landscapes, which refer to the horrors of the Nazi regime.

32 David Peters Corbett compiled a very interesting study about Nash's works after 1919 that puts them in the larger context of modernity in British postwar art. See David Peters Corbett, "'The Third Factor': Modernity and the Absent City in the Work of Paul Nash, 1919–36," *Art Bulletin* 74, no. 3 (1992): 457–74.

ITALIAN FUTURISM'S NOTORIOUSLY PRO-WAR, NATIONALISTIC VIEWS incubated within an ideology of youthful insouciance before World War I that later partially intersected with fascist politics of the interwar period. In praising the poetry of war, the movement's founder and energetic leader, Filippo Tommaso Marinetti, espoused an aggressive militarism that was never outdone but was periodically equaled by similarly extreme positions taken by other members of the group.[1] For futurist artist Carlo Carrà (1881–1966), as with numerous male avant-garde idealists in Italy and around Europe at the time, World War I initially signaled a set of positive developments: the possibilities that moribund cultural traditions might be overcome in a brief, ritual conflagration and that modernist creative genius could be heroically expressed and renewed. In June 1914, Carrà adopted a nationalistic tone, which sharpened further after the war's outbreak in August and prior to Italy's entry in May 1915. His interventionist position at this time was grounded in Italian irredentist claims for the territories of Istria, Trento, and Trieste, claims that were central to Italy's diplomatic push against Austria-Hungary in late 1914 and that yielded the major pretext for declaring war the following spring. Such strident nationalism ended up being short-lived for Carrà, who, unlike many of his futurist colleagues, never volunteered for military duty, though he was later drafted and served briefly in early 1917. By 1915, he was already drifting away from futurist aesthetic ideals, and, while he never recanted his patriotic fervor, it is clear from his paintings, drawings, and writings that he was deeply affected by his traumatic wartime experiences. This momentous shift in Carrà's works pointed away from bellicose exuberance and toward a more contemplative, conscientious approach.

Carlo Carrà's Conscience

DAVID MATHER

To appreciate the extent of Carrà's transformation during World War I, it is useful to revisit the giddy early days of futurism. In early 1910, he responded enthusiastically to Marinetti's audacious appeal to young artists to join a new cultural movement that could challenge the status quo of academic painting and counteract what they perceived to be the stultifying effects of classicism.[2] Soon thereafter, Carrà signed the first futurist manifesto of painting, along with Umberto Boccioni and other painters, and he began participating in its radical aesthetic and political program. In early 1912, his noticeably more experimental artworks appeared in the futurist art exhibition at Gallerie Bernheim-Jeune in Paris, which opened in February, before traveling to numerous venues around Europe until 1914. Although it would be difficult to encapsulate the variety of Carrà's prewar artistic practices (painting, mixed-media collages, free-word poems, and manifestos), many of his visual works explored fragmented compositions in which accumulations of dislocated elements poised between divisionist strokes and cubist planes dissolved naturalistic contours into clusters of multisensory impressions. For futurist painters, visual experimentation offered one

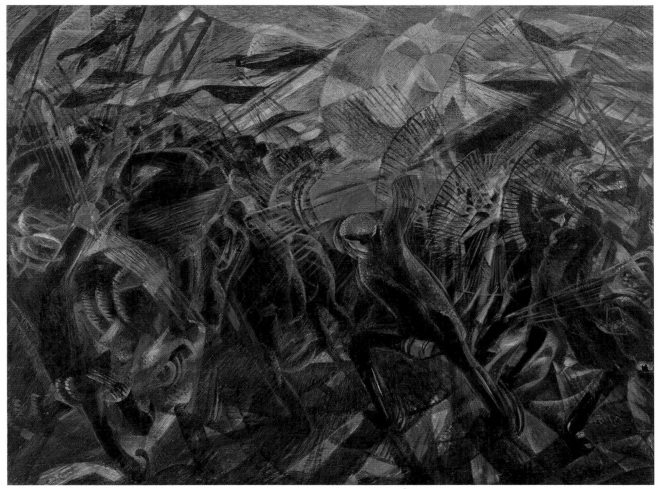

FIGURE 1. CARLO CARRÀ (ITALIAN, 1881–1966). *Funeral of the Anarchist Galli,* 1910–11, oil on canvas, 198.7 x 259.1 cm (78¼ x 102 in.). New York, The Museum of Modern Art.

avenue for expressing radical social and political views, while sociopolitical disruption became an explicit theme in several significant futurist works.

In Carrà's *Funeral of the Anarchist Galli* (fig. 1), for example, a red coffin is held aloft during a funeral for anarchist metalworker Angelo Galli, who died during a factory strike in May 1906.[3] The painting presents a violent confrontation between mourning anarchists and mounted policemen, though historical accounts of this event detail a much less violent incident than the one Carrà depicts.[4] This artwork's visceral power derives from putting the viewer at the center of an agitated crowd.[5] In the eerily backlit scene, a patchwork sky emits golden sunlight that shines past partially legible figures but leaves others inscrutable amid the nervous press of bodies. Repetitive lines of force supply kinetic motion to the figures, even as the opposing camps remain difficult to distinguish precisely. The image plots multiple simultaneous trajectories;

this visual confusion signals the indeterminacy endemic to unplanned action. By mapping out a situation that points to unpredictable outcomes that may or may not catalyze into tangible sociopolitical changes, the painting evokes and comments upon a prevalent myth of political and cultural radicalism: spontaneous revolution.[6]

Carrà's painting of rebelliousness also conveys a dominant aspect of the futurists' behavior overall: they focused on and sought out social conflict. Although this overt contentiousness made a certain sense within the Italian context, it played very differently in avant-garde Paris. In his 1946 autobiography, Gino Severini recounted the futurists' activities from the perspective of an Italian living in Paris.[7] Dismayed by the bellicose language and outrageous antics, he described the antagonism his countrymen felt toward the Parisian art world.[8] This aggressive attitude particularly colored the futurists' dealings with the cubists, who dismissed the Italians and their artworks as juvenile.[9] If Severini thought this antagonism detracted from their artistic pursuits, it is quite likely his fellow futurists perceived their disruptiveness to be integral to their avant-garde practices, as a mode of aesthetic activism.[10] This brashness would lead to numerous controversies both within futurism and with those outside the movement.[11] A postcard to Carrà from his Paris-based acquaintance Sergei Jastrebzoff in May 1914 mentions his uneasiness with the direction of the movement and articulates the hope that Carrà will no longer be associated with futurism in six months, but rather that he will be working peacefully "without punches and without politics."[12] Written in a familiar tone of close confidence, this document suggests, albeit in its broken Italian, that Carrà had mentioned being dissatisfied with futurism before the beginning of the war.

Another important artwork from this prewar period is *Free-Word Painting — Patriotic Festival,* which Carrà made in June 1914 after a period of unsuccessful socialist strikes across Italy called Red Week.[13] Composed in layers of collaged and hand-drawn elements, the multidirectional forces represent a nationalistic gathering.[14] Unmoored from the rules of syntax and usage, the intricate choreography of verbal-visual vectors resonates with signifiers of national pride: white lettering on a black ground spells out patriotic and monarchist chants (e.g., "Long live the king!") that converge around the printed word *Italy.*[15] Within the microclimates of the crowd—here music and festive song, there political slogans, and elsewhere onomatopoeic absurdity (e.g., "traaak tataraak")—verbal and sonic cues interfere and overlap like wireless signals resonating through a cacophonous cityscape. With its references to militarism, this collage represents an ideological realignment: dissatisfied with failed socialist ideals, Carrà gravitated toward supporting the state and its military on the eve of August 1914.

Soon after the war's thunderous start, Carrà's belief in a rejuvenated, heroic Italy manifested in the form of collages and writings strongly opposing Germany and Austria-Hungary and trumpeting the futurists' support for France; a collection of his images, poems, diagrams, and essays (many new ones mixed with several reprints) was published in the spring of 1915 as the book *Guerrapittura* (Warpainting).[16] In the hyperbolic rhetoric of his texts, the military conflict had become a battle between civilizations—French and Italian *joie de vivre* facing down German academicism and the Austro-Hungarian Empire. In his collages, war-related articles

FIGURE 2. CARLO CARRÀ (ITALIAN, 1881–1966). *War in the Adriatic,* 1914–15.
From *Guerrapittura* (Milan: Ed. Futurista di "Poesia," 1915), 11. Los Angeles, Getty Research Institute.

and imagery clipped from newspapers underlie the artist's multivalent inscriptions of symbols, maps, diagrams, instructions, and cubist-inspired renderings. According to these quick episodic bursts, viewers are thrust into the action as artillerymen on the front lines, as officers serving alongside a French general, as prisoners of war, and, from aerial perspectives, as Allied pilots battling the Germans over the Adriatic Sea (fig. 2). Writing to fellow futurist painter and writer Ardengo Soffici at the end of 1914, Carrà lamented feeling powerless and articulated his desire to participate in "the real war—made of blood and heroism," though he expressed uncertainty about whether or not he would volunteer to fight, should Italy eventually intervene.[17] These letters to Soffici illuminate the artist's conflicted mind-set: he was preoccupied with a struggle for relevance in his life and in his work while also deeply engrossed in the news emerging from the conflict's two fronts. At the time he was making these wartime collages for his book, he described a condition of living "in plastic synthesis," which had the effect of connecting his life and work directly to world events.[18] A similar modernist-cum-militarist sentiment motivated his book's concluding essay, "War and Art," in which the author characterized the war as an engine of new sensibilities closely allied with, and even emerging directly from, the futurist movement.[19] This

pro-war, creative excitement would rapidly subside however, because *Guerrapittura* was his last discernibly futurist project.

Once Italy declared war on Austria-Hungary in May 1915, Carrà declined to volunteer with many other futurists for a squadron of bicyclists that he deemed ridiculous and hardly befitting his idea of Italian heroism. During 1915 and 1916, he experimented with nonfuturist visual strategies, through which he sought a coherent, creative response to what became for him a spiritual crisis; this new approach prompted his estrangement from the other futurists, especially when he revisited Italian painters of the fourteenth and fifteenth centuries.[20] In his 1943 autobiography, Carrà insisted his move away from futurism had not resulted from personal quarrels with any of the futurists; rather, he claimed, it emerged from his own "struggle of conscience."[21] Such a dramatic turn away from avant-gardism and toward tradition had been predicted by writer and critic Giovanni Papini in early 1914, if only to condemn this regressive possibility outright.[22] Consequently, after receiving a reproduction in the mail of a recent Carrà painting from late 1916, Soffici remained incredulous that Carrà had been willing "to renounce all of the most modern conclusions (all of futurism)."[23] Even if he knew about his friend's dissatisfaction with the direction of futurism (alluded to in Jastrebzoff's postcard), Soffici was not prepared for such a sweeping repudiation of modernist ideas.[24]

After being drafted in late 1916, Carrà was assigned to the 27th Infantry Regiment near Ferrara, arriving for duty just after the New Year. He encountered trying interpersonal difficulties with other members of his company, including his commander (to whom he unwisely gave a copy of *Guerrapittura*). The artist suffered from severe insomnia and then experienced a nervous breakdown.[25] While recuperating in a military hospital in Ferrara from April to August 1917, he frequently met with the painter Giorgio de Chirico (and his brother Andrea, known as Alberto Savinio), who lived nearby and worked at that hospital after leaving wartime Paris. Together they began to make works following a new set of artistic principles, which came to define metaphysical painting. Many of Carrà's works from this period—at the hospital and then following his military discharge in late 1917—are substantially indebted to de Chirico's visual style: faceless mannequins inhabit nondescript, claustrophobic interiors cluttered with everyday objects and punctuated by ominous shadows and darkened doorways. In *Mother and Son* (fig. 3), two dressmaker's forms—one of which displays a boy's sailor suit—occupy the foreground of a gray room, with shadows cast by a beach ball, an oversized die, a furnace, and a freestanding wall that contains a measuring chart to mark the child's growth over time. Simultaneously removed from the action, under protective care, and thinking of playful activities, the subject of the painting marked the artist's incremental separation from what he took to be the futurist-inspired war.

Dispensing with avant-garde contentiousness in 1915, he had arrived by 1917 at what he described as "aesthetic conscience."[26] In carefully arranged tableaus of recreation, recollection, and make-believe, Carrà had found a kind of pictorial sanctuary—from war and futurism—within which to refocus his passion for crafting images. Alongside his aforementioned reappraisal of historical painting, Carrà espoused the evocative power of ordinary things, such as those appearing in his compositions as

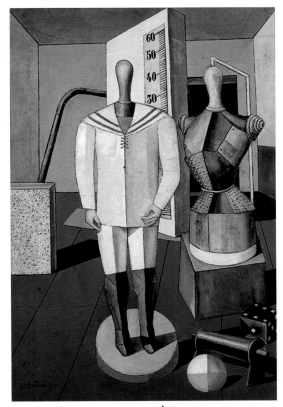

FIGURE 3. CARLO CARRÀ (ITALIAN, 1881–1966). *Mother and Son,* 1917, oil on canvas, 90 x 59.5 cm (35½ x 23½ in.). Milan, Pinacoteca di Brera.

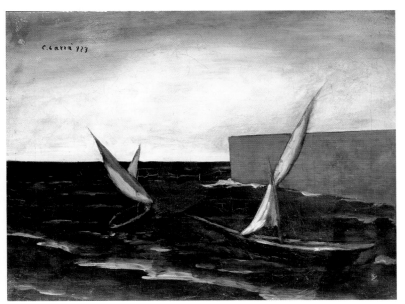

FIGURE 4. CARLO CARRÀ (ITALIAN, 1881–1966). *Sails in the Harbor,* 1923, oil on canvas, 52 x 67 cm (20½ x 26½ in.). Florence, Fondazione Roberto Longhi.

generic shapes located in architectural spaces or else as symbolic visual forms reified by personal memories.[27] In formal terms, his oeuvre began to emphasize cohesive contour lines around objects and symbols, and these contour lines functioned to contain those energetic forces that had been unleashed by futurism. Although this visual tendency marked a notable change from his mature futurist style, which included his studied, architectonic response to cubism (circa 1912–13), the frank simplicity of these visual contours was already prefigured in his prewar sketches *Ballerina* (1913) and *The Trapeze Artist* (1913) and in the cheerfully resonant painting *The Child Prodigy* (1914). What signified for Soffici the disavowal of modernist beliefs might otherwise communicate the reassertion of one aspect of Carrà's earlier style, which was greatly deemphasized in his most successful futurist efforts.

After the war, Carrà continued to pursue metaphysical painting until approximately 1922, when his style gravitated toward simplified, thickset figures within landscapes, seascapes, and other pastoral scenes, which the artist continued to paint well into the post–World War II period. Unable to completely abandon his futurist past, he periodically referred to himself as "an independent futurist," though he had charted an entirely different course from 1915. In his haunting *Sails in the Harbor* (fig. 4), no human or animal figures occupy the stark vantage onto the Ligurian Sea. Illustrating the visual restraint he practiced following his tumultuous futurist years,

the composition delicately balances several opposing qualities: the vista's openness and depth are interrupted by the closure and flatness of a protective seawall, while two small sailboats, themselves emblematic of movement and freedom, remain anchored safely at the port, with their loosely furled sails tracing sinuous curves against rectilinear forms. Echoing his prewar experience with futurism, Carrà initially considered World War I to be the culmination of futurist aesthetic activism, but his subsequent explorations of decidedly nonmodern rhythms of life—first in metaphysical tableaus, then in the folkloric subjects of his native land—amounted to an extensive reconsideration of those avant-gardist impulses.

— NOTES —

1 Examples of Marinetti's prewar texts involving militarism include the speech "The Necessity and Beauty of Violence" (1910), the manifesto "War, the Sole Cleanser of the World" (1911), and the poem *Zang Tumb Tumb* (1912).

2 Marinetti spoke at Teatro Lirico in Milan on 15 February 1910.

3 While the precise circumstances surrounding Galli's death are unknown, it occurred when strikers entered a factory to confirm that all the workers had been allowed to participate in a citywide strike. Later, a factory foreman claimed he stabbed Galli strictly in self-defense. See William Valerio, "Boccioni's Fist: Italian Futurism and the Construction of Fascist Modernism" (PhD diss., Yale University, 1996), 63–73, 85–91; and Oliver Shell, "Cleansing the Nation: Italian Art, Consumerism, and World War I" (PhD diss., University of Pennsylvania, 1998), 21–35, 54–55n40.

4 According to journalistic accounts, the anarchists carrying the coffin into the cemetery tried to break through the line of mounted police to march to the historic center of Milan; after a brief scuffle but unable to pierce through, the marchers proceeded to the gravesite. See Valerio, "Boccioni's Fist," 50–96; and Oliver Shell, "Cleansing the Nation," 21–29, 54–55.

5 In "The Exhibitors to the Public" (1912), the futurist painters prescribed putting the viewer at the center of the picture, exemplified by an image of a riot (obviously Carrà's painting) that employed "sheaves of lines corresponding with all the conflicting forces." Umberto Boccioni et al., "The Exhibitors to the Public," in *Exhibition of Works by the Italian Futurist Painters,* exh. cat. (London: Sackville Gallery, 1912), 14.

6 The myth of spontaneous revolution permeates late-nineteenth-century and early-twentieth-century literature and political thought—from Karl Marx, Georges Sorel, and Enrico Corradini to Marinetti and Walter Benjamin.

7 Gino Severini, *The Life of a Painter* (Princeton, N.J.: Princeton University Press, 1995).

8 Summarizing the prewar period, he observes: "I always deeply regretted the erroneous Futurist feeling of antagonism, of competing with Paris and Cubism; it would have been more advantageous for them to function harmoniously" (trans. Jennifer Franchina). Severini, *The Life of a Painter,* 143.

9 According to Severini, Picasso always disliked the futurists' discussions on painting. Severini, *The Life of a Painter,* 93. Also see Guillaume Apollinaire, "Chroniques d'art: Les futuristes," *Le Petit Bleu,* 9 February 1912, reprinted in Guillaume Apollinaire, *Apollinaire on Art: Essays and Reviews, 1902–1918* (New York: Viking, 1972); and Gertrude Stein, *Autobiography of Alice B. Toklas* (New York: Harcourt, Brace, 1933).

10 Marinetti first employed the term *art-action* (Italian: *arte-azione*) in his book *Guerra sola igiene del mondo* (Milan: Edizione Futuriste di "Poesia," 1915), in which he used this term to describe the integration of aesthetic tendencies with sociopolitical activities.

11 Among the futurists, Carrà took offense to a passage in Umberto Boccioni's book *Pittura scultura futurista* (Milan: Edizioni Futuriste di "Poesia," 1914), in which the author claimed Carrà's idea to make odorous and vaporous paintings had been derived from Boccioni's earlier idea to paint states of mind. In a letter to Marinetti dated 14 March 1914, Carrà expressed his reaction to the controversy: "I will tell you sincerely that Boccioni's megalomania is truly beginning to preoccupy me." See Marinetti

correspondence and papers, 1886–1974, acc. no. 850702, box 2, folder 1, Getty Research Institute, Los Angeles. In addition, Boccioni disagreed with Robert Delaunay about the meaning of the term *simultaneity;* for Boccioni, the word connoted a frenzy of psychophysical activities, sometimes intertwined with memories, while Delaunay's usage was modeled after Michel Eugène Chevreul's theory of simultaneous contrasts, but with added spiritual connotations. All translations are mine unless otherwise noted.

12 Postcard from Sergei Jastrebzoff to Carlo Carrà, postmarked 7 May 1914, Museo d'Arte Moderna e Contemporanea di Rovereto and Trento (CAR.I.74.1).

13 Shell offers an explanation of the relationship between Red Week and Carrà's *Free-Word Painting–Patriotic Festival* (1914; Gianni Mattioli Collection, on extended loan to Peggy Guggenheim Collection, Venice), in "Cleansing the Nation," 73–98. Also see Mario Visani, *La settimana rossa* (Florence: La Nuova Italia, 1978).

14 According to Bohn, this image represents a historical event in Milan called Festa dello Statuo, which included a peaceful parade with military troops and marching bands. Willard Bohn, "Celebrating with Carlo Carrà: 'Festa patriottica,'" *Zeitschrift für Kunstgeschichte* 57, no. 4 (1994): 670–81.

15 The most thorough description to date of this work and its reception is Lewis Kachur's entry in Flavio Fergonzi's *The Mattioli Collection: Masterpieces of the Italian Avant-Garde* (Milan: Skira, 2003), 204–15.

16 Carlo Carrà, *Guerrapittura* (Milan: Edizioni Futuriste di "Poesia," 1915).

17 Carlo Carrà and Ardengo Soffici, *Lettere 1913/1929,* ed. Massimo Carrà and Vittorio Fagone (Milan: Feltrinelli, 1983), 69. See Carrà letters to Soffici dated 12 October and 21 November 1914, 64–65, 69–70.

18 Carrà and Soffici, *Lettere 1913/1929,* 69.

19 Carrà, *Guerrapittura,* 103.

20 Carlo Carrà, *La mia vita* (Milan: Feltrinelli, 1981), 118–19.

21 Carrà, *La mia vita,* 119.

22 In an article in *Lacerba* ("Il cerchio si chiude," 15 February 1914), Papini portrayed the emergence of real-world elements in futurist works as a return to naturalism from avant-gardism. After Boccioni strongly disagreed in print, Papini replied (in "Cerchi aperti," *Lacerba,* 15 March 1914) that, even in Boccioni's works, Papini discerned "a tendency toward order (metaphysical, religious), toward stability," which Papini, Soffici, and even Carrà considered repugnant. Art historian Kenneth Silver documents the "return to order" by avant-garde artists in France, which he identifies as appearing first in 1915. See Kenneth Silver, *Esprit de corps: The Art of the Parisian Avant-Garde and the First World War, 1914–1925* (Princeton, N.J.: Princeton University Press, 1989).

23 Soffici's letter is dated 16 February 1917. See Carrà and Soffici, *Lettere 1913/1929,* 104.

24 In a letter to Soffici from October 1914, Carrà mentions his difficulties with Marinetti as well as his disenchantment with futurist "mediocrity." Carrà and Soffici, *Lettere 1913/1929,* 64–65.

25 Carrà, *La mia vita,* 130–31.

26 Carrà, *Pittura metafisica,* 2nd ed. (Milan: Casa Editrice "il Balcone," 1945), 95.

27 On this new approach, Carrà observed: "I try to penetrate the innermost intimacy of ordinary things, which are the last things to be conquered." Carrà, "Il quadrante dello spirit," *Valori Plastici,* 15 November 1918, 1. Elsewhere, he poetically refers to "the flash of ordinary things." Carrà, *Pittura metafisica,* 211.

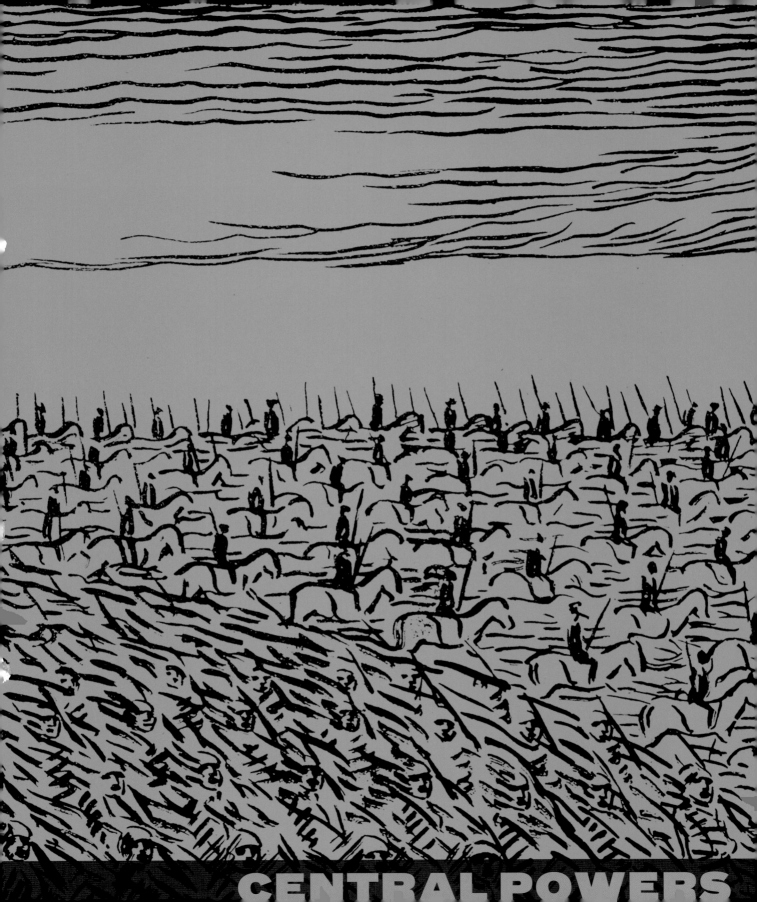

CENTRAL POWERS

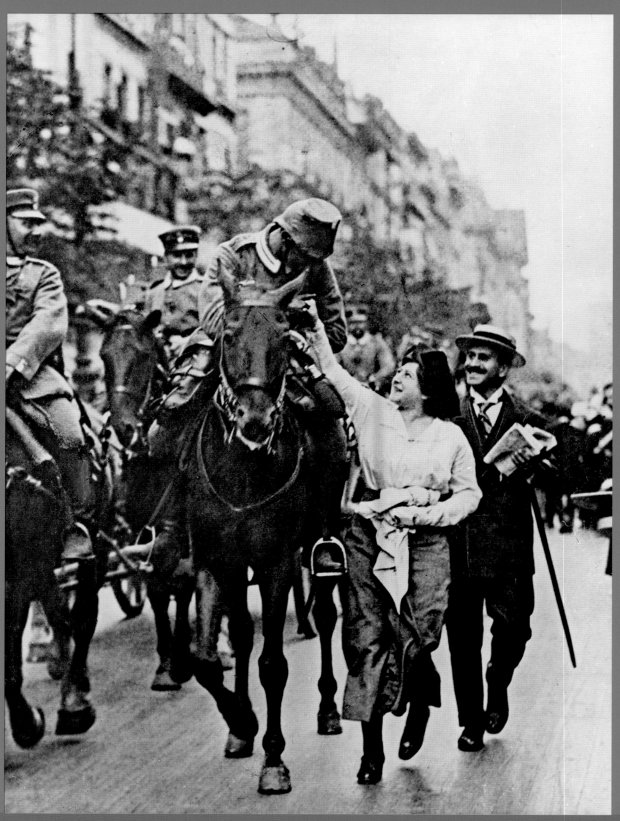

PLATE 19 FAREWELL TO THE TROOPS, AUGUST 1914, BERLIN.
Photographer unknown. Los Angeles, Getty Research Institute.

SOLDATENBRÜDERGRAB.

GELEITE DU DAS STARKE VOLK
O HERR, IN DEINER LIEBE HULD.
VOR ZAGEM ZWEIFEL AN SEIN HEIL
BEWAHRE ES VOR ALLER SCHULD.
VERLEIH IHM KINDLICHES VERTRAUN,
WIE REINEN HERZEN ES BESCHIEDEN,
DASS ES IM STOLZEN VORWÄRTSSCHAUN
ERRINGE SEINES REICHES FRIEDEN.

PETER ROSEGGER

Upper left: **CARL MARIA SCHWERDTNER (AUSTRIAN, 1874–1916).** Screwing medallion, 1915, diameter: **PLATE 20**
5 cm (2 in.). Los Angeles, Getty Research Institute. *Upper right and lower left and right:* **BERTHOLD LÖFFLER (AUSTRIAN,**
1874–1960). Bildmedallions, 1915, lithographs, diameter: 4.4 cm (1¾ in.). Los Angeles, Getty Research Institute.

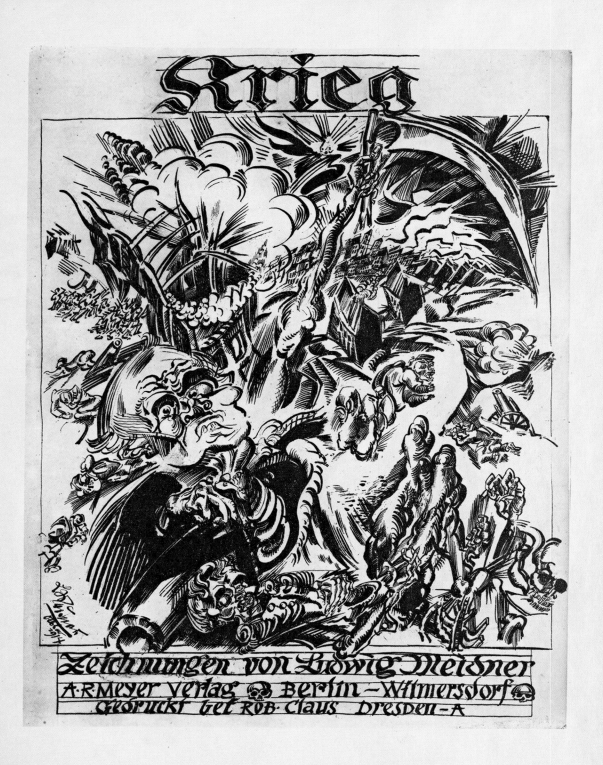

PLATE 21 LUDWIG MEIDNER (GERMAN, 1884–1966). *Krieg* (War), photogravure, 37 x 29.1 cm (14⁹/₁₆ x 11⁷/₁₆ in.).
From *Krieg* (Berlin, 1914), title page. Los Angeles, Getty Research Institute.

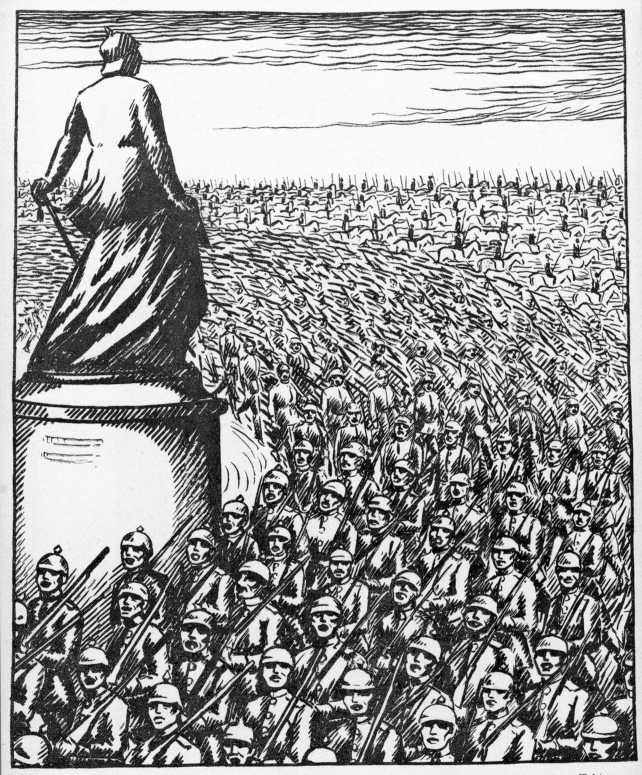

MAX FRÖHLICH (GERMAN). *Let There Be War.* From *Die Front: Kriegsausgabe* **PLATE 22**
von Licht und Schatten 5, no. 12 (1915): n.p. Los Angeles, Getty Research Institute.

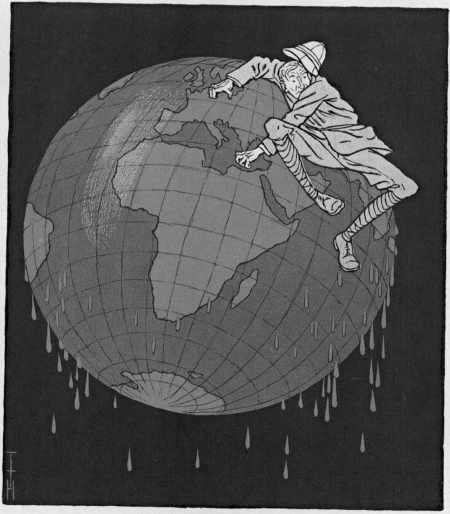

München, 13. Oktober 1914 — Preis 30 Pfg. — 19. Jahrgang Nr. 28

Simplicissimus

Abonnement vierteljährlich 3 Mk. 60 Pfg. — Alle Rechte vorbehalten

Begründet von Albert Langen und Th. Th. Heine

In Österreich-Ungarn vierteljährlich K 4.40

Copyright 1914 by Simplicissimus-Verlag G. m. b. H. & Co., München

Der Engländer und seine Weltkugel

(Th. Th. Heine)

„Oh verflucht, Blut ist doch schlüpfriger als Wasser!"

PLATE 23 **THOMAS THEODOR HEINE (GERMAN, 1867–1948).** *Der Engländer und seine Weltkugel* (The Englishman and his globe).
Cover of *Simplicissimus* 19, no. 28 (13 October 1914). Los Angeles, Getty Research Institute.

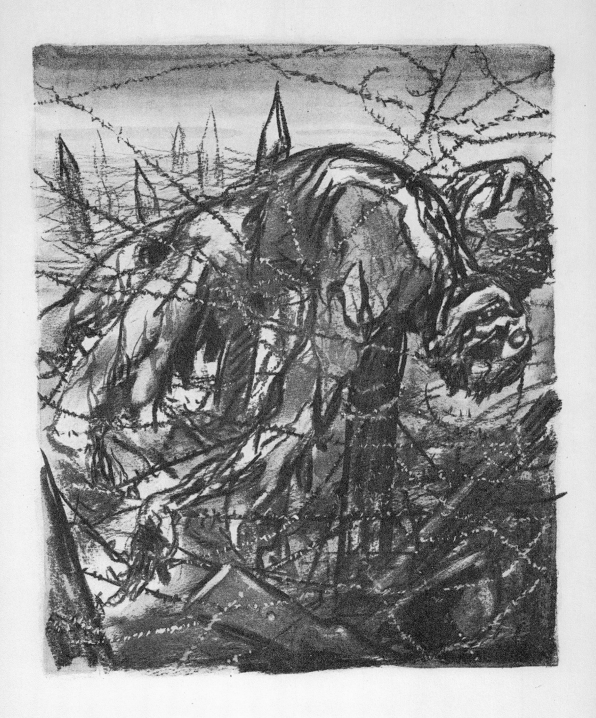

WILLIBALD KRAIN (GERMAN, 1886–1945). Dead soldier caught in barbed wire, lithograph, 35.2 x 24.1 cm (13⅞ x 9½ in.). **PLATE 24**
From Otto Dix et al., *Krieg: 7 Originallithographien*, suite of seven lithographs (Berlin, 1924). Los Angeles, Getty Research Institute.

München, 5. Januar 1915 Preis 30 Pfg. 19. Jahrgang Nr. 40

SIMPLICISSIMUS

Abonnement vierteljährlich 3 Mk. 60 Pfg. Begründet von Albert Langen und Th. Th. Heine In Österreich-Ungarn vierteljährlich K 4.40
Alle Rechte vorbehalten Copyright 1915 by Simplicissimus-Verlag G. m. b. H. & Co., München

Heimweg

(Th. Th. Heine)

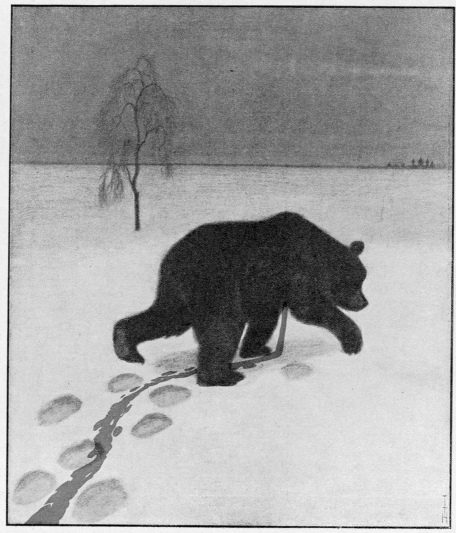

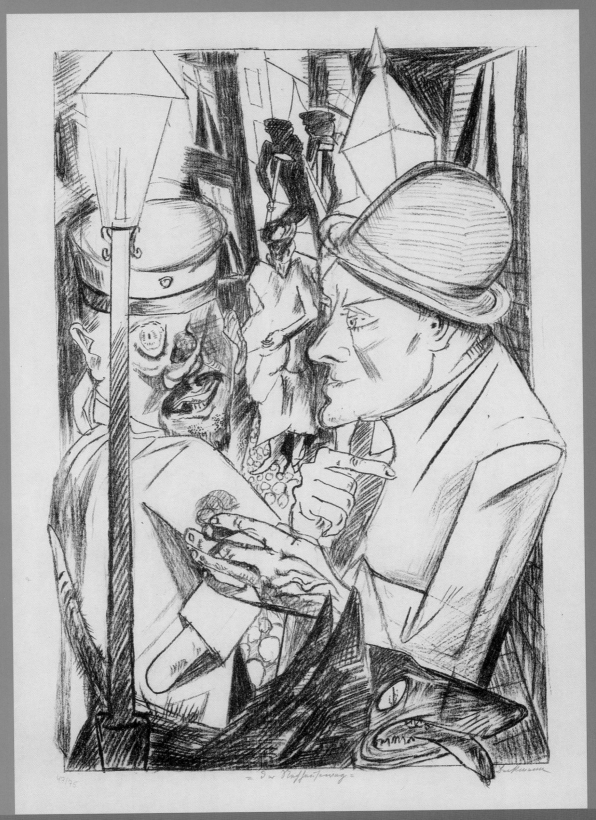

MAX BECKMANN (GERMAN, 1884–1950). *The Way Home,* 1919, lithograph, image: 73.5 x 48.5 cm (29 x 19⅛ in.). From *Die Hölle* (published **PLATE 26**
by I. B. Neumann, German, 1887–1961; printed by C. Naumanns Druckerei, Frankfurt am Main, Germany), plate 2. Saint Louis, Saint Louis Art Museum.

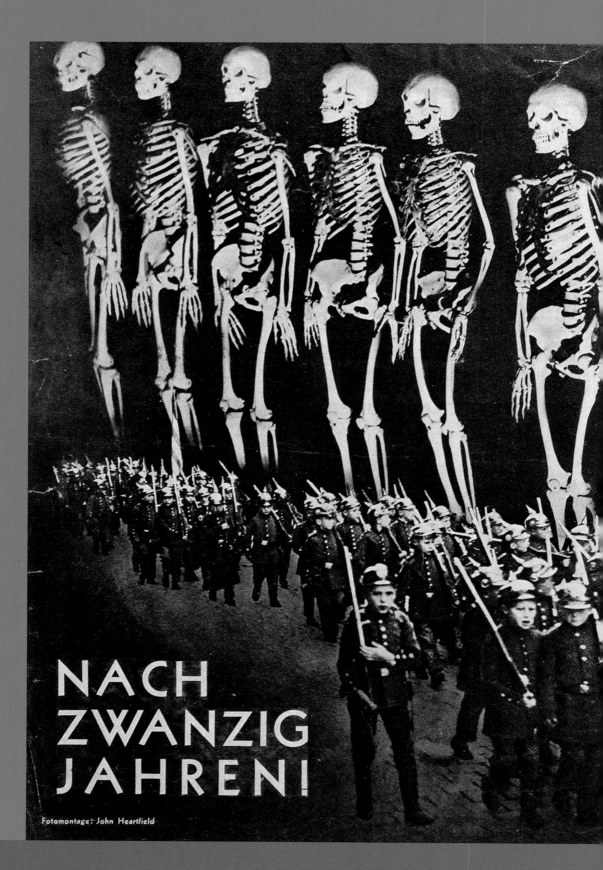

NACH
ZWANZIG
JAHREN!

Fotomontage: John Heartfield

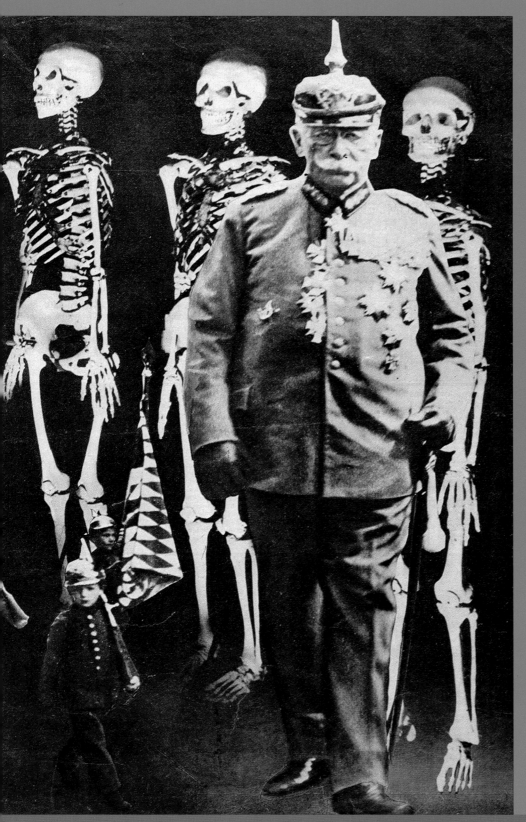

JOHN HEARTFIELD (GERMAN, 1891–1968). *Nach zwanzig Jahren* **PLATE 27**
(After twenty years). From *AIZ* 13, no. 37 (September 1934): 592–93.

AT FIRST GLANCE, THE GERMAN ARTIST OTTO DIX (1891–1969) SEEMS A PARADIGMATIC CASE of a painter radically influenced by twentieth-century warfare. He sketched and painted throughout the four years he fought in World War I, and many of his most famous works of the 1920s and 1930s—his massive canvas *The Trench* (1920–23), the even larger triptych *The War* (1932), and his epic series of etchings, also titled *The War* (1924)—were controversial commemorations of that most recent and devastating European calamity. Despite the impact that the war had on him, however, many of Dix's artistic ideas and tendencies were initially set before the conflagration; the armed conflict—as unprecedented and powerful as it was—was only one important influence among many. War, one could say, changed Dix, but only by confirming and supporting some of his most deeply rooted visual and intellectual affinities.

Long associated with Neue Sachlichkeit (New Objectivity), the naturalistic mode of depiction characteristic of advanced art and literature produced during the Weimar Republic, Dix has generally been praised as both a realist and a social critic.[1] Closer attention to his art, however, discerns a great deal of eclecticism, in terms of form and technique, at nearly every stage of his career. Dix undertook a critical exploration of artistic practices, including those drawn from the painterly tradition and modern and avant-garde art, without making a firm commitment to any one mode or strategy. From the very beginning, Dix refused to identify with a fixed style or movement; and, over his career, he avoided committing to extremes such as pure abstraction or photographic realism. Instead, he balanced acute observation with metaphoric allegory, demonstrating a commitment to the external world that nevertheless recognized the constructive and radically interpretive nature of vision and visual representation in general.[2]

Otto Dix
War and Representation
MATTHEW BIRO

Self-Portrait with Carnation (fig. 1) depicts the twenty-one-year-old Dix, then an art student in Dresden, two years before the hostilities commenced. On the one hand, the painting seems typical of the objectivity for which Dix later became known. The self-portrait is carefully observed and realized; its forms are clearly delineated; and its style accords with traditional modes of realistic representation from the Renaissance onward. On the other hand, the blankness of some of the forms (most notably, the blue background) and overall linearity of the image makes the representation appear iconic and invested with symbolism, something that is heightened by Dix's depiction of the carnation, a symbol of betrothal, held between his fingers. This motif emphasizes the artist's manual dexterity, and the way the flower is grasped evokes a graphic or painterly instrument; the gesture furthermore connects Dix's painting with those of Northern Renaissance masters such as Albrecht Dürer and Hans Baldung, whose works Dix studied in the nearby Gemäldegalerie Alte Meister

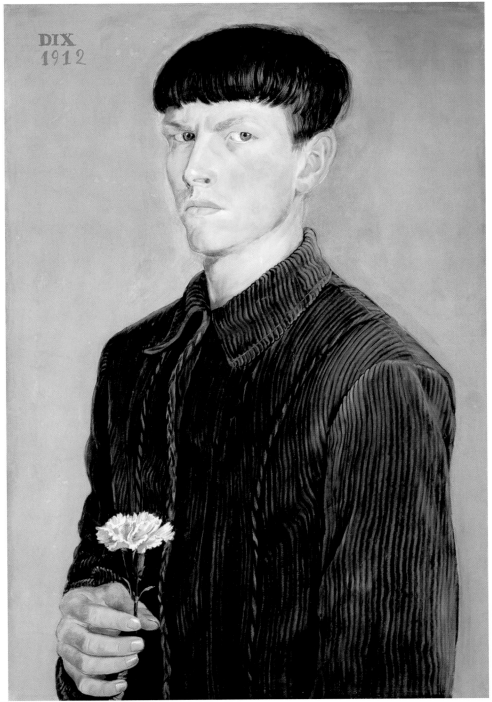

FIGURE 1. OTTO DIX (GERMAN, 1891–1969). *Self-Portrait with Carnation,* 1912, oil and tempera on panel, 73.6 x 49.5 cm (29 x 19½ in.). Detroit, Detroit Institute of Arts.

in Dresden. In this early self-portrait, Dix seems to be concerned with both optical veracity and meaning beyond the visible.

At the same time that he supported realistic representation and forms of dry objectivity, Dix also embraced an active type of gestural painting, one that was indebted to impressionism and expressionism. Between 1911 and 1913, he created landscapes in nature using the *alla prima* (direct painting) technique; and, in the studio, he quickly and emotively rendered still lifes and self-portraits in oil. These latter strategies suggest a more expressionist and subjective side to his art, a counterpoint to Dix's realist tendencies. His engagement with the work of Vincent van Gogh and Die Brücke artists before the war only intensified this expressionist side of Dix's painting, as did his reading of the philosophy of Friedrich Nietzsche, whose bust the artist sculpted in 1912.[3] Like many artists and intellectuals at the time, Dix embraced Nietzsche's view of modern man as living in a time of decline and nihilism and the philosopher's conviction that the arts could reimagine the world and provide a will to go on.[4] In Dix's prewar still lifes and landscapes, nature and everyday life are revitalized by self-referential form, color, and facture. If, as Nietzsche argued, the development of science and rationality had destroyed the plausibility of a transcendental realm of spiritual values, a realm of meaning not created by human beings, then artists had to reenchant the world and develop new icons and values.[5] Dix's prewar gestural works, which employ direct painting as part of an effort to restore aura to the world, suggest this Nietzschean outlook.

Like many of his generation, Dix enlisted voluntarily in August 1914. That fall, at the age of twenty-three, he received artillery training as part of a machine-gun squad, and he subsequently fought for almost four years in the trenches along the western and eastern fronts, during which time he was wounded and promoted, eventually to the rank of master sergeant.[6] In 1918, when the war was coming to an end, Dix reenlisted in the German air force and began training as an aerial observer. He was both repelled by and attracted to armed conflict: "The war was a hideous thing, but there was something tremendous about it, too. I couldn't afford to miss it. You have to see human beings in this unchained condition in order to know something about them."[7] Reflecting Nietzsche's fascination with the "blond beast" and his romantic valorization of the "will to power" of creative individuals who recognized that they were "beyond good and evil,"[8] Dix's romanticization of war was quickly tempered by a clear recognition of its senseless destructiveness and the psychic trauma that it inflicted upon him: "For years, at least ten years, I kept having these dreams in which I would have to crawl through demolished houses, through doorways that barely permitted me to pass. The ruins were incessant in my dreams."[9]

A double-sided oil-on-paper work from 1914, comprising *Self-Portrait as a Soldier* on one side and *Self-Portrait with Artillery Helmet* on the other, shows the intense scrutiny of self that characterized the art of Dix's wartime years (fig. 2). Appropriating an expressionist style suggestive of the work of Emil Nolde or Max Pechstein, these representations seem both closely observed and allegorizing. On the one hand, specific details, such as Dix's shaved head or his new military uniform, appear plucked from life. On the other hand, the paintings' expressive aspects—the slashing painterly brushstrokes and vibrant chromatics—in conjunction with the

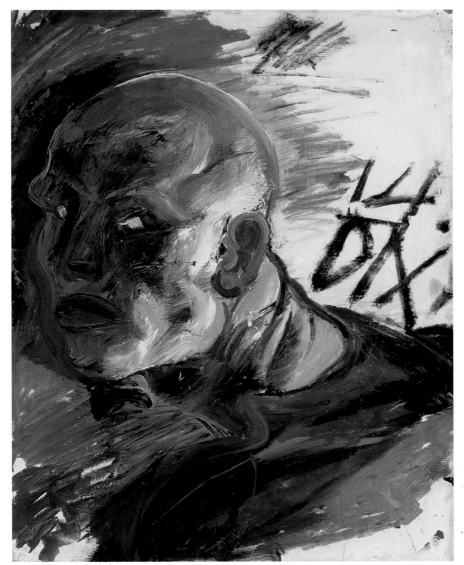

FIGURE 2. OTTO DIX (GERMAN, 1891–1969). *Self-Portrait as a Soldier,*
1914, oil on paper, 68 x 53.5 cm (26¾ x 21⅛ in.). Stuttgart, Kunstmuseum Stuttgart.

idealizing nature of the depictions (the fact that Dix represents himself as powerful and physically whole) imply a sense of himself as a Nietzschean "new man," someone who would not only survive but also develop and evolve through war.

Dix believed that armed conflict, like art, was radically transformative; if he was not killed or maimed, he would be forged into a higher state of being. This was a belief about war that transcended political ideologies at the time, uniting the bohemian but apolitical Dix with right-wing revolutionaries such as Ernst Jünger.[10] As he gained war experience, Dix used strategies of abstraction drawn from cubism and futurism—the interpenetration of solid and void, for example, or the practice of evoking movement or force through repeated lines that parallel one another—to represent himself in his

portraits as a new and unprecedented type of man. Thereby, his practice suggests an intense focus on selfhood that was perhaps designed to assuage his fears of his body's limits and integrity in the face of extreme danger.[11] Dix was always a realist, however, and in his wartime portraiture, the myth of armed conflict could not withstand the experience of its reality. In images of soldiers painted later in the war, human bodies are torn open, spilling organs and blood; and although Dix continued to represent himself as whole, the warrior's body became a site of trauma and emasculation.

In addition to painting the visages and bodies of soldiers, Dix created landscapes and views of military life, sometimes in realist and sometimes in modernist modes. During the conflict, Dix drew and sketched constantly in a variety of graphic media. A collection of fifty-three field postcards sent from the trenches to his close friend Helene Jakob between 1915 and 1918 show the observational side of Dix's practice. Direct, expressive, and linear, these black-and-white works depict army life — a field hospital, the troops' quarters in a captured civilian attic, and a machine-gun stand, for example — as well as fragmentary views of nature and architecture torn apart by bombs and then reconstructed to meet the instrumental mandates of total mobilization. Like the more imaginative scenes in oil, gouache, and watercolor that Dix also produced during the war, the field postcards seem "citational"; that is, they represent Dix's contemporary experience through different expressionist, cubist, and futurist strategies, appropriating past motifs and styles, not simply for their forms but also for their historical and contextual meanings. Although Dix's wartime art played between the poles of realism and allegory, no work was completely devoid of its antithesis.

After the war, Dix resumed his life as an artist, determined, according to his friend and fellow painter Conrad Felixmüller, to be either "famous" or "reviled."[12] In the turbulent early years of the Weimar Republic, he sought controversy, creating a gallery of contemporary urban types and scenes designed to provoke outrage and debate. Surviving first as an art student in Dresden, where he was also a founding member of the short-lived but influential Dresdner Sezession Gruppe 1919,[13] Dix soon received attention as one of Germany's most significant "postexpressionist" artists, a "verist" who critically described the social and political problems of his time. He moved to Düsseldorf in 1922 and then Berlin in 1925; in each city, he developed connections with different individuals and groups who helped to support his career, such as artists George Grosz, Max Liebermann, and Gert Wollheim; dealers Johanna Ey and Karl Nierendorf; and museum directors Gustav Hartlaub and Hans F. Secker. Important critics also quickly took notice, among them Carl Einstein and Paul Westheim. Einstein, in particular, found Dix to be an important but problematic artist, a social realist particularly suited to represent a contemporary German moment that was more brutal, derivative, and suffused with kitsch than ever before.[14]

In 1920, Dix showed with the Berlin Dadaists.[15] Among the works he displayed at the Erste Internationale Dada-Messe (First international Dada fair) was the later-destroyed *The War Cripples* (1920), a large oil canvas also known as *Forty-Five Percent Fit for Work* (fig. 3). Here, four prosthetically augmented former soldiers stroll down a shopping street, while consumer goods in store windows behind them mock their physically diminished conditions. The realism of the canvas — its references

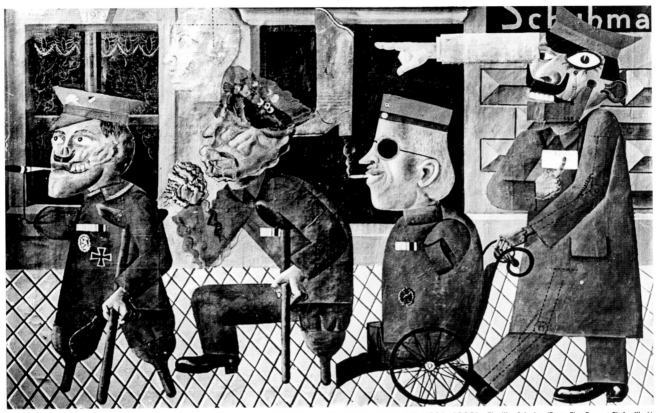

FIGURE 3. OTTO DIX (GERMAN, 1891–1969). *The War Cripples (Forty-Five Percent Fit for Work),* 1920, oil on canvas, 150 x 200 cm (59⅛ x 78¾ in.). Location unknown, believed destroyed in 1942.

to actual places and events—is beyond dispute: at that time in Germany, there were parades by disabled war veterans protesting inadequate pensions. At the same time, the work is anything but realistic; it is grotesque, ruptured, and cartoonlike and thus seemingly critical of its subjects. Dix simultaneously skewers the government for its callousness and the veterans for their persistent militarism. The freakish and vernacular qualities of *The War Cripples,* moreover, question the efficacy of both traditional and modern forms of art in the postwar world. Dix implies that the tradition of painting historical events in a realistic way is dead, and with its demise comes the termination of the role of the nineteenth-century German painter as a propagandist for the state, an official figure who promotes the idea of sacrifice for the good of the nation. Instead, the painter has become an independent contractor, a social and moral critic, who is thrown upon the capitalist market and forced to survive through a combination of realism, provocation, and historically informed caricature.

In 1920, Dix worked productively on a number of large canvases, employing the motif of the mutilated soldier festooned with prosthetics to question the practices of military sacrifice and memorialization. In these works, the trauma of war was

exchanged for the violence of photomontage, and the canvases' realism was the product of artificial and highly interpretive strategies such as caricature, formal and material heterogeneity, dialectical juxtapositions of conflicting elements, and references to current events. Although Dix abandoned photomontage almost as quickly as he took it up under the influence of Dadaism, he continued to be influenced by the Dadaists' use of the grotesque and their focus on contemporary historical occurrences, the body, and everyday life. Indeed, he began to employ other (very nonmodern) formal means to create his art, but his distinctive combination of allegory with different forms of realism continued to play an important role in all his great work created during the Weimar Republic.

In the 1920s and 1930s, Walter Benjamin used the term *allegory* to signify the mournful, modern, and secular modes of representation most commensurate with the experience of modern life. Dix's war-cripple canvases, as well as his work that followed in the 1920s, fit this model of allegorical representation by providing violent, historical, and weakly redemptive descriptions of the contemporary moment.

In addition to serving as a descriptive model for important contemporary art and literature, allegory, for Benjamin, explained the principal characteristics of the German *Trauerspiel,* or royal "mourning play," a baroque dramatic genre that presented courtly life as a metaphor for a battle between good and evil.[16] Formally, the plays relied on strategies of appropriation, the representation of general types, and the static rendering of narrative action. Interludes were used to introduce foreign figures from outside the narrative who would comment upon and interpret the main action, thereby multiplying the systems of meaning in which the story and characters were to be understood. At numerous points in the drama, the narrative's action was brought to a standstill; its parts were dissected and reassembled to form static tableaus that suggested both literal and underlying significance.[17]

Confirming Benjamin's linkage of modernity and the baroque, Dix's paintings of the 1920s depict human types frozen in symbolic actions and embedded in fragmented settings imbued with history and violence. Likewise, Dix's paintings of the Weimar Republic seem to emphasize their sitters' fleshly and instinctual sides. This is apparent in Dix's paintings of prostitutes and scenes of sexual murder (*Lustmord*) from the early 1920s—for example, *Salon I* (1921; fig. 4) or *Sex Murder* (1922). In these and other works, the body and its drives appear to dominate Weimar society. The war, these paintings suggest, continues during peacetime. It is easy to read Dix's depictions of corpulent sex workers and female bodies destroyed by violence as exploring an emasculated German male ego that seeks to overcome its psychic wounds by attacking and demeaning women who resist patriarchal norms or who appear too powerful.[18] According to Benjamin, the violence and the weakly redemptive power of the German mourning plays were connected to the fact that these allegories represented human beings as "creatures," a dialectical term that signified both God's creation and a living being that was instinctive, base, and passionate.[19] Through the extreme emotion and violence suffered by its "instinctive" or "material" side, the human subject was destroyed and then redeemed.[20] In Dix's representations of prostitutes and sexual murder, however, the only form of redemption to emerge is the radical critique of Weimar society.[21]

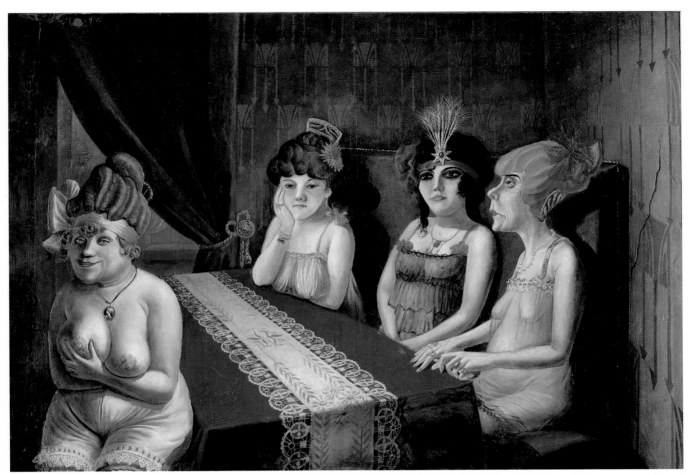

FIGURE 4. OTTO DIX (GERMAN, 1891–1969). *Salon I,* 1921, oil on canvas, 86 x 120.5 cm (33⅞ x 47½ in.). Stuttgart, Kunstmuseum Stuttgart.

Throughout the 1920s, Dix consistently mixed allegory with realism while employing a variety of different styles and methods of painting. Generally, the human figure and the setting were articulated with such attention and profusion of detail that they seemed charged with heightened meaning or aura. No matter how bestial or grotesque Dix's subjects became, they were always redeemed through technique, something that became particularly apparent in the mid-1920s, when Dix began to paint on wood and emulate aspects of the techniques of the Northern Renaissance masters—for example, layers of tempera and oil paints separated by overlays of transparent glaze.[22] In the great mixed-media paintings of the second half of the 1920s, such as *Portrait of the Journalist Sylvia Von Harden* (1926) and *Portrait of the Art Dealer Alfred Flechtheim* (1926), Weimar personalities appear in their particularity while simultaneously embodying social stereotypes. Through their linearity, abstraction, gloss, and close focus on material surfaces, they transcend their documentary

aspects, tying their subjects to what Dix and his audience perceived to be larger cultural forms circulating in the Weimar Republic.

In addition to being violent and weakly redemptive, allegories, according to Benjamin's model, were historical because they sought to represent the newness of their contemporary moment—the direction in which the world was evolving. *The Trench* (1920–23), a monumental canvas, depicts the aftermath of an artillery assault on a German trench on the western front, something that Dix had experienced first-hand only a few years before. An impaled soldier hangs suspended above an earthen channel containing corpses in various states of dismemberment and decomposition. Because of its detail, Dix's depiction of the figures and ground seems accurate, and in fact disgustingly realistic. At the same time, the rendering of the corpses is simplified and exaggerated, and thus they seem slightly caricatured. In addition, there is an interplay between careful depiction and blur created by the atmospheric perspective that combines with the work's overall scale and composition to create a sense of vague allegory. The impaled soldier, crucified by mechanized warfare, seems Christlike, and there is a Nietzschean sense of the world and the subject as comprising a play of forces (something that Dix emphasizes by depicting the breakdown of the soldiers' bodies in a way that suggests that they are fast becoming a biological matrix for new life). Dix insinuates that empathy for the Other was radically diminished by the events of 1914–18 and that, in the future, human beings will treat each other more and more as mere objects.

This massive canvas made Dix famous when it became the centerpiece of one of the most important obscenity trials of the early years of the Weimar Republic.[23] Later, *The Trench* reemerged as one of the best-known works in the Nazis' infamous *Entartete Kunst* (Degenerate art) exhibition in 1937, after which it disappeared and was presumably destroyed. Like his other artworks commemorating the First World War, a theme to which Dix repeatedly returned over the course of the Weimar Republic, *The Trench* attempts to reenvision sacrifice and memorialization. Blending documentation with allegory, it compels its audiences to remember the past while simultaneously attacking their sense of security and propriety. To commemorate the war, Dix asserted in this canvas, one had to continue it at the level of representation. These were the insights gained during the conflict and through Dix's assimilation of late-nineteenth- and early-twentieth-century German culture.

– NOTES –

1 The term *Neue Sachlichkeit* was first coined by museum director Gustav Hartlaub in 1923 in preparation for his exhibition of the same name at the Kunsthalle Mannheim in 1925. Within Hartlaub's typology of German realism, Dix was a "verist," a left-wing, critical, and cynical social realist. On the Mannheim exhibition, see *Ausstellung Neue Sachlichkeit: Deutsche Malerei seit dem Expressionismus* (Mannheim: Städtische Kunsthalle, 1925). On the developing concept of German realism in the 1920s, see Franz Roh, *Nach-Expressionismus: Magischer Realismus* (Leipzig: Klinkhardt und Biermann, 1925); Wieland Schmied, *Neue Sachlichkeit und Magischer Realismus in Deutschland, 1918–1933* (Hannover: Fackelträger-Verlag, 1969); and Fritz Schmalenbach, *Die Malerei der "Neuen Sachlichkeit"* (Berlin: Gebr. Mann, 1973).

2 Dix's stylistic eclecticism has been noted by many scholars. See Dietrich Schubert, *Otto Dix* (Reinbek bei Hamburg: Rohwohlt, 1980), 18; and Eva Karcher, *Otto Dix*, trans. Doris Linda Jones

and Jeremy Gaines (Cologne: Benedikt Taschen, 1992), 20. Andreas Strobl treats this issue at length; see Andreas Strobl, *Otto Dix: Eine Malerkarriere der zwanziger Jahre* (Berlin: Reimer, 1996), 180–83, 200–201, and 204–15.

3 On the utopian collectivism of Die Brücke artists, their embrace of modernity, and their relationship to Nietzschean thought, see Jill Lloyd, *German Expressionism: Primitivism and Modernity* (New Haven, Conn.: Yale University Press, 1991).

4 On the impact of Nietzsche on Dix, see Otto Conzelmann, *Der Andere Dix: Sein Bild vom Menschen und vom Krieg* (Stuttgart: Klett-Cotta, 1983).

5 As the philosopher famously wrote in *The Birth of Tragedy* [1872/1886], his monumental analysis of Greek art and philosophy, "It is only as an aesthetic phenomenon that existence and the world are eternally justified." Friedrich Nietzsche, *The Birth of Tragedy,* trans. Walter Kaufmann (New York: Knopf Doubleday, 1967), 52.

6 Schubert, *Otto Dix,* 22–26.

7 Schubert, *Otto Dix,* 24–25.

8 See Friedrich Nietzsche, *On The Genealogy of Morals* [1887] and *Ecce Homo* [1888/1908], trans. Walter Kaufmann and R. J. Hollingdale (New York: Vintage, 1967).

9 Schubert, *Otto Dix,* 25.

10 See, for example, Ernst Jünger, *Storm of Steel* [1920], trans. Michael Hofmann (London: Penguin, 2003).

11 On soldiers' attempts to psychically reinforce their bodily limits, see Klaus Theweleit, *Male Fantasies,* trans. Stephan Conway et al., 2 vols. (Minneapolis: University of Minnesota Press, 1987).

12 Conrad Felixmüller, *Legenden 1912–1976* (Tübingen: Wasmuth, 1977), 54.

13 On the Dresdner Sezession Gruppe 1919, see Joan Weinstein, *The End of Expressionism: Art and the November Revolution in Germany, 1918–1919* (Chicago: University of Chicago Press, 1990), 107–60.

14 See Carl Einstein, "Otto Dix," *Das Kunstblatt* 7, no. 4 (1923): 97–102; and Carl Einstein, *Die Kunst des 20. Jahrhunderts,* Propyläen-Kunstgeschichte 16, 2nd ed. (Berlin: Propyläen-Verlag, 1928), 147–53, 173–75.

15 On Dix's association with the Berlin Dada artists, see Otto Dix et al., *Dix,* exh. cat. (Stuttgart: Hatje, 1991), 85–91, 95–100.

16 Walter Benjamin, *The Origin of German Tragic Drama* [1925/1928], trans. Josh Osborne, (New York: Verso, 1990), 225.

17 Benjamin, *The Origin of German Tragic Drama,* 192–95.

18 On Dix's images of prostitutes and sexual murder, see Maria Tatar, *Lustmord: Sexual Murder in Weimar Germany* (Princeton, N.J.: Princeton University Press, 1995); and Dora Apel, "'Heroes' and 'Whores': The Politics of Gender in Weimar Antiwar Imagery," *Art Bulletin* 79, no. 3 (1997): 366–84.

19 Benjamin, *The Origin of German Tragic Drama,* 85, 89. See also Beatrice Hanssen, *Walter Benjamin's Other History: Of Stones, Animals, Human Beings, and Angels* (Berkeley: University of California Press, 1998), esp. 103–7 and 150–62.

20 Benjamin, *The Origin of German Tragic Drama,* 216–17.

21 On Dix's critical intent vis-à-vis his pictures of prostitutes, see Sabine Rewald et al., *Glitter and Doom: German Portraits from the 1920s* (New York: Metropolitan Museum of Art, 2006), 66.

22 On Dix's technique, see Bruce F. Miller, "Otto Dix and His Oil-Tempera Technique," *The Bulletin of the Cleveland Museum of Art* 74 (October 1987): 332–55.

23 See Dennis Crockett, "The Most Famous Painting of the 'Golden Twenties'? Otto Dix and the *Trench* Affair," *Art Journal* 51, no. 1 (1992): 72–80.

UNLIKE OTHER GERMAN ARTISTS, ERNST LUDWIG KIRCHNER (1880–1938) WAS NOT ENTHUSIASTIC TO GO TO WAR IN 1914 and did not share the general exaltation many writers, musicians, architects, and artists demonstrated. Their motives varied, but they all were convinced of the necessity of social and political renewal. Going to combat was considered the only sacrificial way to achieve this goal. Most of these artists were initially not critical of the monarch and his government, and they obediently followed the state's call to arms. The feeling of having to be "loyal subjects" was prevalent.[1] Defeating the enemy, especially the old *Erbfeind* (hereditary enemy) France, was much less decisive for the war enthusiasm for many people than the dangerous mix of general patriotism and nationalistic convictions enhanced by state propaganda. Kirchner's opposition to this march to war and his stance during World War I are not easy to understand. Was he not interested in politics? Was he scared, not wanting to give his life for his country? Did he not share any feeling of patriotism?

To approach Kirchner's frame of mind during this period, it is best to gather the facts. Recent scholarship about Kirchner agrees that he did everything he could to remove himself from any engagement with the war. During his time as a military recruit in Halle an der Saale in 1915, he developed a substantial war neurosis that was accompanied by major physical and psychological impairments.[2] However, he later admitted that his "war sickness" was feigned. In a letter to Elfriede Knoblauch from 1929, he wrote:

Ernst Ludwig Kirchner
An Inner War
THOMAS W. GAEHTGENS

> I did not have any "war sickness," I was simply struggling to complete the work I had embarked on, which struck me as more worthwhile than falling victim to a capitalist war and dying the death of a "hero." Since there was no other way, I fell "ill," and I was too unlike the average man of 1914, I had to make excessive demands of my body, and really did end up seriously ill.[3]

One has to keep in mind that these sentences were written more than ten years after the war. Yet they do contain many revealing elements and, above all, make clear that there is no simple explanation for Kirchner's position on the war and that his situation was complicated. In the letter, Kirchner points out that he did not share the common goals of this war, having been "unlike the average man of 1914." He labels the war "capitalist" and deems "dying as a hero" not a reasonable goal he wants to share. Like many of Kirchner's retrospective statements, these sentiments have to be evaluated, especially as there is no proof that he had formed them as early as 1914.

As far as the circumstances are known, Kirchner gave a truthful report concerning his illness; however, it was made during the second chapter of his experience with the military. The artist did not wait to be drafted but volunteered for service, a decision that is not easy to understand. On the one hand, he hoped to obtain a better position in the military by enlisting voluntarily.[4] On the other hand, he definitely wanted to experience the feeling of commitment to a patriotic cause that was so common at this historical moment. He compared combat to the inner struggle of artistic creation: "I also believe that many of those who stood on the battleground discovered humanity and thus are able to appreciate the expression of human feeling in art. The development of these men and of creators is parallel because both set aside their ego in order to fulfill this noble task."[5]

This attitude is similar to that of many of Kirchner's fellow artists, such as Franz Marc and Max Beckmann. However, the reality of military life shocked Kirchner, as can be understood by the appalled remarks he made in a letter to Karl Ernst Osthaus about the primitive conduct of the soldiers, who, according to the artist, had no sensibility.[6] The tough military environment and the lack of sensitive social behavior disgusted Kirchner, and he largely isolated himself.[7] He considered these months a complete loss and wished the time could have been used for artistic creation. The contrast between the rough daily routine of the military, where every recruit was equal, and Kirchner's hitherto bohemian way of life could not have been starker. Therefore, it is not difficult to comprehend why the artist did everything he could to escape his situation.

Kirchner took several photographs of himself in what must have been 1915. In one image, he can be seen standing in his apartment at Körnerstraße, Berlin, wearing a full uniform with spiked helmet and saber (fig. 1). It is unclear if he poses "proudly."[8] Be that as it may, the document attests to the contrast between the bohemian, artistic studio and the bedecked soldier. The photograph highlights the strangeness of this costume in an atmosphere to which it does not belong. Kirchner might not have been exactly opposed to the political goals of the war, but he definitely was not meant to be part of an engagement that required incorporation and subordination.

Kirchner's military experience exhausted him and resulted in a depressive mood. His health worsened, especially because he stopped eating and steadily lost weight. He "deliberately and methodically planned and executed his own physical deterioration," and he struggled with his superiors.[9] His longtime friend and riding instructor, Hans Fehr, finally obtained a leave of absence for him in September 1915, which ultimately resulted in a final release from the military in December.[10]

During the next few years, when the war was devastating Europe, Kirchner was unable to find his mental and corporeal balance. He was driven by dissatisfaction aggravated by the abuse of alcohol and drugs and the loss of two of his closest friends: Hugo Biallowons, who fell at the front, and Botho Graef, who suffered a heart attack.[11] Kirchner was also worried about being drafted again. Even though he never experienced real combat, he was aware and terribly afraid of the horrible events at the front. In his letters, he kept reiterating how senseless and gruesome the

FIGURE 1. ERNST LUDWIG KIRCHNER (GERMAN, 1880–1938).
Self-Portrait as a Soldier in the Berlin-Frideau Atelier, Körnerstraße 45, 1915, glass negative,
18 x 13 cm (7⅛ x 5⅛ in.). Davos, Kirchner Museum Davos.

war was to him.[12] Unable to find a satisfactory creative process, he was overwhelmed by fear of the war, the world in general, and his own death—a hysterical condition that he expressed in many letters:

> The pressure of war and the prevailing superficiality weighs heavier on me than anything else. I always have the impression of a bloody carnival. How will it all end?...Swollen, one staggers to work, even though all work is futile and the onslaught of mediocrity tears everything down. Like the prostitutes I painted am I now myself. A mere brushstroke now, gone the next time. Nevertheless, I am still trying to bring order to my thoughts and to create from all this confusion an image of our time, which is my task.... The lunacy of this war is incomprehensible.... The most painful thing is the gradual dissolution of oneself and the feeling of not being able to help. The gradual decease without death.[13]

In this moving letter, Kirchner describes his psychological and physical situation in an alarmingly precise way. The numerous attempts to recover in various sanatoria in Germany and Switzerland, most extensively at the Bellevue Sanatorium in Kreuzlingen, and his ultimate escape to the mountains of Davos in 1917 become understandable.[14] However, the artist's mental and physical condition remained unstable far beyond the war years.

Kirchner's experience was very different from those of other artists who came to regret their initial war enthusiasm after having seen the horrors of the trenches. He felt the pressure of meeting the expectations of military life and engagement while being convinced that his calling as an artist was so important that he had no right to give his life away. This situation created an inner conflict that conditioned his poor health and depressive mood during the war years. Over all this time, the artist, despite his pitiful situation, never neglected his creativity. Sometimes painting, sometimes producing woodcuts or sculptures, but always drawing, Kirchner expressed his feelings in works of art. In a way, he fought against his physical and mental instability and his inner struggle in the best way he could — by being creative: "I am torn inside and immunized in all directions, but I fight to also express that in art."[15]

Kirchner's Art during World War I

The first works of art Kirchner executed in Halle as a recruit were drawings in sketchbooks and woodcuts. Some images demonstrate more genre-like renderings of his impressions, such as *Artilleryman Mounting a Horse* (1915, Hannover, Museum August Kestner);[16] several were executed as paintings.[17] Only a few woodcuts, such as *Execution* from 1915,[18] tangibly evoke aggressive situations and show the artist's attempt to come to terms with a militant and brutal environment.

Kirchner could not create many paintings during his time in the military, although three he did manage to complete, all from 1915, are major works. The famous *Red Tower in Halle* (1915, Essen, Museum Folkwang) continues his earlier Berlin cityscapes. *Artillerymen in the Shower* (1915, New York, Solomon R. Guggenheim Museum) receives different interpretations. It might go too far to label it as an antiwar painting or a "metaphor for a degrading existence that reduces the individual to basic bodily functions."[19] Rather, the image follows Kirchner's painterly interests before the war, which focused, among other things, on the depiction of outdoor nudes. *Self-Portrait as a Soldier* (fig. 2) has to be understood as a very personal expression of Kirchner's moral situation. A gruesome image of self-mutilation, it symbolizes his personal castration as an artist.[20] Evidently, the painting represents the impossibility of working as an artist when serving in the military. Yet, regarding the work as an antiwar painting would be a misinterpretation. Never having experienced the trenches, physical pain, or mutilation, Kirchner could not express "trauma, martyrdom, and suffering in war"[21] in his *Self-Portrait as a Soldier;* instead, he reveals the inner conflict between being part of the military and his vocation as an artist. He maintained the conviction that the social role of an artist should be valued at a higher level — as high as fighting at the front — and that it cannot be spoiled by forcing the artist into "simple" military service.

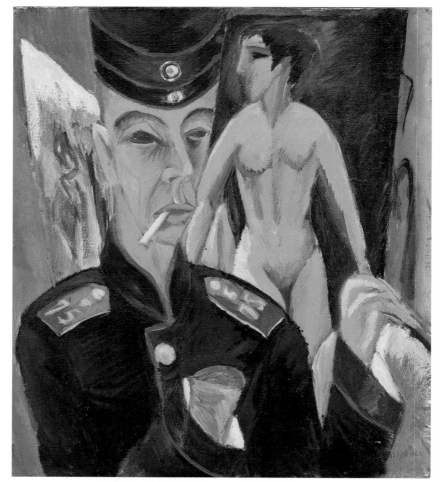

FIGURE 2. ERNST LUDWIG KIRCHNER (GERMAN, 1880–1938).
Self-Portrait as a Soldier, 1915, oil on canvas, 69 x 71 cm (27¼ x 28 in.). Oberlin, Ohio, Allen Memorial Art Museum.

Kirchner argued this belief in several letters. On 24 September 1915, he wrote to Karl Ernst Osthaus from Halle: "It's so awful; I am merely tolerated there, I'm of less use than the worst soldier, whereas here I could do something new. I so yearn to go back to work, it's driving me crazy, especially when, out of sheer exhaustion, I have no control over my body."[22]

The months in the military were more than a period of rebelling against regulations, obedience, subordination, the military in general, or even the war;[23] Kirchner came to recognize his identity as an artist and the role he should play in society in a new way. If this moment in his life can be designated a crisis, then it should be understood as one of nagging insecurity regarding his destination and self-determination. He was longing for self-confidence and was deeply torn about which direction to go: "I am very nervous and dead and have an unbearable pressure on my brain which [leaves] me insecure and broken; [it] is doing its part in making my life a living hell."[24]

It seems that Kirchner's interest in illustrating fictional and religious stories such as Adelbert von Chamisso's *Peter Schlemihls wundersame Geschichte* (1814; Peter

FIGURE 3. ERNST LUDWIG KIRCHNER (GERMAN, 1880–1938). Title page of *Peter Schlemihls wundersame Geschichte,* 1915, color woodcut, 29.3 x 26.3 cm (11⅝ x 10⅜ in.). Essen, Museum Folkwang.

Schlemihl's miraculous story) has to be interpreted in the context of the war.[25] The story of Schlemihl, who makes a pact with the devil and loses his shadow, functions as a metaphor for the artist's instability. It is significant that the artist, on the opening page of the series, includes a self-portrait with a military hat (fig. 3). Furthermore, Schlemihl's outfit in woodcut number five, *Encounter of Schlemihl with the Gray Man on the Road,* resembles the military attire Kirchner wore in Halle. There can be no doubt that the artist identified himself with Schlemihl, as he confirms in a letter to Gustav Schiefler in 1919: "The military uniform comes from the fact that I found myself in a similar mental state during this time. The sale [of the shadow] to the little gray man represents the voluntary engagement for which I carry full responsibility."[26] Kirchner uses the well-known text as a frame and transcends it by giving it the relevance of his own life. In Günter Gercken's convincing interpretation of the story, Kirchner negotiates three existential issues in his life: his position as an artist in society; the sensual-erotic relation to his spouse, Erna Schilling; and his experience of military life.[27]

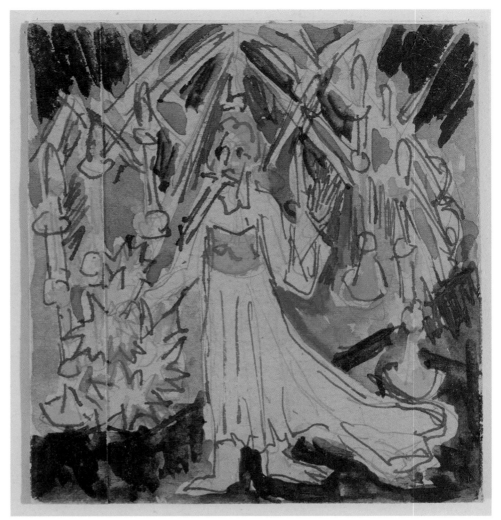

FIGURE 4. ERNST LUDWIG KIRCHNER (GERMAN, 1880–1938). *Saint John's Vision of the Seven Candlesticks,* 1917, pencil and watercolor on cigarette box, 6.6 x 6 cm (2⅝ x 2⅜ in.). From Kirchner's album containing drawings of the Apocalypse. Los Angeles, Getty Research Institute.

At the Bellevue Sanatorium in Kreuzlingen in 1917, Kirchner executed a series of miniature illustrations of the Apocalypse (fig. 4).[28] Even though no written statements explain the artist's interest in the Revelation, it can be assumed that his choice of subject was related to the war, which at this time was entering its most disastrous phase.[29]

Kirchner opens the *Apocalypse* series with a self-portrait with Death, a pairing with a tradition among artists that goes back to the Renaissance and was revived at the end of the nineteenth century. Kirchner certainly knew the respective paintings by Hans Thoma, Arnold Böcklin, and Lovis Corinth.[30] As in *Schlemihl*, the image here establishes a direct relationship between the artist and the story of the Revelation. By illustrating the plagues described in Saint John's book, Kirchner refers to the catastrophic destruction of all civilization around him. But by juxtaposing it with the self-portrait with Death, he couples this more general outlook with his personal "angst."

Kirchner's attitude during the years of World War I was ambivalent. He did not fight in the trenches and never experienced the apocalyptic events of the war, unlike Max Beckmann, who wrote:

> Very peculiar and strange. In all these holes and armed trenches. These eerie corridors and artificial forests and houses. The fatal hissing of projectiles and the bang of artillery. Curiously surreal, moonscape cities were formed. A peculiar sound is created by the disrupted air when the large artillery is fired. Like a pig being slaughtered. Corpses were hauled past us, I drew a Frenchman, who was halfway visible in his grave.... I actually am not very afraid, enveloped by a strangely fatalistic feeling of safety I was able to draw quietly, while not too far away sulfur shells hit, and the toxic yellow and green clouds slowly wafted by.[31]

Many artists and intellectuals considered the war a requisite purgatory for a purified society of the future. They were convinced of the necessity of sacrifice and therefore prepared to address their own death. Full of illusion, Franz Marc wrote from the front to his friend and fellow founder of Der Blaue Reiter, Vassily Kandinsky, about the war, which he understood as a beneficial and necessary process of a European resurrection: "[It] will not set people back" but purge Europe and "prepare it."[32] His longing for a new religious or mystic synthesis of God and the world became evident in his later abstract paintings. However, this mystic approach, deeply inspired by romanticism, represented an understanding of modernity in art contrary to Kirchner's, who encountered a different artistic struggle.

During the war period, Kirchner experienced a time of drastic changes and challenges that are, even though sometimes subtly, reflected in his work. After the parting of Die Brücke in 1913, he had a very active period in Berlin, from which his famous street scenes derived. He also created many landscapes, nudes, and portraits while searching for a consolidation of his personal expression. In addition, Kirchner intensively studied former art historical periods as well as contemporary trends by reading and contemplating numerous art historical volumes. The war disrupted this development. The artist's encounter with the military triggered a deep personal crisis that became visible in a series of portraits and self-portraits, such as *Self-Portrait during Illness* (1917, from sketchbook no. 54, fol. 5, Davos, Kirchner Museum).

However, Kirchner always stayed active and, in fact, was rather successful. He simultaneously showed work in five solo exhibitions and executed major mural decorations in Karlsruhe and Königstein. In the years 1917–18 alone, he earned ten thousand reichsmarks for his art, which made him quite a prosperous artist during a period when most of his colleagues were fighting in the trenches or otherwise incapacitated.[33]

Ernst Ludwig Kirchner's experience with World War I is a distinctive chapter in art history, one in which an artist got involved in the events in a very individual way. Kirchner fought differently than other artist-soldiers. Instead of engaging the enemy in combat on the battlefield, he fought a personal struggle over his artistic identity. He definitely suffered from a lack of stamina that prevented him from enduring the

challenges of the military. However, while battling depression and physical illness, he also discovered that his place as an artist was not at the front. Rather than portraying the human disaster unfolding around him, Kirchner's art turned inward and reflected himself and his position as an artist during a period of crisis, something he considered to be participation in the general cataclysm and equivalent to fighting the enemy with a weapon in the hand.

– NOTES –

1 This attitude was described in the most impressive way by Heinrich Mann in his famous novel *Der Untertan,* written in 1914 but not published until 1918. The novel was translated into English using several titles, such as *The Patrioteer* (1921), *Little Superman* (1945), *Man of Straw* (1947, 1972, 1984), and *Loyal Subject* (1998).

2 The most thorough summary of Kirchner's time in the military can be found in Peter Springer, *Hand and Head: Ernst Ludwig Kirchner's Self-Portrait as Soldier* (Berkeley: University of California Press, 2002), 22–42; see also Roland Scotti, "War, Art and Crisis: Ernst Ludwig Kirchner 1914–1918," in Jill Lloyd et al., eds., *Ernst Ludwig Kirchner, 1880–1938,* exh. cat. (London: Royal Academy of Art, 2003), 27–32; and Javier Arnaldo, "War and Breakdown," in Felix Krämer, ed., *Ernst Ludwig Kirchner Retrospective,* exh. cat. (Ostfildern, Ger.: Hatje Cantz, 2010), 151–55. The author would like to thank Lucius Grisebach, Anja Foerschner, and Rebecca Zamora for their contributions to this essay.

3 Elfriede Dümmler and Hansgeorg Knoblauch, eds., *Ernst Ludwig Kirchner: Briefwechsel mit einem jungen Ehepaar, 1927–1937* (Bern, Ger.: E. W. Kornfeld, 1989), 76. Translation in Scotti, "War, Art and Crisis: Ernst Ludwig Kirchner 1914–1918," 27.

4 See Ernst Ludwig Kirchner to Gustav Schiefler, 28 December 1914, in Wolfgang Henze, ed., *Ernst Ludwig Kirchner–Gustav Schiefler Briefwechsel, 1910–1935/1938* (Stuttgart, Ger.: Belser, 1990), no. 45. It was a German tradition that people volunteering for service were able to choose their military branch.

5 Ernst Ludwig Kirchner to Gustav Schiefler, 27 January 1915, in Henze, *Ernst Ludwig Kirchner–Gustav Schiefler Briefwechsel, 1910–1935/1938,* no. 47. Unless otherwise indicated, all translations are by the author. When evaluating Kirchner's letters, it is always important to take into account the artist's inclination to tailor his opinions according to his correspondent. As Schiefler's son served as an officer, Kirchner usually showed restraint when discussing the war with him.

6 See Henze, *Ernst Ludwig Kirchner–Gustav Schiefler Briefwechsel, 1910–1935/1938,* no. 249.

7 A detailed description of Kirchner's time in Halle is given by Hans Fehr in Roman Norbert Ketterer, *Dialoge* (Stuttgart, Ger.: Belser, 1988), 1:66–73.

8 See Springer, *Hand and Head,* 46.

9 See Springer, *Hand and Head,* 39.

10 See Ketterer, *Dialoge,* 66–67, and Springer, *Hand and Head,* 36–37. Hans Fehr was a Swiss legal historian who taught, among other institutions, at the university in Jena. Kirchner's friendship with him goes back to his time as chair of the local Kunstverein (1908–12).

11 Kirchner's use of drugs and irregular lifestyle date back long before his months in the military, which aggravated his bad physical and mental condition.

12 See Henze, *Ernst Ludwig Kirchner–Gustav Schiefler Briefwechsel, 1910–1935/1938,* nos. 49, 60, 78.

13 Ernst Ludwig Kirchner to Gustav Schiefler, 12 November 1916, in Henze, *Ernst Ludwig Kirchner–Gustav Schiefler Briefwechsel, 1910–1935/1938,* no. 65.

14 Kirchner was not the only artist who faked illness to escape the military. Tristan Tzara and Richard Huelsenbeck are other examples. They, however, were politically engaged antiwar members of the Dada group. The Bellevue Sanatorium, directed at that time by Dr. Ludwig Binswanger, was a rather popular place with artists or writers in political opposition to the government and the general war euphoria. See Hansdieter Erbsmehl, "Der Erste Weltkrieg, Erwartung-Realität-Reaktion," in Patricia Rochard and

Eberhard Roters, eds., *Der Traum von einer neuen Welt, Berlin 1910–1930,* exh. cat. (Mainz, Ger.: von Zabern, 1989), 55–63, 62. In 1921, art historian Aby Warburg was hospitalized to heal from his depression and schizophrenia. See Aby Warburg, *Le rituel du serpent* (Paris: Édition Macula, 2003), 15–18.

 15 Henze, *Ernst Ludwig Kirchner–Gustav Schiefler Briefwechsel, 1910–1935/1938,* no. 70.

 16 Annemarie and Wolf-Dieter Dube, eds., *E. L. Kirchner: Das Graphische Werk,* vol. 2 (Munich: Prestel, 1980), woodcut no. 269.

 17 Donald E. Gordon, *Ernst Ludwig Kirchner, mit einem kritischen Katalog sämtlicher Gemälde* (Munich: Prestel, 1968), nos. 432, 433.

 18 Dube, *E. L. Kirchner: Das Graphische Werk,* lithograph no. 298.

 19 Springer is right in saying: "A careful assessment, in fact, reveals neither criticism nor accusation in this picture." See Springer, *Hand and Head,* 32.

 20 Springer's exhaustive study has revealed the iconographic tradition of this painting and deepened our understanding of the different layers of its interpretation.

 21 Gordon, *Ernst Ludwig Kirchner, mit einem kritischen Katalog sämtlicher Gemälde,* 109; Springer successfully refutes this often-repeated interpretation. See Springer, *Hand and Head,* 36.

 22 See Hans Delfs, ed., *Ernst Ludwig Kirchner: Der gesamte Briefwechsel,* vol. 1 (Zurich: Scheidegger & Spiess, 2010), no. 251. English translation from Springer, *Hand and Head,* 36.

 23 Springer states correctly that Kirchner's "extremely unstable mental state," which was in many ways self-inflicted and led to a serious breakdown in 1916, was not based on Kirchner's "opposition to the military and to the war." See Springer, *Hand and Head,* 40.

 24 Ernst Ludwig Kirchner to Gustav Schiefler, 28 March 1916, in Delfs, *Ernst Ludwig Kirchner: Der gesamte Briefwechsel,* no. 52. Translation in Springer, *Hand and Head,* 41.

 25 It is interesting to note that Chamisso (1781–1838), when writing *Schlemihl,* was in a situation not unlike Kirchner's. Born a Frenchman but residing in Germany, Chamisso was not able to participate in the Prussian war of liberation against Napoleon but witnessed it from home. The English translation, *Peter Schlemihl,* was first published in 1823.

 26 Henze, *Ernst Ludwig Kirchner–Gustav Schiefler Briefwechsel, 1910–1935/1938,* 121.

 27 See Günther Gercken, *Ernst Ludwig Kirchner, Holzschnittzyklen: Peter Schlemihl, Triumph der Liebe, Absalom* (Stuttgart, Ger.: Belser, 1980), 13–14; see also Springer, *Hand and Head,* 49–56.

 28 See Ernst Ludwig Kirchner, "Album with Drawings of the Apocalypse" (1917), Ernst Ludwig Kirchner Letters and Papers, 1905–45, ID no. 850463, box 2, Research Library, Getty Research Institute, Los Angeles. A digital facsimile of the complete album, including the versos of the cigarette-pack supports for the tipped-in drawings, can be accessed via the Getty Research Institute's digital collections. For an in-depth study, see Thomas W. Gaehtgens and Anja Foerschner, "Ernst Ludwig Kirchner's Drawings of the Apocalypse," *Getty Research Journal,* no. 6 (2014): 83–102.

 29 Kirchner had planned on creating a series of related woodcuts, of which only two were realized in 1918. In 1935, his interest in the topic was sparked again as he prepared for the design of a mural at a chapel in Davos-Frauenkirch that was never realized. See Gaehtgens and Foerschner, "Ernst Ludwig Kirchner's Drawings of the Apocalypse," 84, 99.

 30 In 1872, Arnold Böcklin painted his famous *Self-Portrait with Death Playing the Fiddle* (Berlin, Nationalgalerie). Three years later, Hans Thoma followed with his *Self-Portrait with Amor and Death* (Karlsruhe, Staatliche Kunsthalle). And, in 1896, Lovis Corinth painted *Self-Portrait with Skeleton* (Munich, Staatliche Galerie im Lenbachhaus).

 31 Klaus Gallwitz, Uwe M. Schneede, and Stephan von Wiese, eds., *Max Beckmann, Briefe, 1899–1925* (Munich: Piper, 1993), 1:124–25.

 32 Klaus Lankheit, ed., *Wassily Kandinsky, Franz Marc, Briefwechsel* (Munich: Piper, 1983), 263.

 33 See Scotti, "War, Art and Crisis: Ernst Ludwig Kirchner 1914–1918," 28n8. During and right after the First World War, the currency changed a number of times in the German Reich. Although the reichsmark did not become the official currency until 1924, it was used by Scotti and other historians to indicate a uniform currency for the German Reich during the war years.

LOOKING BACK ON HIS WARTIME EXPERIENCE FROM THE MIDST OF ANOTHER WORLD WAR, Max Ernst (1891–1976) laconically noted: "Max Ernst died on the 1st of August 1914."[1] Ernst "resuscitated" on the eleventh of November 1918, the day the Allied powers signed a ceasefire agreement with Germany at Rethondes, France. The war, said Ernst, was a "big beastly trashy affair," to which any mode of response seemed inadequate or worse. "What can he do against military life — its stupidity, its hideousness, its cruelty? Screaming, swearing, vomiting with rage doesn't accomplish anything."[2] Indeed, there is a striking lack of rage in Ernst's pictorial response to the war. The main body of work produced in the immediate aftermath of the war — an extraordinary sequence of diagram works, overpaintings, and assemblages — is characterized by an eroded, broken, rigidified, and fossilized imagery, a doing to death of both illusion and imitation.[3] When Ernst revived in 1918 "to find the myth of his time,"[4] he was not (or not simply) seeking the archetype for his age but actively destroying the mythology of the present. Ernst declared his war against the very avant-garde that gave the state ideological support. Among those who were found most guilty of aesthetic propaganda was Ernst himself, and he felt compelled to turn his pictorial arsenal against his wartime self.

Killing "Max Ernst"

TODD CRONAN

Germany declared war on Russia on the first of August, and on France by the third; and with the German invasion of Belgium on the fourth, the United Kingdom declared war on Germany. Ernst and his brother Karl were mobilized in the third week of August, entering into the Twenty-Third Artillery Regiment of the Rhine. Ernst was at the western front as early as the fall of 1914.[5] By midsummer 1915, he was stationed as an artilleryman near Laon, France, where — so the story goes — Lieutenant Wohlthat recognized Ernst and his work from an exhibition at the Alfred Flechtheim gallery in Düsseldorf and reassigned the artist to a staff position.[6]

As a result of his newly secure position, Ernst was able to produce an astonishingly profuse amount of work during the war. Ernst assembled fifty works for a two-person exhibition at Der Sturm gallery in Berlin in January 1916; it was the largest display of his work to this point. Among the works exhibited were nineteen paintings (four on glass) and thirty-one drawings. While it is difficult to identify most of the works listed in the catalog, one can get a vivid sense of his visual language with paintings such as *Flowers and Fish, Vegetation, Towers,* and *Laon,* all of 1916. *Towers* (fig. 1) and *Laon* express a peculiar convergence of his experience on the western front with his expressionist models, one of which was certainly Robert Delaunay's *Towers of Laon* of 1912. Well before his encounter with Giorgio de Chirico's haunted pictorial architecture in the summer of 1919, Ernst was focused on crystalline architectural scenes. Divided into three vertical zones of brown, green, and red, *Towers* is organized around a triangular structure seemingly made of brick and stone. While the central

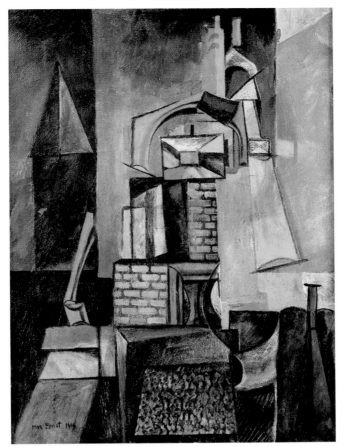

FIGURE 1. MAX ERNST (GERMAN, 1891–1976). *Towers*, 1916, oil on canvas, 60 x 43 cm (23⅝ x 17 in.). Edinburgh, Scottish National Gallery of Modern Art.

view indicates the tower's elevation, several elements, such as the thatched form at the bottom and the rectangle near the top of the structure, appear to be a top-down or aerial view onto the structure. The high-keyed oranges and reds at right suggest the form might be ablaze and that the view into the brick layers of the structure is a result of the searing heat.

The crystalline aesthetic of Ernst's wartime period resembles the work of a range of his expressionist colleagues, including Marc Chagall, Vassily Kandinsky, August Macke, and Franz Marc. There is every sense that Ernst fully embraced the expressionist ethos of the moment, an ethos predicated on the formative power of subjectivity. In addition to his pictorial output, Ernst published a series of ambitious and ideologically charged articles during the war in the *Kölner Tagblatt,* including, in 1917, "Vergleichung" (Comparison) and "Vom Werden der Farbe" (On the origins of color). The theme of these essays is the priority of "will" as the means to "pure world formation." "The 'I' assertion of the will—its germination into form [*Form-werdung*]—is the origin of freedom and is thus the artist's mission," he wrote in "Vom Werden der Farbe."[7] In "Vergleichung," he contrasted cubism, futurism, and expressionism—with them "the world has become more beautiful, stronger-willed:

the spirit of our will"—with impressionism. Impressionism, its French origins being essential here, was the epitome of a feminized, passive will-lessness, "spread wide to conceive at any moment."[8] "Impressionism did not yet know the voluptuousness of forming. For it, forming would appear to be interpretation, myth, metaphysics." Impressionism lacked the strength that comes with the "masculine spirit" of the northern mythic imagination: "Impressionism feared everything clear, intrinsic, and strong-willed as it would its own death."[9] It was this vision of the artist struggling to express a mythic ideal that Dada Ernst would target for destruction; it was the "myth of his time" that became his subject.

Ernst's postwar "resuscitation" seemingly coincides with joining Karl Nierendorf's Gesellschaft der Künste (Society of arts) just after its foundation in November 1918. Ernst immediately began contributing to the Gesellschaft journal and exhibiting works at the associated Sturm gallery. The Gesellschaft was a branch of Berlin's Arbeitsrat für Kunst (Workers council for art), whose program, written by architect Bruno Taut, appeared at Christmas 1918. Taut's program summed up a basic cultural attitude that survived the wartime period and was seemingly unaffected by it. Or rather, the wartime period exacerbated the expressionist utopia of political-artistic unity:

> From now on the artist, as shaper of the sensibilities of the people, is alone responsible for the external appearance of the new nation. He must determine the boundaries of form from statuary down to coins and stamps.... The disrupted tendencies can achieve a unity only under the auspices of a new art of building, in such a way that each separate discipline will contribute to it. At that point there will be no boundaries between the crafts, sculpture, and painting, all will be one: Architecture.
>
> A building is the direct carrier of spiritual values, shaper of the sensibilities of the general public which slumbers today but will awake tomorrow. Only a total revolution in the realm of the spiritual can create this building; yet this revolution, this building, does not happen by itself. Both have to be sought—today's architects must prepare the way for this edifice.[10]

Despite the obvious differences between Taut's (fantasized) architecture and Ernst's pictorial architecture, there is utter consensus about the formative power of the artist to "shape the slumbering sensibilities of the people." Taut's vision of the unity of the *Volk* through unity of the arts was of course at the center of Bauhaus aesthetics. At this same moment, Walter Gropius was calling on the architect to be the "leader of art. Only he is able to raise himself up...to be art's superhuman guardian and organizer of its undivided totality."[11] Throughout the war, Ernst embraced the collective avant-garde vision of the artist as the dictator of "pure world formation," but unlike his colleagues, he turned around and ferociously attacked this vision at the moment of its deepest consolidation.

Ernst took direct aim at Taut and the "activist" ethos associated with Taut's teacher Kurt Hiller in *Die Schammade* of 1920. Ernst's "Lucrative History-Writing" opens ominously with "prole to the right prole to the left rubin in the middle" ("rubin"

was a loosely coded anti-Semitic slur against the Jewish Hiller).[12] Hiller was associated with the Linkspazifismus (Leftist Pacifism) campaign calling for a refusal to fight in wars between capitalist states, and, in 1914, he organized the movement for "literary activism." Iain Boyd Whyte defines Taut and Hiller's activism as "elevating psychological revolt to the level of practical and social reform."[13] But it would be more correct to say the activists elevated psychological revolt through privileged media (the stained glass of the cathedral, above all) *against* practical reform. According to the activists, art *replaces* any form of practical politics: "social welfare organizations, hospitals, inventions, or technical innovations and improvements — these will not *bring new culture* — but glass architecture will."[14] Of course, Ernst's wartime crystalline aesthetic, some of it executed on glass, embraced this vision of art as salvation. It was this ideal that became the critical thematic of his rigidified aesthetics of the Dada diagrams, overpaintings, and assemblages.[15]

Compare, for instance, Ernst's now-lost *Architecture* assemblage (fig. 2) of early fall 1919 with the wartime *Towers*. *Architecture* appeared in the *Bulletin D* catalog produced as a counter to the ideals of the concurrent exhibition by the Gesellschaft der Künste at the Cologne Kunstverein in November 1919. From evidence of a related work, Ernst's extraordinary *Fruit of a Long Experience* (fig. 3), we know that the *Architecture* relief was constructed of wire, lumber, and milled wood elements including blocks, rods, spools, and dislocated parts of practical devices. These wood marks were then nailed and screwed together and put into dialogue with more conventional painterly elements. *Architecture* consists of three vertically oriented elements: an indented steplike object along the left edge, internally framed along its left side by a thin piece of wood; an upright form composed of tubelike elements, the whole of which seems to balance on a small piece of shaped wood that is likely inserted into the inner frame at left; and a larger rectangular shape at right, whose upper form is pierced by two tubular parts and whose upper section takes the form of a column with capitols at top and bottom. Body and architectural form are collapsed into one as the shapes denote both architectural and human members. The tubular body-architecture imagery recurs in Ernst's *Fruit of a Long Experience,* which plays a variation on the forms in *Architecture.* Here the bodily dimension of *Architecture* is made explicit with the phallic form at left, which points in the direction of the hovering reversed-L form at right. The plus and minus signs near the bottom on the right further express the male-female polarity. The cut into the board at the lower left suggests that the sexual architecture awaits an insertion before it begins to move, while the lightly inscribed undulating lines just above indicate the "oil" that potentially facilitates the movement. Ludger Derenthal provides a reading of the work that draws an analogy between the broken cylinders and "broken canons," which further opens interpretation beyond the architectural body to the destroyed architecture and bodies of the war.[16] Indeed, Ernst's suggestive title provides another layer of meaning. In this instance, the "fruit" of the title could indicate the child born of the architectural machines, but it also suggests that the war has altered, desiccated the forms of "long experience" that existed before the war. The German ideal of the bildungsroman is one that embodies a full range of lived experience, from birth to family to death. With *Fruit of a Long Experience,* Ernst is interrogating the (bourgeois) ideal that "long experience" can (and should) bear fruit

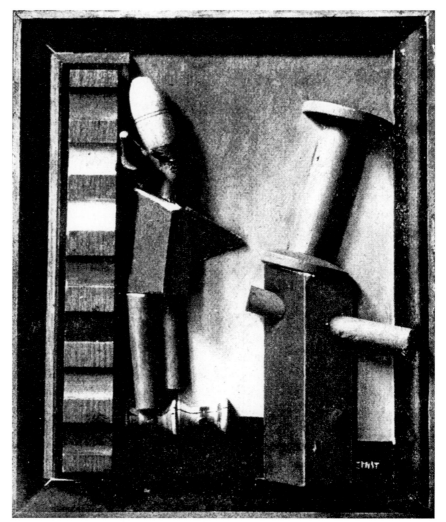

FIGURE 2. MAX ERNST (GERMAN, 1891–1976). *Architecture,* 1919,
relief with wood found objects, dimensions unknown. Location unknown.

in the form of a well-rounded aesthetic-human whole. The fruit born of the wartime experiences does not appear edible. One need only compare the 1919 version of *Fruit of a Long Experience* with its prewar version, *Fruit d'une longue expérience* of 1913 (fig. 4). Like *Towers, Fruit* is a tightly organized cubist-expressionist construction. A series of vertical elements contrast with triangular forms and diagonal lines at top, at the lower left and right, a circular collaged form to the right of center, and a half-moon shape at upper right. The whole suggests a kind of cityscape elevation with interlocking architectural forms without a trace of the bodily or sexual dynamic at the center of his postwar work. The "fruit" of "experience" in the 1913 work is a symbol of the artist's mastery of a cubist vocabulary and perhaps of the control society has managed to exert over the natural environment — both themes fodder for Dada contempt.

Johannes Baargeld provides a perverse commentary on the tubular forms in *Architecture* and the 1919 *Fruit of a Long Experience* in his "Tubular Settlement or

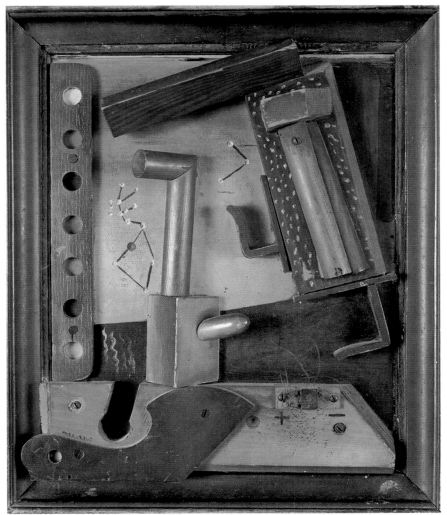

FIGURE 3. MAX ERNST (GERMAN, 1891–1976). *Fruit of a Long Experience,* 1919,
relief with wood and metal wire, painted, 45.7 x 38 cm (18 x 15 in.). Geneva, private collection.

Gothic" published in *Die Schammade* in 1920. Baargeld pokes fun at the phony decla-
rations of the Wilhelm Worringer–inspired expressionists who dwell in "smokeless
solemnity" and whose "empathy with communal Gothic" resulted in the "disman-
tling of marriage." This is not a holy loss of difference—not a loss of individuated
selves—but rather the further ramification of difference in the "nationalization of
one's wife."[17] Ernst's tubular architectural bodies were parodic images of Gothic
structural members that transmitted curative powers to the inhabitants and to
those beneath the "city crown" who bathed in its auratic splendor. "Tubular archi-
tecture must be on and in the tubes," Baargeld continues. "Standing tubes. Gothic is
the grimacing exhibitionism of concrete eggs. A Gothic artist is a suicide in sexual
disguise."[18] Baargeld's critical identification of Gothicism and sex, architecture and
salvation exemplifies the thematic concerns of Ernst's postwar project and Cologne
Dada more generally.

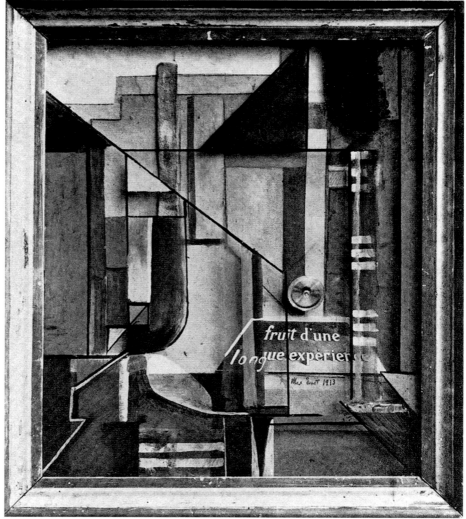

FIGURE 4. MAX ERNST (GERMAN, 1891–1976). *Fruit d'une longue expérience*, 1913, collage and oil on cardboard, dimensions unknown. Location unknown.

For Baargeld and Ernst, the aesthetic-political framework for the war was a vision of German nationalism defined by a psychologically formative account of the Gothic. The vision of Germany as the site of the Gothic weltanschauung was most famously formulated by Worringer in his *Formprobleme der Gotik* (Form in Gothic) of 1911, a book that later galvanized members of the Arbeitsrat and the Bauhaus. Ernst first met Worringer in March 1914, when Worringer delivered a lecture at the Cologne Kunstverein. (The Worringer family was, in fact, a cultural presence in Cologne; Worringer's mother ran a well-known restaurant in the zoological gardens.) As Magdalena Bushart shows, Worringer's influence was utterly ubiquitous within avant-garde circles in the period between 1911 and 1918.[19] The effect of *Formprobleme* was immediate. Gropius began to describe the industrial architecture he was involved with as *Kathedrale* as early as 1911, and in 1916, in his draft recommendations for a school of

the arts in Weimar, he characterized his ideal work as the construction of "medieval 'loges,' where numerous related artist-craftsmen . . . came together in a homogenous spirit and humbly contributed their independent work to common tasks resting upon them." "This was done," Gropius concludes, "out of respect for the unity of idea which inspired them and the meaning of which they understood."[20] Worringer's defining ideas can even be seen in the writings of Ernst's lifelong friend and collaborator Hans Arp (Ernst and Arp met in the spring of 1914 at an exhibition of Parisian art). "The works presented here are *Bauten* of lines, planes, forms, colors," Arp writes in a 1915 catalog introduction to a group exhibition. "They seek to approach the ineffable truth concerning mankind and the eternal." Arp goes on to reject the "egotistical" illusionism of Greek art and the Renaissance. Like Worringer, Arp positions abstraction against illusionism, and praises the "anonymity" and "shared reality" "most recently [practiced] during the Gothic Age."[21] If this was Arp in 1915, Baargeld described a bewildering change of heart by 1920: "[A]rp claims to have reached the conclusion that Gothic is an erective vomitation resulting from rotten teeth, and is traveling to a drainage outlet with the help of the tubular system."[22]

Anti-Gothicism was the defining trait of Cologne Dada. In the same issue of *Die Schammade,* Ernst published his scathing "Worringer, Profetor Dadaisticus," in which the scholar hears the "new deep-drinking society" from atop his "invisible cathedral for intellectuals and private prophets."[23] "Today red," Ernst declares, "tomorrow gothic mimmi. kri." The latter suggests both mimicry and the anticipated cry of the decaying Gothic. The piece ends "kille killi" and "picastrate Eum!," suggesting castration and the identification of contemporary cubism with the decadence of the Gothic ideal.[24]

Ernst further interrogates the Gothic ideal of aestheticized politics in "Lucrative History-Writing" under the heading "Salvation of the Correct Effect of Pictures." Salvation *through* pictorial effect.[25] The salvation ideal, penned by Paul Scheerbart in polemical aphorisms on the virtues of glass, was inscribed along the stringcourse of Taut's *Glass Pavilion* of 1914 at the Cologne Werkbund exhibition (where Ernst could directly encounter it) with the idea that "colored glass destroys hatred." It naturally followed that media could produce degenerative effects as well; thus, in Taut's words (again borrowed from Scheerbart), "Building in brick only does harm."[26] Ernst expressed similarly redemptive sentiments associated with materials in "On the Origins of Color" as well as a prewar text, "Art and Ability," in which he described the great artist as one with an innate "sensibility for the inherent life of lines and colors. . . . To an artist the most mundane and the most uncommon things can be an experience — a harmony of colors, an interweaving of lines."[27]

Within months of the Arbeitsrat call for the unity of the arts under the dictatorship of the artist that Ernst declared that his art, which he now called Dada, had "nothing in common with the Society of Arts."[28] In November 1919, Ernst was invited to participate in the Gesellschaft der Künste exhibition at the Kunstverein, and it was there that he and Baargeld organized a separate room within the shared exhibition space called Section D and issued their scathing *Bulletin D.* The two set themselves in direct confrontation with the Arbeitsrat mission, Baargeld declared, "There is no 'activist' art. The artist is part of the life he destroys."[29] It was the crucial

period between joining the Gesellschaft and his refusal of its aims that marked the turning point in Ernst's career and defined his basic outlook from this period forward; it was also the moment when he came to terms with his own involvement with wartime expressionism.

Ernst's attack on the expressionist vision of dictatorial unity emerges fully formed with the appearance of *Der Ventilator* in February 1919. Producing five issues over the spring, *Der Ventilator* was dedicated to a refusal of the politics of unity spelled out by the expressionists, which fed the aesthetic politics of the war. From the beginning, *Der Ventilator* parodied the sacrificial *Gemeinschaft* (community) ideal of the expressionists: "I feel the forceps birth of my spirit from the all-encompassing community of your *naked soul:* SHEER LIFE! What else counts, the *incidental* (incl. life), and how wonderful it would be to sacrifice oneself to it. In the roiling mud of the Nile swamps is a modicum of me. In the youngest germ-cell of every young everyday, wherein history smarts, which we cannot outsmart."[30] The authors deride the anti-human utopia of the movement of *Geist* (spirit): "Above all, you will alleviate matters by taking an epoch seriously *without* its human beings, whereby you tremendously obligate *others* while relieving yourselves of the same."[31] Ernst is parodying the attitudes of the activists who insisted that the great work of building glass cathedrals would require all the efforts of humanity, up to the limit of their capacities. The task of constructing an alpine cathedral would be "full of sacrifice," Taut explained.[32] "The Impossible is so seldom required of Man," he cites Goethe as saying and boasts how the "costs will be colossal, and what sacrifices!" Ernst described his own wartime practice in exactly the terms being attacked: at that time, "spontaneity was *de rigueur*. . . . We were united by a thirst for life, poetry, liberty, the absolute knowledge."[33] Ernst's Dada was defined by a response to Ernst's own involvement in the aesthetic politics of "spontaneity" that provided the crucial ideological support for the war. There was no space apart from the war from which to interrogate it, so it was that the "artist is part of the life he destroys." The battle had to be waged against himself, in the hope that killing "Max Ernst" would mean saving himself and his art.

— NOTES —

1 Max Ernst, "Some Data on the Youth of M.E. as Told by Himself," in *Beyond Painting* (New York: Wittenborn, 1948), 29.

2 Max Ernst, *Écritures* (Paris: Gallimard, 1970), 25; my translation.

3 I am relying here on the brilliant analyses of Ernst's Dada work by Ralph Ubl in *Prehistoric Future: Max Ernst and the Return of Painting between the Wars,* trans. Elizabeth Tucker (Chicago: University of Chicago Press, 2013).

4 Ernst, "Some Data on the Youth of M.E.," 29.

5 There is some dispute as to when Ernst completed his basic training and moved to the front. William Camfield claims that Ernst arrived at the front sometime in the spring of 1915, while Johann Heusinger von Waldegg suggests he had moved to the front by the summer of 1914. See William Camfield, *Max Ernst: Dada and the Dawn of Surrealism* (Munich: Prestel, 1998), 50; and Johann Heusinger von Waldegg, "Max Ernst und die rheinische Kunstszene, 1909–1919," in Wulf Herzogenrath, ed., *Max Ernst in Köln: Die rheinische Kunstszene bis 1922* (Cologne: Rheinland, 1980), 99.

6 After his short reassignment, Ernst was redeployed to Soissons, France, for the remainder of the war.

7 Max Ernst, "Vom Werden der Farbe," in Herzogenrath, *Max Ernst in Köln,* 75; my translation.

8 Max Ernst, "Vergleichung," in Herzogenrath, *Max Ernst in Köln,* 87; my translation.

9 Ernst, "Vergleichung," in Herzogenrath, *Max Ernst in Köln,* 87.

10 Bruno Taut, "Arbeitsrat für Kunst Program," in Rose-Carol Washton Long, ed., *German Expressionism: Documents from the End of the Wilhelmine Empire to the Rise of National Socialism,* trans. Nancy Roth (New York: G. K. Hall, 1993), 193–95.

11 Gropius, "Architecture in a Free Republic," in Long, *German Expressionism,* 199.

12 Max Ernst, "Lucrative History-Writing," trans. Gabriele Bennett, in Lucy R. Lippard, ed., *Dadas on Art* (Englewood Cliffs, N.J.: Prentice-Hall, 1971), 126–27.

13 Iain Boyd-Whyte, *Bruno Taut and the Architecture of Activism* (Cambridge: Cambridge University Press, 1982).

14 Adolph Behne, "Glass Architecture," in Ulrich Conrads and Hans G. Sperlich, eds., *Architecture of Fantasy: Utopian Building and Planning in Modern Times,* trans. C. C. Collins and George R. Collins (New York: Praeger, 1962), 132.

15 I am further following Ralph Ubl here, when he writes that "the Dadaist war pictures parody the crystalline freedom of the heavens and the maternal uncanniness of the earth" and thus served as "instruments with which Ernst dissected and amputated his own war expressionism." Ubl, *Prehistoric Future,* 154.

16 Ludger Derenthal, "Max Ernst: Trois tableaux d'amitié," *Les cahiers du Musée national d'art moderne* (1990): 81.

17 Johannes Baargeld, "Tubular Settlement or Gothic," trans. Jane Ennis in Dawn Ades, ed., *The Dada Reader: A Critical Anthology* (Chicago: University of Chicago Press, 2006), 236. (Translation modified.)

18 Baargeld, "Tubular Settlement or Gothic," 237.

19 Magdalena Bushart, *Der Geist der Gotik und die expressionistische Kunst: Kunstgeschichte und Kunsttheorie 1911–1925* (Munich: Schreiber, 1990).

20 Walter Gropius, "Recommendations for the Founding of an Educational Institution as an Artistic Counseling Service for Industry, the Trades and the Crafts," in Hans M. Wingler, ed., *The Bauhaus: Weimar, Dessau, Berlin, Chicago,* trans. Wolfgang Jabs and Basil Gilbert (Cambridge, Mass.: MIT Press, 1978), 23–24.

21 Hans Arp, "Introduction to a Catalogue," trans. Nicholas Walker, in Charles Harrison and Paul Wood, eds., *Art in Theory, 1900–2000* (Malden, Mass.: Blackwell, 2003), 276–77.

22 Baargeld, "Tubular Settlement or Gothic," 237.

23 Max Ernst, "Worringer, Profetor Dadaisticus," in Ades, *The Dada Reader,* 241.

24 Ernst, "Worringer, Profetor Dadaisticus," 241. Gabriele Bennett notes that "kille, killi" means something like "kitchy, kitchy koo" (Lucy R. Lippard, ed., *Dadas on Art* [Englewood Cliffs, N.J.: Prentice-Hall, 1971], 126).

25 Eric Michaud brilliantly analyzes the modernist vision of salvation through form and medium in *La fin du salut par l'image* (Nîmes, Fr.: Jacqueline Chambon, 1992).

26 Paul Scheerbart and Bruno Taut, *Glass Architecture and Alpine Architecture,* ed. Dennis Sharp, trans. James Palmes and Shirley Palmer (New York: Praeger, 1972), 14.

27 Ernst, quoted in Camfield, *Max Ernst,* 37.

28 Camfield, *Max Ernst,* 58.

29 Johannes Baargeld, "Bulletin D," in Lippard, *Dadas on Art,* 133.

30 "???Macchab in Cöln???" in Werner Spies, *Max Ernst Collages: The Invention of the Surrealist Universe,* trans. John William Gabriel (London: Thames & Hudson, 1991), 281. Baargeld similarly took up the cudgel against the activist fetishism for "life": "The old conceals itself and calls itself 'Simply Life.' . . . 'Simply Life' is there to feed the new." Baargeld, "Bulletin D," in Lippard, *Dadas on Art,* 134.

31 "Macchab 'intime,'" in Spies, *Max Ernst Collages,* 281.

32 Scheerbart and Taut, *Glass Architecture and Alpine Architecture,* 123.

33 Ernst quoted in Camfield, *Max Ernst,* 37.

I am infinitely lonely, that is, am alone with my doppelgängers, phantom figures, in which I can make certain dreams, ideas, tendencies, etc., come true. . . . I even believe in these imaginary pseudonyms.

— George Grosz[1]

George Grosz and World War I

TIMOTHY O. BENSON

LEFT-LEANING PUBLISHER AND WRITER WIELAND HERZFELDE RECALLED ENCOUNTERING GEORGE GROSZ (1893–1959) at Berlin's venerable Café des Westens; he was seated "at a small table with a round marble top . . . [Grosz was] powdered chalk white, his lips painted red, in a chocolate brown suit, holding between his knees extended, a slender black cane the knob of which was in ivory skull."[2] Herzfelde realized in an instant that he had met this seemingly aloof character not long before in Ludwig Meidner's garret studio, a gathering point de rigueur for meeting Berlin's bohemia. It was here that Grosz, again impeccably attired, had masqueraded an entire evening as an enthusiastic yet coldly calculating war profiteer from neutral Holland who saw in Germany's burgeoning population of disabled and often-neglected war veterans an opportunity for cheap labor in the manufacture of paperweights and ashtrays from shrapnel, an idea that left the writers and artists present aghast — except of course, the knowing Meidner, who feigned humility and tolerance while introducing the philosophy of Tolstoy to spur the conversation to new heights.[3]

Whether retrospectively embellished or based on Grosz's masquerade self-portraits (such as *The Lovesick,* 1916, Düsseldorf, Kunstsammlung Nordrhein-Westfalen), the deeply sarcastic image relayed by Herzfelde of Grosz the depraved dandy conveys the troubled state of the artist after his first experience of military service. It shows not only how Grosz was as deeply affected by World War I as any of his colleagues — even if, unlike Otto Dix or Fernand Léger, he never saw action — but also how he embodied the wrenching psychological dilemma of his generation. Were there any viable alternatives to the extreme isolation of the individual, any productive communal enterprises that could contravene the collective insanity of war? By his actions, Grosz seemed to be as skeptical of the avant-garde as he was loathing of the military.

Though opposed to the war, Grosz had volunteered for the Royal Prussian Kaiser Franz Garde Grenadier, Regiment No. 2, at recruitment Depot 1, Berlin, on 13 November 1914, simply to have some control over where he would be deployed. On his way to the front, he was admitted to a military hospital with a high fever and underwent a medical operation for suppurative frontal sinusitis; he was released on 11 May as unfit for service. Yet even en route to the battlefields, he made drawings

portraying battle scenes, many littered with corpses, in his sketchbook titled "The Medical Journal of Dr. William King Thomas USA Oct. 15 to 15 Nov. 15";[4] his pseudonym was the name of a notorious criminal who had blown up a ship in Bremen to collect the insurance money.[5] Grosz was unable to escape being confronted with the casualties of war because the Unterrichtsanstalt (Teaching Institute of the Berlin Arts and Crafts Museum), where he was studying, had been partially converted to a military hospital in August 1914.[6]

Grosz's first brush with the military may have recalled some of his earlier encounters with authority, beginning with his expulsion for disobedience from the Oberrealschule he attended in the provincial town of Stolp, Pomerania (now Słupsk, Poland). Adept at sketching scenes from adventure, crime, and horror stories encountered in penny dreadfuls and satirical magazines such as *Fliegende Blätter,* he soon excelled at the Akademie der Bildenden Künste in Dresden. With an honorary diploma, he entered the Kunstgewerbeschule in Berlin in January 1912 on a state scholarship, and, by the summer, he was studying at the Unterrichtsanstalt with artist Emil Orlik. Support from the Adolf and Julius Lesser Foundation allowed Grosz to spend several months in 1913 at the Académie Colarossi in Paris, where he learned to sketch briefly posed nudes in a style still informed by Albrecht Dürer

FIGURE 1. GEORGE GROSZ (GERMAN, 1893–1959). *Untitled (Sitting Female Nude, [Dolly Wibach]),* 1915, reed pen and pen and ink on laid paper, 22.4 x 28.4 cm (8⅛ x 11¼ in.).

and Michelangelo (fig. 1).[7] The Unterrichtsanstalt brought Grosz the opportunity to mature as an artist and to form lasting relationships, both personal and artistic. Eva Peter, who was often photographed playacting with Grosz in his studio, would become his wife. And Peter's sister Lotte would marry Grosz's classmate and future Dada colleague Otto Schmalhausen, a well-dressed graphic artist born to a German merchant family living in Antwerp and a likely inspiration for Grosz's "merchant from Holland" persona described by Herzfelde above.[8]

Grosz's associates quickly found their way into his drawings, lithographs, and books. In *Ecce Homo* (1923), Peter appears in the guise of a prostitute (fig. 2); and in *Good Old Student Days* (1922; *O alte Burschenherrlichkeit*), the bespectacled Schmalhausen carouses with Orlik, himself a reputed dandy, and poet Theodor Däubler. Orlik the dandy appeared at the annual costume balls held at the Unterrichtsanstalt; in 1913, the dandy and the hussar were popular personas when Grosz appeared as an officer.[9] But Grosz's favorite personas derived from his cult of America; they dated from his childhood, when he read James Fenimore Cooper's *Leatherstocking Tales* (1823–41) and the works of Karl May (whom he also visited).[10] His antics during the teens were just another transformation of this obsession and included being photographed as a gangster, cowboy, trapper, and boxer in his studio full of American advertisements and the sounds of American jazz.[11] Grosz, Herzfelde, and Herzfelde's brother Helmut (who, like Grosz, Anglicized—or even Americanized—his name, to John Heartfield in 1916) were photographed in Wannsee in the guises of Daniel Defoe's Robinson Crusoe or Karl May's Old Shatterhand.[12]

Grosz's *Amerikanismus* helped drive his artistic achievement to new heights, as evidenced by the *First George Grosz Portfolio* (1916–17), which featured a combined New York–Chicago metropolis in *Memory of New York* and a frontier setting in *Texas Picture for My Friend Chingachgook*, an homage to Cooper's Indian chief from *The Leatherstocking Tales*. For Grosz (and his later Dada colleagues Otto Dix and Rudolf Schlichter), the mythology of America offered an alternative to the stifling cultural bureaucracy of Wilhelm II and to the refined "primitivism" of the expressionists of Die Brücke showing in the Sturm gallery in Berlin. While Grosz's images in the *First George Grosz Portfolio* retain a nearly magical charm, violent episodes are glanced through windows or in the background. Grosz dwells more intensely on the bestial nature of man in the *Little Grosz Portfolio* (fig. 3). Ordinary citizens become predators stalking one another in order to survive in the tumultuous and fragmentary urban jungle they inhabit. Murderers, prostitutes, and connivers of various sorts who prey on their victims personify the dehumanizing consequences of raw instinct. Yet while Grosz offers no solutions to the ills of his starkly sinister world, he allows us glimpses of enchanting cityscapes intended, perhaps, as consolation for his hapless victims. But by the time these images were published in 1917, Grosz had already been drafted again (on 4 January), and his pessimism was about to profoundly deepen.

Grosz's assignment in the Landsturm Infantry Batallion Guben III/10 was to train recruits to watch over and help transport prisoners. However, on his first night of reenlistment, he had a psychotic incident and was sent to the Guben military hospital, where he apparently got into an altercation with a hospital sergeant and other patients.[13] In February, he was transferred to the Görden insane asylum

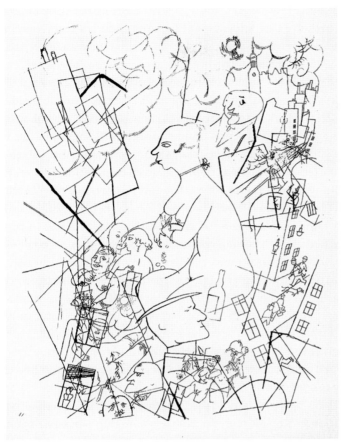

FIGURE 2. GEORGE GROSZ (GERMAN, 1893–1959). *Eva*,
1918, offset lithograph on wove paper, image: 27.5 x 20.7 cm (10⅞ x 8¼ in.).
From George Grosz, *Ecce Homo*, edition C (Berlin: Malik, 1922–23).

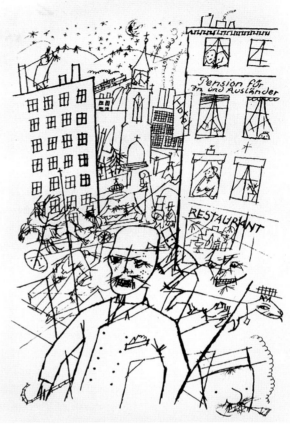

FIGURE 3. GEORGE GROSZ (GERMAN, 1893–1959).
Street, 1915–16, transfer lithograph on japan paper, 23.9 x 15.8 cm
(9½ x 6¼ in.), irregular. From *Little Grosz Portfolio*
(*Kleine Grosz Mappe*), 1915–16, plate 2.

in Brandenburg an der Havel. Writing to Schmalhausen, he proclaimed, "My nerves gave away again near the front, this time before I got within sight of rotting corpses and barbed wire.... My nerves...each little fiber signals abhorrence and revulsion.... Total incapacity for action, despite all the official regulations in the world."[14] After testing, Grosz was deemed unfit for service based on the diagnosis of sexologist Magnus Hirschfield, and possibly because his scribbled drawings of the *First George Grosz Portfolio* appeared to the authorities as evidence of insanity;[15] he was released on 27 April.

Grosz now began to see success with a series of futurist-inspired turbulent paintings, some filled with riotous figures and explosions. Already the subject of an enthusiastic article by Theodor Däubler in 1916,[16] his exhibition in August 1918 at the Neue Kunst Hans Goltz gallery in Munich secured him a contract with the gallery.[17] He was also hired with Heartfield to make a propaganda film titled *Sammy in*

Europe—a project engineered by longtime patron and collector of modern art Harry Graf Kessler.[18] Kessler had been impressed by the contradictions in Grosz, the brutality of his nudes, and his refusal "to be abstract, to ignore reality.... I think Grosz has something demonic in him."[19] With Herzfelde and others, Grosz represented to Kessler "big-city art...brutally realistic, and at the same time fairytale like."[20] Herzfelde had also rebelled against his military service (including through desertion and subordination), and in 1916 assumed control of the periodical *Neue Jugend,* which received financial support from Kessler and many members of the Berlin literary and artistic circles he and Grosz frequented, including Däubler, Richard Huelsenbeck, Else Laskar-Schüler, and Heartfield, whose innovative typographical layout was perfectly matched to the content of this proto-Dada endeavor.[21] To broaden their pacifist program, Herzfelde and Heartfield founded the Malik Verlag publishing house in 1917, with the *First George Grosz Portfolio* as their inaugural publication, followed by the *Little Grosz Portfolio*—support clearly of paramount importance in gaining an audience for Grosz.[22] When Heartfield, Herzfelde, and Erwin Piscator joined the German Communist Party (Kommunistische Partei Deutschlands, or KPD) in the winter of 1918–19, Grosz joined as well, perhaps affording him a way to "gain control of his confused emotional life."[23] Yet Grosz never followed any ideological line, nor was he sparing in his criticism of the proletariat, finding instead criminality and stupidity in all social classes, as is evident in his 1923 Malik publication, *Ecce Homo.* However, in his acerbic portfolio *God with Us* (1920, *Gott mit Uns*), the proletariat is victimized by rampant militarism, a message conveyed straightforwardly without the explosive futurist tumult and overlaying forms of his earlier style; indeed, it is presented so directly that Grosz's usual cast of mediating personas is entirely absent—a rare moment in his artistic production.

The focus of *God with Us* is the demise of the Bavarian Soviet Republic in the aftermath of the assassination of Kurt Eisner, the leader of the Independent Social Democratic Party (Unabhängige Sozialdemokratische Partei Deutschlands, or USPD), on 21 February 1919, which led on 2 April to a Communist seizure of power. In early May, elements of the German army accompanied by Freikorps (paramilitary groups of veterans and others financed ostensibly by the USPD) invaded Munich, defeating the Communists in bloody street battles. Like many within the avant-garde in the wake of the Russian Revolution, Grosz had hoped for a more equitable social order for the proletariat. But he now witnessed similar events in Berlin, including the murder of KPD founders Karl Liebknecht and Rosa Luxemburg on 15 January 1919—events that also served to divide the Berlin Dada movement in which Grosz was becoming active.[24]

In the wake of Germany's defeat, Dada benefited from the collapse of regulatory structures, allowing artists such as Grosz to dare to take an openly antimilitarist stance, a singular taboo during the war. Using as his title the motto inscribed on soldiers' regulation belt buckles, *Gott mit Uns,* Grosz presented scathing portrayals of the brutality accompanied by captions in three languages, which were not literal translations but rather antinationalist and pacifist contexts for the events portrayed. In one image, two capitalists dine lavishly, while behind them soldiers slaughter the protesters; the caption is "Die Kommunisten fallen—und die Devisen steigen" (The Communists fall and the foreign exchange rises), a quotation adopted from Luxemburg, who was describing

proletarians fighting one another during the war.[25] In *Feierabend ("Ich dien")*, a soldier nonchalantly contemplates swollen bodies in the river Isar against a landscape that includes the towers of Munich's Frauenkirche (fig. 4).

Offered for sale at the 1920 *Erste Internationale Dada-Messe* (First international Dada fair), all copies of the portfolio were confiscated in September and October 1920, including the printing plates. In a famous court ruling on 20 April 1921, most of the charges were dropped, but Herzfelde was required to pay a nominal fine of three hundred marks and Grosz six hundred marks for defaming the German army,[26] a

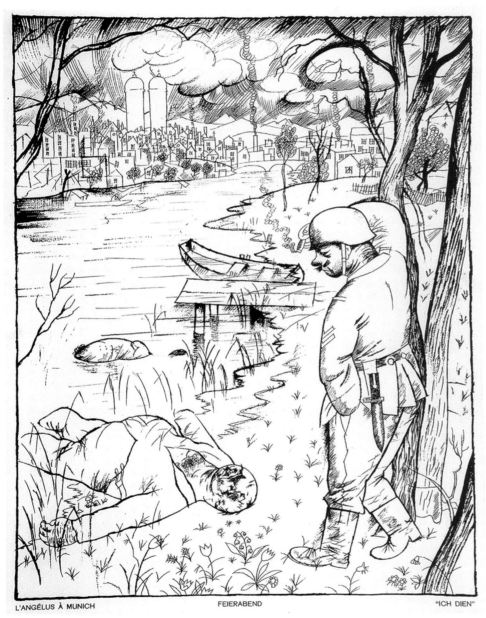

L'ANGÉLUS À MUNICH FEIERABEND "ICH DIEN"

FIGURE 4. GEORGE GROSZ (GERMAN, 1893–1959). *Feierabend ("Ich dien"),* 1919,
photolithograph on G. F. Drey Könige laid paper, image: 38.8 x 30 cm (15¼ x 11⅞ in.); sheet: 48.3 x 39.1 cm
(19 x 15⅜ in.). From *God with Us* (*Gott mit Uns*), (Berlin: Malik-Verlag, 1920), plate 3.

result that enhanced the defendants' fame and notoriety. Yet Grosz remained dubious of straightforward political explanations of the world and continued to approach it through imaginary personas. "Dada-Grosz" and "Propaganda-Marschall" became "George Grosz, Constructor," a major shareholder in the "Grosz-Heartfield Konzern" who created the "machine art" promulgated at the *Dada-Messe* as well as the faceless *Republican Automatons* (1920, New York, Museum of Modern Art). But perhaps the most enduring persona was "Böff," Grosz's bourgeois alter ego who typified the close resemblance between Grosz the satirist and his victims, as noted by critic Ernő Kállai: "He probably has to empathize to a certain extent with what he opposes."[27]

Grosz was never capable of fully identifying with political constituencies (his allegiance to communism lessened after his visit to Russia in early 1922). The war merely drove him deeper into the conundrum he perhaps captured more pointedly than any other artist at the time. When the urgency of the war and subsequent revolution eventually did subside, so did the profundity and mastery of Grosz's art. His art was thus bound to that historical moment of doubt and hope: the doubt that humanity was irretrievably condemned, and the hope (which caused the doubt) that utopian visions espoused by some of Grosz's generation might come true.

– NOTES –

1 George Grosz to Robert Bell, end of September 1915, in Herbert Knust, ed., *Briefe 1913–1959* (Reinbek bei Hamburg, Ger.: Rowohlt, 1979), 30–31. All translations are mine unless otherwise noted.

2 Wieland Herzfelde, *Immergrün* (Berlin: Aufbau, 1949; reprint, Berlin: Aufbau, 1996), 175.

3 Herzfelde, "Ein Kaufmann aus Holland," in *Immergrün* (1996), 164–81, esp. 171. Although never taken to Grosz's exaggerated extent, soldiers did in fact make a variety of (usually decorative or commemorative) objects from shell casings and other battlefield residue. See Claire Garnier and Laurent Le Bon, eds., *1917: Catalogue d'exposition,* exh. cat. (Metz, Fr.: Centre Pompidou Metz, 2012), 36–62.

4 Ralph Jentsch, *George Grosz: Berlin-New York,* exh. cat. (New York: Skira, 2008), 60. Several drawings from the Grosz estate are illustrated (pp. 60–61).

5 Alexander Dückers, *George Grosz: Das druckgraphische Werk* (San Francisco: A. Wofsky Fine Arts, 1996), 142–43. For pertinent sketches, see Beth Irwin Lewis, "'The Medical Journal of Dr. William King Thomas. U.S.A. Oct. 15 to 15 Nov. 15': Sketchbook 1915/2," in Peter Nisbet, ed., *The Sketchbooks of George Grosz,* exh. cat. (Cambridge, Mass.: Harvard University Art Museums, 1993), 41–61, esp. 52–55. See also Catherina Lauer, "Die Skizzenbücher," in Peter-Klaus Schuster, ed., *George Grosz: Berlin-New York,* exh. cat. (Berlin: SMPK Nationalgalerie, 1995), 498.

6 With patients auditing classes and with wards, an operating room, and a mortuary mixed in with the classrooms, director Bruno Paul was soon worried about the spread of infection. Michael White, *Generation Dada: The Berlin Avant-Garde and the First World War* (New Haven, Conn.: Yale University Press, 2014), 116–17.

7 For a detailed account of Grosz's experiences at the Unterrichtsanstalt, see White, *Generation Dada,* 106.

8 Matthias Eberle, *World War I and the Weimar Artists: Dix, Grosz, Beckmann, Schlemmer* (New Haven, Conn.: Yale University Press, 1985), 55–57; and White, *Generation Dada,* 114–15.

9 White, *Generation Dada,* 107–8.

10 Ralph Jentsch, "Kindertraum Amerika," in *George Grosz: Das Auge des Künstlers–Photographien New York 1932* (Weingarten, Ger.: Weingarten, 2002), 15–21.

11 For a detailed account of Americanism (*Amerikanismus*) among Grosz's generation and especially Grosz, Schlichter, and Dix, see Beeke Sell Tower et al., *Envisioning America: Prints, Drawings,*

Mass.: Busch-Reisinger Museum, Harvard University, 1990). For Grosz and jazz, see Jeanpaul Goergen, "Apachentänze in Futuristenkellern: Dada–Grosz–Musik," in Schuster, *George Grosz: Berlin-New York,* 219–23.

12 For some of these photographs, see Jentsch, *Berlin-New York,* 258–60; and, more recently, White, *Generation Dada,* 80–81. For the suggestion that Georg Groß "Americanized" his name, see Jentsch, *Berlin-New York,* 257.

13 George Grosz, *Ein kleines Ja und ein großes Nein* (Reinbeck bei Hamburg, Ger.: Rowohlt, 1974), 110.

14 Grosz, *Briefe,* 48; translated in Jentsch, *Berlin-New York,* 66.

15 George Grosz, *Spießer-Spiegel* (Dresden: Carl Reissner, 1925), 9. Lothar Fischer and Helen Adkins, *George Grosz* (Reinbek bei Hamburg, Ger. : Rowohlt, 1993), 44; and Barbara McCloskey, *George Grosz and the Communist Party: Art and Radicalism in Crisis, 1918 to 1936* (Princeton, N.J.: Princeton University Press, 1997), 34–35, who notes as further evidence poetry by Grosz deposited in his medical files.

16 Theodor Däubler, "Georg Grosz," *Die Weissen Blätter* 3, no. 11 (1916): 167–70.

17 These paintings included *Metropolis: View of the Big City* (1916–17), Madrid, Museo Thyssen-Bornemisza; *Explosion* (1917), New York, Museum of Modern Art; and *Dedicated to Oskar Panizza* (1917–18), Stuttgart, Staatsgalerie (illustrated in Jentsch, *Berlin-New York,* 75, 76, 83).

18 Kessler was at the time directing a large propaganda effort from the German consulate in Bern and could arrange this project under the auspices of the Auswärtiges Amt (Federal Foreign Office). For a detailed account, see Jeanpaul Goergen, "'Filmisch sei der Strich, klar, einfach': George Grosz und der Film," in Schuster, *George Grosz: Berlin-New York,* 211–18.

19 Diary entry from 18 November 1917, translated in Laird M. Easton, ed., *Journey to the Abyss: The Diaries of Count Harry Kessler, 1880–1918* (New York: Alfred A. Knopf, 2011), 792–93.

20 Easton, *Journey to the Abyss,* 792–93.

21 Taking over an extant periodical was a way of avoiding censorship. For a recent account of this periodical, see Christian Weikop, "Transitions: From Expressionism to Dada–*Neue Jugend* (1914, 1916–17); *Die freie Strasse* (1915–18); and *Club Dada* (1918)," in *The Oxford Critical and Cultural History of Modernist Magazines,* vol. 3, *Europe 1880–1940,* ed. Peter Brooker et al. (New York: Oxford University Press, 2013), 798–815.

22 Hans Hess considered this "the single most important event in George Grosz's life." Hans Hess, *George Grosz* (New Haven, Conn.: Yale University Press, 1985), 67.

23 Eberle, *World War I,* 64. They joined immediately upon the KPD's formation; see Ulrich Faure, *Im Knotenpunkt des Weltverkehrs: Herzfelde, Heartfield, Grosz und der Malik Verlag, 1916–1947* (Berlin in Weimar: Aufbau, 1992), 87.

24 See McCloskey, *George Grosz and the Communist Party,* 48–103.

25 Dückers, *George Grosz: Das druckgraphische Werk,* 194.

26 Jentsch, *Berlin-New York,* 103.

27 Ernst Kallai, "Dämonie und Satire," *Das Kunstblatt* 11 (1927): 100–101; translated in Eberle, *World War I,* 63. Hungarian art critic Ernö Kállai used the name Ernst Kallai in his German publications.

THE LIFE AND WORK OF KÄTHE KOLLWITZ (1867–1945) HAVE BECOME VIRTUALLY SYNONYMOUS in the popular literature with the tragedy of World War I: a bereaved mother who lost her younger son on the battlefield in the opening days of the war, Kollwitz, or so the story goes, was a dedicated pacifist who enlisted a particularly female aesthetic to depict the human tragedy of war. As art and gender-studies historian Viktoria Schmidt-Linsenhoff has pointed out, though, for most of her early artistic career, Kollwitz was no "feminine" pacifist.[1] In fact, the most acclaimed woman artist in late Wilhelmine Germany produced ambitious and technically accomplished prints with themes of radical insurrection that often featured violent female aggression. Kollwitz's experience of the war, however, created a seismic shift in her work as she struggled in the wake of her son's death to make sense of the war. By 1918, she had abandoned her belief in revolutionary change and retreated from the combative power and sophisticated technique that marked her early work. As she sought in a new body of work to give pictorial form to the impact of war on its victims, female revolutionaries gave way to passive mothers and wives, and the complexities of etching were discarded in favor of the direct appeal of woodcut. What resulted was not resistance to war, only a mute attitude of reproach.

Käthe Kollwitz, the First World War, and Sacrifice

JOAN WEINSTEIN

The outlines of Kollwitz's early career are well established. The granddaughter of an 1848 revolutionary, her parents and siblings were active Social Democrats, as was her husband, Karl Kollwitz, who established his medical practice in a working-class district in Berlin. Her initial success as an artist came with her first graphic cycle *Weavers' Revolt* (1893–97), based on the naturalist writer Gerhart Hauptmann's drama about an uprising of Silesian workers in 1844. When the jury awarded Kollwitz a small gold medal for *Weavers' Revolt* at the Grosse Berliner Kunstausstellung in 1898, the emperor promptly vetoed it because of the portfolio's radical social content. Still, the prestigious Dresden Kupferstich-Kabinett soon purchased the entire portfolio for its permanent collection and, as Kollwitz wrote retrospectively, she was catapulted "in one fell swoop into the foremost rank of artists."[2]

Kollwitz followed the *Weavers' Revolt* with an even more politically radical portfolio, *Peasants' Revolt,* commissioned in 1904 for the Verbindung für historische Kunst (Association for historical art) and therefore assured distribution through a fairly large edition.[3] Completed four years later, the seven etchings were loosely inspired by Wilhelm Zimmermann's *Allgemeine Geschichte des grossen Bauernkriegs* (1841/43), an account of a 1535 peasant revolt in southern Germany. In this series, Kollwitz developed her highly skilled etching techniques, combining hard and soft ground, aquatint, and various print techniques. Dispensing with a straightforward historical narrative in *Peasants' Revolt,* she imagined episodes from various stages of the rebellion in emotionally pitched but realistically rendered detail, often featuring

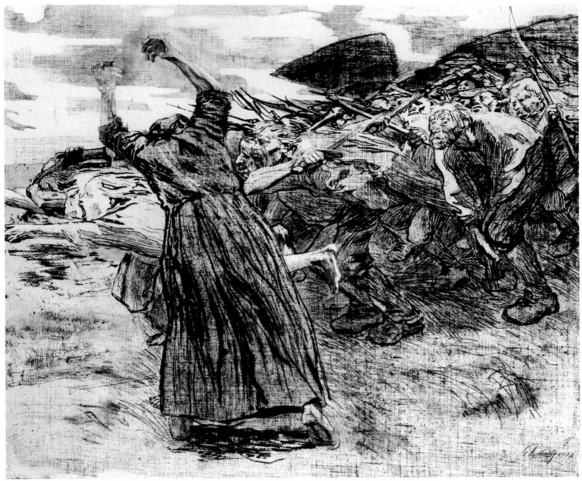

FIGURE 1. KÄTHE KOLLWITZ (GERMAN, 1867–1945). *Outbreak,* 1903, etching, engraving, and aquatint, 49.4 x 56.6 cm (19½ x 22⅜ in.), irregular. From *Bauernkrieg* (*Peasants' Revolt*), 1908, plate 5. London, British Museum.

female insurrectionists whose outpouring of aggression seems disturbing even today. In the print *Outbreak* (fig. 1), created to gain the *Peasant's Revolt* commission, Kollwitz portrayed the historical figure Black Anna, who catalyzed the peasants' outrage at their oppression into retaliatory revolt. Seen from behind with her body strained and her arms raised to incite the crowd, Black Anna also becomes a point of identification for the viewer. We know that the artist herself at one time empathized with such revolutionary violence, albeit in a support role, writing that she "used to daydream about deeds of heroism, with father and Konrad [her brother] fighting behind the barricades, and I beside them loading their rifles."[4] As Schmidt-Linsenhoff has argued so persuasively, *Peasants' Revolt* seems to legitimate militant female anger as a wholly appropriate response to suffering and injustice, thereby calling into question acts of violence as constitutive only of masculinity and male heroism.[5] Struggling to

explain the work, contemporary critics uniformly commented on its "masculinity," a backhanded acknowledgment of Kollwitz's technical mastery—unexpected from a woman artist—if not of the reversal of accepted gender roles.[6]

World War I proved a decisive turning point for Kollwitz. When the Social Democratic Party voted for war credits, Kollwitz, like many other artists and intellectuals, resigned herself to the war's necessity and even admired the selfless idealism of youthful volunteers. She prevailed upon her reluctant husband to grant permission to their underage son Peter to enlist. On 10 August 1914, she wrote in her diary, "This unique hour. This sacrifice he [Peter] made me make and which we make Karl [her husband] make." And a few days later, she commented, "The boys go with their hearts undivided. They offer themselves joyfully, like a pure, undefiled flame, rising straight to the sky."[7] Kollwitz seemingly accepted the wartime role ascribed to women by the military state to summon up the strength for sacrifice. She repeatedly, and not without some self-doubt, returned to the idea of "sacrifice" and "self-sacrifice" in her diary entries. For example, on 27 August 1914 she recorded her reaction to an essay by the novelist Gabriele Reuter published in *Tag* on the responsibilities of women in wartime. "She [Reuter] spoke of the eros of sacrifice—a phrase that struck me hard. Where do all the women who have watched so carefully over the lives of their loved ones get the heroism to send them to face the canon?"[8] While Kollwitz rejected the perversely erotic tone of Reuter's phrase, she nonetheless tacitly accepted that women's sacrifice was a form of "heroism." A month later, though, she wrote, "The whole thing [the war] is so ghastly and insane. Occasionally there comes the foolish thought: how can they possibly take part in such madness? And at once the cold shower: they must, must! All is leveled by death. Down with all the youth. Then one is ready to despair. Only one state of mind makes it all bearable: to receive the sacrifice into one's will. But how can one maintain such a state?"[9] Sacrifice becomes the recompense for the seemingly unrequited loss of youth and its idealism—and perhaps of her own idealism. Her husband saw things in a more critical light, later accusing her of having the "strength to sacrifice and let go" but not the strength to hold on to life.[10]

Kollwitz publicly became part of the patriotic consensus in the German art world when she contributed a lithograph to the 28 October 1914 issue of Paul Cassirer's stridently chauvinistic *Kriegszeit,* a weekly four-page broadsheet dedicated to artistic responses to the war by leading members of the Berliner Secession. Kollwitz's lithograph, *Das Bangen* (Fear) (fig. 2), differed from the contributions of her male colleagues, who offered sanitized images of the battlefield, caricatures of the enemy, or allegorical images of inevitable German victory. Instead, she turned to the home front, producing a close-up image of a woman shrouded in darkness, her eyes closed and hands folded in front. In the context of the war journal, the lithograph suggested an anxious wife or mother awaiting news from the front. To a certain extent, the image reinforced the wartime role ascribed to women to summon up the strength for sacrifice. At the same time, though, it suggested not Reuter's seductive "eros of sacrifice" but a certain tension: the repose of the face, which appears almost as a death mask, fits uneasily with the immobile, rigid torso. In any case, with its suggestion of waiting and suffering, the lithograph was the antithesis of Kollwitz's aggressively activist prewar female figures.

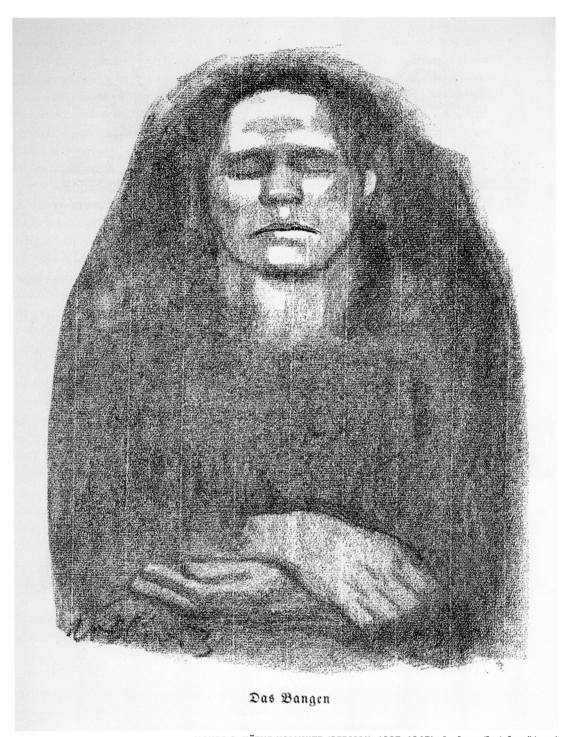

Das Bangen

FIGURE 2. KÄTHE KOLLWITZ (GERMAN, 1867–1945). *Das Bangen* (Fear). From *Kriegszeit Künstlerflugblätter* 1, no. 10 (28 October 1914), n.p. Los Angeles, Getty Research Institute.

Only two days after the lithograph appeared in *Kriegszeit,* Kollwitz received the news that her son Peter had died in action in Flanders. Her diary entries over the next two years reflect a painful effort to reconcile her growing disillusionment with the war with her need to believe that Peter's "sacrifice" was not in vain. As late as April 1916, she still clung to the pathos of fate about the war in all its contradictions: "The great experience of this war was simply death. The senseless and yet necessary, the involuntary and yet freely chosen death."[11] Only in October 1916 did Kollwitz forthrightly express her doubts: "So have the youth in all those countries been betrayed? Has their capacity for devotion been used to bring about this war? Who are the culprits? Do they exist? Have we ALL been betrayed? Was it mass hysteria? When and how will we wake up?"[12] This was no political analysis, nor did it recognize any personal agency in opposing the war. Instead, her diary entry participated in what became a more general war weariness on the part of ever-wider segments of the German population, particularly in the wake of the Battle of the Somme. Cassirer had already reflected this war weariness in April 1916, when he ceased publishing *Kriegszeit* and replaced it almost overnight with *Der Bildermann,* which sought consolation for the horrors of war in the "higher and purer" realm of art.[13] Kollwitz contributed a small lithograph, *Mother with a Child in Her Arms,* to the second issue.

Kollwitz openly opposed the war only in its final days, reacting to the writer Richard Dehmel's appeal in the Social Democratic newspaper *Vorwärts* for a last-ditch patriotic sacrifice by German youth. She declared in an open letter of protest, "Is it responsible to send them [German youth] to the front to die by the thousand when they have only just begun to live? *Enough have died! Let not another one fall!"* Invoking Goethe, she concluded, "Against Richard Dehmel I ask that the words of an even greater poet be remembered: Seed for the planting must not be ground."[14] This quotation has been cited often as confirmation of Kollwitz's pacifism by the end of the war. But as art historian Dora Apel has pointed out, the preceding part of her letter qualified her protest.[15] "I respect Richard Dehmel in once more volunteering for the front, just as I respect his having volunteered in the fall of 1914. But it must not be forgotten that Richard Dehmel has already lived the best part of his life." Kollwitz opposed, not the idea of war in principle, but rather the loss of German youth and the idealism they represented for an unsullied future.

While the war years brought Kollwitz widespread critical acclaim and financial success, she struggled after 1914 to produce new work. When Cassirer mounted a large-scale traveling exhibition in 1917 to celebrate the artist's fiftieth birthday, it included virtually no work from the war years. Kollwitz noted in her diaries an ongoing inability to work during long periods of depression. Even more importantly, she struggled with the ambitious new task she had set for herself—to produce a body of work that would adequately represent the war pictorially. Numerous trials and preliminary studies—which she rejected as inadequate—provide insight into this aesthetic preoccupation that focused on themes of sacrifice, mourning, and grief. These themes came to dominate her work in the years immediately following the war, although under radically different social and political conditions.

With the end of the war, the collapse of the German government, and the November revolution, Kollwitz was forced to reevaluate not only her judgments

about the war but also her current political stance. She remained loyal to the Social Democrats, defending them against the parties further to the left, and maintained this allegiance even after they called on the notorious paramilitary Freikorps to brutally suppress the communists. Although she conceded in her diary just weeks before these events that "without the constant pressure from the left . . . we would not have freed ourselves from total militarism," she concluded nonetheless, "One will have to suppress them now in order to recover from the chaos, and there is a certain right to that."[16] Despite misgivings "that the troops have not been called out for nothing, that the reaction is on the march,"[17] Kollwitz voted for the Social Democrats and, like the party, abandoned her commitment to revolutionary politics.

Ironically, her political stance took shape in *Memorial Sheet for Karl Liebknecht* (fig. 3), her first major work after the war, which commemorated the slain Communist Party leader murdered by the Freikorps in January 1919. Kollwitz had gained access to the morgue where Liebknecht's corpse awaited burial; there she completed a few

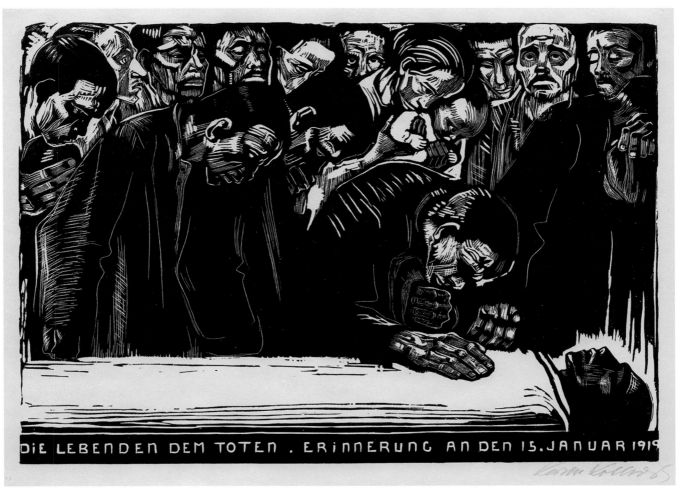

FIGURE 3. KÄTHE KOLLWITZ (GERMAN, 1867–1945). *Memorial Sheet for Karl Liebknecht*, 1920, woodcut on paper, 40.4 x 55.7 cm (16 x 22 in.). Williamstown, Massachusetts, Sterling and Francine Clark Art Institute.

quick sketches, capturing in realistic detail the "slightly open mouth, painfully distorted," and the flowers covering the collapsed skull, all noted in her diary.[18] Over the next two years she experimented with an appropriate form for the memorial, settling on the compositional scheme of the prone body surrounded by mourners that drew on readily recognizable religious iconography. Kollwitz was plagued by doubts throughout, questioning whether she had "the right to represent the workers' leave-taking from Liebknecht, even dedicate [the work] to them, without following Liebknecht politically."[19] After numerous attempts in etching and lithography, she abandoned both as unsuitable and turned to woodcut for the first time in her career. The simplified, even crude woodcut technique heightened the stylization of the figures, and the heavier line, more solid and staid, aligned well with the immobility of the final print. What resulted was a depoliticized homage that reflected Kollwitz's lack of socialist commitment. The words she inscribed at the bottom, "THE LIVING TO THE DEAD. REMEMBRANCE OF 15 JANUARY 1919," reversed the title of Ferdinand Freiligrath's stirring poem of the 1848 revolution, "The Dead to the Living" ("Die Toten an die Lebenden"), which was the very poem that had inspired her in her youth to "daydream about deeds of heroism" on the barricades. Now the living are no longer called on to carry on the struggle, only to mourn the dead — an act of passive acceptance.

Kollwitz also turned to woodcut for the 1923 portfolio *War,* the culmination of years of frustrated effort to give aesthetic form to the war experience. Scholars have pointed to the portfolio as evidence of Kollwitz's fervent pacifism, particularly as the prints were exhibited in 1924 at the newly founded Internationales Anti-Kriegs-Museum in Berlin. Kollwitz, though, privately doubted her own pacifism,[20] and these doubts are confirmed in the woodcuts themselves.

The artist summarized her ambitions for the seven woodcuts in an October 1922 letter to French pacifist writer Romain Rolland: "Again and again I have tried to give shape to war. I was never able to capture it. Now finally I managed a series of woodcuts that express to some extent what I want to say…this is what it was like — this is what we endured during these unspeakably hard years."[21] Giving "shape to war" involved depicting not the battlefield but rather the "unspeakably hard years" on the home front. The initial woodcuts symmetrically addressed the gendered moral economy of wartime "sacrifice" that so preoccupied Kollwitz throughout the war. In the first, *The Sacrifice,* a naked mother surrounded by a stylized calyx lifts up her newborn child toward a halo of light. With the crude woodcut technique, Kollwitz was able to capture some of her own ambivalence about mothers' sacrifice: the upward gesture is countered by the solidity of the body, and the angular cuts in the face evoke pain and reluctance. In the pendant *The Volunteers* (fig. 4), the volunteers ecstatically follow the drummer of death into battle. The curved aura of light above them, which does not appear in any of the preparatory versions, lends the self-sacrifice something vaguely sacred and heroic. The woodcut technique eliminated the more personalized features of earlier drawings and lithographs, making the image more timeless and universal.

The Sacrifice and *Volunteers* seem to endorse the notion of war as a permanent human condition that must always be deplored but can never be changed. Kollwitz did not address the causes of the war, nor did she question the authority that demanded

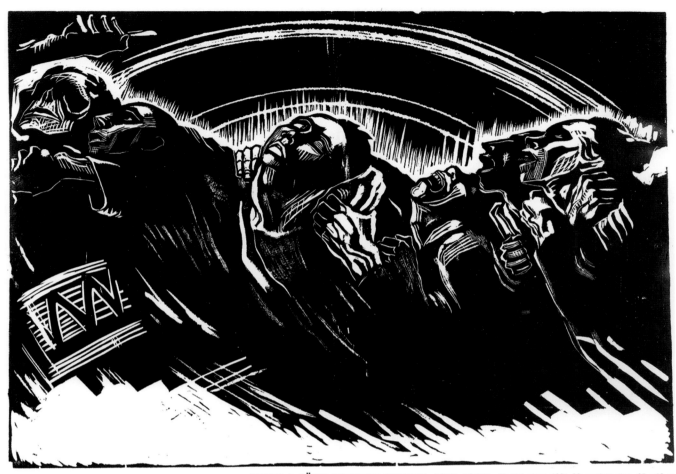

FIGURE 4. KÄTHE KOLLWITZ (GERMAN, 1867–1945). *The Volunteers,* 1921-22, woodcut, plate: 35 x 49 cm
(13⅞ x 19⅜ in.). From *Krieg* (War), portfolio (Dresden, 1923), plate 2. Moritzburg, Museum Schloss Moritzburg.

sacrifice, whether fate, militarism, or imperialist patriarchy. To be sure, other wood-cuts in the series movingly portray the human cost of war and evoke compassion for its victims. For example, *The Mothers* introduced a compositional scheme the artist would return to repeatedly, with fearful mothers surrounding their children in a desperate effort to protect them. These images rested upon common gender stereo-types, with women overwhelmingly depicted as passive victims, expressing neither accusation nor resistance, only helplessness and fear. Yet the thematization of the grief and pain of those left behind in the wake of the war functions, in the end, as a kind of guarantee of political innocence, releasing the victims from any responsibility for the war.[22]

The Mothers can also be read against the gendered ideology of mainstream Social Democratic pacifism in Germany, which insisted on women's special respon-sibility to oppose war because of their "innate" peacefulness.[23] For example, the guidelines adopted in 1922 by the pacifist Bund neues Vaterland (Federation for a new fatherland) promoted the "triumph of motherliness" to "overcome hatred and barbarism."[24] The implication that women are particularly endowed to protect their children, though, can be seen as the flip side of the claim that they have the special strength required to sacrifice them. Such logic, of course, also ignored the fact that the overwhelming majority of women, including Kollwitz, had supported the war effort in 1914.

Kollwitz continued throughout the Weimar Republic to retreat from the aggres-sive power and complex narratives of her earlier work and to focus instead on radi-cally simplified images of female forbearance and the capacity to suffer that evoke not action but only empathy. The sophisticated artistic quality of her work also receded, with the complexity of her etchings replaced by the solidity and even passivity of the woodcuts. Although she lent her drawings and woodcuts unstintingly to a variety of leftist and pacifist causes, the work itself emphasized human sentiment over politics. It was only under the National Socialist dictatorship, when she was no longer free to exhibit, that Kollwitz once again found the power to indict in her art, with mothers assertively protecting their children and resisting victimhood.

– NOTES –

1 Viktoria Schmidt-Linsenhoff, "Käthe Kollwitz: Weibliche Aggression und Pazifismus," *Kritische Berichte* 3 (1986): 36–47. I am indebted to the insightful work of Schmidt-Linsenhoff for this essay.

2 Hans Kollwitz, ed., *Ich sah die Welt mit liebvollen Blick* (Hannover, Ger.: Fackelträger, 1968), 274. All translations are mine unless otherwise noted.

3 Hildegard Bachert, "Collecting the Art of Käthe Kollwitz: A Survey of Collections, Collectors, and Public Response in Germany and the United States," in Elizabeth Prelinger, ed., *Käthe Kollwitz*, exh. cat. (Washington, D.C.: National Gallery of Art, 1992), 119. One of the etchings, *Outbreak*, was completed to gain the commission.

4 Käthe Kollwitz, *Erinnerungen* [1923], in Jutta Bohnke-Kollwitz, ed., *Käthe Kollwitz: Die Tagebücher* (Berlin: Siedler, 1989), 727.

5 Schmidt-Linsenhoff, "Käthe Kollwitz," 38. See also Kollwitz's *Carmagnole* (1901), an image of a frenzied woman dancing around the guillotine that recalls the refrain from "La Carmagnole," a song of the French Revolution. Kollwitz radically transferred the setting from the French Revolution to the slums of contemporary Hamburg.

6 See, for example, Werner Weisbach, "Käthe Kollwitz," *Zeitschrift für Bildende Kunst* 16 (1904–5): 85–92.

7 Quoted in Hanna Behrend, "Seedcorn Must Not Be Ground Down," in Franz Karl Stanzel et al., eds., *Intimate Enemies: English and German Literary Reactions to the Great War 1914–1918* (Heidelberg, Ger.: Universitätsverlag C. Winter, 1993), 434.

8 Kollwitz, *Die Tagebücher,* 158.

9 Kollwitz, *Die Tagebücher,* 166 (diary entry 30 September 1914).

10 Kollwitz, *Die Tagebücher,* 176 (diary entry 27 November 1914).

11 Kollwitz, *Die Tagebücher,* 239 (diary entry 22 April 1916).

12 Kollwitz, *Die Tagebücher,* 279 (diary entry 11 October 1916).

13 Peter Paret, *The Berlin Secession: Modernism and Its Enemies in Imperial Germany* (Cambridge, Mass.: Harvard University Press, 1980), 240.

14 Käthe Kollwitz, *Vorwaerts,* 30 October 1918, quoted in Hans Kollwitz, ed., *The Diary and Letters of Käthe Kollwitz,* trans. Richard Winston et al. (Evanston, Ill.: Northwestern University Press, 1989), 88–89.

15 Dora Apel, "'Heroes' and 'Whores': The Politics of Gender in Weimar Antiwar Imagery," *The Art Bulletin* 79 (1997): 366–84.

16 Kollwitz, *Die Tagebücher,* 388–89 (diary entry 8 December 1918).

17 Kollwitz, *Die Tagebücher,* 399 (diary entry 12 January 1919).

18 Kollwitz, *Die Tagebücher,* 402 (diary entry 25 January 1919).

19 Kollwitz, *Die Tagebücher,* 483 (diary entry 19 October 1920).

20 Kollwitz, *Die Tagebücher,* 483 (diary entry 19 October 1920).

21 Quoted in Hans Kollwitz, ed., *Käthe Kollwitz: Briefe der Freundschaft und Begegnungen* (Munich: List, 1966), 56.

22 See the excellent psychoanalytic reading by Viktoria Schmidt-Linsenhoff, "Kohl und Kollwitz: Staats- und Weiblichkeitsdiskurse in der Neuen Wache 1993," in Annette Graczyk, ed., *Das Volk: Abbild, Kunstruktion, Phantasma* (Berlin: Akademie, 1996), 185–203.

23 For more on the pacifist movement, see Karl Holl and Wolfrom Wette, eds., *Pazifismus in der Weimarer Republik: Beiträge zur historischen Friedensforschung* (Paderborn, Ger.: Schöningh, 1981).

24 Quoted in Apel, "'Heroes' and 'Whores,'" 379, which includes a thoughtful discussion of art and pacifism in Germany.

LÁSZLÓ MOHOLY-NAGY (1895–1946) ENLISTED IN THE AUSTRO-HUNGARIAN ARMY A YEAR AFTER THE OUTBREAK OF THE FIRST WORLD WAR. In early 1916, he was deployed to Galicia in an artillery unit as part of a large-scale troop buildup along the eastern front.[1] By summer's end, Moholy-Nagy and his compatriots found themselves pinned against the Carpathian Mountains and suffering heavy losses fighting against the Russians, caught in what would later be known as the Brusilov Offensive.[2] It was one of Russia's few decisive victories, and it forced the Central powers to redirect resources from the western to the eastern front. Moholy-Nagy somehow escaped unscathed, but the next summer he shattered his left thumb fighting in the same area. Given the intensity of the engagements, the injury was relatively minor. Nonetheless, it did require several months of convalescence in a hospital. By some accounts, he suffered from shock. His thumb did not heal correctly, and he underwent cycles of infection, partial recovery, and reinfection.[3] In 1918, he returned to military service and was made an instructional sergeant; he never went back to the battlefield.[4]

There are explicit ways Moholy-Nagy documented his early war experience in his art. During active duty, he produced a prodigious number of postcard sketches that recorded the day-to-day activities of life on the front. The sketches are mostly prosaic, featuring fellow soldiers eating, reading, or otherwise waiting for orders in the trenches; and they occasionally capture Galician peasants at work outdoors. They were executed quickly, his hand growing ever more adept at economizing the figural possibility of a graphic gesture.[5]

László Moholy-Nagy
Reconfiguring the Eye

JOYCE TSAI

After he left the front, he took up the horrors of war as a motif, using it in explicit, ambitious drawings and in his poetry as well. In one sense, these drawings make use of a dramatic, violent vernacular to represent the chaos of war, cleaving volumes apart with highly charged outlines, shredding planes into rough-hewn shards. This is exemplified by a grease crayon drawing Moholy-Nagy made depicting terrain caught behind a nest of barbed wire rendered with jagged, tangled marks (fig. 1). Such work directly recalls his experiences at the front and was executed in a manner that suggests war's cataclysmic power. However, looking at his work in other genres from that same period, it becomes apparent that his nudes and formal portraits were just as likely to have figures ensnared with deliberately frenzied lines. In both style and subject matter, these early figurative works were undoubtedly important. They represent Moholy-Nagy's first attempts to engage with the avant-garde art being produced as antiwar sentiments mounted and as an expressionism inflected by futurism and cubism took hold among the Hungarian avant-garde circles to which he belonged.[6]

Moholy-Nagy would never address the war so directly again, and he would later abandon that early commitment to figural, expressionist drawing in favor of a more rigorous geometric form. However, the experience of war stamped itself on

FIGURE 1. LÁSZLÓ MOHOLY-NAGY (HUNGARIAN, 1895–1946). *Drahtverhau*, ca. 1918, grease crayon on paper mounted on board, 31 x 28 cm (12¼ x 11⅛ in.). Collection of Hattula Moholy-Nagy.

Moholy-Nagy's art in less obvious, but, I would argue, in more fundamental ways that have to do specifically with his training as a soldier. Moholy-Nagy's official papers indicate that he served as an artillery reconnaissance officer (*Aufkläreroffizier*) in a field howitzer regiment.[7] Moholy-Nagy's role as *Aufklärer* was to serve as a pathfinder who rode ahead of the advancing troops on horseback to identify enemy targets and to secure viable passages not only for his comrades on foot but also for the howitzers, each weighing over two thousand pounds.[8] The job required cartographic literacy and facility, both to allow him to navigate unfamiliar terrain and to render what he observed in a legible, graphic form that could be transmitted without error.

One small map Moholy-Nagy drew, folded to fit a coat pocket, shows how he rendered the roads and waterways into a network of standardized marks (lines, dots, and dashes), the topographical contours punctuated by numbered elevations set at

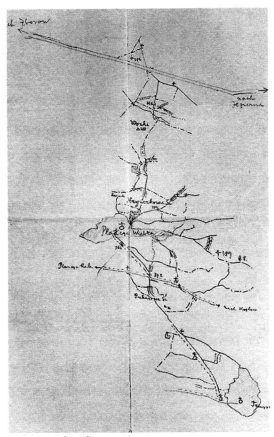

**FIGURE 2. LÁSZLÓ MOHOLY-NAGY (HUNGARIAN,
1895–1946).** Field map, between 1915 and 1918, ink on paper.
Budapest, private collection.

**FIGURE 3. ARTILLERY OBSERVATION POSTS WITH
FIELD TELEPHONE IN GALICIA.** From the album *Kriegserinnerungen*
(War memories), ca. 1915. Vienna, Österreichische Nationalbibliothek.

crossroads and landmarks (fig. 2).[9] The map distilled and schematized the most nec-
essary features for a survey of the few square kilometers between the cities of Zborów
and Jezirna (then in eastern Galicia and part of the Austro-Hungarian Empire, now
part of western Ukraine).

The kind of drawing Moholy-Nagy had to make as a scout differed from the
quick postcard sketches he produced that captured the spontaneous expressivity
of his graphic line. As a reconnaissance officer, he regimented his hand and eye. He
saw with eyes augmented by optical tools, including field glasses, clinometers, and
theodolites.[10] The data he gathered on the field had to be relayed to his superiors for
tactical purposes and was used to calculate the vertical and horizontal levels that
determined the aim for his unit's howitzers.[11] In order to translate that visual data
into standardized marks, he had to draw in a manner that erased the personal residue
of his distinctive hand. The role of the reconnaissance officer was a crucial part of
the system for artillery shelling in the war, because these weapons were not typically
fired straight at a visible target. Instead, artillery pieces launched shells at targets
obliquely, using techniques known as indirect fire that allowed for shelling from
hidden, remote, "covered" positions. Because the enemy target would not be directly

visible in battle, a scout, in the midst of an active shelling, would have to find a position from which to observe the accuracy of fire and gather additional information, if necessary, to allow for the recalibration of their gun. The data required for accurate calculation and aiming of these weapons went far beyond eyewitness reports. It also made use of information gleaned from listening posts — primitive assemblages of microphones wired outside trenches that allowed the sheltered listener to estimate locations and distances of blasts. Aerial photography also became an increasingly important part of the information collection arsenal of the artillery unit. The tactical power of indirect artillery fire intensified when it was deployed in a coordinated manner, a practice made possible through the use of then-advanced technologies of transmission that included radio, telegraph, and telephonic networks.[12]

Artillery's gruesome efficacy was the result of its very modernity. Heavy industry emerged and was corralled in the unprecedented, managed manufacture of new guns and munitions, enabling large-scale production. The use of an extensive rail network throughout Europe permitted the transportation of these enormous, unwieldy weapons to the front. The use of artillery required soldiers and officers with unprecedented technical literacy to work complex parts. The accuracy of aim depended upon the reconnaissance officer's abilities to see with a highly mediated, technologized vision and to communicate with absolute clarity.

Moholy-Nagy arrived at the front in Galicia when his superiors in the Central powers were convinced that the technological and material advantages they had secured would almost certainly assure victory over Russian forces on the eastern front.[13] Press photographs featured high-command visits to newly built, tidy observation posts. An album given to the archduchess of Austria included a photograph that showcased the technological sophistication of Hapsburg artillery reconnaissance in Galicia (fig. 3). The photograph features a soldier attentively observing from his post, as two officers look skyward; next to them is a field telephone operator on alert with a giant handset, ready to relay the gathered intelligence. Further enhancing the staging of Austro-Hungarian preparedness in a positive light is a report issued by Hapsburg high command from March 1916 emphasizing that the strength of their forward artillery would be enough to defeat the disorganized Russians.[14] Despite intelligence in the spring that all but announced Russian general Aleksei Andreyevich Brusilov's preparations for a major summer offensive, the generals who guided the Central powers chose not to recognize the seriousness of the threat.[15]

By contrast, Brusilov began laying the groundwork for his offensive over the course of several months, intensifying the pursuit of military intelligence in part to compensate for the comparatively limited access the Russians had to munitions and supplies. He brought in technical experts to train mechanics to serve provisionally as aerial photographers. They correlated the images obtained with reports gathered from prisoners of war, spies, and defectors to create maps of Austro-Hungarian positions with an astonishing degree of accuracy.[16] With this intelligence, they choreographed an approach that economized their use of both shells and infantry along the front. By attacking key nodes in communication, command, and supply networks, the Russians transformed Hapsburg fortifications into unwieldy liabilities.[17] The consequences of Hapsburg blindness and overconfidence were profound. The Brusilov Offensive,

which military historians cite to exemplify Austro-Hungarian strategic incompetence, forced the Germans to redirect forces west to the eastern front and contributed to a shifting tide in favor of the Triple Entente.[18] In those brief months, over 750,000 men in the Austro-Hungarian Army died on the eastern front as a result of the offensive, with another 380,000 captured. They never recovered from what came to be known as the *Katastrophensommer*.[19]

In the aftermath of the offensive, Moholy-Nagy sketched several self-portraits, titled *Én* (Me), on postcards. In one, his face is gaunt and he wears his collared uniform (fig. 4). His eyes are obscured by a pair of glasses, the lenses darkened like those worn by the blind. Years later, he would recall the retreat, describing a "never-ending march over soaked ground, mud to the knees, face beaten by wind and hail, half blind, every step falling then advancing." Moholy-Nagy continued, "I was left behind in the dark on the open field alone, without strength." What saved him was not high command, not his fellow soldier, but his trusty steed: "My horse appeared: I wept and kissed him, overcome with joy."[20]

The Brusilov Offensive readily illustrates that the mere possession of technology secures no tactical advantage, an observation that was made well before the war began. Writing in 1911, Otto von Stülpnagel, later a German general in the Luftwaffe, remarked that the use of aerial reconnaissance to support artillery units, for instance, "is not nearly as self-evident as it is often characterized."[21] Beyond the physical demands of seeing from a perspective unmoored from the ground, being launched into motion above unfamiliar terrain and forced to contend with constantly changing light and meteorological conditions, the photographer had to learn to spot hidden positions as the pilot avoided ever-more-advanced antiaircraft fire from the ground. Furthermore, the photographs had to be confirmed and correlated with data and intelligence gathered on the ground for them to serve any tactical purpose. Aerial photography in the service of artillery reconnaissance, Stülpnagel argued, demanded nothing less than the "systematic reconfiguration [*Durchbildung*] of the eye."[22]

Stülpnagel's language anticipates one of the central claims that undergirds what would come to be known as "New Vision," closely associated with Moholy-Nagy's art and theory. Roughly a decade after Moholy-Nagy's experience on the front, he published his highly influential book *Malerei Photografie Film* (1925; Painting, photography, film). The slim volume, published as a part of the Bauhaus book series, makes a passionate appeal to the reader to embrace the world made newly visible through technological means. More than half the book is given over to illustrations, organized to break habits of seeing shaped by the tradition of easel painting. It urges viewers to see with X-ray eyes, to observe the world through a microscope's lens, to imagine a future in which images will be projected not only by film but through the wireless telegraph as well. Photography, film, and these nascent imaging technologies could train the eye to become responsive to the demands of modern life. In the closing lines of his text, Moholy-Nagy announces, "The traditional picture [*Bild*] has become anachronistic and is over."[23]

Malerei Photografie Film comprises two sections: the argument laid out textually in the first twenty-some pages and then again visually over the course of more than a hundred carefully arranged illustrations. To demonstrate the urgency of

overcoming the hold painting had had on photography, Moholy-Nagy's first two illustrations feature a pair of photographs that emulate painting in their mode of presentation. The first edition of the book, from 1925, begins with Alfred Stieglitz's photograph of a street in New York City. Rendered through the scumbled scrim of painting, the horse-drawn carriage, wide boulevard, and frontal figures all coalesce into an image that could easily be conflated with an impressionist canvas of nineteenth-century Paris. On the right facing page is a composite photograph of a zeppelin set against a dramatic sky, with sun glinting off the rough seas below (fig. 5).

Moholy-Nagy reversed the order of these first two pages in the second revised edition of *Malerei Fotografie Film,* published in 1927, so that the zeppelin appears first. In a sense, the reversal might seem minor because both orders so clearly exemplify the photographic practices trapped by painterly conventions that Moholy-Nagy criticized. However, by opening the second edition with the photograph of the zeppelin, he shifted the stakes of the book. Moholy-Nagy had never been interested in engaging in the internecine battles among advocates of Stieglitz's pictorialism and apologists of sharply focused, idiosyncratically shot, avant-garde photography. To open with Stieglitz risked inviting readers to see *Malerei Fotografie Film* as a salvo launched against partisans of

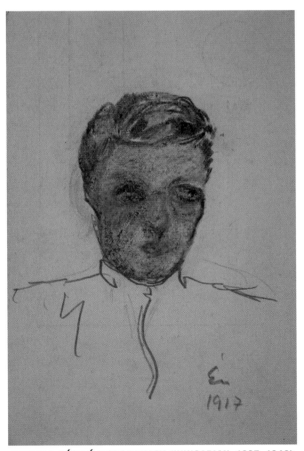

FIGURE 4. LÁSZLÓ MOHOLY-NAGY (HUNGARIAN, 1895–1946).
Én (Me), 1917, graphite and crayon on postcard, 14 x 8.9 cm
(5½ x 3½ in.). Newark, Delaware, University Museums, University of Delaware.

Zeppelin III fliegt über den Ozean.

Photo: **GROSS.**
Aus: **Zeitbilder.**

Das ist die „romantische" Landschaft. Nach der glänzenden Periode der Daguerrotypie hat der Photograph alle Richtungen, Stile, Erscheinungsformen der Malerei nachzuahmen versucht. Es dauerte ca. 100 Jahre, bis er zur Verwendungsmöglichkeit seiner eigenen Mittel kam.

8, 4·

41

FIGURE 5. *ZEPPELIN III FLYING OVER THE OCEAN.*
From László Moholy-Nagy, *Malerei Photografie Film*, 1st ed. (Munich:
Albert Langen, 1925), 41. Los Angeles, Getty Research Institute.

pictorialism in a conflict over style. By contrast, to begin with the press photo of the zeppelin, as he did in the second edition, Moholy-Nagy alerted the reader to a broader problem of aesthetic and technological incommensurability.

The zeppelin, we should note, was quintessentially modern. The first commercial airline comprised zeppelins, not planes. Zeppelins were some of the first successful platforms for aerial reconnaissance because of their steadiness in flight. Early airplanes were too unstable to accommodate heavy cameras with glass-plate negatives that required relatively long exposure times. The military utility of the zeppelin was recognized early on, even before the First World War, and once hostilities commenced, they were used by the Germans not only for reconnaissance but also in bombing campaigns against the British and French. The image Moholy-Nagy selected, the press photograph of the zeppelin, exemplifies the absurdity of imposing the conventions of painting upon the photographic depiction of such a modern invention. The brushy clouds and breaking waves frame the airship in improbably dramatic light. Despite the use of photographic technology, the resulting image converted this signal achievement in flight into nothing more than a motif in what Moholy-Nagy called in the picture's caption a "'romantic' landscape." "It has taken about a hundred years," the caption continues, "to arrive at the appropriate deployment of photography's own means."[24]

Malerei Fotografie Film served as an important vehicle for the promotion of "New Vision," which is marked by the frequent use of aerial or low-angle perspectives generated through the technological mediation of the camera lens. The lens sees wholly differently than the biological eye. Learning to see the world through this lens extends human vision, transforms it. It renders perception "objective" by training the viewer to abandon the reliance on outdated habits of seeing and thinking.[25] It is worth considering again the closing lines of Moholy-Nagy's book, which appeared just before the section of illustrations opened by the photograph of the zeppelin: "The traditional picture [*Bild*] has become anachronistic and is over. Opened eyes and ears will be filled with the richness of optical and phonetic wonders. In just a few vibrant, forward-oriented, progressive years, with a few more enthusiastic followers of photographic techniques, it will become general knowledge that photography constitutes one of the most important factors that contributes to the start of new life."[26]

In the summer of 1916, what Moholy-Nagy's open eyes and ears saw and heard as an artillery reconnaissance officer could hardly be characterized as "wonders," in the positive sense of the word. However, the crucible of war forged the key insights that would find articulation in *Malerei Fotografie Film* roughly a decade later. The Great War proved the adaptive capacity of human beings to accommodate themselves to unprecedented technical demands. Technologized seeing had powerful effects when properly deployed, as the Brusilov Offensive demonstrated. The dire consequences of refusing to see clearly what technologized vision laid bare was made evident in the unimaginable casualties suffered in battle. Military strategists and avant-gardists alike understood the urgency of training individuals to grasp and respond to the objective truth illuminated by technology. For those like Stülpnagel, "systematic reconfiguration of the eye" would produce more effective soldiers. For Moholy-Nagy, by contrast, the propagation of technologized seeing, or "New Vision," promised to prepare clear-eyed masses for a new utopian future.

The author would like to thank Gordon Hughes, Lynette Roth, Ben DeVane, and Ralph Ubl for their comments and insights.

1 Oliver A. I. Botar, *Technical Detours: The Early Moholy-Nagy Reconsidered* (New York: The Salgo Trust for Education, 2006), 21. John Schindler, "Steamrolled in Galicia: The Austro-Hungarian Army and the Brusilov Offensive, 1916," *War in History* 10, no. 1 (2003): 28.

2 Lloyd Engelbrecht, *Moholy-Nagy: Mentor to Modernism* (Cincinnati, Ohio: Flying Trapeze, 2009), 44.

3 Engelbrecht, *Moholy-Nagy,* 48–49.

4 Botar, *Technical Detours,* 24.

5 For an overview of Moholy-Nagy's early wartime sketches, see Belena S. Chapp, *László Moholy-Nagy: From Budapest to Berlin 1914–1923,* exh. cat. (Newark, Del.: University of Delaware, 1995).

6 Botar, *Technical Detours,* 21–30.

7 "Personalblatt," 29 September 1918, László Moholy-Nagy Papers, microfilm reel 951, frame 0017, Archives of American Art, Washington, D.C.

8 Gottfried Gilbert, *Der Artillerist: Unterrichtsbuch für Rekruten, Kanoniere, Unteroffiziere und deren Lehrer* (Berlin: Offene Worte, 1928), 1059. Gilbert's book provides an extensive overview of the complexity both of training and of coordinating an artillery unit. Published initially in 1923, the book was written as a training manual that drew extensively from the experience of the First World War, in many cases reprinting excerpts from existing resources.

9 Published in Levente Nagy, "The Beginning of the Multifaceted Career of László Moholy-Nagy," in Chapp, *László Moholy-Nagy,* 23.

10 Gilbert, *Der Artillerist,* 623–32.

11 Gilbert, *Der Artillerist,* 612–20.

12 B. J. C. McKercher and Michael A. Hennessy, eds., *The Operational Art: Developments in the Theories of War* (Westport, Conn.: Praeger, 1996), 11–12.

13 Timothy C. Dowling, *The Brusilov Offensive* (Bloomington: Indiana University Press, 2008), 88.

14 Dowling, *The Brusilov Offensive,* 51.

15 So unperturbed by reports gathered as early as March 1916 indicating Russian preparations for a large-scale offensive, German general Erich Luddendorff went on holiday after dismissing the findings. Dowling, *The Brusilov Offensive,* 35.

16 Dowling, *The Brusilov Offensive,* 44.

17 Dowling, *The Brusilov Offensive,* 42–47.

18 Dowling, *The Brusilov Offensive,* 176.

19 John Schindler, "Steamrolled in Galicia," 59.

20 László Moholy-Nagy, "In Answer to Your Interview," *The Little Review* 7, no. 2 (1929): 55.

21 Bernhard Siegert, "Luftwaffe Fotografie: Luftkrieg als Bildverarbeitungssystem 1911–1921," *Fotogeschichte: Beiträge zur Geschichte und Ästhetik der Fotografie* 45/46 (1992): 42.

22 Siegert, "Luftwaffe Fotografie," 42.

23 László Moholy-Nagy, *Malerie Photographie Film* (Munich, Ger.: Albert Langen, 1925), 37. Translation mine.

24 László Moholy-Nagy, *Malerie Fotografie Film* (Köthen, Ger.: Köthen, 1927), 46.

25 Moholy-Nagy, *Malerie Fotografie Film* (1927), 26.

26 Moholy-Nagy, *Malerie Fotografie Film* (1927), 43. Translation mine.

I entered the war because of a love affair—to be honest it was a flight from a seemingly hopeless situation. I was spared the fate of many others, who lost their lives. That makes a difference. So I pondered: it is like on the stage, someone else dies, and when the curtain falls, one goes home.

— Oskar Kokoschka[1]

BY THE TIME THE AUSTRO-HUNGARIAN EMPIRE DECLARED WAR ON SERBIA ON 28 JULY 1914, Oskar Kokoschka (1886–1980) was perhaps more infamous than famous as an artist. In various exhibitions in Austria and Germany and abroad, his expressive portraits had drawn the attention of collectors, curators, and critics alike. The latter were initially rather skeptical and even sarcastic, calling him a "chief savage" (*Oberwildling*)[2] and his art both dreadful and "extremely original."[3] But Kokoschka's work met with a lot of interest as early as 1908, when he was still an art student and exhibited in Vienna at the *Kunstschau,* a show of contemporary art organized by Gustav Klimt and other fellow artists. Klimt subsequently called him the greatest talent of his generation.[4] Architect Adolf Loos saw Kokoschka's work at the exhibition and encouraged him to start painting. Loos convinced a large number of his friends and acquaintances to pose for Kokoschka, which resulted in the production of about seventy portraits between 1909 and 1914. He introduced Kokoschka into Viennese cultural and intellectual circles that included figures such as writer Peter Altenberg, publicist Karl Kraus, and composers Arnold Schoenberg and Anton von Webern. Kokoschka later said about this period that he preferred to focus on the human being rather than the ornament.[5]

Oskar Kokoschka
The Great War and Love Lost
BEATRICE VON BORMANN

In his portraits, he showed an absolute lack of interest in exterior beauty or depicting "reality." "It is the psyche which speaks," proclaimed Kokoschka in 1912.[6] Like many contemporary artists, Kokoschka tried to depict his personal vision of reality, practically reinventing his manner of painting with each portrait. After the eclecticism of historicism and the focus on ornaments in art nouveau, artists felt the need to go back to the basics, to elementary forms; this brought about a revolution in art, architecture, literature, and music. Kokoschka's unflattering portraits, with their focus on the expression of the face and hands, were an important part of this. Art historian Gerbert Frodl has dubbed this accentuation, or rather exaggeration, of particular characteristics "Viennese individualism," a style that goes back to the "character heads" by Franz Xaver Messerschmidt in the late eighteenth century and leads right up to the expressiveness of Viennese actionism of the 1960s and Arnulf Rainer's "face farces" of the early 1970s.[7]

On 12 April 1912, Kokoschka met Alma Mahler, then 32-year-old widow of Gustav Mahler. It was the beginning of a tempestuous love affair that lasted almost three years and resulted in some of Kokoschka's best early work. The relationship with Alma Mahler is key to some of the changes of Kokoschka's work around the First World War, as well as perhaps the main reason he volunteered for military service. This unhappy love affair haunted Kokoschka until at least 1919, by which time he had changed his style completely.

A lot has been written and said about the relationship between Kokoschka and Alma; she herself summed up the relationship with the words "Never before had I tasted such agony, such hell, such paradise."[8] Kokoschka was completely enthralled by her, to the point of obsession; he wrote her love letters almost every day and made countless portraits of her, both drawn and painted. The three double portraits of him and Alma count among the highlights of Austrian expressionism. In his art, he clearly conveyed the arc of his emotions: his hope to marry Alma and build a future with her; his bitter disappointment at her refusal to marry him and her abortion of their child in 1913; and his suffering when the relationship turned sour.

Perhaps his most famous testimony to the intensity of their relationship is *Bride of the Wind,* painted between April and December 1913 (fig. 1). This large-scale painting shows the couple lying in a wrecked boat, surrounded by the violence of the

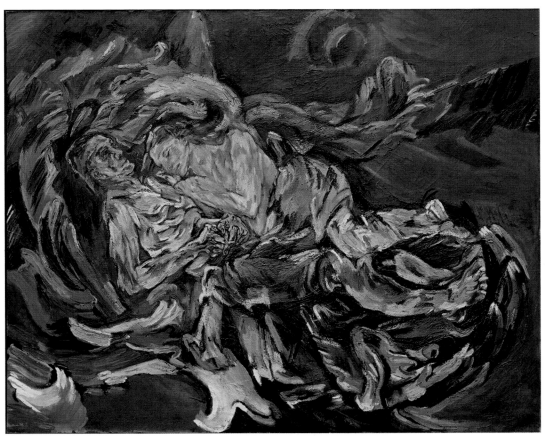

FIGURE 1. OSKAR KOKOSCHKA (AUSTRIAN, 1886–1980). *Bride of the Wind,* 1913, oil on canvas, 180.4 x 220.2 cm (71⅛ x 86¾ in.). Basel, Kunstmuseum Basel.

elements. The painting was inspired by the observation of a storm in Naples, where Kokoschka and Alma had traveled in the spring of 1913.[9] It was the expressionist poet Georg Trakl who came up with the title *Bride of the Wind* when he composed his poem "Die Nacht" (The night) in front of the painting in Kokoschka's studio:

> Over blackish cliffs
> The wind's glowing bride
> Plunges drunken with death.[10]

Kokoschka applied the paint with thick, clearly visible brushstrokes, the movements of which reflect the tempestuous mood. Because of the dynamic brushwork and the strong emotional impact of the scene, the painting is considered a masterpiece not only within Kokoschka's work but of expressionism in general. In his letters, Kokoschka referred to it as the "red painting."[11] At some stage, he changed the main color scheme of the painting from red to blue; there are very few red brushstrokes left in the painting now. While, for Kokoschka, red was the color of life, love, and passion, he considered blue to be a cold, weak color.[12] With this painting, finished in December 1913, he seemed to be anticipating the end of the relationship, even though it would take another year and a half before it really ended.

"I Beg to Stop This World War, I Want to Work"

In December 1914, Kokoschka voluntarily enlisted in the military. He would have been drafted anyhow—at the age of twenty-eight, he was liable for military service—but he preferred to choose the regiment. Also, as Alma's daughter Anna later remembered it, Alma, wishing to be rid of him, called him a coward until he volunteered to go.[13] Loos managed to get him into the 15th Lower Austria and Moravian Dragoons (Archduke Joseph's), a regiment that consisted almost exclusively of members of the aristocracy. With the proceeds of *Bride of the Wind* and an anonymous grant from the philosopher Ludwig Wittgenstein, he was able to buy a horse and have a uniform made: "I was a wonderful target with my light blue tunic with white facings, red breeches and a gilt helmet, when the Russians had already learned from the Japanese to camouflage in khaki clothes and to hide themselves with spades."[14] Kokoschka started his military training in January 1915 in Wiener Neustadt. He suffered from not being able to keep up with the other soldiers on horseback and felt quite isolated among the representatives of a class with which he had little in common. And he was plagued by financial troubles and had to borrow money from Loos and others, including Alma.[15]

His correspondence with Alma, which continued during this time, brought little solace, as she was mostly distant and critical, whereas he continued to declare his love. In early February 1915, she wrote to him: "You deserve to be cheated on. Who knows. Alma,"[16] thus announcing her renewed affair with architect Walter Gropius, with whom she had had an affair during her marriage to Mahler. In April, Kokoschka was sent to the reserve officer school at Holíč in Czechoslovakia to get more training, but he soon volunteered for active service. According to his autobiography, he did so to escape being degraded for insubordination,[17] but his letters to friends reveal that he was simply fed up with the harsh military training; he thought he might be able to return to his studio

faster if he went to the front and got wounded.[18] An additional motivation may have been the realization that he had lost Alma. Just before he was sent off to Ukraine with his regiment, he wrote her a good-bye letter: "Now you have crossed the magical bridge and I have remained in hopelessness, in the darkest incarnation of self-deceit."[19]

In Ukraine, Kokoschka was confronted with famine, cholera, destroyed villages, and Cossacks hiding in the forests and making surprise attacks. In late August 1915, he was seriously injured. Loos described the event in a letter to artist and critic Herwarth Walden: "OK was shot in the temple during an attack on 29 August near Luck, after he had been in the field for a month. The bullet pierced his ear canal and exited at the neck. His horse also fell. He found himself under four dead horses, managed to scramble out, a Cossack pierced his chest with a lance. (Lung)."[20] While recovering in Vienna, Kokoschka met up with old and new friends — including poet Rainer Maria Rilke, who was doing his military training in Vienna at the time — and heard of Alma's marriage to Gropius in August of that year.

During most of 1915, Kokoschka was unable to paint. But shortly before volunteering again for military service, Kokoschka began work on a large-scale painting depicting himself as a kind of medieval knight (fig. 2). He finished the *Knight Errant* sometime in 1915, presumably while recovering from his wounds in Vienna in November or December of that year. Kokoschka portrayed himself as a fallen knight, his hands stretched out helplessly, floating above a dark landscape consisting of a stormy sea, cliffs, and a black sky that recalls the landscape of *Bride of the Wind*. A birdlike creature with a human face (Kokoschka's soul?) perches on the branch of a dead tree; it calls to mind the birdlike creatures with Kokoschka's and Alma's faces on

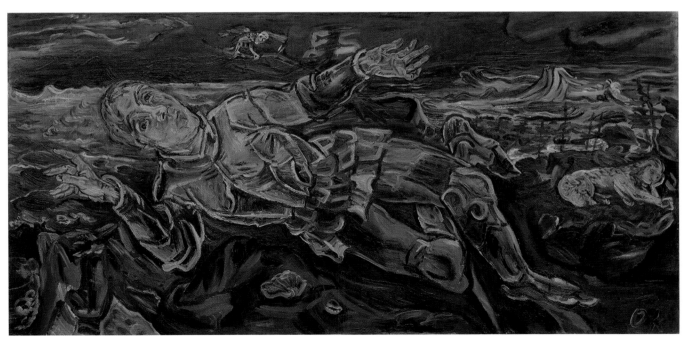

FIGURE 2. OSKAR KOKOSCHKA (AUSTRIAN, 1886–1980). *Knight Errant*, 1915, oil on canvas, 89.5 x 180 cm (35¼ x 70⅞ in.). New York, Solomon R. Guggenheim Museum.

the fourth sheet of *Allos Makar* (1914; the title is an anagram of Oskar and Alma), the graphic series of illustrations to a poem written by Kokoschka about this tormented relationship. In the background to the right, the figure of a woman crouches in the muddy water. Her face, red with emotion, rests on her hand in the classic pose of Melancholy. She has Alma's features.

Kokoschka was not the only artist to paint a self-portrait as a soldier at that time. German painter Lovis Corinth and Polish artist Jacek Malczewski painted a *Self-Portrait in Armour* in 1914, with the important difference that they both presented themselves proudly upright (Corinth with a lance in his hand), whereas Kokoschka's painting is more of an allegory of the isolated and helpless artist at the mercy of fate.[21] Other contemporaries, such as Otto Dix and Ernst Ludwig Kirchner (see Gaehtgens, fig. 2, p. 122), also painted self-portraits as soldiers, but in modern-day uniforms and without any allegorical references, although Kirchner included the figure of a naked woman in his self-portrait of 1915. Kokoschka's self-portrait is quite representative of his expressive style of just before the war; he uses clearly visible, thickly applied brushstrokes, a rather dark palette, a mixture of realistic and imaginary elements, and various perspectives at the same time—the knight is shown from above, the figure of Alma from the side. Like a lot of his prewar works, it is also quite linear; for example, he outlined the figure of the knight with white lines. In the course of a year, he would completely change his visual language.

In the middle of July 1916, he was sent to war again. At his own request, he was assigned as a war artist to a Hungarian regiment at the army command at Tolmino on the Italian front, called the "Isonzo front" because most of the fighting took place around the river Isonzo, in what is now Slovenia. Italy had entered the war in May 1915; in the first half of August 1916, the sixth battle of the Isonzo took place, claiming a huge number of casualties, especially on the Italian side. Kokoschka found himself at the most forward reaches of the front, between Tolmin, Idriya, and Selo. During this time, Kokoschka made about thirty drawings with colored chalks and sometimes a bit of watercolor. In keeping with Kokoschka's assignment as an official war artist, these drawings are essentially of a documentary nature, showing the events in a realistic if simplified manner: soldiers firing their guns, ruins in landscapes, and troop movements.[22] In 1917, he would make a series of more expressive drawings depicting the horrors of war, planning to have them printed in a portfolio, but this never happened and today they are little known.[23]

On 28 August 1916, almost exactly a year after his first injury, a bridge over the Isonzo exploded while Kokoschka was approaching it. He became severely shell-shocked and was once more sent off to a field hospital.

Recovery and a New Beginning

Kokoschka was discharged from the field hospital after a short time and allowed to recover in Berlin. There, in September and October 1916, he painted Herwath Walden's second wife, Nell, and Princess Mechtilde Lichnowsky. These paintings show a remarkable difference from those he painted while recovering in Vienna in the spring of 1916, which are quite dark, with black lines defining the figure. Although the black outlines do not disappear altogether, for the portraits painted in Berlin, he

used strong blues and greens and highlighted the figures with a thick impasto of light colors. He built up the figure from within, as if sculpting it with paint.[24]

Kokoschka signed a lucrative contract with the Paul Cassirer gallery in Berlin in October 1916, thus becoming financially independent. At the same time, he tried to get a professorship in order to escape further military duty. He moved to Dresden in December 1916 in the hope of bettering his position, but in spite of all his efforts and contacts, he was not nominated for a professorship at the Dresden art academy until August 1919. Until the end of 1917, he received regular treatments for his war injuries at the sanatorium of Dr. Heinrich Teuscher in Dresden–Weisse Hirsch, a wealthy suburb on the hills overlooking Dresden. There he had, as he wrote to his parents, "friends among the doctors," who tried to help him get declared unfit for further military service.[25] One of these doctor friends was Fritz Neuberger, who was at the heart of a group of writers and actors that met up at the Felsenburg (a hotel near the sanatorium) and would become Kokoschka's friends. Kokoschka portrayed a number of them in the group portraits *The Emigrants* (1916–17) and *The Friends* (1917–18), gloomy paintings with earthy colors, as well as dark blue and purple. Kokoschka was still recovering from his physical and emotional wounds, and his newly found friends helped him through it.

At that time, Kokoschka painted his *Self-Portrait* (fig. 3). It shows the artist in a pose that he seems to have borrowed from Albrecht Dürer's famous self-portrait from 1500 (Munich, Alte Pinakothek), in which the 28-year-old artist likened himself to Christ, with long hair, a frontal pose, and his hand pointing at his chest as if it were pointing at his wound. Kokoschka also painted himself in a frontal pose, pointing at himself with his right hand. Although this gesture links the self-portrait to traditional

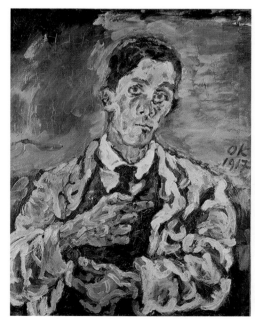

FIGURE 3. OSKAR KOKOSCHKA (AUSTRIAN, 1886–1980). *Self-Portrait,* 1917, oil on canvas, 79 x 62 cm (31⅛ x 24½ in.). Wuppertal, Von-der-Heydt-Museum.

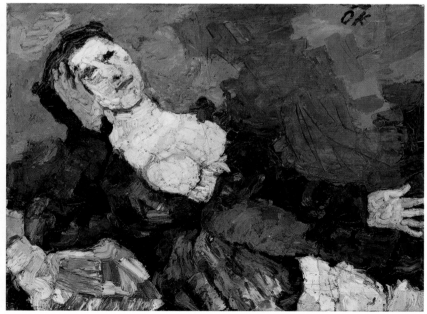

FIGURE 4. OSKAR KOKOSCHKA (AUSTRIAN, 1886–1980). *Woman in Blue,* 1919, oil on canvas, 78 x 103 cm (30¾ x 40⅝ in.). Stuttgart, Staatsgalerie Stuttgart.

images of the suffering Christ, it also reveals Kokoschka's newly found self-confidence as an artist—he presents himself proudly in a suit and a painter's coat. In spite of the relatively dark colors, there is a new dynamism in the loose brushstrokes that make up the figure and in the almost-baroque movement in the blue background.

In July 1918, Kokoschka commissioned a life-size doll after Alma Mahler from Munich artist and doll maker Hermine Moos, writing her letters full of detailed instructions. When the doll arrived in April 1919, he was terribly disappointed with the less-than-lifelike result; he did, however, use it as a model. One of the most important "portraits" of the doll is *Woman in Blue* of 1919 (fig. 4); it marks another turning point in his manner of painting. Kokoschka was now pouring out color and distributing it across the canvas with big movements of his palette knife and brush. Kokoschka's immersion into the lively Dresden art scene—with exhibitions of contemporary art full of vibrant colors, which critics admired enthusiastically—must have worked as a catalyst, speeding up the transition in his art toward a brighter color scheme after 1919.[26] However, the changes were gradual rather than sudden, as has often been assumed. Perhaps the biggest shift, in Berlin in late 1916, was his move from a linear manner of painting—a faint echo of the linearity of art nouveau—to one that uses color to build up the figure. It is quite possible that the relief of having survived, being back at his easel, and being financially secure after signing the contract with Paul Cassirer allowed this change to happen.

The aftermath of the war took many shapes in art, from images of insanity and deformation to ghosts and sexual murder. In Kokoschka's case, it took the shape of a "fetish" (the doll) that he painted in all its ghastly lifelessness while, at the same time, infusing it with an inner light through the use of brilliant colors that reflected his memory of the love he lost. He called it a "larva, which hibernates in a silk cocoon and turns into a butterfly."[27] By painting the doll and his masterpiece *The Power of Music* (1920, Eindhoven, Van Abbemuseum), both with bright colors, Kokoschka found the "spiritual luminosity" he had been looking for and finally managed to shake off the shadows of the war.[28]

— NOTES —

1 Oskar Kokoschka, *Mein Leben* (Vienna: Metroverlag, 2008), 162 (translation mine).

2 Ludwig Hevesi, *Altkunst–Neukunst, Wien 1894–1908* (Vienna: Carl Konegen, 1909), 313. All translations of German quotes are mine.

3 Art historian Richard Muther in "Zeit," quoted in Agnes Husslein-Arco and Alfred Weidinger, eds., *Oskar Kokoschka: Träumender Knabe, Enfant terrible,* exh. cat. (Vienna: Bibliothek der Provinz, Weitra, 2008), 132.

4 Berta Zuckerkandl, "Als die Klimt-Gruppe sich selbständig machte: Erinnerungen anläßlich der Kunstschau," *Neues Wiener Journal* 35, no. 11991 (10 April 1927): 8.

5 Husslein-Arco and Weidinger, *Oskar Kokoschka,* 54.

6 Oskar Kokoschka, "On the Nature of Visions" [1912], quoted in Tobias G. Natter, ed., *Oskar Kokoschka: Early Portraits from Vienna and Berlin, 1909–1914,* exh. cat. (New York: Neue Galerie, 2002), 236.

7 Gerbert Frodl, "Expressionistisches von Romako bis Rainer," in G. Frodl and T. G. Natter, *Oskar Kokoschka und der frühe Expressionismus* (Vienna: Österreichische Galerie Belvedere, 1997), 9–12.

8 Alma Mahler-Werfel, *Mein Leben* (Frankfurt: S. Fischer, 1960), 58.

9 On the creation of *Bride of the Wind* see, among others, Alfred Weidinger, *Kokoschka and Alma Mahler* (Munich: Prestel [Pegasus Series], 1996), 34–39.

10 Kokoschka, *Mein Leben,* 132. For Trakl's poem, see Margitt Lehbert, *The Poems of Georg Trakl* (London: Anvil Press Poetry, 2007), 180.

11 Letter from Oskar Kokoschka to Alma Mahler, end of May/beginning of June 1913, in Olda Kokoschka and Heinz Spielmann, eds., *Oskar Kokoschka, Briefe* (Düsseldorf: Claassen, 1984–88), 1: 115–116. There is no other painting with a larger amount of red from this period, and Walter Feilchenfeldt, who was portrayed by the artist in 1952, recalls the artist telling him that *Bride of the Wind* used to be red, before it was painted over (Walter Feilchenfeldt, personal communication, September 2013).

12 Oskar Kokoschka to Josef P. Hodin, 12 May 1958, in Kokoschka and Spielmann, *Oskar Kokoschka,* 4:82.

13 Husslein-Arco and Weidinger, *Oskar Kokoschka,* 250.

14 Kokoschka, *Mein Leben,* 140.

15 Oskar Kokoschka to Albert Ehrenstein, 24 April 1915, and Oskar Kokoschka to Alma Mahler, end of June 1915, in Kokoschka and Spielmann, *Oskar Kokoschka,* 1:220, 222.

16 Kokoschka and Spielmann, *Oskar Kokoschka,* 1:200. Kokoschka occasionally quoted Alma back to her in his letters.

17 Kokoschka, *Mein Leben,* 140–42.

18 "I beg to stop this world war" is from Oskar Kokoschka to Albert Ehrenstein, 27 December 1915, in Kokoschka and Spielmann, Oskar Kokoschka, 1:232. Oskar Kokoschka to Ludwig von Ficker, 21 February 1915, in *Oskar Kokoschka Letters, 1905–76* (London: Thames & Hudson, 1992), 61.

19 Oskar Kokoschka to Alma Mahler, beginning of July 1915, in Kokoschka and Spielmann, *Oskar Kokoschka,* 1:224.

20 Adolf Loos to Herwarth Walden, 18 October 1915, quoted in Husslein-Arco and Weidinger, *Oskar Kokoschka,* 252.

21 Johann Winkler and Katharina Erling, *Oskar Kokoschka: Die Gemälde, 1906–1929* (Salzburg: Galerie Welz, 1995), 68–69 (no. 115).

22 Régine Bonnefoit and Gertrud Held, "Oskar Kokoschka, 1915–1917: Vom Kriegsmaler zum Pazifisten," in *Die Avantgarden im Kampf,* exh. cat. (Cologne: Snoeck), 2013, 246–53. In this article, the authors describe Kokoschka's work as a war artist and his circumstances during the war in more detail.

23 See Oskar Kokoschka to Leo Kestenberg, 31 March 1917, in Kokoschka and Spielmann, *Oskar Kokoschka,* 1:264f. See also Bonnefoit and Held, "Oskar Kokoschka, 1915–1917," 251–52.

24 Alfred Weidinger is of the opinion that the change of style from angular to rounded shapes that became so clear in the paintings first announced itself in the drawings he made at the front. Alfred Weidinger in Husslein-Arco and Weidinger, *Oskar Kokoschka,* 256.

25 Kokoschka and Spielmann, *Oskar Kokoschka,* 1:259. It seems that Kokoschka was only really declared unfit for military service while in Sweden in late 1917, after getting a medical opinion from Robert Barany, a Viennese physiologist and Nobel Prize winner.

26 Birgit Dalbajewa, "Kokoschka und Dresdens 'allgemeine Farbenfreudigkeit' um 1919," in Frodl and Natter, *Oskar Kokoschka,* 85–94. See also Stephan Koja, "'Ich ging wieder meinen Künstlerweg allein': Beobachtungen zur Bildkunst Emil Noldes und ihren Reflexen in der österreichischen Malerei," in Agnes Husslein-Arco and Stephan Koja, eds., *Emil Nolde: In Glut und Farbe,* exh. cat. (Munich: Hirmer, 2013), 32–35. In this text, Koja argues that Kokoschka's change in style around 1919 was brought on by paintings by Emil Nolde that he saw at the exhibition of the Dresden Künstlervereinigung in the summer of 1919.

27 Kokoschka, *Mein Leben,* 183–84.

28 Kokoschka, *Mein Leben,* 190.

"NOW RELEASED FROM THE HOSPITAL, 'FIT FOR SERVICE,' ALTHOUGH I FEEL SHATTERED. I'M NOT THE SAME MAN WHO VOLUNTEERED IN AUGUST."[1] Oskar Schlemmer (1888–1943) (fig. 1) made this remark in a letter of January 1915 after recovering from a leg injury suffered on the western front, where he had seen action near Verdun and Lille in the fall of 1914. Just months earlier, as a student at the Stuttgart Akademie der bildenden Künste working under Adolf Hölzel, Schlemmer had been consumed by the possibilities of cubism and abstract painting, as well as by the politics of reform at the academy. Back in Stuttgart in early 1915, Schlemmer, ashamed of his idleness, accepted that there was "no escape, [and felt] desperate eagerness to return to the front."[2] Deployed to the eastern front in June, Schlemmer suffered another minor injury, this time in his arm. For the rest of the war, Schlemmer would remain behind the front lines. In 1916, he was assigned to a surveying unit based in Mullhouse and later in Colmar, where he wrote: "Am surrounded by vast sheets of paper and colored inks and geometry, and still I complain."[3] In 1918, as Schlemmer began officer training in Berlin, the war ended.

Oskar Schlemmer's *Triadic Ballet* and the Trauma of War

PAUL MONTY PARET

Throughout the war years, Schlemmer was able, off and on, to paint as well as to develop new experiments in dance. Indeed, his wartime diaries are as filled with wide-ranging thoughts on art, literature, and religion as they are with accounts of the war and his life as a soldier. "I, unlike other, more fortunate beings," he remarks in his diary, "do not regard being a soldier as an end in itself. I love life — the life of the mind."[4] Receiving a four-month educational leave in late 1915, Schlemmer pushed the flattened, cubism-influenced surfaces he had been developing before the war toward an increasing abstraction and formal rigor (for example, *Composition on Pink,* 1916, private collection, and *Painting K,* 1916, private collection). Some of this new work was included in the exhibition *Hölzel and His Circle,* shown in Freiburg and Frankfurt in 1916.

More significantly, although the full details are unknown, Schlemmer used a charity event for his regiment in Stuttgart in December 1916 as an opportunity to stage early versions of several dances from his *Triadic Ballet,* a project that was strikingly shaped by the war and would consume Schlemmer during the postwar years.[5] Following demobilization, Schlemmer returned briefly to the Stuttgarter Akademie. He left again in early 1920 to focus on the *Triadic Ballet,* an increasingly ambitious work of choreography and costume design that might be understood, especially in its distorted and physically punishing costumes, as a restaging of the traumatic experience of war.

By the fall of 1920, Schlemmer — who also held exhibitions that year at Herwarth Walden's Der Sturm gallery in Berlin (with Willi Baumeister and Walter Dexel) and at the Galerie Ernst Arnold in Dresden (with Baumeister and

Kurt Schwitters)—had been invited by Walter Gropius to teach at the new Staatliche Bauhaus in Weimar. Schlemmer would spend most of the next decade, the core of his career, at the Bauhaus, throwing himself into the program and life of the school, where, at various times between 1921 and 1929, he led the mural painting, stone and wood sculpture, and stage workshops.

• • •

World War I is etched into the foundations of the Bauhaus. Henry van de Velde's forced resignation in 1915 from the Großherzoglich Sächsische Kunstgewerbeschule in Weimar, due to his Belgian nationality, opened the door for Gropius's postwar appointment in 1919 to lead the Staatliche Bauhaus, a reconfigured combination of the former Kunstgewerbeschule and the Großherzoglich Sächsische Hochschule für Bildende Kunst in Weimar. Gropius had served as a sergeant major and then lieutenant on the western front, where he was seriously wounded in 1918. Collectively, the students and masters who would soon constitute the school experienced all facets of the war.

Schlemmer's future student Joost Schmidt, who in 1927 would become a master at the Bauhaus in Dessau, provides a particularly illuminating account of how closely the Bauhaus and its early ethos were wrapped into the war. As a frustrated student of applied arts in Weimar before the war, Schmidt was planning a study trip to Paris and was determined to visit the Gothic cathedrals of northern France on his way. With the outbreak of war, it was perversely as a soldier, not as an artist, that Schmidt would make part of this journey. "Yes," he recalls in his unpublished memoir, "I got to see the French cathedrals, but how! The first was the cathedral of St. Quentin.

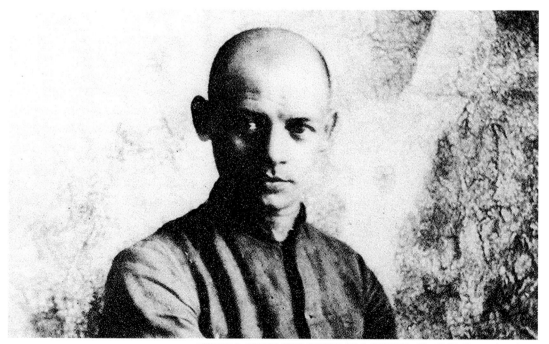

FIGURE 1. OSKAR SCHLEMMER AS A SOLDIER, CA. 1917. Photographer unknown.

In 1914 I saw it undamaged, and in 1918 its ruins." Still on his way to the front near Reims, Schmidt snuck away from his transport long enough to quickly explore the Laon cathedral:

> In the fall of 1914 we were sent to the front for the first time, just outside Reims. The dead from the last battles still lay before the trenches. Beyond no-man's land was the city with the cathedral towering above it. Through binoculars I marveled at its details. One night German shelling set Reims ablaze. From the sea of flames of the burning city, the dark silhouette of the cathedral stood out. Its roof burned brightly [*lichterlich*]. The dead between the front lines were illuminated like ghosts [*gespentisch*]. This macabre image ate into [*einfressen sich in*] my soul.[6]

When the Bauhaus opened five years later in October 1919, the image and concept of the Gothic cathedral loomed large as a model of artistic collaboration, community, and the unification of the arts and crafts. Not only was the cathedral the central metaphor of Gropius's 1919 *Bauhaus Manifesto* (with Lyonel Feininger's cubo-futurist woodcut *Cathedral* on its cover); it was also used by Schlemmer in a programmatic statement he drafted for the 1923 Bauhaus exhibition, in which he refers to the Bauhaus ambition "to build the cathedral of socialism."[7] Schmidt's accounts of Reims and Saint Quentin are particularly instructive for the way they reframe the Bauhaus rhetoric of the cathedral within the lived experience of the First World War. To the romanticized communal idealism and optimism of the early Bauhaus, Schmidt's wartime recollections of devastated French cathedrals add a countervailing note of destruction, trauma, and death.

• • •

Never the direct subject of his work, the experience of war remained latent in Schlemmer's postwar practice; it was a force that manifested itself only in complex and unspoken ways. It is important to note that even before the war Schlemmer had a tendency toward clean lines and a rationalized geometric language. Thus, while it is tempting to look, for example, at his 1922 "Bauhaus Head" signet — a starkly simplified geometric head in profile with an expression of steeled determination that was used at the Bauhaus in many variants — as an icon of a new postwar hardening, Schlemmer, in fact, had developed this basic design before the war and used it in a 1914 exhibition poster in Stuttgart.[8] The war and its traumatic memories may be more apparent in the figures from Schlemmer's work in painting, sculpture, and theater in the early 1920s that, still working within a geometric language, are also strongly characterized by disfiguration, dismemberment, and prosthesis. This is particularly evident in Schlemmer's costume design for the *Triadic Ballet,* which had its full premiere in September 1922 at the Würtembergische Landestheater in Stuttgart, followed a year later by performances in Weimar and Dresden.[9]

Schlemmer began to work seriously on choreography and dance in 1912 after meeting dancers Albert Burger and Elsa Hötzel in Stuttgart. In 1916, as noted above, he managed to stage his initial sketches for what would become the *Triadic Ballet*

(performed by Burger and Hötzel) at a benefit for his regiment in Stuttgart. By 1919, the development of the *Triadic Ballet* had become Schlemmer's near-constant pre-occupation. He left Stuttgart for nearby Canstatt in 1920 in order to work with his brother Carl, or "Casca," on the ballet's elaborate costumes.[10] The same year, he hesitated for months to accept Gropius's offer to join the Bauhaus for fear of disrupting his work on the *Triadic Ballet,* even receiving "permission to stay away until the ballet project is finished."[11]

In its fullest version, the *Triadic Ballet* included three acts (yellow, rose, and black), which corresponded to three sequences of dances Schlemmer labeled the "cheerful burlesque," "ceremonious and solemn" [*festlich-getragene*], and "mystical-fantasy," with a total of twelve dances performed as solos, duets, or trios by three dancers in eighteen costumes.[12] Some of the dances incorporated naturalistic movements and traditional ballet forms, while others pushed forcefully toward an abstraction that would "follow the plane geometry of the dance surface and the solid geometry of the moving bodies, producing that sense of spatial dimension that necessarily results from tracing such basic forms as the straight line, the diagonal, the circle, the ellipse, and their combinations."[13] Conceived as a trinity on many levels—three acts, three dancers, three moods, a trinity of music (for which Schlemmer never found an adequate solution), costume, and dance, and so on—the *Triadic Ballet* was dominated, nonetheless, by its sculptural, highly structured costumes. Through visual reference and startling physical constraints, Schlemmer's costumes defined the ballet's characters, reordered their bodies, and restricted their movements.

The Abstract (fig. 2), perhaps the ballet's central character and something of an alter ego for Schlemmer (who danced the role himself on several occasions), wears a large one-eyed mask and wields both a sword and a club. Split into unequal areas of light and dark punctuated by areas of red and blue, The Abstract is marked especially by a permanently outstretched, oversized conical white leg that cannot be bent, be held up for any length of time, or even fully support the weight of the dancer. Although clearly phallic, The Abstract is also impotent, as the permanently outstretched leg reduces the dancer to a limping, one-legged hop.[14]

Other characters in the *Triadic Ballet* carry more extreme undercurrents of violence and dismemberment. Gold Sphere is dominated by an armless ovoid torso, whose missing limbs have either been severed or pulled back within the figure's protective shell. Sphere Hands is a figure whose handless arms end in swollen colored balls. The twin Disk Dancers, whose heads and bodies are set with thin blade-like disks, move toward each other from opposite directions, appearing to slowly slice through one another as they merge together. The glittering Wire (fig. 3), who is prevented from lowering her arms by the dense rows of wire hoops ringing her waist and repeated on her head, can appear as a figure snarled within coils of barbed wire. And The Diver (fig. 4), from the ballet's so-called cheerful burlesque sequence, is armless, grotesquely deformed, and, given the oversized diver's mask, perhaps even headless.

What deformities may lurk beneath the shells of these costumes? As a soldier returning to active duty in 1915, Schlemmer asked himself rhetorically: "What does the mighty chaos of war hold in store for me? A bullet through the chest?...Will I be crippled? Will I lose my right hand, my right arm, my sight?"[15] Each of these fears

could serve as descriptors of one or more of the bodies Schlemmer would later devise for the *Triadic Ballet*. For all their whimsy, Schlemmer's figures are also specters of the soldier's experience, alluding to and echoing the mutilated bodies, artificial limbs, and reduced abilities of the war's wounded veterans. As he noted to his soon-to-be wife, Helena "Tut" Tutein, in 1919, around the time he was crafting these costumes: "My true self—which, in fact, is my innermost being—is usually surrounded by a shell formed by the outside world. If I accidentally reveal some of it, it is always in the form of a joke, or between the lines."[16]

Schlemmer later acknowledged and justified the physical inhibitions and indeed violence of his costumes in formal terms when he explained that "the seemingly violated body achieves new expressive forms of dance the more it fuses with the costume."[17] That is, for Schlemmer, the tension and kinesthetic sense created by the restrictive costumes was precisely the point; the dancers' bodies would transcend the limitations of both costume and convention to produce new aesthetic forms.

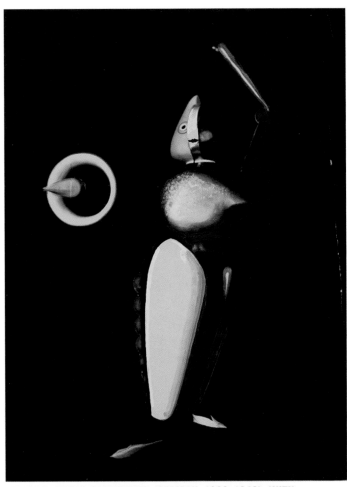

FIGURE 2. OSKAR SCHLEMMER (GERMAN, 1888–1943), WITH PHOTOGRAPHS BY ATELIER GRILL (KARL GRILL). *The Abstract* (detail), 1927, pencil, crayons, and watercolor on graph paper with pasted photographs, 29.7 x 20.9 cm (11¾ x 8¼ in.). From *Das Triadische Ballett: Regieheft für Hermann Scherchen, darin Figurenplan, Gruppenfoto und 8 Szenenfotos mit Anweisungen, Alle Abbildungen im Bildmodul*, page 7, number 5. Berlin, Bauhaus-Archiv.

Art historian Juliet Koss has written persuasively about the "human dolls" of the Bauhaus theater, connecting the "eerily charming" character of Schlemmer's figures (which combine the "familiar playfulness of dolls and sinister hollowness of mechanical creatures") to Freud's theory of the uncanny, the simultaneous experience of familiarity and estrangement.[18] More precisely, we might identify the uncanny in the figures of the *Triadic Ballet* through the violent imaginary of Schlemmer's costumes. For all of their whimsy, what is strangely familiar in Schlemmer's figures may be less their marionette-like appearance as half-human, half-mechanical beings, and more their grotesque combination of disfigurations and prosthetic attachments — something that had an uncomfortable parallel in the legions of wounded war veterans in Germany and throughout Europe.

In another example, Schlemmer's *Free Sculpture G (Abstract Figure)* (1923), with its precise geometries and mechanical rigidity, has often been interpreted as a classicizing ideal of machine-age beauty. Closely modeled after examples of antique

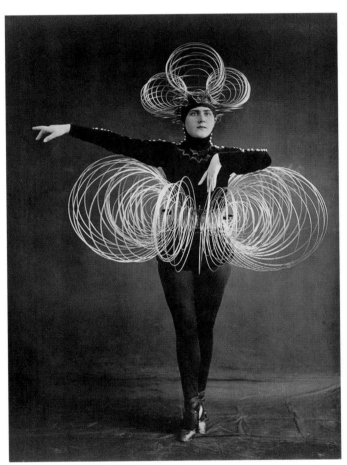

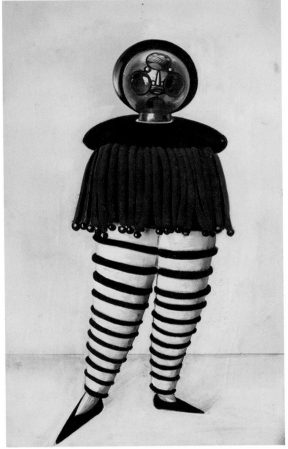

FIGURE 3. KARL GRILL (GERMAN PHOTOGRAPHER, ACT. 1920S). *The Wire* costume from Oskar Schlemmer's *Das Triadische Ballett*, 1926, gelatin silver print, 22.5 x 16.2 cm (8⅞ x 6⅜ in.). Los Angeles, J. Paul Getty Museum.

FIGURE 4. OSKAR SCHLEMMER (GERMAN, 1888–1943), WITH PHOTOGRAPHS BY ATELIER GRILL (KARL GRILL). *The Diver* (detail), 1927, pencil, crayons, and watercolor on graph paper with pasted photographs, 29.7 x 20.9 cm (11¾ x 8¼ in.). From *Das Triadische Ballett: Regieheft für Hermann Scherchen, darin Figurenplan, Gruppenfoto und 8 Szenenfotos mit Anweisungen, Alle Abbildungen im Bildmodul*, page 4, number 2. Berlin, Bauhaus-Archiv.

statuary, *Abstract Figure* might also be considered a wounded body with prosthetic replacements and a defensive armor protecting it from further damage.[19]

As is often the case in Schlemmer's work, the geometric language of rationalist modernism used for the basic structure and form of *Abstract Figure,* as well as for the *Triadic Ballet,* belies a powerful specter of vulnerability, violation, and bodily damage. These works, in other words, are haunted by the unspoken memory of war and shaped by its traumatic return.

Insisting on such an interpretation as the main way to understand Schlemmer's figures from the *Triadic Ballet* would be misguided. I have chosen selectively. But like so much of European modernism between the wars, Schlemmer's work deals in part with the four and a half years of war and its exceptional human cost in dead and wounded.[20] Schlemmer's grotesquely costumed figures and other works from the early 1920s using formal strategies of disfiguration, fragmentation, and dismemberment gain richer meanings when understood against this backdrop.

• • •

Schlemmer left the Bauhaus in 1929 to join the Staatliche Akademie für Kunst und Kunstgewerbe Breslau, where in 1932 he would paint *The Bauhaus Staircase* (New York, The Museum of Modern Art) as a memorial to the school in the throes of persecution and closure. Soon the academy would also close. In 1933, Schlemmer was summarily dismissed from a new teaching appointment in Berlin, and in 1937 his works were included in the *Entartete Kunst* (Degenerate art) exhibition. Confounded by the cultural politics of National Socialism, Schlemmer would not outlive the Second World War.[21] He died in 1943 while supporting himself working in a painting factory owned by a sympathetic supporter in Wuppertal.

A quarter century earlier, in November 1917, Schlemmer wrote from his cartographic unit in Alsace with the mix of humor, transcendent idealism, and despair that characterized so much of his life and work: "A forest near Colmar. When I am feeling tired, empty, and numb I go there. A narrow path and almost at once the eminently calming green gathers all good spirits around me. Hölderlin appears, and with him everything that is good. I am known as a Schlemihl, the man without a shadow, when in fact what people see is the shadow without the man"—a man, it might be added, now in the midst of the idealized peace of nature and of Hölderlin's verse, far from the front, but still assaulted by its memory.[22]

– NOTES –

1 Oskar Schlemmer, *The Letters and Diaries of Oskar Schlemmer,* ed. Tut Schlemmer, trans. Krishna Winston (Evanston, Ill.: Northwestern University Press, 1972), 17. Translation altered.

2 Schlemmer, *Letters and Diaries,* 19. Translation altered.

3 Schlemmer, *Letters and Diaries,* 43.

4 Schlemmer, *Letters and Diaries,* 21. "In fact," Schlemmer further claimed to his friend Otto Meyer-Amden, "painting is the major source of my uneasiness, even in the trenches, if you can believe that." Schlemmer, *Letters and Diaries,* 33–34.

5 Dirk Scheper, *Oskar Schlemmer: Das Triadische Ballett und die Bauhausbühne* (Berlin: Akademie der Künste, 1988), 24; Nancy Troy, "The Art of Reconciliation: Oskar Schlemmer's Work for

the Theater," in Arnold L. Lehman and Brenda Richardson, eds., *Oskar Schlemmer* (Baltimore: Baltimore Museum of Art, 1986), 129–30; and Andreas Hunneke, "Der 'Tänzer-Mensch' Oskar Schlemmer," in Maria Muller, ed., *Oskar Schlemmer: Tanz Theater Bühne* (Ostfildern-Ruit, Ger.: Hatje, 1994), 11.

6 Joost Schmidt, "Wie ich das Bauhaus Erlebte," 1947, Bauhaus-Archiv, Berlin. Translation mine.

7 Oskar Schlemmer, "The Staatliche Bauhaus in Weimar, Manifesto from the Publicity Pamphlet 'The First Bauhaus Exhibition in Weimar July to September 1923,'" in Hans Maria Wingler, *The Bauhaus: Weimar, Dessau, Berlin, Chicago,* trans. Wolfgang Jabs and Basil Gilbert (Cambridge, Mass.: MIT Press, 1969), 65–66. Written at Gropius's request, the text had a strongly left-leaning tone that surprised Gropius, who, facing growing right-wing attacks, collected and destroyed most of the printed copies before they were distributed. See Schlemmer, *Letters and Diaries,* 200; and Karen Koehler, "The Bauhaus Manifesto Postwar to Postwar: From the Street to the Wall to the Radio to the Memoir," in Jeffrey Saletnik and Robin Schuldenfrei, eds., *Bauhaus Construct: Fashioning Identity, Discourse and Modernism* (New York: Routledge, 2009), 20–21.

8 See especially Magdalene Droste, "The Head as a Successful Design: Oskar Schlemmer's Bauhaus Head," in Wolfgang Thöner, ed., *Bauhaus: A Conceptual Model* (Ostfildern, Ger.: Hatje-Cantz, 2009), 128–30.

9 For accounts of these and later iterations of the performance, see Scheper, *Triadische Ballett.* On the relation of the *Triadic Ballet* to the First World War, see also Eric Michaud, "Das 'Triadische Ballett' zwischen Krieg und Technik," in Muller, *Schlemmer: Tanz Theater Bühne,* 46–49; and Kate Elswit, "The Some of the Parts: Prosthesis and Function in Berthold Brecht, Oskar Schlemmer, and Kurt Jooss," *Modern Drama* 51, no. 3 (2008): 389–410.

10 A skilled craftsman, Carl Schlemmer worked briefly at the Bauhaus in 1921 and 1922 as craft master for the wall painting and stained glass workshops.

11 Schlemmer, *Letters and Diaries,* 96.

12 Oskar Schlemmer, László Moholy-Nagy, Farkas Molnar, *The Theater of the Bauhaus,* ed. Walter Gropius, trans. Arthur S. Weininger (Middleton, Conn.: Wesleyan University Press, 1961), 34.

13 Schlemmer, *Letters and Diaries,* 127–28.

14 Elswit, "The Some of the Parts," 401.

15 Schlemmer, *Letters and Diaries,* 21.

16 Schlemmer, *Letters and Diaries,* 74.

17 Oskar Schlemmer, "Bühnenelemente" (lecture, 1931), quoted in Karin von Maur, *Oskar Schlemmer: Monographie* (Munich: Prestel, 1979), 134. Translation mine.

18 Juliet Koss, *Modernism after Wagner* (Minneapolis: University of Minnesota Press, 2010), 234; Sigmund Freud, "The Uncanny," in idem, *Writings on Art and Literature* (Stanford, Calif.: Stanford University Press, 1997), 193–233.

19 See Paul Paret, "Picturing Sculpture: Image, Object, Archive," in Saletnik and Schuldenfrei, *Bauhaus Construct,* 163–80.

20 See Anton Kaes, *Shell Shock Cinema: Weimar Culture and the Wounds of War* (Princeton, N.J.: Princeton University Press, 2009); Amy Lyford, *Surrealist Masculinities: Gender Anxiety and the Aesthetics of Post–World War I Reconstruction in France* (Berkeley: University of California Press, 2007); and Hal Foster, *Prosthetic Gods* (Cambridge, Mass.: MIT Press, 2004).

21 On Schlemmer under National Socialism, see Otto Werckmeister, "Moderne Kunst, totalitäre Politik: Pawel Filonow, Oskar Schlemmer," in Eugen Blume and Dieter Scholz, eds., *Überbrückt: Aesthetische Moderne und Nationalsozialismus: Kunsthistoriker und Künstler 1925–1937* (Cologne, Ger.: Walter König, 1999), 211–22; Magdalene Droste, "Bauhaus-Maler im Nationalsozialismus: Anpassung, Selbstentfremdung, Verweigerung," in Winfried Nerdinger and Ute Brüning, eds., *Bauhaus-Moderne im Nationalsozialismus: Zwischen Anbiederung und Verfolgung* (Munich: Prestel, 1993), 113–41; and John-Paul Stonard, "Oskar Schlemmer's 'Bauhaustreppe,' 1932: Part II," *The Burlington Magazine* 152, no. 1290 (2010): 595–602.

22 Schlemmer, *Letters and Diaries,* 47. Translation altered. "Schlemihl" is a reference to Adelbert von Chamisso's 1814 novella *Peter Schlemihls wundersame Geschichte* (Peter Schlemihl's miraculous story).

APPENDIX

Selected Cultural Figures Who Served in World War I

HANNAH FULLGRAF WITH BETSY STEPINA ZINN

	Killed	Wounded	Western Front	Eastern Front	Italian Front	Alpine Front	Balkans	Gallipoli Campaign	Galicia	Macedonia	Middle Eastern Theater	Mediterranean Theater
AUSTRALIA												
Herbert Baldwin (UK citizen)			●									
Charles Bean		●	●					●				
Will Dyson		●	●									
Alexander Evans		●	●					●				
Frank Hurley			●								●	
Fred Leist			●									
James Peter Quinn			●									
Hubert Wilkins			●									
AUSTRIA												
Alfred Basel						●			●			
Albin Egger-Lienz						●						
Carry Hauser												
Oskar Kokoschka		●		●	●							
Oskar Laske					●				●			
Max von Poosch				●								
Arnold Schoenberg												
BELGIUM												
Alfred Théodore Joseph Bastien												
Maurice Langaskens			●									
CANADA												
Cyril Henry Barraud (UK citizen)		●	●									
John William Beatty			●									
Maurice Galbraith Cullen			●									
Kenneth Forbes		●										
Alexander Young Jackson		●	●									
Augustus John (UK citizen)			●									
William Rider-Rider (UK citizen)		●	●									
Gyrth Russell			●									
Charles Walter Simpson			●									
Frederick Horsman Varley			●									

	Killed	Wounded	Western Front	Eastern Front	Italian Front	Alpine Front	Balkans	Gallipoli Campaign	Galicia	Macedonia	Middle Eastern Theater	Mediterranean Theater
CZECHOSLOVAKIA												
Otto Gutfreund			●									
Bohumil Kubišta												
František Kupka			●									
FRANCE												
Guillaume Apollinaire		●	●									
Louis Aragon												
Paul Baignères			●									
Joë Bousquet		●	●									
Georges Braque		●	●									
André Breton			●									
Ricciotto Canudo (Italian citizen)		●	●							●		
Paul Castelnau			●									
Blaise Cendrars (Swiss citizen)		●	●									
Auguste-Elysée Chabaud			●									
Jean Cocteau			●									
André Derain			●									
Raymond Duchamp-Villon			●									
Charles Dufresne		●	●									
Jean Dufy			●									
Raoul Dufy												
André Dunoyer de Segonzac			●									
Paul Eluard		●	●									
Jean Fautrier		●	●									
André Favory												
André Fraye			●									
Othon Friesz			●									
Jean Galtier-Boissière			●									
Henri Gaudier-Brzeska	●		●									
Albert Gleizes			●									
Lucien-Victor Guirand de Scévola			●									
Paul Jouve			●									
Jean-Émile Laboureur			●									

	Killed	Wounded	Western Front	Eastern Front	Italian Front	Alpine Front	Balkans	Gallipoli Campaign	Galicia	Macedonia	Middle Eastern Theater	Mediterranean Theater
Roger de La Fresnaye			●									
Fernand Léger		●	●									
Georges Paul Leroux			●									
André Lhote			●									
Ivan Lönnberg (Swedish citizen)	●		●									
Jean Marchand												
André Mare		●	●									
André Masson		●	●									
Luc-Albert Moreau		●	●									
Léonce Rosenberg												
Jacques Vaché			●									
Henry Valensi												
Jacques Villon			●									
Édouard Vuillard			●									
Ossip Zadkine (Russian citizen)		●	●									
GERMANY												
Ernst Barlach												
Max Beckmann			●	●								
Peter August Böckstiegel												
Otto Dix		●	●	●								
Heinrich Ehmsen			●									
Adolf Erbslöh			●									
Max Ernst			●									
Conrad Felixmüller												
Hermann Glöckner			●	●								
Walter Gramatté												
Walter Gropius			●									
George Grosz												
Erich Heckel			●									
Otto Herbig			●									
Willy Jaeckel (Polish citizen)												
Rudolf Jahns												
Walter Kaesbach			●									
Max Kaus			●									
Anton Kerschbaumer			●									
Ernst Ludwig Kirchner												
Paul Klee (Swiss citizen)			●									

	Killed	Wounded	Western Front	Eastern Front	Italian Front	Alpine Front	Balkans	Gallipoli Campaign	Galicia	Macedonia	Middle Eastern Theater	Mediterranean Theater
Georg Kolbe				●								
Fritz Lang		●		●								
Wilhelm Lehmbruck												
August Macke	●		●									
Franz Marc	●		●									
Ludwig Meidner												
Ludwig Mies van der Rohe							●					
Otto Müller			●	●								
Otto Niemeyer-Holstein		●	●									
Otto Pankok			●									
Max Pechstein			●									
Anton Räderscheidt		●	●									
Rudolf Theodor Rocholl			●									
Oskar Schlemmer		●	●	●								
Karl Schmidt-Rottluff				●								
Otto Schubert		●	●									
Max Slevogt			●									
Jacob Steinhardt				●						●		
Heinrich Vogeler				●								
Albert Weisgerber	●		●									
HUNGARY												
André Kertész		●		●								
László Moholy-Nagy		●		●								
ITALY												
Umberto Boccioni	●					●						
Carlo Carrà												
Filippo Tommaso Marinetti		●				●						
Ubaldo Oppi		●										
Ugo Piatti						●						
Luigi Russolo		●				●						
Antonio Sant'Elia	●				●							
Mario Sironi						●						
THE NETHERLANDS												
Theo van Doesburg			●									

	Killed	Wounded	Western Front	Eastern Front	Italian Front	Alpine Front	Balkans	Gallipoli Campaign	Galicia	Macedonia	Middle Eastern Theater	Mediterranean Theater
NEW ZEALAND												
George Edmund Butler (UK citizen)			●									
NORWAY												
Per Krohg			●									
POLAND												
Armin Horovitz				●		●						
RUSSIA												
Pavel Filonov				●								
Mikhail Larionov		●		●								
Piotr Miturich				●								
SWITZERLAND												
Félix Vallotton			●									
TUNISIA												
Albert Samama-Chikli			●									
UKRAINE												
Vladimir Burlyuk	●									●		
UNITED KINGDOM												
David Bomberg		●	●									
Muirhead Bone			●									
John Warwick Brooke			●									
Alfred G. Buckham		●	●									
Frank Dobson			●									
Thomas Cantrell Dugdale							●			●		
Jacob Epstein			●									
Colin Unwin Gill			●									
James H. Hare			●									
Adrian Hill			●									
Charles Sargeant Jagger		●	●							●	●	
Eric Kennington			●									
Henry Lamb		●	●									●

	Killed	Wounded	Western Front	Eastern Front	Italian Front	Alpine Front	Balkans	Gallipoli Campaign	Galicia	Macedonia	Middle Eastern Theater	Mediterranean Theater
T. E. Lawrence											●	
Gilbert Ledward					●							
Wyndham Lewis			●									
John Hodgson Lobley												
Edward Loch			●									
James McBey			●								●	
Ambrose McEvoy			●									
David McLellan			●	●								
John Nash			●									
Paul Nash			●									
Christopher Nevinson			●									
William Orpen			●									
Herbert Read			●									
William Roberts			●									
Isaac Rosenberg	●		●									
William Rothenstein			●									
Charles Sims			●									
Gilbert Spencer										●		
Stanley Spencer										●		
Algernon Talmage			●									
Henry Tonks			●		●							
Louis Weirter			●									
Norman Wilkinson												●
UNITED STATES OF AMERICA												
William James Aylward												
Walter Jack Duncan			●									
Harvey T. Dunn			●									
Kerr Eby			●									
George Matthews Harding			●									
Ernest Hemingway		●	●									
Wallace Morgan			●									
Ernest Clifford Peixotto			●									
J. Andre Smith			●									
Paul Strand			●									
Harry Everett Townsend			●									
Claggett Wilson		●	●									

Contributors

TIMOTHY O. BENSON is the curator of the Robert Gore Rifkind Center for German Expressionist Studies at the Los Angeles County Museum of Art, where he has curated more than forty exhibitions, including most recently *Hans Richter: Encounters* (2013) and *Expressionism in Germany and France: From Van Gogh to Kandinsky* (2014). His publications include *Raoul Hausmann and Berlin Dada* (1987), *Nolde: The Painter's Prints* (1995), and *Between Worlds: A Sourcebook of Central European Avant-Gardes* (2002), which he coedited with Éva Forgács. Benson has received the Order of Merit of the Federal Republic of Germany; awards from the Society of Architectural Historians, the International Association of Art Critics, and the American Alliance of Museums; and research grants from the Humboldt Foundation, the German Academic Exchange Service (DAAD), and the Kress Foundation.

MATTHEW BIRO is a professor of modern and contemporary art in the Department of the History of Art at the University of Michigan, where he has been chair since 2010. Originally trained as a Continental philosopher, Biro came to art history through an interest in aesthetics and visual thinking. He is the author of *Anselm Kiefer and the Philosophy of Martin Heidegger* (1998), *The Dada Cyborg: Visions of the New Human in Weimar Berlin* (2009), and *Anselm Kiefer* (2013). Biro is currently writing a book on the photographer Robert Heinecken.

PHILIPP BLOM is an independent historian, writer, curator, and broadcaster. After obtaining a PhD in history from Oxford University, he has lived and worked in London, Los Angeles, Paris, and Vienna. In 2012–13, Blom was a guest scholar at the Getty Research Institute. He is currently working on a cultural history of Europe and the United States from 1918 to 1938.

BEATRICE VON BORMANN is curator of modern art and head of collections at the Museum der Moderne Salzburg. Previously, she worked as a freelance art historian in Amsterdam, curating shows such as *Max Beckmann in Amsterdam* (2007), *Dix/Beckmann: Myth and Reality* (2013–14), and *Oskar Kokoschka: Humanist and Rebel* (2013–14). She has taught at the University of Amsterdam and published extensively on Beckmann, Herbert Fiedler, Kokoschka, and Aristide Maillol, among others.

KAREN K. BUTLER is an associate curator at the Mildred Lane Kemper Art Museum at Washington University in St. Louis. She was the Andrew W. Mellon Fellow at the Barnes Foundation in Merion, Pennsylvania, from 2005 to 2009. She has curated exhibitions on contemporary art, post–World War II French art, photography, and nineteenth-century American landscape painting. Butler was cocurator of the exhibition *Georges Braque and the Cubist Still Life, 1928–1945* (with Renée Maurer of the Phillips Collection, 2013). She is a contributor to the catalog *Matisse in the Barnes Foundation* (forthcoming).

LEO COSTELLO is an associate professor of art history at Rice University, where he teaches eighteenth- and nineteenth-century European art. His book, *J. M. W. Turner and the Subject of History,* was published by Ashgate in 2012. He has also written on twentieth-century art and is now at work on a book about romantic painting titled *Pictures of Nothing: Romantic Figurations of the Void.*

TODD CRONAN is an associate professor of art history at Emory University, where his research centers on modern art and art theory, with particular emphasis on problems around expression, intention, affect, form, and meaning. He is the author of *Against Affective Formalism: Matisse, Bergson, Modernism* (2014). Cronan's articles have appeared in *The Brecht Yearbook, British Journal for the History of Philosophy, Design and Culture, New German Critique, qui parle, Radical Philosophy,* and *Zeitschrift für Kunstgeschichte.* He is a founding editor of *nonsite.org.*

ANJA FOERSCHNER is a research specialist at the Getty Research Institute. She received her PhD in art history from the Ludwig-Maximilians-Universität at München. Her research encompasses modern and contemporary art, with a special emphasis on contemporary art from Los Angeles.

HANNAH FULLGRAF is a PhD student in art history at Rice University in Houston, Texas. She has held positions at the Saint Louis Art Museum, the Pulitzer Foundation for the Arts, and the Dallas Museum of Art. In 2011, she received her master's degree from the Courtauld Institute of Art in London, England.

THOMAS W. GAEHTGENS is the director of the Getty Research Institute. Previously, he served as a professor and chair of art history at the Freie Universität Berlin and was the founding director of the German Center for the History of Art (DFK) in Paris. His research focuses on eighteenth- to twentieth-century French and German art and the history of the museum.

GORDON HUGHES specializes in early-twentieth-century European modernism, with a particular emphasis on French painting. He has published extensively on Robert Delaunay, most recently his book *Resisting Abstraction: Robert Delaunay and Vision in the Face of Modernism* (2014). He has also published on the paintings and film of Fernand Léger and the still lifes of Georges Braque, as well as on American art of the 1960s, '70s, and '80s, including essays on Douglas Huebler and Jenny Holzer. He coedited, with Hal Foster, *October Files: Richard Serra* (2000). In 2012–2013 he was a scholar in residence at the Getty Research Institute. His current book project is titled *Seeing Red: Murder, Abstraction, Machines.*

DANIEL MARCUS is a PhD student in the history of art at the University of California at Berkeley, where he is completing a dissertation that explores intersections between modernism and the automobile in interwar France. His writing on contemporary art, culture, and politics has appeared in *Artforum, Art in America, October,* and elsewhere. He has been a visiting scholar in the History of Art Department at the University of Pennsylvania and a teaching fellow in the histories of art, media, and design at Art Center College of Design in Pasadena.

DAVID MATHER, a former postdoctoral fellow at the Getty Research Institute (2012–13), is currently the Andrew W. Mellon Postdoctoral Fellow in the History, Theory, and Criticism of Architecture and Art program in the Department of Architecture at the Massachusetts Institute of Technology; this position is also affiliated with the MIT Center for Art, Science, and Technology (CAST). Mather received his PhD from the University of California, San Diego, in 2011. He is writing a book on visual movement in early Italian futurism.

CHARLES PALERMO is an associate professor of art history at the College of William and Mary in Williamsburg, Virginia. He works on modern art and has written on Guillaume Apollinaire, Peter Henry Emerson, Michel Leiris, Joan Miró, and Pablo Picasso. Palermo is the author of *Fixed Ecstasy: Joan Miró in the 1920s* (2008) and *Authority and Modernisms: Around Picasso, Around 1900* (forthcoming). He is a founding editor of *nonsite.org.*

PAUL MONTY PARET is an associate professor of art history and the associate dean of the Honors College at the University of Utah in Salt Lake City, where he writes and teaches on modern and contemporary art and visual culture. His research concerns the Bauhaus, the relationship of sculpture to the visual and material culture of modernity, and issues of land use in contemporary art.

JOYCE TSAI is an assistant professor of modern and contemporary art history at the University of Florida, Gainesville. Her research focuses on the recurrent artistic engagement with abstraction from the nineteenth to the twenty-first century across media. Her interests include the history of photography, technical art history, history of animation, aesthetic philosophy, and the intersection of art and technology. She is currently completing her book *László Moholy-Nagy: Painting after Photography.*

JOAN WEINSTEIN is the deputy director of the Getty Foundation. She is the author of *The End of Expressionism: Art and the November Revolution in Germany, 1918–19* (1990), as well as numerous articles on art in imperial and Weimar Germany.

BETSY STEPINA ZINN is a PhD student in art history at Rice University in Houston, Texas. From 2002 to 2010, she was an editor in the Department of Publications at the Art Institute of Chicago. She also holds an MA in art history from the University of Illinois at Chicago.

About the Plates

The plates in this volume are mainly drawn from the Getty Research Institute's Special Collections and illustrate aspects of the war explored in the exhibition *World War I: War of Images, Images of War*. These images present themes that differ from the publication's focus on the evolution of individual artists. Here we see examples of the visual culture of World War I expressed in a range of media, from journals and posters to prints and photographs.

The popular media demonstrate that World War I was a conflict not only of modern weaponry but also of cultural dominance over the European continent as it transitioned into the twentieth century. Less concerned with honored alliances or broken treaties than with the fate of European civilization, nations on both sides of the conflict used striking and inventive propaganda to establish their cultures as innately superior while denigrating those of their enemies.

For example, two covers of the German satirical journal *Simplicissimus* mock Russian cowardice and British imperialism, respectively, by showing the Russian bear retreating along a trail of blood and a spindly British soldier straddling a bloody globe. The journal *Le Mot* exemplifies a distinctive French modernism while ridiculing German militarism. Russian popular prints transform Kaiser Wilhelm II into a multiheaded devil. Propaganda posters such as the American *Destroy This Mad Brute—Enlist* bluntly attack suggested German barbarism—an accusation countered by images of German unity, such as the crowd of soldiers honoring Bismarck in the journal *Die Front*.

Interspersed with these images of rival cultures are personal renderings by individual artists. Prints by Henry de Groux, Willibald Krain, Frans Masereel, and Félix Vallotton capture the devastating modernity of this war in haunting depictions of artillery shells, poisonous gas, and barbed wire, while stereographs and photographs document the experience at the front. Small Austrian *Bildmedallions* instill national pride and perseverance through scenes of battle and patriotic poetry. By contrast, the Italian futurist Filippo Tommaso Marinetti used his invented genre of *parole in libertà* (words-in-freedom) to expose the filth at an Austrian army camp. Experimental media and radical visual language, as seen in John Heartfield's, Max Beckmann's and Fernand Léger's works, illustrate how artists struggled to come to terms with the war in its aftermath.

Nancy Perloff and Anja Foerschner

Illustration Credits

Every effort has been made to identify and contact the copyright holders of images published in this book. Should you discover what you consider to be a photo by a known photographer, please contact the publisher. Photographs of items in the collection of the Getty Research Institute are courtesy the Research Institute. The following sources have granted additional permission to reproduce illustrations in this book:

Introductory Plate
Pl. 1. © 2014 The Trier-Fodor Foundation.

Hughes
Fig. 1. Courtesy Graves Family Collection.
Fig. 2. Courtesy Gordon Hughes.

Allied Powers Plates
Pl. 4. © 2014 Artists Rights Society (ARS), New York / VG Bild-Kunst, Bonn.
Pl. 5. © 2014 Artists Rights Society (ARS), New York / ADAGP, Paris.
Pl. 10. Atkin Family Collection, Modern Graphic History Library, Department of Special Collections, Washington University Libraries, 2014–01. Photo: Washington University in St. Louis, Modern Graphic History Library.
Pl. 12. © 2014 Artists Rights Society (ARS), New York / ADAGP, Paris.
Pl. 14. Gift of Dr. and Mrs. Richard Simms.
Pl. 16. © 2014 Artists Rights Society (ARS), New York / SIAE, Rome.
Pl. 18. Photo: J. Paul Getty Museum, 84.XP.458.7.

Palermo
Works by André Masson are © 2014 Artists Rights Society (ARS), New York / ADAGP, Paris.
Fig. 1. Photo: University of Michigan, History of Art Department, Visual Resources Collections.
Fig. 2. 1856,0909.15. Photo © The Trustees of the British Museum / Art Resource, NY.
Fig. 3. Photo: Comité André Masson.
Fig. 4. Photo: Courtesy Galeria Marc Domènech.
Fig. 5. Photo: Jochen Littkemann, Berlin.

Marcus

Works by Fernand Léger are © 2014 Artists Rights Society (ARS), New York / ADAGP, Paris.

Fig. 1. The Louise and Walter Arensberg Collection, 1950, 1950-134-123. Photo: Philadelphia Museum of Art.

Fig. 2. From Douglas Cooper, *Fernand Léger: Dessins de Guerre, 1915–16* (Paris: Berggruen, 1956), plate 20.

Fig. 3. Inv. AM1985-426. Photo: Georges Meguerditchian. © CNAC / MNAM / Dist. RMN-Musée national d'art moderne—Centre Georges Pompidou / Art Resource, NY.

Fig. 4. Photo: Bibliothèque nationale de France.

Butler

Works by Georges Braque are © 2014 / Artists Rights Society (ARS), New York / ADAGP, Paris.

Fig. 1. The Louise and Walter Arensberg Collection, 1950. Photo: The Bridgeman Art Library.

Fig. 2. Photo: Albertina, Vienna—Batliner Collection, Inv. GE18DL.

Fig. 3. Bequest of Florene M. Schoenborn, 1995 (1996.403.11). Image © The Metropolitan Museum of Art / Art Resource, NY.

Fig. 4. Photo: Kunsthaus Zürich, Vereinigung Zürcher Kunstfreunde.

Costello

Works by Wyndham Lewis are © 2014 The Wyndham Lewis Memorial Trust / The Bridgeman Art Library.

Fig. 1. Photo: Tate, London / Art Resource, NY.

Fig. 2. Photo: Imperial War Museum / The Art Archive at Art Resource, NY.

Fig. 3. Photo © Tate, London 2014.

Fig. 4. Photo: The Bridgeman Art Library.

Foerschner

Fig. 1. © Tate, London 2014. From Roger Cardinal, *The Landscape Vision of Paul Nash* (London: Reaktion Books, 1989), 51.

Fig. 2. Photo: The Bridgeman Art Library.

Fig. 3. Photo © The Trustees of the British Museum. All rights reserved.

Fig. 4. Photo: The Bridgeman Art Library.

Mather

Works by Carlo Carrà are © 2014 Artists Rights Society (ARS), New York / SIAE, Rome.

Fig. 1. Acquired through the Lillie P. Bliss Bequest. Digital Image © The Museum of Modern Art / Licensed by SCALA / Art Resource, NY.

Figs. 3, 4. Photos: Scala / Art Resource, NY.

Central Powers Plates

Pl. 21. © 2014 Ludwig Meidner-Archiv, Jüdisches Museum der Stadt Frankfurt am Main.

Pls. 23, 25. © 2014 Artists Rights Society (ARS), New York / VG Bild-Kunst, Bonn.

Pl. 24. © 2014 Peter Krain.

Pl. 26. Neumann/Frumkin Collection, Museum Purchase 395:2002. Photo: Saint Louis Art Museum. © 2014 Artists Rights Society (ARS), New York / VG Bild-Kunst, Bonn.

Pl. 27. © 2014 Artists Rights Society (ARS), New York / VG Bild-Kunst, Bonn. Photo: bpk, Berlin / Art Resource, NY.

Biro

Works by Otto Dix are © 2014 Artists Rights Society (ARS), New York / VG Bild-Kunst, Bonn.

Fig. 1. Gift of Robert H. Tannahill. Photo: The Bridgeman Art Library.

Fig. 2. Photo: Kunstmuseum Stuttgart.

Fig. 3. Photo: bpk, Berlin / Bayerische Staatsbibliothek, Munich / Art Resource, NY.

Fig. 4. Photo: Erich Lessing / Art Resource, NY.

Gaehtgens

Fig. 1. Gift of the Ernst Ludwig Kirchner Estate, 1992. Photo: Kirchner Museum Davos.

Fig. 2. Charles F. Olney Fund, AMAM 1950.29. Photo: Allen Memorial Art Museum, Oberlin College, Ohio.

Fig. 3. Inv. A 259/57. Photo © Museum Folkwang, Essen.

Fig. 4. Ernst Ludwig Kirchner sketchbooks, 1917–1932, 850463, box 2.

Cronan

Works by Max Ernst are © 2014 Artists Rights Society (ARS), New York / ADAGP, Paris.

Fig. 1. GMA 3969, Bequeathed by Gabrielle Keller 1995. Photo: Courtesy National Galleries of Scotland.

Figs. 2–4. From William A. Camfield, *Max Ernst: Dada and the Dawn of Surrealism* (Munich: Prestel, 1993), fig. 33 and pls. 4 and 35.

Benson

Works by George Grosz are © Estate of George Grosz / Licensed by VAGA, New York, NY. Digital Images © 2014 Museum Associates / LACMA. Licensed by Art Resource, NY.

Fig. 1. Los Angeles, Los Angeles County Museum of Art, The Robert Gore Rifkind Center for German Expressionist Studies. Purchased with funds provided by the Robert Gore Rifkind Foundation, Beverly Hills, California (M.2009.25.2).

Fig. 2. Los Angeles, Los Angeles County Museum of Art, The Robert Gore Rifkind Center for German Expressionist Studies. Purchased with funds provided by Anna Bing Arnold, Museum Associates Acquisition Fund, and deaccession funds (83.1.73.51).

Fig. 3. Los Angeles, Los Angeles County Museum of Art, The Robert Gore Rifkind Center for German Expressionist Studies (M.82.288.72b).

Fig. 4. Los Angeles, Los Angeles County Museum of Art, The Robert Gore Rifkind Center for German Expressionist Studies (M.82.288.73c).

Weinstein

Works by Käthe Kollwitz are © 2014 Artists Rights Society (ARS), New York / VG Bild-Kunst, Bonn.

Fig. 1. Photo: The Bridgeman Art Library.

Fig. 3. Photo: The Bridgeman Art Library.

Fig. 4. Edition "A" (56/100). Photo: Foto Marburg / Art Resource, NY.

Tsai

Works by László Moholy-Nagy are © 2014 Artists Rights Society (ARS), New York / VG Bild-Kunst, Bonn.

Figs. 1, 2. Photos: Courtesy the Estate of László Moholy-Nagy.

Fig. 3. Photo: ÖNB/Wien + ImageID Pk 5067,57.

Fig. 4. Accession 1994.010.0023. Photo: Courtesy University Museums, University of Delaware.

Bormann

Works by Oskar Kokoschka are © 2014 Fondation Oskar Kokoschka / Artists Rights Society (ARS), New York / ProLitteris, Zürich.

Fig. 1. Purchased with a special credit from the Basel government, Inv. 1745. Photo: Erich Lessing / Art Resource, NY.

Fig. 2. Estate of Karl Nierendorf, By purchase, 48.1172.380. Photo: Solomon R. Guggenheim Museum.

Fig. 3. Photo: Erich Lessing / Art Resource, NY.

Fig. 4. Inv. Nr. 2401. © Photo: Staatsgalerie Stuttgart.

Paret

Fig. 1. From Arnold Lehman and Brenda Richardson, eds., *Oskar Schlemmer* (Baltimore Museum of Art, 1986), 196.

Fig. 2. Photo: Bauhaus-Archiv Berlin, Inv. Nr. 1222_s7.

Fig. 3. Photo: J. Paul Getty Museum, 84.XM.127.8.

Fig. 4. Photo: Bauhaus-Archiv Berlin, Inv. Nr. 1222_s4.

Acknowledgments

Neither this book nor the exhibition with which it is in dialogue, *World War I: War of Images, Images of War,* held at the Getty Research Institute in Los Angeles and the Mildred Lane Kemper Art Museum in Saint Louis, would exist were it not for Thomas W. Gaehtgens, director of the Getty Research Institute. The original idea for both the book and the exhibition came from Thomas, as did the determination to make them happen. To our fellow curators—Nancy Perloff, Anja Foerschner, and Thomas—and to our curatorial assistant, Christina Aube (Jeeves to our Bertie Wooster), we offer particular thanks, not only for making us feel so welcome at the Getty but also for the rich exchange of ideas that made working on this exhibition such a pleasure.

The unique contribution of this book—tracking a range of artists changed by the experience of war—lies in the extraordinary essays contained herein; profuse thanks to all of the authors: Charles Palermo on André Masson; Daniel Marcus on Fernand Léger; Karen Butler on Georges Braque; Leo Costello on Wyndham Lewis; Anja Foerschner on Paul Nash; David Mather on Carlo Carrà; Matthew Biro on Otto Dix; Thomas Gaehtgens on Ernst Ludwig Kirchner; Todd Cronan on Max Ernst; Timothy Benson on George Grosz; Joan Weinstein on Käthe Kollwitz; Joyce Tsai on László Moholy-Nagy; Beatrice von Bormann on Oskar Kokoschka; and Paul Monty Paret on Oskar Schlemmer. We're very appreciative of the extensive research done by Hannah Fullgraf and Betsy Stepina Zinn in compiling the appendix—the first of its kind in print—that follows these essays.

For her Fitzcarraldo-like efforts in hauling this book over the mountain, we are especially grateful to our editor at Getty Research Institute Publications, Lauren Edson. Managing editor Michele Ciaccio did her best to keep things on track when we were doing our best (or so it must have seemed) to the contrary. Research assistants Andrew Goodhouse, Anna Kelner, Ashley Newton, and Sarah Zabrodski kept the smallest of details from falling through the cracks. Gail Feigenbaum, associate director of research and publications, provided a bird's-eye view onto this book at crucial moments, greatly improving its conception, content, and design. And we extend our deep thanks to Jim Drobka and Stacy Miyagawa for designing and producing such a beautiful book.

Finally, for being so patient with the time we have spent in the trenches, we thank Veronica Buckley, Jennie King, and Oscar King Hughes.

Gordon Hughes and Philipp Blom

Index

Note: page numbers in italics refer to figures.

abreaction, 20
abstract art
 Arp on, 135
 Léger and, 55, 57, 59–60
 Lewis and, 74, 75
 Schlemmer and, 172
Académie Colarossi (Paris), 139–40
Académie Royale des Beaux-Arts
 (Brussels), 44
Action (Lewis), 78
actionism, Viennese, 164
Adams, Henry, 5
Adolf and Julius Lesser Foundation, 139
aerial photography, 159, 160, 162
After the Battle (Nash), 84
agency
 accounts of in combat neurosis therapy, 20
 in origin of war, debate on, 22
 structuralist and poststructuralist
 accounts, 22–23
Akademie der Bildenden Künste
 (Dresden), 139
Alfred Flechtheim gallery, 128
alla prima (direct painting) technique, 110
allegory
 Benjamin on, 114, 116
 in Dix, 108, 110, 114, 115, 116
*Allgemeine Geschichte des grossen
 Bauernkriegs* (Kollwitz), 146
Allos Makar (Kokoschka), 167–68
All Quiet on the Western Front
 (Remarque), 49
Amerikanismus, of Grosz, 140
amnesia, combat neurosis and, 19–20
antiwar sentiment, 2, 8, 126n14, 150, 156.
 See also disillusionment; pacifism
Apel, Dora, 150
Apocalypse series (Kirchner), 11, 124, *124*
Apollinaire, Guillaume, 49
Apple Pickers (Nash), 81–82
Appleton, Jay, 72
Après le théâtre: Le rêve du poilu
 (Roubille), *32*

Arbeitsrat für Kunst, 130, 134, 135
architecture
 German Gothicism and, 133–34
 in political program of Taut, 130
Architecture (Ernst), 131, *132*, 132–33
Arp, Hans, 135
art-action, as term by Marinetti, 94n10
artillery
 casualties inflicted by, 69n18
 French 75mm cannon: Léger on, 55, 59,
 60; as source of French pride, 61n8
 as modern weapon, 159
 observers for, 157–59, *158*
 soldiers' fear of, 65, 69n18
Artilleryman Mounting a Horse
 (Kirchner), 121
artillerymen, Lewis on, 72–73
Artillerymen in the Shower (Kirchner), 121
artists' responses to war
 in France, 63
 in Germany, 118, 121, 125, 148
 return to tradition as, 10
art nouveau, 164, 170
Artois, Battle of, 63
Augusterlebnis ("August experience"), 8
automatic drawing, 48, 52, 52n10
avant-gardism
 Carrà and, 92, 94
 Ernst and, 128, 130–31, 132
 Grosz and, 138
 Léger and, 54
 and modern technology, 9
 Moholy-Nagy and, 156
 retreat from, after 1915, 92, 95n22
 Russian Revolution and, 142
 war and, 10, 88
 See also futurism

Baargeld, Johannes, 132–34, 135
Baldung, Hans, 108
Ball, Hugo, 5, 6–7, 10, 13
Ballerina (Carrà), 93
Das Bangen (Kollwitz), 148, *149*

Barbusse, Henri, 16, 17, 49
Bartók, Béla, 6
Bataille, Georges, 44, 47, 48, 49
Battery Position in the Wood (Lewis,
 1918), 72
A Battery Shelled (Lewis), 72–73, *73*, 74,
 77, 78, 79n17
Battle of San Romano (Uccello), 74
Baudry de Saunier, Louis, 54
Bauhaus
 aesthetics of, 130
 exhibition (1923), 174
 Moholy-Nagy and, 160
 Schlemmer and, 3, 173, 174, 175
 World War I and, 173–74
 Worringer and, 134
 See also Staatliche Bauhaus
"Bauhaus Head" signet (Schlemmer), 174
Bauhaus Manifesto (Gropius), 174
The Bauhaus Staircase (Schlemmer), 178
Beckmann, Max, *105*, 119, 125
being, Masson on nature of, 44–45
Benjamin, Walter, 4, 10, 17, 114, 116
Berliner Secession, 148
Der Bildermann (periodical), 150
Bildmedallions (Löffler), *99*
bildungsroman, German ideal of, 131, *133*
biography, as interpretation, 22–23
Blast! (periodical), 71–72, 76, *77*, 77
Blasting and Bombardiering (Lewis), 72,
 74, 75, 76–77
Der Blaue Reiter, 125
Blunden, Edmund, 16, 17, 20
Boccioni, Umberto, 1, 6, 88, 94–95n11,
 95n22
bodies, mutilated and disfigured
 in Epstein, 11
 and neoclassicism, 10, 11
 in postwar art, 11–12
 postwar ubiquity of, 3, 9
 in Schlemmer, 3, 174, 175–78
 See also prosthesis
Bohn, Willard, 95n14

bolshevism, postwar turmoil and, 11, 12
Braque, Georges, 62–68
　aesthetic theory of, 62, 63, 69n16
　career of, 6
　correspondence, 62–63
　materiality, focus on, 62, 63–64
　psychological rupture implicit in, 64–68
　repression of war experiences in, 3, 62,
　　63, 65, 68
　style of, 3, 62, 63, 65
　on tactile space, 3, 62, 64, 65–66, 68
　wartime experiences, 3, 62–63, 65–66
　works by, 64, *64*, *66*, 66–68, *67*, 69n16
Breton, André, 44, 52
Bride of the Wind (Kokoschka), *165*, 165–66,
　171n11
British Artists at the Front series, 87n27
Brown, William, 19–20
Die Brücke artists, 110, 125, 140
Brusilov Offensive, 156, 159–60, 162
The Buffet Table (Braque), *66*, 66–67
Bulletin D (Ernst and Baargeld), 131, 135
Bund neues Vaterland, 154
Burger, Albert, 174–75
Bushart, Magdalena, 134

Carfax Gallery, 80
Carmagnole (Kollwitz), 154n5
Carrà, Carlo, 88–94
　and aesthetic conscience, 92–93
　correspondence, 90, 91, 94n11, 95n24
　disillusionment of, 3
　futurism of, 88–92, 93, 94
　and metaphysical painting, 92, 93, 94
　nervous breakdown, 92
　psychological trauma of, 3
　style of, 3, 92–93, 95n27
　views on war, 88, 90, 91, 94
　wartime experiences, 3, 88, 92
　works by, *89*, 89–90, 90–92, *91*, *93*, 93–94
Carso = Topaia (Marinetti), *41*
Cassirer, Paul, 148, 150, 169, 170
Cathedral (Feininger), 174
cathedrals
　Bauhaus movement and, 134, 173–74
　and German Gothicism, 135, 136
Cendrars, Blaise, 11, 17, *30*
censorship, in Germany, 142, 143–44,
　145n21, 146
Chagall, Marc, 129
Chamisso, Adelbert von, 122–23, 127n25
Chaos Decoratif (Nash), 82, *83*
Chaplin, Charlie, 10

Chemin des Dames, 3, 45–46, 48–49
Chevreul, Michel Eugène, 95n11
The Child Prodigy (Carrà), 93
The City (Léger), 54, 59
Skull City (Masson), *48*, 48–49
civil rights movement, prewar culture and, 6
Clark, Christopher, 21, 22, 23
Clark, T. J., 22–23
classical art, Arp on, 135
Cologne Werkbund exhibition (1914), 135
combat neurosis. *See* psychological trauma
Combat No. 2 (Lewis), 75, 76, *76*, 77
Composition (Lewis), 71, *71*, 72, 78
Composition in Pink (Schlemmer), 172
Conradi, Hermann, 4
conscience, aesthetic, Carrà and, 92–93
Contrasts of Forms series (Léger), 54,
　55–57, *56*
Cooper, James Fenimore, 140
Corbett, David Peters, 70–71, 74, 87n32
Corinth, Lovis, 124, 168
Cuban Missile Crisis, 21
cubism
　of Braque, 3, 62, 63, 65
　Carrà and, 88, 93
　cultural origins of, 6
　Dix and, 111, 112
　Ernst and, 129–30, 132, 135
　futurism and, 90
　of Léger, 54, 55, 57–60
　Masson and, 44, 51
　Moholy-Nagy and, 156
　Schlemmer and, 172
　wartime fragmentation and, 55, 57–58,
　　59, 61n9
culture, traditional, technology and, 5–6, 10

Dadaism
　Ball and, 5
　Berlin Dada, 2, 112, 142
　Cologne Dada, 133–34, 135
　Dix and, 112, 114
　Ernst and, 2, 130, 132, 135–36
　exhibitions, 112
　German defeat and, 142
　Grosz and, 2
　and opposition to war, 126n14
Dagen, Philippe, 63
Damblans, Eugène, *34*, *36*
Dans Verdun (Léger), 61n15
Däubler, Theodor, 140, 141, 142
Dead soldier caught in barbed wire
　(Krain), *103*

Dead soldiers (Masereel), *29*
"The Dead to the Living" (Freiligrath), 152
death and eroticism, in Masson, 47–48, 52,
　52n10
Debout les morts (Masereel), *29*
de Chirico, Andrea (Alberto Savinio), 92
de Chirico, Giorgio, 3, 92, 128
degenerate art, Nazis and, 2, 116, 178
De Groux, Henry, *28*
Delaunay, Robert, 95n11, 128
Derenthal, Ludger, 131
Der Sturm gallery (Berlin), 128, 172
Destroy This Mad Brute—Enlist (Hopps), *35*
detachment
　and automatic drawing, 48
　in Graves, 17–19, 20, 24n21
　as symptom of combat neurosis, 19
　treatment of, 19–20, 24–25n25
The Devil's Bagpipes (anon.), *40*
Dewey, John, 10
direct painting (*alla prima*) technique, 110
Disasters of War (Goya), 74
disillusionment, 1
　of Carrà, 3
　fascism and bolshevism as response to, 11
　impact of war and, 71
　of Kollwitz, 150
　of Lewis, 72, 74
　machine-based war and, 7–8, 10
The Disks (Léger), 54, 59
Dix, Otto, 108–16
　allegorical overtones in, 108, 110, 114,
　　115, 116
　artistic training, 108–10
　influences on, 11, 110, 111, 115, 116
　and mythology of America, 140
　political commentary of, 108, 112–13,
　　114–16
　self-scrutiny in, 110–12
　style of, 11, 85, 108, 110, 112, 113–14,
　　115, 116
　themes in, 2
　views on war, 110, 111–12, 112–14, 116
　wartime experiences, 2, 4, 108, 110, 116
　works by, 11, 108–10, *109*, 110–11, *111*,
　　112–13, *113*, 114, *115*, 115–16, 168
Dr. Jekyll and Mr. Hyde (1931 film), 12
Dresden Kupferstich-Kabinett, 146
Dresdner Sezession Gruppe 1919, 112
The Drillers (Léger), 57–58, *58*
Dürer, Albrecht, 11, 108, 139–40, 169
Dying Lioness (Assyrian bas relief), 47, *47*

Ecce Homo **(Grosz),** 140, *141*, 142
Ecce Homo (Nietzsche), 44
École nationale supérieure des Beaux-
 Arts, 44
Edwards, Paul, 77, 78n1
Einstein, Carl, 54, 60, 112
Eisner, Kurt, 142
The Emigrants (Kokoschka), 169
*Encounter of Schlemihl with the Gray Man
 on the Road* (Kirchner), 123
Der Engländer und seine Weltkugel
 (Heine), *102*
Én portraits (Moholy-Nagy), 160, *161*
Entartete Kunst exhibition, art included
 in, 2, 116, 178
Epstein, Jacob, 11
Ernst, Karl, 128
Ernst, Max, 128–36
 on artists and "pure world formation,"
 130
 and the avant-garde, 128, 130–31, 132
 career of, 6
 and cubism, 129–30, 132, 135
 and Dadaism, 2, 130, 132, 135–36
 exhibitions, 128, 135–36
 and expressionism, 128–30, 132, 135–36
 and Gothicism, 132–35
 influences on, 128–29
 and redemptive power of materials, 135
 style of, 2, 128–29, 132
 views on war, 128
 wartime experiences, 2, 4, 128, 136n5
 wartime ideological publications,
 129–30
 works by, 128–29, *129*, 131–33, *132*,
 133, 134
eroticism and death, in Masson, 47–48,
 52, 52n10
Erste Internationale Dada-Messe (1920),
 112, 143
Execution (Kirchner), 121
"The Exhibitors to the Public" (1912), 94n5
Exposition Universelle (1900), 5
expressionism
 Austrian, 165
 Baargeld on, 133
 of Dix, 110, 112
 Ernst and, 128–29, 129–30, 132, 135–36
 Grosz and, 140
 Kokoschka and, 165
 Moholy-Nagy and, 156
 political program of, 130

Farewell to the troops (anon.), *98*
fascism
 futurism and, 88
 postwar crisis and, 11, 12
 See also Nazis
Feierabend ("Ich dien") (Grosz), 143, *143*
Feininger, Lyonel, 174
Felixmüller, Conrad, 112
Le feu (Barbusse), 16, 49
The Field before the Wood (Nash), 80
film, postwar, 10, 12
First George Grosz Portfolio (Grosz), 140,
 141, 142
Flowers and Fish (Ernst), 128
Formprobleme der Gotik (Worringer),
 134–35
*Forty-Five Percent Fit for Work (The War
 Cripples)* (Dix), 112–13, *113*
Frankenstein (1931 film), 12
Franz Ferdinand, Archduke of Austria, 21
Free Sculpture G (Abstract Figure)
 (Schlemmer), 177–78
Free-Word Painting—Patriotic Festival
 (Carrà), 90, 95n13
Freiligrath, Ferdinand, 152
French military
 mutinies and revolts within, 49
 poor leadership of, 45–46
Freud, Sigmund, 6, 19, 20, 177
The Friends (Kokoschka), 169
Frodl, Gerbert, 164
Fröhlich, Max, *101*
Fruit d'une longue expérience (Ernst),
 132, *134*
Fruit of a Long Experience (Ernst),
 131–32, 132–33, *133*
Funeral of the Anarchist Galli (Carrà),
 89, 89–90, 94nn3–4
Fussell, Paul, 15, 17–18, 71
futurism
 Carrà and, 3, 88–92, 93, 94
 cubism and, 90
 Dix and, 111, 112
 doctrine of, 88–89, 90, 94n5
 Ernst on, 129–30
 exhibitions, 88
 Grosz and, 141
 and interwar fascism, 88
 Marinetti and, 71
 Moholy-Nagy and, 156
 in Paris, 90
 views on war, 3, 6, 9

Galerie Ernst Arnold (Dresden), 172–73
Gallerie Bernheim-Jeune (Paris), 88
Galli, Angelo, 89, 94nn3–4
Gemäldegalerie Alte Meister (Dresden),
 108–10
Gercken, Günther, 123
German nationalism, and Gothicism,
 134–35
Germany
 censorship in, 142, 143–44, 145n21, 146
 film industry, postwar, 12
 political turmoil of interwar years, 12
 prewar technological advances, 4
 war weariness in, 150
Gesellschaft der Künste, 130, 131, 135
gestural painting, in Dix, 110
Glass Pavilion (Taut), 135
God with Us (Grosz), 142–43, *143*
Goethe, Johann Wolfgang von, 136, 150
Der Golem (1920 film), 12
Goodbye to All That (Graves)
 events described in, 15, 17–18
 Graves on writing of, 17
 mix of fact and fiction in, 15–18, 24n5
 narrator's detachment in, 17–19, 20,
 24n21
Good Old Student Days (Grosz), 140
Gossips (Lewis), 73
Gothicism, German, 133–35
Gott mit Uns (Grosz), 142–43, *143*
Goya, Francisco de, 11, 74
Grandgérard, Lucien Henri, *37*
Graves, Robert, *14*
 and new forms of storytelling, 17
 psychological breakdown of, 18
 reported death of, 15, *16*
 "Two Fusiliers," 23
 wartime experiences, 15
 See also *Goodbye to All That*
Grobherzoglich Sächsische Hochschule
 für Bildende Kunst (Weimar), 173
Grobherzoglich Sächsische Kunstgewerbe-
 schule (Weimar), 173
Gropius, Walter
 Alma Mahler and, 166, 167
 and Bauhaus aesthetic, 130, 134–35,
 174, 179n7
 Schlemmer and, 172–73, 175
 wartime experiences, 173
Grosse Berliner Kunstausstellung, 146
Grosz, George, 138–44
 Amerikanismus of, 140
 artistic training, 139–40

career of, 142
Dix and, 112
films by, 141–42
and German censorship, 143–44
influences on, 139–40
personas adopted by, 138, 139, 140, 144
politics of, 142
psychological illness of, 138, 140–41, 142
style of, 141
themes in, 2
wartime experiences, 2, 4, 138–39, 140–41
works by, 138–39, *139*, 140, 141, *141*,
 142–43, *143*, 144
Guerrapittura (Carrà), 90–92, *91*
Guitar and Pipe (Polka) (Braque), 64, *64*
Guitar and Still Life on a Mantelpiece
 (Braque), *67*, 67–68
Guns exhibition (Lewis), 72, 74, 75
The Guns of August (Tuchman), 21

The Hands of Orlac (1924 film), 12
Hartlaub, Gustav, 112, 116n1
Hauptmann, Gerhart, 146
Heartfield, John, *106–7*, 140, 141–42
Heimweg (Heine), *104*
Heine, Thomas Theodor, *102*, *104*
Heraclitus, 44–45
Herzfelde, Helmut, 140. *See also*
 Heartfield, John
Herzfelde, Wieland, 138, 140, 142, 143–44
Hiller, Kurt, 130–31
historicism, 164
The Hobbit (Tolkien), 12
Hoffman, Daniel, 19, 24n21
Hogarth, William, 78
Hölzel, Adolf, 172
Hölzel and His Circle (1916 exhibition), 172
Hopps, Harry R., *35*
Hötzel, Elsa, 174–75
Huelsenbeck, Richard, 126n14, 142
human worth, technology and, 5–6, 8, 13

illusionism, Arp on, 135
impressionism, Ernst on, 129–30
In a Garden under the Moon (Nash), 87n23
individual, relation to universe in
 Masson, 47
individualism, Viennese, 164
In Stahlgewittern (Jünger), 16
intelligence, Brusilov Offensive and,
 159–60
Internationales Anti-Kriegs-Museum
 (Berlin), 152

Iribe, Paul, 31, *38*
Isonzo, battles of, 168
Italy, and World War I, 88, 92
Ivanov, Vyacheslav, 6

***J'ai tué* (Cendrars),** 17, *30*
Jakob, Helene, 112
Jastrebzoff, Sergei, 90, 92
*Je suis là, mon capitaine, vous ne tomberez
 pas* (Iribe), *38*
Jones, David, 11
Jünger, Ernst, 9, 11, 16, 17, 111

Kahnweiler, Daniel-Henry, 51
Kandinsky, Vassily, 6, 125, 129
Karte von Europa im Jahre 1914 (Trier),
 vi–vii
Kennedy, John F., 21
Kessler, Harry Graf, 142
King Kong (1933 film), 12
Kirchner, Ernst Ludwig, 118–26
 artistic training, 125
 on artists, social importance of, 121
 career of, 6, 125
 on combat and artistic creation, 119
 correspondence, 118, 119, 122, 123
 illness, 118, 119, 121, 124, 125, 126
 influences on, 11
 inner turmoil of, 121, 122, 123, 125–26
 overwhelming fear of, 119–21
 self-portraits, 119, *120*, 121, *122*, 124, 168
 views on war, 118, 119–21
 wartime experiences, 2, 118, 119
 works by, 11, 121, *122*, 122–23, *123*, 124,
 124, 168
Klimt, Gustav, 164
Knight Errant (Kokoschka), *167*, 167–68
Knoblauch, Elfriede, 118
Kodály, Zoltán, 6
Kokoschka, Oskar, 164–70
 Alma Mahler and, 2, 165–68, 170
 career of, 6, 164, 169, 170
 exhibitions, 164
 influences on, 169
 style of, 164, 165, 166, 168–69, 170
 wartime experiences, 2, 166–67, 168
 works by, 164, *165*, 165–66, *167*, 167–68,
 168–70, *169*
Kollwitz, Karl, 146, 148
Kollwitz, Käthe, 146–54
 background, 146
 career of, 146, 150
 death of son and, 2, 146, 148, 150

early themes and style, 146–48
pacifism of, 146, 150, 152, 154
politics of, 146, 147, 150–52
postwar themes and style, 2, 146, 151–54
struggle to depict war, 150, 152–54, *153*
views on war, 148, 150–51, 152
and women, portrayals of, 146–48, 154,
 154n5
woodcuts, 2, 146, *151*, 151–54
works by, 146–48, *147*, *149*, 150, *151*,
 151–52, 152–54, *153*, 154n5
Kollwitz, Peter, 2, 148, 150
Kölner Tagblatt (periodical), 129
Koss, Juliet, 177
Krain, Willibald, *103*
Krauss, Rosalind, 23
Krieg (Meidner), *100*
Krieg: 7 Originallithographien (Dix et. al),
 103
Der Krieg (1924 series, Dix), 11, 108
Der Krieg (1932, Dix), 108
Kriegsbriefe deutscher Studenten (Wittkop,
 pub.), 8
Kriegszeit (periodical), 148, 150
Kunstgewerbeschule (Berlin), 139, 173
Kunstschau (Vienna, 1908), 164
Kunstverein (Cologne), 131, 134, 135

Lanchner, Carolyn, 51
Lang, Fritz, 10
Laon (Ernst), 128
Lapré, Marcelle, 62
Laqueur, Thomas, 21, 22
Laskar-Schüler, Else, 142
Leatherstocking Tales (Cooper), 140
Léger, Fernand, 54–60
 career of, 6
 correspondence, 54, 57, 59, 61n4
 machines, depictions of, *59*, 59–60
 style of, 54, 55, 57–60
 technologies of war, interest in, 2, 55, 59
 wartime experiences, 4, 54, 57
 works by, *30*, 55–57, *56*, 57–58, *58*, 59, 60,
 61n15
Leicester Galleries, 84
Let There Be War (Fröhlich), *101*
Lewis, Wyndham, 70–78
 autobiography, 72, 74, 75, 76–77
 Blast! periodical and, 71–72, 76, 77
 career of, 6
 correspondence, 70–71
 humor in, 73
 influences on, 74, 78

Lewis, Wyndham (continued)
 pre- and postwar periods and, 70, 74–78
 prescient anticipations of war in, 77–78
 response to war, 70–72, 74, 76–77
 and sentimentalism, rejection of, 70–72
 style of, 2, 74–75, 78
 themes in, 2
 wartime experiences, 72–73, 74, 76, 78n1
 works by, 71, *71*, 72–73, *73*, 74, *75*, 75–76, *76*, *77*, *77*, 78
Leys, Ruth, 19, 20, 22, 24–25n25
Lichnowsky, Mechtilde, 168
Liebknecht, Karl, 142, *151*, 151–52
Linkspazifismus (Leftist Pacifism), 131
Little Grosz Portfolio (Grosz), 140, *141*, 142
Löffler, Berthold, *99*
Loos, Adolf, 164, 166, 167
The Lovesick (Grosz), 138
"Lucrative History-Writing" (Ernst), 130–31, 135
Luxemburg, Rosa, 142

Macke, August, 129
Mahler, Alma, 2, 165–68, 170
Mahler, Gustav, 165
Malczewski, Jacek, 168
Malerei, Fotografie, Film (1927, Moholy-Nagy), 161–62
Malerei, Photographie, Film (1925, Moholy-Nagy), 160–61, *161*
Malik Verlag publishing house, 142
Man and Lioness (Masson), *46*, 47
Mann, Heinrich, 126n1
The Mantelpiece (Braque, 1921), 67–68
The Mantelpiece (Braque, 1928), *67*, 67–68
Marc, Franz, 1, 6, 119, 125, 129
Marinetti, Filippo Tommaso, *41*, 71, 88, 94n10, 94n11, 95n24
masculinity, soldiers' hope to regain, 7–8, 9
Masereel, Frans, *29*
Masked Soldiers (De Groux), *28*
Massacre (Masson), *51*, 52
Masson, André, 44–52
 artistic training, 44
 and automatic drawing, 48, 52, 52n10
 death and eroticism in, 47–48, 52, 52n10
 influences on, 44
 philosophical beliefs of, 44–45, 47
 on pleasure in war, 49
 postwar life, 49–51
 psychological trauma of, 3
 style of, 3, 44, 51, 52, 52n10

 themes in, 3, 44
 violence of works by, 51, 52
 wartime experiences, 3, 45–46, 48–49, 52, 53n20
 works by, *46*, 47, *48*, 48–49, *50*, 51, *51*, 52
May, Karl, 140
McDougall, William, 20
Mechanical Elements (Léger), 59
medallions, *99*
"The Medical Journal of Dr. William King Thomas USA Oct. 15 to 15 Nov. 15" (Grosz), 138–39
Meidner, Ludwig, *100*, 138
Memoirs of George Sherston (Sassoon), 16
memoirs of war
 blending of fact and fiction in, 16
 storytelling forms and, 17, 23
Memorial Sheet for Karl Liebknecht (Kollwitz), *151*, 151–52
Memory of New York (Grosz), 140
The Menin Road (Nash), 85, *85*, 87n28
Messerschmidt, Franz Xaver, 164
metaphysical painting of Carrà, 3, 92, 93, 94
Metropolis (1926 film), 10
military service, efforts to avoid, 54, 118, 119, 126n14, 142, 169
Miró, Joan, 49
modernism, 112
modernity
 prewar impact of, 4–6
 volunteers' hope to escape from, 7–8
 war as encounter with, 7, 10, 12–13
Modern Times (Chaplin), 10
Moholy-Nagy, László, 156–62
 and New Vision, 160–62
 political views of, 162
 style of, 156–57; impact of wartime experiences on, 157–58, 160–62
 technologies of war, interest in, 2
 wartime experiences, 156, 157–60, *158*
 works by, 156, *157*, 160–62, *161*
Monahan, Laurie, 52, 52n10
Moore, Thomas Sturge, 70–71, 72
Mother and Son (Carrà), 92, *93*
The Mothers (Kollwitz), 154
Mother with a Child in Her Arms (Kollwitz), 150
The Motor (Léger), 59
The Mule Track (Nash), 85
Munton, Alan, 74, 79n17
Myers, C. S., 20

Nach Zwanzig Jahren (Heartfield), *106–7*
Nash, Paul, 80–86
 artistic training, 80, 86n9
 correspondence, 82, 84, 87n21
 early struggle for artistic voice, 80–82
 exhibitions, 80, 84
 influences on, 80–81, 84
 romantic sensibility of, 80, 82, 83
 style of, 80–81, 83–84, 84–86
 themes in, 2
 on war, 80, 81, 82–83
 wartime experiences, 4, 81–82, 87n21
 on work of war years, 85, 86
 works by, 80, *81*, 81–82, *83*, *84*, 84–85, *85*, 87n23
naturalism, of Lewis, 74
Nazis, and degenerate art, 2, 116, 178
neoclassical aesthetic, war and, 10, 11
Neuberger, Fritz, 169
Neue Jugend (Grosz), 142
Neue Kunst Hans Goltz gallery (Munich), 141
Neue Sachlichkeit, 108, 116n1
Nevinson, C. R. W., 84, 86n9
New Objectivity, 108, 116n1
New Vision, 160–62
Nierendorf, Karl, 112, 130
Nietzsche, Friedrich, 2, 44–45, 110, 111, 116
A Night Bombardment (Nash), 85, 87n28
Nivelle, Robert, 45–46, 49
Nolde, Emil, 110
Nord-Sud (periodical), 63
Normand, Tom, 72, 73
Norton Cru, Jean, 16
Nosferatu (1922 film), 12
Notre joujou, le Kaiser Wilaine (Iribe), *31*

O alte Burschenherrlichkeit (Grosz), 140
Orlacs Hände (1924 film), 12
Orlik, Emil, 139, 140
Orr, H. Scott, *43*
Osthaus, Karl Ernst, 119, 122
Our Boys in France Learning to Correctly Use Gas Masks (Keystone View Company), *42*
Outbreak (Kollwitz), *147*, 147–48

pacifism
 of Heartfield and Herzfelde, 142
 of Kollwitz, 146, 150, 152, 154
 Leftist (Linkspazifismus), 131
 of Social Democratic Party, 154

Painting K (Schlemmer), 172
Papini, Giovanni, 92, 95n22
Passchendaele, battle of, 78, 87n21
Pastoral Toilet (Lewis), 73
Peasants' Revolt (Kollwitz), 146–48, *147*
Pechstein, Max, 110
"Pensées et réflexions sur la peinture"
 (Braque), 63, 69n16
Pétain, Henri-Philippe, 49
Peter, Eva, 140
Peter Schlemihls wundersame Geschichte
 (Chamisso), 122–23, *123*
photography
 aerial, 159, 160, 162
 and New Vision, 160–62
 by soldiers, 68n5
Picasso, Pablo, 6, 10, 22–23, 62, 94n9
pictorialism, Moholy-Nagy and, 161–62
Piscator, Erwin, 142
Pittura scultura futurista (Boccioni), 94n11
Das Plakat (Trier), *vi–vii*
Planners: Happy Day (Lewis), 75, *75*, 76, 78
Plan of War (Lewis), 77
*Portrait of the Art Dealer Alfred
 Flechtheim* (Dix), 115–16
*Portrait of the Journalist Sylvia Von
 Harden* (Dix), 115–16
postcubism, of Braque, 3
postexpressionism, of Dix, 112
postimpressionism, Nash and, 81
Poughon, Louis, 54, 57, 59
The Power of Music (Kokoschka), 170
pre- and postwar as terms, 70, 74–78
Priestley, J. B., 23
Princip, Gavrilo, 21
propagandistic images, 1
prosthesis
 in postwar art, 3, 11–12, 112–13, *113*, 174,
 177–78
 postwar ubiquity of, 9
psychological trauma
 and art of war, 3
 detachment as symptom of, 18–19
 of Graves, 18
 hidden, 9–10
 high incidence of, 3, 9, 19
 sources of, 7–8
 symptoms of, 9, 18
 treatment of, 19–20, 24–25n25
 See also detachment
psychotherapy, for combat neurosis, 19–20,
 24–25n25
The Pyramids in the Sea (Nash), 87n23

***Rain, Lake Zillebeke* (Nash),** *84*, 85
Rainer, Arnulf, 164
realism, of Dix, 108–10, 112, 115
reason, rapid cultural change and, 5, 10, 11
Red Duet (Lewis), 78
redemptive power of materials, in German
 Gothicism, 135
Red Tower in Halle (Kirchner), 121
Red Week (June 1914), 90, 95n13
Remarque, Erich Maria, 11, 49
Rembrandt van Rijn, 11
The Repast (Masson), *50*, 51
Republican Automatons (Grosz), 144
Reuter, Gabriele, 148
Le rêve (Zislin), *33*
revolution, spontaneous, myth of, 90, 94n6
Richmond, Sir William, 86n4
Richter, Gerhard, 23
Rilke, Rainer Maria, 167
Rivers, W. H. R., 24n21
Roberts, William, 86n9
Rock Drill (Epstein), 11
Rolland, Romain, 152
romanticism
 of Marc, 125
 of Nash, 80, 82, 83
Rosenberg, Léonce, 54
Rossetti, Dante, 80–81
Roubille, Auguste Jean Baptiste, *32*
royal mourning plays (*Trauerspiel*), 114
Rubin, William, 47, 48
Run Ration (Lewis), 73
Russian Revolution, avant-garde and, 142
Rutherston, Albert, 80–81

sacrifice, Kollwitz on, 148, 152
The Sacrifice (Kollwitz), 152
Sails in the Harbor (Carrà), *93*, 93–94
*Saint John's Vision of the Seven Candle-
 sticks* (Kirchner), 124, *124*
Salon I (Dix), 114, *115*
Sammy in Europe (Grosz and Heartfield
 film), 141–42
Sassoon, Siegfried, 15, 16, 17, 24n21
Savinio, Alberto (Andrea de Chirico), 92
Die Schammade (periodical), 130, 135
Scheerbart, Paul, 135
Schiefler, Gustav, 123
Schlemmer, Oskar, 172–78, *173*
 Bauhaus and, 173, 174, 175
 career of, 173, 175, 178
 dance work, 172, 174–75
 disfigured figures in, 3, 174, 175–78

exhibitions, 172–73
 unspoken influence of war on, 174–78
 wartime experiences, 3, 172, 178
 works by, 3, 172, 177–78
 See also *Triadic Ballet*
Schlichter, Rudolf, 140
Schmalhausen, Otto, 140, 141
Schmidt, Joost, 173–74
Schmidt-Linsenhoff, Viktoria, 146, 147
Schwerdtner, Carl Maria, *99*
Schwitters, Kurt, 172–73
sculpture, responses to war, 11
Self-Portrait (Kokoschka), *169*, 169–70
Self-Portrait as a Soldier (Dix), 110–11, *111*
Self-Portrait as a Soldier (Kirchner), 121, *122*
Self-Portrait during Illness (Kirchner), 125
self-portraits as soldiers
 of Dix, 110–11, *111*, 168
 of Kirchner, 119, *120*, 121, *122*, 124, 168
 of Kokoschka, *167*, 167–68
 of Moholy-Nagy, 160, *161*
Self-Portrait with Artillery Helmet (Dix),
 110–11
Self-Portrait with Carnation (Dix),
 108–10, *109*
Le semeur de fausses nouvelles
 (Damblans), *34*
September 11th terrorist attacks, 21
Severini, Gino, 90, 94nn8–9
Sex Murder (Dix), 114
shell shock. *See* psychological trauma
*The Shooting Down of a German Dirigible
 over London* (Orr), *43*
Siege Batteries Pulling In (Lewis, 1918,
 Manchester City Art Galleries), 72
Siege Batteries Pulling In (Lewis, 1918,
 private collection), 72
Signorelli, Luca, 78, 79n35
Le silence des peintres (Dagen), 63
Silver, Kenneth, 57, 61n9, 95n22
Simonds, Frank, 48–49
Simplicissimus (periodical), *102*, 104
Slade School of Fine Art, 80, 86n9
The Sleepwalkers (Clark), 21
Slow Attack (Lewis), 77, 78
Social Democratic Party (Germany),
 146, 148, 150, 151, 154
socialists, opposition to war, 8
social order, new, as goal of war, 1, 2, 3
social realism, of Dix, 112
Soffici, Ardengo, 91, 92, 95n22, 95n24
soldiers
 antiwar sentiment in, 8

soldiers (continued)
French, Léger on, 55, 57–58, *58*
Lewis's depictions of, 73
naive enthusiasm of, 1, 8
See also volunteers
Somme, Battle of, 9, 15, 45, 62–63, 150
Spencer, Stanley, 86n9
Staatliche Akademie für Kunst und Kunstgewerbe Breslau, 178
Staatliche Bauhaus, 173, 175
Stade, George, 15
Stern, Fritz, 21
Stieglitz, Alfred, 161–62
Still Life: Alarm Clock (Léger), 56–57
Still Life with Guitar I (The Mantelpiece—Waltz) (Braque), 67–68
Storm of Steel (Jünger), 16
Stravinsky, Igor, 6, 10
Stülpnagel, Otto von, 160, 162
Sturm gallery (Berlin), 130, 140
Stuttgart Akademie der bildenden Künste, 172
Summer Garden, *81*, 81–82
surrealism
Masson and, 3, 44, 52, 52n10
Nash and, 86
political component of, 52
as response to war, 10
Sykes-Picot Agreement, 21

tactile space, Braque on, 3, 62, 64–66, 68
Tag (periodical), 148
Les tanks (Damblans), *36*
Taut, Bruno, 130–31, 135, 136
technologies of war, new
artists' fascination with, 2
cubism as response to, 61n9
and disillusionment of soldiers, 7–8, 10
horrors of, 3, 7, 65
as shock, 1
technology, interwar, views on, 10, 12
technology and mechanization, prewar
artistic responses to, 6
cultural impact of, 4–6, 9, 10
volunteers' hope to escape, 7–8
Témoins (Norton Cru), 16
Texas Picture for My Friend Chingachgook (Grosz), 140
"To His Dead Body" (Sassoon), 15
Tolkien, J. R. R., 12
Tonks, Henry, 80

"Die Toten an die Lebenden" (Freiligrath), 152
Towers (Ernst), 128–29, *129*, 131
Towers of Laon (Delaunay), 128
Trakl, Georg, 166
La tranchée (Vallotton), *39*
The Trapese Artist (Carrà), 93
Trauerspiel (royal mourning plays), 114
Trees in Bird Garden (Nash), 80
The Trench (Dix), 108, 116
Triadic Ballet (Schlemmer), 3, 172, 174–78
characters and costumes, 175–77, *176*, *177*, 178
structure of, 175
Trier, Walter, *vi–vii*
"Tubular Settlement or Gothic" (Baargeld), 132–33
Tuchman, Barbara, 21, 22
Tutein, Helena "Tut," 176
"Two Fusiliers" (Graves), 23

Uccello, Paolo, 74
Under Fire (Barbusse), 16, 49
Undertones of War (Blunden), 16
unions, prewar cultural change and, 6
Unterrichtsanstalt (Berlin), 139–40
Untitled (Sitting Female Nude) (Grosz), *139*, 139–40

Vallier, Dora, 63
Vallotton, Félix, *39*
van de Velde, Henry, 173
van Gogh, Vincent, 110
Vegetation (Ernst), 128
Der Ventilator (periodical), 136
Verbindung für historische Kunst, 146
Verdet, André, 63
Verdun, *viii*, 57, 59, 61n15
"Vergleichung" (Ernst), 129–30
Le Vieil-Armand (Hartmannswillerkopf) (Grandgérard), *37*
Le visage de la victoire (De Groux), *28*
volunteers, motives of, 7–8, 9
The Volunteers (Kollwitz), 152, *153*
"Von Werden der Farbe" (Ernst), 129
vorticism, 2, 71, 84
Vorwärts (periodical), 150

Walden, Herwarth, 167, 168, 172
Walden, Nell, 168
Walking Wounded (Lewis), 74
war
and artistic production, 70

causes of, 22
pleasures within, 49
War (Kollwitz), 152–54, *153*
The War (1924 series, Dix), 11, 108
The War (1932, Dix), 108
"War and Art" (Carrà), 91
The War Cripples (Forty-Five Percent Fit for Work) (Dix), 112–13, *113*
War in the Adriatic (Carrà), 91, *91*
wartime experiences
difficulty of capturing, 7, 11, 17, 23
impact on artists, 4
The Way Home (Beckmann), *105*
We Are Making a New World (Nash), 85
Weavers' Revolt (Kollwitz), 146
Westheim, Paul, 112
Whyte, Iain Boyd, 131
Wilhelm II (emperor of Germany), *31*, 140
Winter, Jay, 16
Wittgenstein, Ludwig, 166
Woman in Blue (Kokoschka), *169*, 170
women
Dix's depictions of, 114
German postwar pacifism and, 154
Kollwitz's portrayals of, 146–48, 154, 154n5
women's movement, prewar change and, 6
World War I
avant-garde and, 10, 88
casualties in, 21
ceasefire agreement, 128
cultural changes prior to, 4–6
cultural figures serving in, *180–85*
historical fissure created by, 23, 70–71
historical repercussions of, 21
as time of creativity and destruction, 70
Worringer, Wilhelm, 133, 134–35
"Worringer, Profetor Dadaisticus" (Ernst), 135

zeppelins, *43*, *161*, 161–62
Zimmermann, Wilhelm, 146
Zislin, Henri, *33*

Other books published by the Getty Research Institute

Los Angeles Union Station
Edited by Marlyn Musicant, with contributions
by William Deverell and Matthew W. Roth
ISBN 978-1-60606-324-8 (hardcover)

Chatting with Henri Matisse: The Lost 1941 Interview
Henri Matisse with Pierre Courthion
Edited by Serge Guilbaut
Translation by Chris Miller
ISBN 978-1-60606-129-9 (hardcover)

Las Vegas in the Rearview Mirror:
The City in Theory, Photography, and Film
Martino Stierli
Translation by Elizabeth Tucker
ISBN 978-1-60606-137-4 (paper)

Overdrive: L.A. Constructs the Future, 1940–1990
Edited by Wim de Wit and Christopher James Alexander
ISBN 978-1-60606-128-2 (hardcover)

Surrealism in Latin America: Vivísimo Muerto
Edited by Dawn Ades, Rita Eder, and Graciela Speranza
ISBN 978-1-60606-117-6 (paper)

Farewell to Surrealism: The Dyn *Circle in Mexico*
Edited by Annette Leddy and Donna Conwell
ISBN 978-1-60606-118-3 (paper)

Pacific Standard Time: Los Angeles Art, 1945–1980
Edited by Rebecca Peabody, Andrew Perchuk,
Glenn Phillips, and Rani Singh, with Lucy Bradnock
ISBN 978-1-60606-072-8 (hardcover)

Modern Japanese Art and the Meiji State:
The Politics of Beauty
Dōshin Satō
Translation by Hiroshi Nara
ISBN 978-1-60606-059-9 (hardcover)

Brush & Shutter: Early Photography in China
Edited by Jeffrey W. Cody and Frances Terpak
978-1-60606-054-4 (hardcover)

G: An Avant-Garde Journal of Art, Architecture, Design,
and Film, 1923–1926
Edited by Detlef Mertins and Michael W. Jennings
Translation by Steven Lindberg with Margareta Ingrid
Christian
ISBN 978-1-60606-039-1 (hardcover)

Visual Planning and the Picturesque
Nikolaus Pevsner
Edited by Mathew Aitchison
Introduction by John Macarthur and Mathew Aitchison
ISBN 978-1-60606-001-8 (hardcover)

Meyer Schapiro Abroad: Letters to Lillian
and Travel Notebooks
Edited by Daniel Esterman
ISBN 978-0-89236-893-8 (hardcover)

California Video: Artists and Histories
Edited by Glenn Phillips
ISBN 978-0-89236-922-5 (hardcover)

The Getty Research Institute Publications Program
Thomas W. Gaehtgens, *Director, Getty Research Institute*
Gail Feigenbaum, *Associate Director*

Published by the Getty Research Institute, Los Angeles
Getty Publications
1200 Getty Center Drive, Suite 500
Los Angeles, California 90049-1682
www.getty.edu/publications

Lauren Edson, *Manuscript Editor*
Jim Drobka, *Designer*
Stacy Miyagawa, *Production Coordinator*
Printed in the United States of America
Type composed in Sentinel, Bau, and Berthold Akzidenz Grotesk
18 17 16 15 14 5 4 3 2 1

Library of Congress Cataloging-in-Publication Data
Nothing but the clouds unchanged : artists in World War I / edited
by Gordon Hughes and Philipp Blom.
 pages cm
 Includes bibliographical references and index.
 ISBN 978-1-60606-431-3
1. World War, 1914–1918—Art and the war. 2. World War, 1914–
1918—Influence. 3. War artists. 4. War in art. I. Hughes, Gordon,
1965– editor. II. Blom, Philipp, 1970– editor.
 N8260.N68 2014
 709.04'1—dc23
 2014016079

Hardcover: Max Fröhlich (German). Detail of *Let There Be War.*
From *Die Front: Kriegsausgabe von Licht und Schatten* 5,
no. 12 (1915): n.p. See plate 22.

Frontispiece: Otto Dix (German, 1891–1969). Detail of *Self-
Portrait as a Soldier*, 1914. See Biro, fig. 2.

This volume accompanies a related exhibition titled *World War I:
War of Images, Images of War,* on view at the Getty Research
Institute from 18 November 2014 to 19 April 2015 and the
Mildred Lane Kemper Art Museum at Washington University
in St. Louis from 11 September 2015 to 4 January 2016.